D1288286

EARLY ROCK ART
OF THE AMERICAN WEST

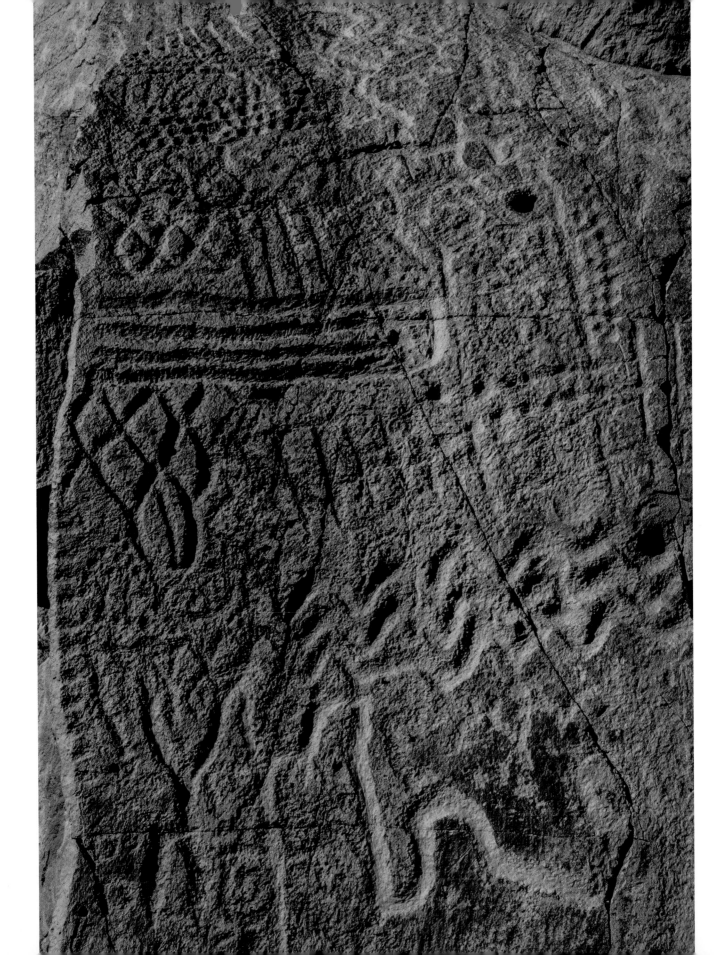

EARLY ROCK ART
OF THE AMERICAN WEST

THE GEOMETRIC ENIGMA

*For Nita Moore,
a most compatible seat-mate
on our unforgettable expedition
to Fumane. I'm very glad to
have got to know you.
Ellen Dissanayake
IFRAO - 2018
Torino o Valcamonica
Italy, August 31*

EKKEHART MALOTKI

ELLEN DISSANAYAKE

UNIVERSITY OF WASHINGTON PRESS
Seattle

Early Rock Art of the American West was made possible in part by generous gifts from Nancy Aiken, Dorothée and Horst Antes, Peter Blystone, Nina Bowen, Betsy and John Darrah, Harold Fromm, the Bertram S. and Ruth M. Grand Charitable Gift Foundation, Carter Hagerman, Joseph and Karen Hendrickson, Jim I. Mead, Keith and Pieter Schaafsma, Roger Seamon, Christina Singleton, Charles and Susan Routh, Pat Soden, and Marilyn Trueblood.

Copyright © 2018 by the University of Washington Press
Printed and bound in South Korea
Design by Laura Shaw Design
Composed in NCT Granite, typeface designed by Nathan Zimet; and Intro Rust, typeface designed by Ani Petrova, Svet Simov, and Radomir Tinkov
22 21 20 19 18 5 4 3 2 1

All rights reserved. No part of this publication may be reproduced or transmitted in any form or by any means, electronic or mechanical, including photocopy, recording, or any information storage or retrieval system, without permission in writing from the publisher.

Photographs are by Ekkehart Malotki unless otherwise noted.
Frontispiece: Classic Carved Abstract Style petroglyphs from Arizona, exemplifying the earliest rock markings of the American West

University of Washington Press
www.washington.edu/uwpress

Library of Congress Cataloging-in-Publication Data
Names: Malotki, Ekkehart, author. | Dissanayake, Ellen, author.
Title: Early rock art of the American west : the geometric enigma / Ekkehart Malotki and Ellen Dissanayake.
Description: Seattle : University of Washington Press, 2018. | Includes bibliographical references and index. |
Identifiers: LCCN 2017050791 (print) | LCCN 2017051145 (ebook) | ISBN 9780295743622 (ebook) | ISBN 9780295743608 (hardcover : alk. paper) | ISBN 9780295743615 (pbk. : alk. paper)
Subjects: LCSH: Indians of North America—West (U.S.)—Antiquities. | Petroglyphs—West (U.S.). | Picture-writing—West (U.S.) | Rock paintings—West (U.S.) | West (U.S.)—Antiquities.
Classification: LCC E78.W5 (ebook) | LCC E78.W5 M27 2018 (print) | DDC 709.01/130978—dc23
LC record available at https://lccn.loc.gov/2017050791

The paper used in this publication is acid-free and meets the minimum requirements of American National Standard for Information Sciences—Permanence of Paper for Printed Library Materials, ANSI Z39.48–1984. ∞

TO ALL THE PALEOAMERICANS, WHOSE PRICELESS LEGACY OF ROCK ART
OFFERS US AN EVER-PRESENT SOURCE OF MYSTERY AND MARVEL

CONTENTS

ACKNOWLEDGMENTS

EKKEHART MALOTKI

Reflecting on how this book came to be, I see the fortuitous conjunction of several factors and events. Communing photographically with rock art sites and trying to capture the essence of petroglyphs and pictographs in their surroundings has been a passion of mine for many years. After completing my comprehensive overview of Arizona's wealth of rock art in 2007, I felt the need for a new undertaking that would allow me to roam the desert-, mountain-, and canyon-scapes of the American West in search of rupestrian paleoart.

Two years earlier I had experienced an unforgettable high in my rock art life when, in the company of French prehistorian Jean Clottes, I had the great privilege of standing in front of the fabulous Ice Age bestiary of Grotte Chauvet-Pont d'Arc. Marveling at the breathtaking images, I was struck by the fact that such naturalistic depictions, with a few exceptions, appeared to be completely absent at any of the earliest rock art sites in the American West. Surely we can assume that the first Paleoamericans arrived on a continent teeming with Pleistocene megafauna. If so, why had they refrained from painting or engraving images of these animals, some of which they depended on for food, and others that were dangerous and had to be feared? Why did they choose instead, almost exclusively, to make purely abstract-geometric motifs? These questions seemed worth probing.

Furthermore, what accounted for the uniformity of all those archetypal geometric designs? Similar motifs have been found on every continent, with the exception of Antarctica. Was it thinkable that all of them were created by trancing shamans, as advocated by David Lewis-Williams? Disenchantment with this explanatory hypothesis had already taken root in me while considering and discussing Arizona's geometric paleoart. In addition, I now also had the opportunity to observe my grandson, Emil, as his drawing behavior developed like that of all young children. He certainly was not

a little shaman, experiencing an altered state of consciousness as he created his dots, lines, and circle elements. What inspired him to do so?

I meanwhile had also been exposed to two eye-opening publications, *What Is Art For?* and *Homo Aestheticus: Where Art Comes From and Why*, by Ellen Dissanayake. Ellen is hard to label. An interdisciplinary scholar, she bases her ideas on knowledge derived from the fields of ethology, evolution, cultural anthropology, neuroscience, developmental psychology, theory and practice of the various arts, and now, for this book, paleoarchaeology and cognitive archaeology. Her insight that art is an innate behavior that had been critical in the evolutionary process of human survival, sparked in me a flash of comprehension tantamount to an epiphany. Ellen first defined artful behavior as "making special" and later coined the term "artifying" as a more academically acceptable synonym. This concept offered a useful, all-encompassing framework for considering the multitude of iconographic expressions of the rock art I knew. Among the tens of thousands of impressive paintings and engravings that populate the western landscape, there are a million more that do not meet the modern art criteria of beauty and outstanding aesthetic appeal, but which nevertheless demonstrate artful behavior, or "artifying." Here was an epistemological approach that would be useful in dealing with the abstract paleoart of the American West—an approach that regarded rock art not as something to be viewed like paintings in an art gallery but understood as the residue of ceremony and ritual in which performance (doing and making) mattered more than the resulting graven or painted image.

Encouraged by the fact that Ellen had agreed to read my manuscript on Arizona's rock art and then actually wrote a blurb for the book, I offered to introduce her, who had visited some of the well-known French caves including Lascaux, to the world of open-air rock art by taking her to some of my favorite petroglyph and pictograph sites in northern Arizona. The rest is history, and the results are reflected in the individual chapters of this book. The decision to collaborate on the book would provide Ellen, as one concerned with the arts of all kinds in all times and places, with the opportunity to delve into a new field, rock art. For me it would be an opportunity to indulge in my favorite pastime: the pursuit of rock art research and photography. Clearly, during the past three decades, some of the happiest hours of my life were spent engaging photographically with a newly discovered rock art painting or engraving. Such "close encounters" with rupestrian images were further enhanced when I was joined by friends who shared my enthusiasm. One of my most memorable occasions of this kind occurred when I was able to introduce my son Patrick, his wife, Julia, and my two grandchildren, Emil and Annelie, to Utah's Upper Sand Island panel with the two exceptional mammoth depictions.

In developing the book, the task of writing about most archaeological aspects and observations fell to me, and Ellen was eager to apply some of her concepts about the arts in general to mark-making and rock art. The terms "to artify," "artification," and "artifier" are now so ingrained in my rock art vocabulary that I find it almost impossible to discuss the topic of paleoart without using them. Many friends who have shared my

rock art ventures and heard my lectures over the years have been equally taken with the usefulness of these concepts. We therefore hope that the terms will also be found appealing to some of our readers, both aficionados and professionals, who make up the rock art community at large.

This book would not exist without Ellen's unique perspective on the arts. What I instigated, she brought to fruition as my mentor, colleague, and friend. For this I am profoundly grateful to her.

With regard to the field work aspect of our collaborative undertaking which, during the course of eight years, would take me beyond the familiar Four-Corner states of Arizona, Utah, Colorado, and New Mexico all the way to California, Nevada, Oregon, Idaho, and Texas, I was most fortunate to be aided and encouraged by a great many people in a variety of ways.

While most nights in the field I spent car-camping in my Tacoma truck, on a number of occasions I was able to rely on the hospitality of friends who offered me, often more than once, the comfort of a guest room to use as a base for my photographic pursuits. In this regard, I owe heartfelt thanks to John and Susan Anderson of Reno, Nevada; Michael and Mari Barnard of Tijeras, New Mexico; Jasper and Laura Blystone of Lone Pine, California; Jon and Sue Gum of St. George, Utah; Ken Husted of Lyden, New Mexico; Dale and Carmen Johnson of Taos, New Mexico; and Don and Gayle Weyers of Ajo, Arizona.

For greatly appreciated companionship during rock art excursions into remote areas, which frequently included the offer to guide me to a particular site and/or also relieve me of the tedium of driving, I would like to express my sincere gratitude to Brent Abel, Ilona Anderson, Michael Barnard, Mike Baskerville, Bill Baxter, Phil Blacet, Peter Blystone, Terry Burgess, Ned and Edna Clem, Richard Colman, Bill Davis, Lila Elam, Ann Fulton, Patrick Grant, Jon and Sue Gum, Richard Hammer, Mark Henderson, Winston Hurst, Eric Iseman, Carmen Johnson, Steve Kline, Wesley Layman, Larry Midling, Frank Oatman, Glenn Omundson, Brian Ouimette, Reeda Peel, Robby Pond, Eric Ritter, Annie Robertson, George Rudebusch, Noah Stalvey, Karl Stein, Scott Thybony, Faith Walker, and Paul Wilson.

I am also much indebted to all those who generously shared site information in the form of maps, GPS coordinates, photos, and literature: Brent Abel, Tom Bicak, Pamela Baker, Carl Bjork, Candie Borduin, Penni Borghi, Nina Bowen, Don Christensen, Art Cloutier, Richard Colman, Tonya Fallis, Richard Ford, Bob Forsyth, Suzie Frazier, Phaedra Greenwood, Gary Grief, John Gunn, Ed Healy, Cliff Hersted, Leslie James, Boma Johnson, Richard Lange, Andy Laurenzie, Daniel Leen, Farrel Lytle, Janet McKenzie, Trudy Mertens, Russel Micnhimer, Carolynne Merrell, Inga Nagel, Bill Nightwine, Breck Parkman, Shelley Rasmussen, Dixon Spendlove, Susan Rigby, David Rigsby, Kevin Smith, Solveig Turpin, David Sucec, Tom Tynan, Katherine Wells, Paul Williams, Gordon Zittig, and Beatrice Zueger.

In addition to my own photographic work, numerous friends and colleagues contributed much appreciated pictures or drawings that greatly expanded the visual scope

of our work. Although credited for their valuable contributions in the captions, they deserve to be listed here too: Stephen Alvarez, Douglas Beauchamp, Carl Bjork, Peter Bostrom, Jean Clottes, Richard Colman, George Crawford, Leslie Davis, Stewart Finlayson, Harald Floss, Stephanie Fysh, François Gohier, Andrew Hemmings, Eric Iseman, Maureen MacKenzie, Robert Mark, Alva Matheson, Brian Ouimette, Breck Parkman, Mary Ricks, Paul Roetto, Todd Surovell, Pierre-Jean Texier, Philip Van Peer, Clark Wernecke, Mark Willis, and Ron Wolf. In addition, Douglas Beauchamp, Brian Ouimette, and Paul Wilson deserve to be singled out for going out of their way to visit specific rock art sites on our behalf and provide us with quality images that we would otherwise not have obtained. In passing we need to mention that because of the vulnerability of open-air rock art sites, we have not provided information on their locations beyond their occurrence in a particular state. This also pertains to sites whose names are established and whose whereabouts are in the public domain.

Always available as resonant sounding boards were my friend Ken Gary and his wife, Ann. As a first line of "editorial vetting" they never tired of reacting to my writings, and with keen attention to detail suggested innumerable useful criticisms and/or improvements. For their generous rendering of this service far beyond the bonds of friendship, I extend my deepest thanks. It was their input, then, that gave me the confidence to pass my thoughts on to Ellen, who in turn left her editorial imprint. A couple of chapters have also profited from critical remarks by Douglas Beauchamp, Peter McIntosh, Ulla Haselstein, and Harold Fromm, who are hereby gratefully acknowledged.

As emeritus at Northern Arizona University, where I spent my entire academic career, I enjoyed the ongoing support of my old department, recently renamed Global Languages and Cultures. In particular I wish to thank Michael Vincent, dean of the College of Arts and Letters, for providing technical assistance through the facilities of the Emeriti Office. Cyber issues that required serious trouble-shooting and occasional upgrades of my hardware and software were professionally addressed and solved by the Help Desk staff and other individuals at NAU's Information Technology Services. The university's Interlibrary Loan department, over the years, procured literally hundreds of journal articles and books for me without which I could not have accomplished my research. To each and every one of those librarians, even if not personally known to me, I owe my sincere thanks. Finally, a special thank-you to Russ Gilbert at the School of Communication for high-end scanning of some of my slides.

ELLEN DISSANAYAKE

Had I been told in mid-2006 that I would soon be invited to collaborate on writing a book about rock art (and its basis in the fields of paleoarchaeology and cognitive archaeology), I would have been both astonished and dubious. A surprise telephone call from a stranger with a German accent led to our eventual meeting in Flagstaff in October 2007, where we made an eye-opening rock art circuit, and discussed the possibility of my collaboration with him on the book. At that time I had other obligations, but in March 2009, I visited with Ekkehart again. In addition to his enthusiasm and persuasive ways, three others who were there—Ken Gary, Ann Gary, and Henry Wallace—helped me to appreciate what my approach could contribute to such a project. I took the risk and signed on.

My first and deepest thanks must go to Ekkehart (who might well have been named "Rokke Art") for his belief in me, the opportunity to expand my ideas about artification into an unfamiliar and rewarding realm, and for his patience as I learned about these new fields from him. We brought very different gifts and personalities to the project, which somehow were negotiated with surprising grace on both sides.

My other acknowledgments are few, since Ekkehart was the facilitator of this mega-project with a cast of thousands. Like him, I wish to honor the advice and help that was always forthcoming from Ann and Ken Gary. As always, I am ever indebted to the late John Eisenberg, from whom I learned about ethology and evolution, the late S. B. Dissanayake, who for fifteen years shared with me everyday life in Sri Lanka, and the late Joel Schiff, who always took an abiding interest in my incipient ideas about human behavior and their realization in print. My three siblings, Richard Franzen, Elizabeth Ratliff, and Susan Anderson, and my two children, Karl Eisenberg and Elise Forier Edie, are indelible parts of my history. I have relied overmuch on their indulgence and welcomed their affection.

James Chisholm carefully read and commented on a longer version of chapter 7. Marialuisa Ciminelli directed me to research on the Jarawa for chapter 6. Ted Grand has been a generous and like-minded friend since we first met in Madagascar in 1966.

Ekkehart and I both acknowledge with thanks the two outside reviewers of our manuscript, who read it with expertise and care, giving us encouragement when needed and helpful suggestions where necessary.

It is with the greatest satisfaction that I publish for the fourth time (in the span of thirty years) a book with the University of Washington Press. Only one of the original staff is still there—our acquiring editor, Lorri Hagman. Her tact, thoughtfulness, and enthusiasm for our project, and meticulous editorial directing is much appreciated. Pat Soden and Marilyn Trueblood, the director and managing editor, respectively, when I published my third book, have been and remain staunch supporters of my work. The late and legendary Naomi Pascal, editor in chief at the press for many years, took a chance on an unknown scholar in 1985, when she persuaded the Editorial Board to accept my first book—thereby launching my career. Current staff members at the press

have carried on their good work—we mention specifically Julie Van Pelt, Margaret K. Sullivan, Katrina Noble, Laura Shaw, Beth Fuget, and copyeditor Ellen Wheat.

———

It was necessary to find donors to contribute to the cost of reproducing the approximately 200 images in color. We are indebted beyond measure to the generosity of Peter Blystone and Christina Singleton. We also gratefully acknowledge gifts from Pat Soden and Marilyn Trueblood, Nina Bowen, the Bertram S. and Ruth M. Grand Charitable Gift Foundation, Dorothée and Horst Antes, Roger Seamon, Keith and Pieter Schaafsma, Nancy Aiken, Betsy and John Darrah, Harold Fromm, Jim I. Mead, Carter Hagerman, Joseph and Karen Hendrickson, and Charles and Susan Routh.

EARLY ROCK ART
OF THE AMERICAN WEST

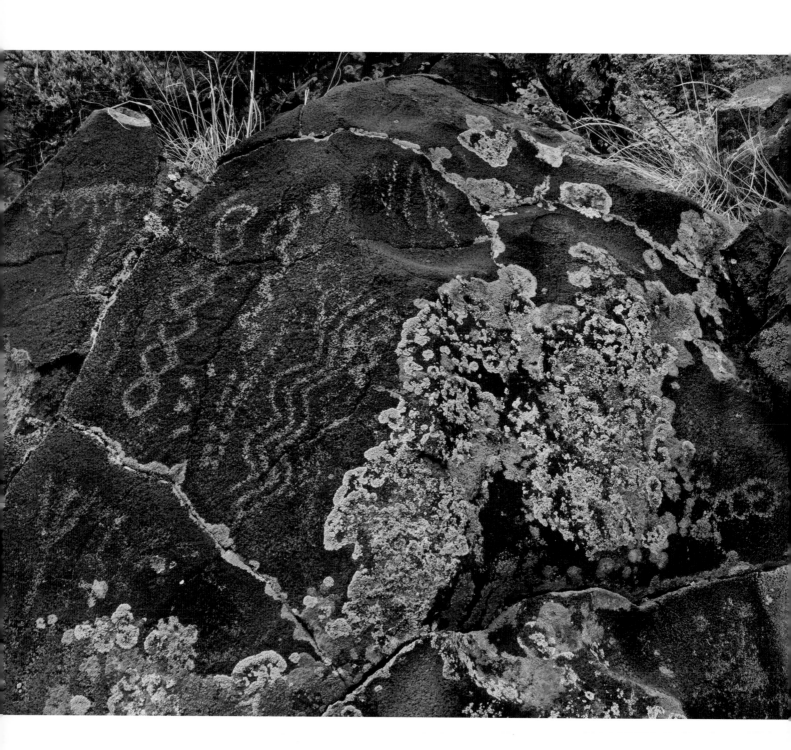

INTRODUCTION

EKKEHART MALOTKI AND ELLEN DISSANAYAKE

SINCE THE 1870S, when for the first time cave paintings were discovered in Spain, humankind has become aware that skilled artists were at work centuries before pyramids were built in Egypt or temples erected in Greece and Rome. Who would have dreamed that hidden deep underground were unknown masterpieces from the prehistoric past, majestic and lifelike animals painted on cave walls by people like ourselves? It is not surprising that these relics of the Ice Age have captured the imagination of everyone who hears about their existence or sees their images in books, magazines, or films. They are the celebrities—the "rock stars"—of rock art.

In this book, we deal with a very different kind of rock art—one that depicts nothing from the natural world. Rather than lying dormant for millennia and protected in sealed sanctuaries like the famed Ice Age paintings of powerful animals, most of the images we portray here are "abstract" or "geometric"—carved, pecked, hammered, or painted on inert stone, outdoors, and then left exposed to sun, wind, and rain. Even though this art is abundant in the American West, it has not attracted much attention from the general rock art community, since it lacks the emotional appeal and possibilities of interpretation of the more popular figurative markings. As one scholar has observed, hunter-gatherer imagery is "often overlooked because of its 'abstract' quality; it fails to meet our biased expectations of prehistoric rock art. Additional prejudice [exists] against Archaic art because it is not 'pretty' like later Puebloan styles."[1]

We hope to demonstrate just how enigmatic and worthy of appreciation abstract-geometric marks are. Although in the New World the oldest marks date from the final stages of the Late Pleistocene (currently believed to be at least 13,000 or 14,000 years ago), they join a body of much older parietal art across the globe that all together, along with portable art, provide some of the earliest surviving evidence of human cultural activity wherever it is found. To be sure, some hand axes are more than a million and a

I.1 (*opposite*) Basic geometric motifs of the Western Archaic Tradition: meanders, random dots, connected circles, a sawtooth element, a diamond chain, and a trident-shaped design, New Mexico

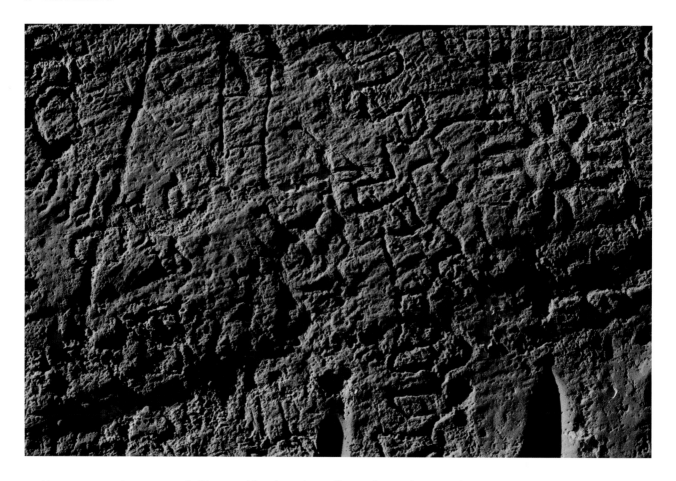

I.2 Abstract-geometric primitives, including a deeply carved and heavily revarnished starburst, Utah

half years older than the earliest paleoart, but cupules and geometric incisings precede other indications of antiquity, such as burials and hearths.[2]

Before going further in our study, some perhaps troublesome matters need clarification. To begin with, this general body of anthropogenic marks does not even have an agreed-upon comprehensive name. In addition to descriptive adjectives such as geometric, abstract, noniconic, or nonpictorial—used everywhere—more general terms have been tried. In the New World context, the marks have understandably been called "archaic," although by archaeological measures the Late Pleistocene starting point is relatively recent. In addition, we find the word "archaic" to be misleading because, in some areas of the American West, the markings remained more or less the same from their earliest occurrence until the arrival of Euro-Americans, when they coexisted alongside later iconic (figurative) marks.

For the sake of clarity, we will sometimes use the well-established overall descriptive label "Western Archaic Tradition" (WAT, for convenience), and generic terms such as (paleo)mark, (paleo)design, or simply paleoart, as well as the descriptors noniconic, nonfigurative, and nonrepresentational.[3] These all refer to the same thing. In this book we often use terms that are common to anthropology, archaeology, and various other disciplines; these are explained in a glossary at the back of the book.

Even the term "abstract" is freighted, having a range of meanings and connotations that are not always clear. Unlike many rock art scholars, we do not assume or suggest that an "abstract" mark is either more or less sophisticated than a representational one. For us, "abstract," like "noniconic," is a neutral term, used in contrast to "representational," even though some abstract marks may "represent" an idea or thing. Ultimately, in our opinion, the "meaning" or cognitive status of abstract-geometric paleoart is an enigma.

Another point of interest is whether (or how) human-made geometric markings are different from naturally occurring geometric shapes, such as the crystalline structure of quartz, honeycombs, snowflakes, tree rings, sand ripples, and so forth.[4] Perhaps, like the Catalan architect Antoni Gaudí, humans actually copied or adapted shapes from the regularities they saw in nature—the geometric weavings of spiderwebs, the linear strata in rock walls, or the spiral new-growth tips of ferns. Few natural geometric forms are strictly geometric, as if drawn with a compass and ruler, but then few human-made marks are either. In chapter 1, where the hypothesis is introduced, we describe universal "aesthetic operations" that humans use to "artify" in any medium, including making marks on rock, bodies, tools, or other surfaces. These operations (which include formalization, repetition, and elaboration) tend to result in abstract-geometrics, which in most cases set them visually and emotionally apart from marks made by physical forces or nonhuman creatures.

Although abstract-geometric designs preceded figurative art, they have continued to exist in a variety of modes: fully integrated into naturalistic depictions, as counterpoints or complements to representational motifs, or as singular aesthetic statements. One can find a high level of sophisticated abstraction and geometric complexity in some of the meticulously orchestrated designs on artifacts such as pottery, basketry, and weavings that were produced 800 to 1,000 years ago by some of the ancestral groups of present-day Pueblo Indians.[5] Similar highly developed and carefully crafted geometric arrangements of these designs may occur, often in splendid isolation, at more recent rock art sites in the form of petroglyphs and pictographs.[6] However, such elaborate ornamental renderings are not the focus of our work (figs. I.3–I.5). Our main emphasis, instead, is devoted to the early, more rudimentary nonfigurative markings that populate rock surfaces of the natural landscape in a generally haphazard manner.

Numerous archaeologists have suggested that the vast majority of known prehistoric rock art consists of noniconic markings. Specifically, in regard to Ice Age art in Europe, Robert Bednarik claims that "an estimated more than three-quarters of the graphic [Ice Age] art is non-figurative."[7] Obviously, there is no way to fact-check this figure. As prehistorian Jean Clottes points out, quantification of iconic versus noniconic images ultimately depends on the counting method.[8] To make his point he refers to one of the panels in Chauvet-Pont d'Arc Cave, which consists of more than 200 dots made with the palm of the hand. Clearly, the result will differ if the grouping is counted as one coherent motif or each dot individually. According to archaeologist Paul Bahn, nonfigurative Paleolithic markings "are two to three times more abundant than figurative, and in some areas far more."[9]

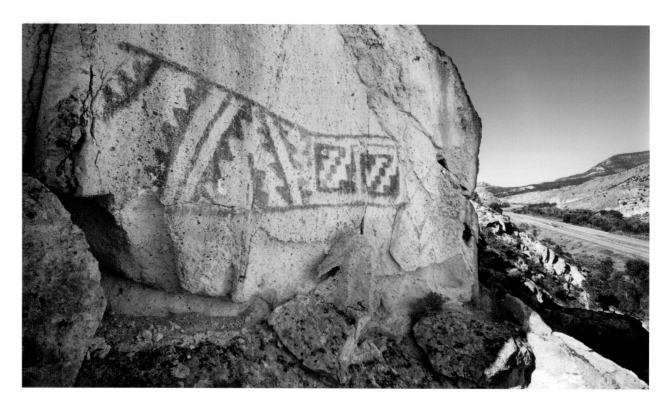

I.3 (*top*) Large Fremont-style pictograph, featuring terraced and serrated diagonals, Utah. Overall length, 3.2 m. *Photograph courtesy of François Gohier.*

I.4 (*right*) Intricate curvilinear Hohokam-style petroglyphs, Arizona

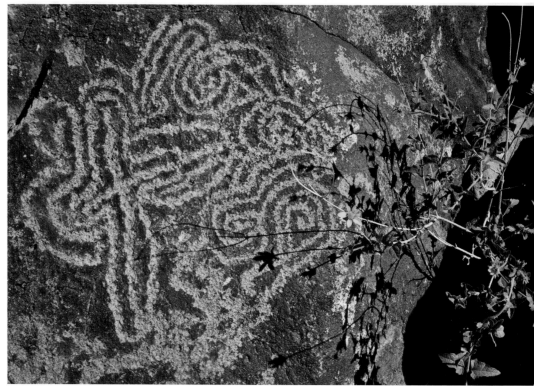

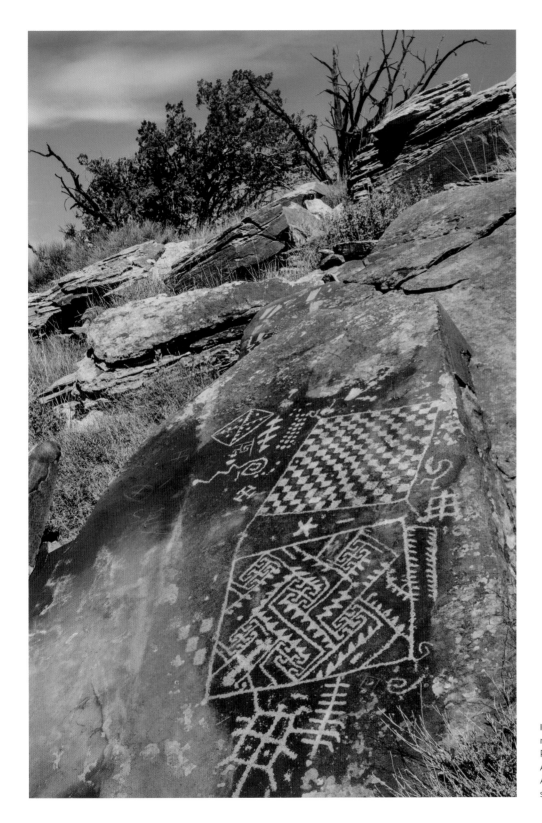

I.5 Sophisticated rectilinear Ancestral Puebloan (formerly Anasazi) engravings, Arizona. Width of bottom square, 51 cm.

Although it is impossible to count every documented instance, we can nevertheless say, in agreement with a growing number of rock art scholars, that abstract-geometric marks represent the majority of rock art worldwide.[10] Paul Bahn, for example, stresses that "apparently non-figurative art—motifs which convey nothing to our eyes other than patterning—has existed from the beginning,"[11] and neuroarchaeologist Derek Hodgson sees the genesis of art with a discernible trend from pre-representational or proto-art phases to eventual representation.[12] For educator and writer Susan Sheridan, the trend reflects the point that is summed up in the phrase "[ontogeny] recapitulates phylogeny."[13] While readily conceding that ontogeny also modifies phylogeny, she concludes that "early hominins scribbled first, drew schematically second, and then developed observational/representational drawing." This global evolutionary trend of art from schematization to naturalism is clearly mirrored in the natural unfolding of children's drawings.[14]

In addition to their quantity, geometric marks are almost unbelievably ancient—with some being made by our remote ancestors in the Lower Paleolithic era (ending about 180,000 years ago) and continuing through the Middle Paleolithic (ending about 40,000 years ago) and Upper Paleolithic (ca. 40,000 to 10,000 years ago), when they became more complex and widespread, even accompanying (and outnumbering) representational images in caves and elsewhere. In contrast, most figurative markings—with a few exceptions—begin to appear only in the Late Upper Paleolithic (ca. 15,000 years ago) and continue through the Holocene (ca. 10,000 years ago and after) to recent times.[15] If human mark-making were an activity that had a trajectory of sixty minutes on a clock face, the pictorial cave paintings would enter the scene at about four minutes before the hour.

People wonder why the Ice Age animals were painted, what purpose they served. The same question can be asked of noniconic shapes. Moreover, although the marks have attracted the interest of a small number of archaeologists, the human behavior of which they are the residue—mark-*making*—has received almost no attention. Worldwide, abstract-geometric marks are remarkable for being *persistent* (enduring in time and recurring over time and space), *consistent* (having similar style and content wherever on Earth they are found), and *resistant* (to change over time and to change in the individuals or cultures that created them).

Perhaps because simple noniconic rock markings do not enjoy the subterranean mystique of the cave menageries, their existence both in the Americas and elsewhere remains little known among the general public. Despite their abundance and often striking appearance, abstract-geometric petroglyphs and pictographs may seem stolidly mundane and uninteresting compared to their coddled famous cousins in France and Spain. We believe, however, that as a phenomenon they deserve book-length treatment. For their intriguing designs, the native peoples of this continent used as marking surfaces not only canyon walls, rock outcroppings, boulders, and the inside of rock shelters but also mammoth ivory, bone, and stone. The images are often so complex and

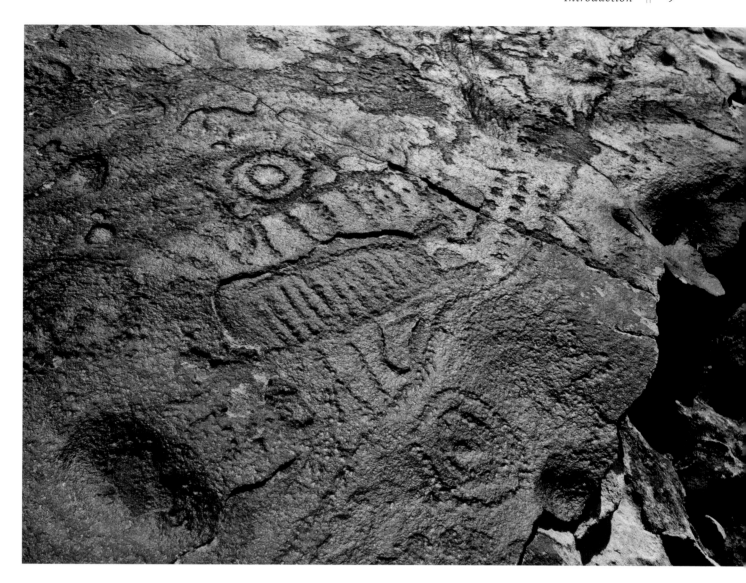

arresting that a book of photographs that simply reveals them to the world would be significant in itself.[16]

In addition to offering photographic documentation throughout this book, we draw upon a large body of research by specialists in order to describe and discuss these WAT paleomarks comprehensively—for the first time in one volume—with regard to terminology, chronology, and dating and the range of abstract-geometrics. We treat cupules (fig. I.7), the presumably oldest marks both in the Americas and the world, as abstract-geometrics, although many scholars think of them simply as curiosities, if they think of them as rock art at all.

We are also intrigued by more speculative and theoretical issues about mark-making. Most lovers of rock art understandably want to know what ancient abstract-geometric

I.6 Assortment of noniconic engravings, showing same degree of patination as the parent rock, Utah

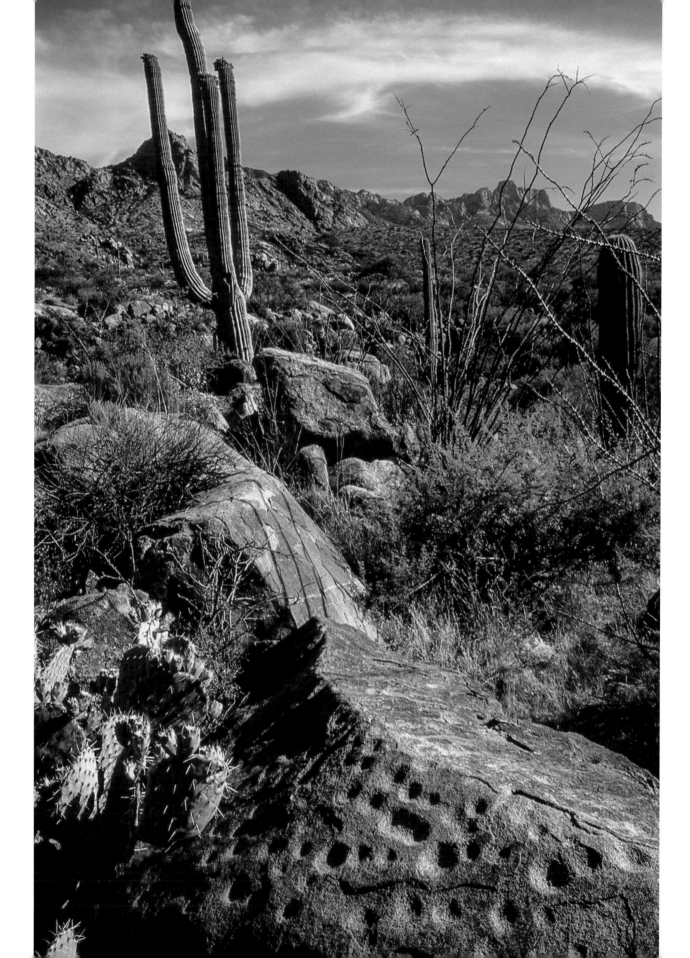

designs "mean." In some cases, ethnographic information offers definitive cultural meaning for an individual group, as when in the eyes of the present-day Hopi Indians of Arizona, zigzags are understood to portray lightning and spirals are seen as symbols of their multiple migrations in the past. Nevertheless, we believe that questions of specific meaning—even in representational rock art—are largely unanswerable. One of the major (and controversial) themes of our book is that the assumption that any human mark is evidence of symbolic cognition should be reexamined and that the overemphasis on the intellectual development of early humans ignores other important affective (emotional) components of their responses to their physical and social environments and their motivations to make marks. We even claim that in many cases marks may have been made without symbolic intent at all.

The subtitle of our book refers to three enigmatic questions that are hidden in abstract-geometric paleomarks, both in the American West and elsewhere. Generally, why are the earliest markings everywhere in the world geometric? In particular, with regard to the American West, why are the earliest petroglyphs also geometric—even though the first arrivals to the continent were as cognitively modern as other human populations who were already making representational images of animals? And again, generally, why did humans begin to make marks on rock surfaces in the first place? We touch on these questions here and there throughout the chapters of the book, and confront them again in the conclusion—even though ultimately we remain unable to resolve them.

The new concept, artification, the subject of chapter 1, can be used to approach all instances of what are usually called "the arts"—from their earliest to their most recent manifestations—as one phenomenon, of which mark-making is a variety or kind. The concept considers the ubiquity and great antiquity of anthropogenic markings as evidence of this indelible human trait, evolved in the distant past, that lies at the heart of the famous painted galleries of Chauvet-Pont d'Arc (ca. 36,000 years ago) or Lascaux (ca. 20,000 years ago) as well as much earlier in cupules at the Sai Island site in Sudan (ca. 200,000 years ago).[17] Indeed, we regard cupules as archetypal or, borrowing zoological terminology, a "type specimen" of artification.

Even though the earliest paleoart of the Americas is much more recent than examples encountered elsewhere in the world, its complex imagery and what can be gleaned of its history provides an occasion to rethink some of the reigning assumptions within the larger field of paleoarchaeology. Hotly debated interrelated questions about the early human mind include: Was there a sudden "creative explosion" in human cognitive ability in the Upper Pleistocene or a gradual development throughout the evolution of the entire genus *Homo*? Are all paleomarks symbolic? Although many scholars assume that "art" is inherently "symbolic," the early appearance of geometric paleoart allows us to wonder what ancestral minds were like before humans made symbols. What has been left out of paleoarchaeological assumptions about "cognitive modernity" in our species? These questions, too, are relevant to the geometric enigma.

I.7 (*opposite*) Haphazard grouping of cupules on a boulder in the southern Arizona desert

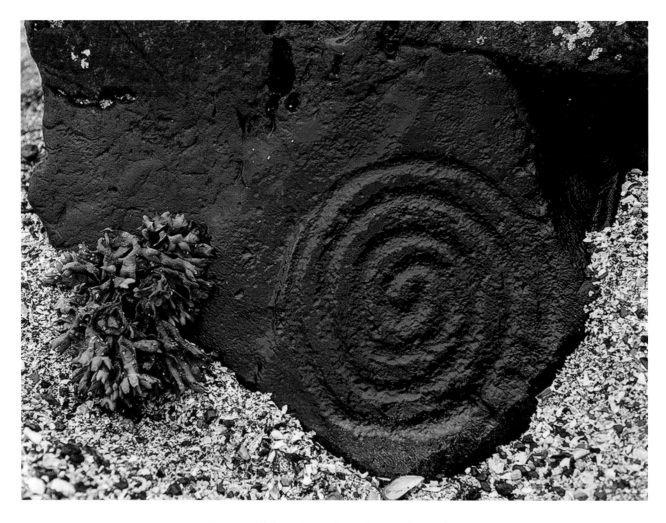

I.8 Deeply incised clockwise spiral, Alaska. *Photograph courtesy of Stephanie Fysh.*

After examining eleven hypotheses about the origin and function of abstract-geometric markings, we ask, and answer, questions that can be addressed by established principles in ethology and evolutionary theory: What might have motivated mark-making? Were there evolutionary steps? What did mark-making contribute to the lives of its makers? Do geometric (noniconic) marks indicate more, or less, cognitive complexity than representational (iconic) ones?

Because we propose that artification, including mark-making, is a universal human behavior, we see it as having evolved and being adaptive. That is, individuals who made marks and the social groups within which such individuals lived would have had evolutionary selective advantages over individuals and social groups that did not artify. With the notion of artification and its biological foundations, we hope to introduce new thinking and a broader context to the study of rock art—worldwide, humanity's most ancient visual record.

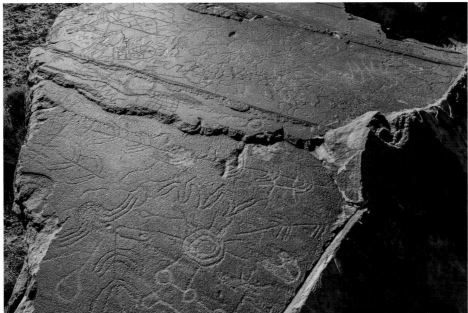

I.9 Boulder platform solidly decorated with archaic geometrics from two separate engraving episodes indicated by differential repatination, Nevada

BACKGROUND

As collaborators, we bring quite different backgrounds to our study of the enigma of abstract-geometric mark-making. Yet from these different starting points our personal experiences have led to the same conviction: people everywhere, despite the variety of their cultures, have a fundamental psychobiological similarity—what can be called a specifiable human nature. We also hold that this nature includes making and experiencing the arts. In this book, we use mark-making as a focus for this claim.[18]

Although it is gaining some acceptance today, our conviction that human psychobiological universals exist has been out of favor among anthropologists and social scientists for a half century or more. We hope that our book will help reintroduce this way of thinking in paleoarchaeology. Students of anthropology will remember that in the nineteenth century, a German ethnologist named Adolf Bastian coined the phrase "the psychic unity of mankind." The notion influenced his student Franz Boas, who became an eminent comparative anthropologist in the United States, holding a position at Columbia University in New York. Along with psychic unity, Bastian also noted the importance of cultural variation. Although in his writing (and Boas's masterpiece, *Primitive Art*)[19] the two ideas were compatible, they later bifurcated into competing rather than complementary schools of thought. Since the 1930s, promoted by students of Boas like Ruth Benedict and Margaret Mead, cultural relativism that emphasizes the uniqueness of each culture (rather than human universalism) has dominated anthropological thought in the United States. Today, awareness of the variety and plurality of our hominin ancestors and relatives has contributed to an academic emphasis on the anatomical differences among one single species and the presumption of psychological differences as well.

Our position in this book is fundamentally an evolutionary one, which does not dichotomize "nature" (the universal species nature of humans) and "culture" (the diverse ways in which different human societies foster, mold, and express that nature). The philosopher Mary Midgley has used a helpful analogy of a basic cake mix (which we might call the "psychic unity" of humankind) to which cultures add their individual textures and flavorings—raisins, nutmeats, coconut flakes, chocolate chips, lemon rind, milk or water, more or less liquid, more or fewer eggs, and so forth.[20] After baking, one may find quite different results although the basic ingredients have remained the same.

And interestingly, as an aside, in the case of archaic rock art markings, the unadulterated basic cake mix was used for several hundred thousand years, underscoring it as a good example of universalism.

Among the pioneers in search of human commonality was the anthropologist George Murdock. Collecting descriptions of various cultural practices in hundreds of different societies, he compiled a lengthy catalogue (now popularly called Murdock's Atlas) in which specific cultural characteristics were coded and could be compared cross-culturally. Many common traits, which he called cultural universals, provided proof, to him, that "modern humans are of one biological family and one species."[21]

Before we became acquainted, both of us had read the influential book *Human Universals* by anthropologist Donald E. Brown.[22] Building on Murdock's seminal work and aware of linguist Noam Chomsky's notion of a Universal Grammar, Brown proposed the concept of a Universal People (UP). Arguing that a key to understanding UP rests in human biology and evolutionary psychology, Brown suggested that humans everywhere share fundamental behavioral traits and characteristics (or at least predispositions) for "those features of culture, society, language, behavior, and psyche for which there are no known exceptions in their existence in all ethnographically or historically recorded human societies."[23] Human universals can confidently be posited because human beings everywhere share essentially the same biological endowment, are equipped with the same nervous system, and are endowed with brains "wired" with the same emotions, drives, and needs.

I.10 Simple geometric marks at left, nearly obliterated by lichen, Oregon

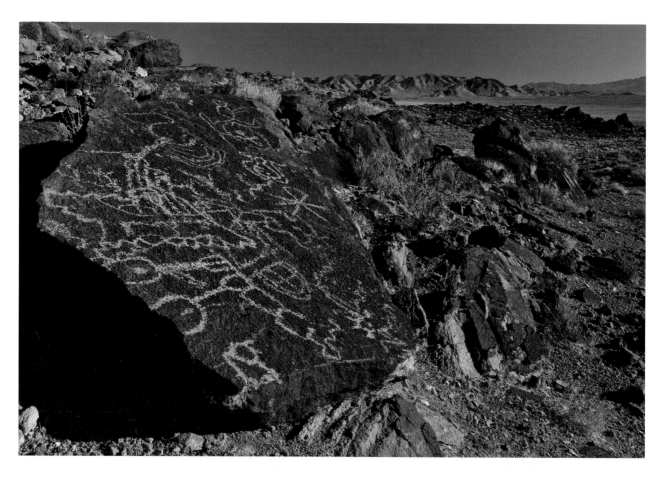

I.11 Seemingly hodge-podge placement of Great Basin geometrics, Nevada

Foremost among the hundreds of absolute and innate traits identified by Brown are rule-governed language and symbolic speech, and gestures and facial expressions for communicating basic emotions.[24] Universal People exhibit fears, including a phobic reaction to snakes, and they use tools to make tools. They have various strategies to make themselves feel better, including the taking of mood-altering substances such as stimulants, narcotics, or intoxicants. They use magic and attempt to predict and plan for the future. They have leaders, laws, ethics, morality, incest taboos, and they practice etiquette and hospitality. They engage in gossip, thumb sucking, ethnocentrism, xenophobia, pretend-play, violence, revenge, and compassion. Universal People also have religious or supernatural beliefs in something beyond the visible and palpable or even in things that are demonstrably false. They perform rituals, cry for and mourn the dead, dream and attempt to interpret their dreams. In short, "the sheer richness and detail in rendering of the Universal People comes as a shock to any intuition that the mind is a blank slate or that cultures can vary without limit."[25]

Interestingly, Brown did not include "art" in his list of biologically founded behaviors, although he did cite "aesthetic standards" and dancing and making music. His omission of art was perhaps because the word is so vague and culture-specific. We would

add artification to such a list and would include dancing and music-making as instances of that label. Even mark-making (encompassing children's proclivity to mark, draw, and paint to the worldwide phenomenon of making petroglyphs and pictographs) would certainly seem to qualify for universal status. The repertoire of the earliest human marks is uniform—specific geometric motifs such as parallel lines, lattices, zigzags and meandering lines, convergent lines, circles, radial designs, and dot patterns.[26]

Our species is scientifically described as *sapiens*—that is, "wise" or "knowing." Other Latin-derived species adjectives have sometimes been used to single out defining diagnostic behaviors and characteristics that set humans apart from other animals: *faber* (toolmaking, skillful), *politicus* (political, social), *oeconomicus* (economic), *religiosus* (religious), *symbolicus* (symbol-using), *ridens* (laughing), *ludens* (playing), and *performans*. Ellen's studies showing that humans are innately art-makers and users inspired her 1992 book title, *Homo Aestheticus*, although she realized that "aestheticus" (if defined as "appreciating art or beauty") was misleading in its apparent emphasis on experience and only part of the story. However, other Latin synonyms seemed less accurate: *artisticus* seemed to emphasize "artiness," which could be interpreted as possessing artistic talent or taste, making the idea too restrictive; *pictor* (painter) was too specialized—disregarding other visual media as well as omitting music, dance, and literary or other arts; *artifex* (art-making), although accurate, left out the act of responding to the arts, sounded mechanical, and might not be easily understood.

The problem with finding a suitable Latin adjective, she finally concluded, lay in the peculiar concept of art itself—a tangled skein of connotations, associations, and varied uses throughout the ages that made the word essentially unusable. This may be why many scholars of petroglyphs hesitate to call their subject of study "art" at all (see chapter 1).

Ekkehart's individual road to the concept of human universals began in 1972, when he decided to learn the Hopi language, with the ultimate goal of verifying or falsifying Benjamin Lee Whorf's sensational (and subsequently highly influential) claim of Hopi as a "timeless language."[27] Whorf had been a student of Edward Sapir, an anthropological linguist from the Boas school of anthropology, who wrote about the relationship

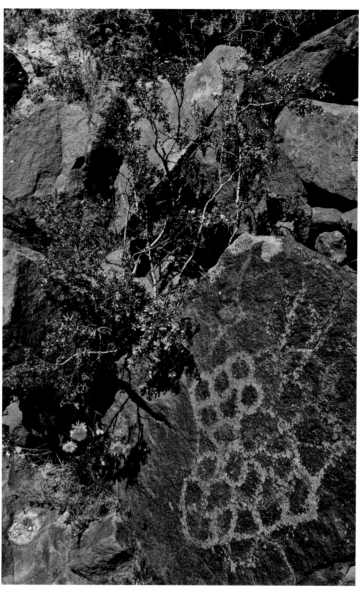

I.12 Reticulated pattern, California

between culture and language. The Boasian school claimed that nonliterate cultures were as complex and sophisticated as European ones, a tenet with which we agree. Sapir, however, placed an emphasis on the diversity of ways in which languages carve up and/or organize the natural world into different cultural and cognitive categories. Intrigued with Sapir's seminal observations, Whorf radicalized them into what is popularly known as the Sapir-Whorf (or linguistic relativity) hypothesis.

According to Whorf, it is our language, with its inherent grammatical and lexical categories, that shapes and colors our thoughts and our picture of the universe. What our language does not classify or verbalize, "we don't see, don't readily see, and don't attend to."[28] For most linguists today Whorf's concept of linguistic relativism is acceptable only if it is understood as having a *mild* effect on our cognitive behavior.[29]

Most of the controversial ideas that Whorf presented on the interdependence of language and thought were developed in a partial comparison between Hopi (a Uto-Aztecan language spoken in east-central Arizona) and Western European languages. While some of Whorf's ideas were published prior to his death in 1941, they did not begin to capture the imagination of a wider public until they became available in 1956 in a book edited by John B. Carroll, *Language, Thought, and Reality*. What really catapulted Whorf into notoriety and contributed to an almost cultish spread of his relativity hypothesis were his comments on the Hopi language, especially his claim that Hopis were endowed with a fundamentally different concept of time:

> I find it gratuitous to assume that a Hopi who knows only the Hopi language and the cultural ideas of his society has the same notions, often supposed to be intuitions, of time and space that we have, and that are generally assumed to be universal. In particular, he has no general notion or intuition of TIME as a smooth flowing continuum in which everything in the universe proceeds at an equal rate, out of a future, through the present, into a past. After long and careful study and analysis, the Hopi language is seen to contain no words, grammatical forms, constructions, or expressions that refer directly to what we call "time," or past, present, or future, or to enduring or lasting. . . . Hence, the Hopi language contains no reference to "time," either explicit or implicit.[30]

Whorf's observations indeed created a sensation, first in scientific and later in lay circles. Philosophers, psychologists, and anthropologists in particular tried to fathom the implications of his startling findings, with the result that they were frequently distorted or radicalized: "Time as a primary category is something of which Hopi is innocent."[31] "The English concept of time is nearly incomprehensible to Hopis."[32] "The Hopis do not possess the notions of space and time that we do; even less do they have an intuitive awareness of them which could be considered necessary and universal."[33]

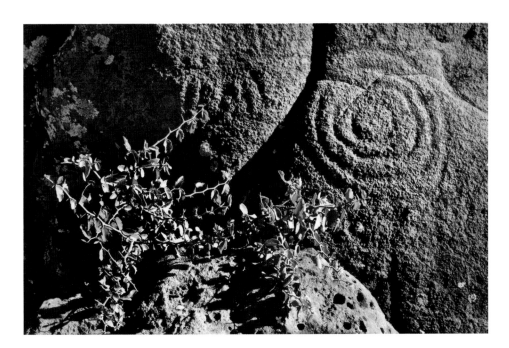

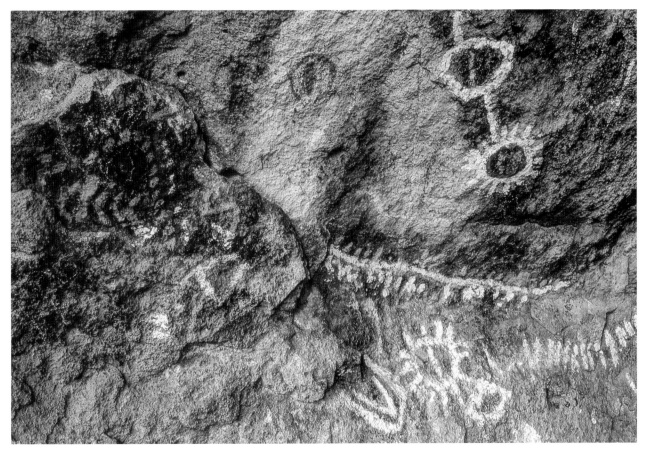

I.13 (*left*) Concentric circles and set of vertical bars, Arizona

I.14 (*bottom*) Colorful circular and linear markings, most likely finger-painted, Nevada

Ekkehart's thorough study of Hopi language and culture revealed that Whorf's conclusions in regard to Hopi time and space were not borne out linguistically, and it will always remain a mystery how Whorf could have erred so drastically. For instance, the metaphorical transfer of spatial notions to the nonspatial concepts of time is so pervasive throughout the Hopi language that in Ekkehart's 1983 monograph *Hopi Time,* he devoted some 200 pages (out of 670) to documenting the phenomenon. Perhaps most striking among the hundreds of contextual examples he collected during several years of fieldwork is the spatial use of *qeni,* "vacant lot, space" for the notion of "time." When employed metaphorically, *qeni,* "an area void of physical objects," takes on the sense of "time free to pursue an activity."[34]

Additionally, a multitude of lexical terms (such as "yesterday" and "tomorrow," "at midnight," "during harvest time," "meanwhile," and so on) indicate that Hopi speakers orient themselves quite accurately in the domain of time. Most of the data Ekkehart contributed to the Hopi Dictionary project were extracted from storytelling contexts that often contained sentences loaded with temporal locutions. The following example illustrates this very nicely: "Then indeed, the following day, quite early in the morning at the hour when people pray to the sun, around that time then he woke up the girl again."[35] In his monograph, Ekkehart was also able to document how the Hopi divide up the day and operate with months, lunar phases, seasonal points, and the year; how they adhere to a ceremonial calendar; and how they practice dating and timing methods employing such sophisticated devices as knotted calendar strings and notched calendar sticks, including the monumental stratagem of a horizon-based sun calendar.[36]

Space in this book does not permit further description of the many erroneous misconceptions of the Sapir-Whorf hypothesis, but Ekkehart's ultimate conclusion is that underpinning all languages is a deep structure of thought that, because we all have the same model brain, the same perceptual organs, and we inhabit the same model universe, must be the same for all human beings.

In our view, the metaphor of a surface and a deep structure (as expressed by the Universal Grammar theory) also holds for all known rock art in the world. Superficially, rock arts may differ drastically in style, execution, and motifs, depending on the cultural group that a given maker is born into (just as we speak the language of the group we are born into), but underneath, in their deep structure, they are governed by innate, underlying principles, predispositions, and capacities that are universal aspects of our nature as human beings. As cultures have "invented" their own languages, but did not invent the predisposition or ability to speak, similarly, artists and cultures have "invented" their own arts but did not invent the predispositions and abilities to engage in and value the arts.

If Ekkehart came to a belief in human universals through his work in the social sciences as a linguist and anthropologist, Ellen discovered the same conviction from her studies of evolutionary biology and ethology, a subfield of zoology that observes and studies what animals naturally do in their natural environment. For ethologists,

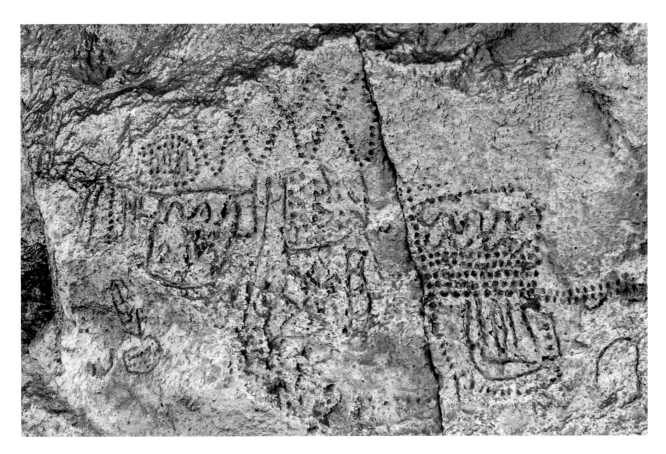

I.15 Cliff face, artified with a variety of ordered dot patterns, California. *Photograph courtesy of Ron Wolf.*

an animal's *behavior* is as much a product of evolution as its anatomy and physiology. Activities such as courtship, parenting, aggressive display, and other kinds of social behavior, as well as characteristic group size and general temperament, are adaptations to an animal's way of life—in forest, desert, savannah, or snowy waste—as much as are its coat color, means of locomotion, dietary preferences, or body configuration. All members of a species or subspecies behave in ways that other members of the species recognize and respond to, usually with little or no learning.

This way of thinking is acceptable when applied to animals, but with regard to humans, cultural relativism generally prevails in the social sciences, along with its attendant axiom that human behavior varies, like language and thought, from culture to culture. Yet knowing that humans are an animal species that evolved from earlier forms, Ellen began to wonder what was adaptive about such obviously universal human behaviors as play (which children everywhere spontaneously engage in, just like many other young animals) or singing and dancing. Or "art."

A contribution to her thinking came from sixteen years of residence in Sri Lanka, the island nation off the southern tip of India. Adapting to, and eventually even adopting, different, non-Western norms and values should have made her an ardent cultural relativist, but she found that deep down, humans, like their languages, were mutually

I.16 Small-scale undulating and serrated pictographs, Arizona

translatable. They could understand each other's motivations, needs, and responses, even though not always agreeing with or feeling the same way about them. True, humans are cultural creatures, but Ellen began to see that different cultures could be viewed as having different ways—some better, some worse—of reaching the same goal—getting what all individuals ultimately need, psychologically and emotionally as well as physically, for survival and reproductive success.

Ellen's investigations of subjects that pertained to an understanding of "art" as a species characteristic of humans led her to publish three books about art in general and a number of articles and book chapters about music (including song and rhythmic movement) and poetic language as evolved predispositions, confirming that people engage in them easily and eagerly if a culture provides avenues for their realization. Her later hypothesis of artification attracted Ekkehart's attention because he saw it as a fresh approach to studying rock art, and this led to a collaboration that allowed application of her ideas to a visual art form that was unfamiliar to her. The result is this volume—a blend of rock art science, archaeology, and an adaptationist theory of the arts.

Together we have produced the kind of book that neither of us would or could have written on our own.

Underlying our project is the conviction that a human predisposition to make marks is universal: it characterizes marks in every style and geographical region, uniting the painters of animals in deep caves with their ancestors, forebears, cousins, and descendants who carved, hammered, and otherwise made marks on rock surfaces in their surroundings all over the world. The concept of art as a behavioral predisposition (artification) allows us to approach the study of paleoart as manifested in rock art or portable art with a hypothesis that mark-making was an activity that ancestral humans engaged in because it helped them to survive and to survive better than they would have without it.[37] This evolutionary and ethological approach underpins every idea in this book.

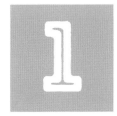

THE CONCEPT OF ARTIFICATION

ELLEN DISSANAYAKE

THE ANCIENT MARKINGS found on boulders, cliff walls, and in caves are usually referred to as "rock" (or "rupestrian" or "parietal") art. But what does "art" mean in this context—or indeed in any other? If the term is examined carefully, it reveals a landmine of irrelevant and confusing assumptions. As recently as the nineteenth century, the term "art" could be applied to almost anything. It meant skill, in the sense of fully understanding the principles involved in an endeavor—such as the art of Japanese cooking, the art of boat-building, or—today—even the "art" of medical diagnosis or psychotherapy. While skill is involved in all these disciplines, it is evident that the term "art" also implies that even scientifically based fields make use of intuitive, emotional, and nonrational expertise.

In addition to skill and intuition, other qualities and characteristics pervade ideas about art today:

- *artifice* (something contrived, "artificial" rather than natural, imitative rather than the real thing)

- *beauty and pleasure* (admiration and enjoyment)

- the *sensual quality of things* (color, shape, sound)

- the *immediate fullness of sense experience* (as contrasted with habituated, unregarded experience)

- *order or harmony* (shaping, pattern-making, achieving unity or wholeness)

- *innovation* (exploration, originality, creativity, invention, seeing things a new way, surprise)

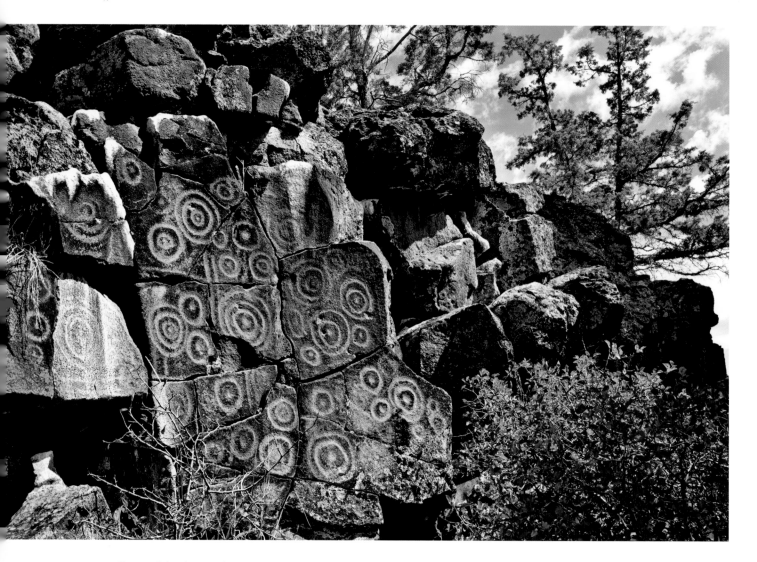

1.1 Cluster of deeply carved dotted and concentric circles, Oregon

- *adornment* (decoration, display)

- *self-expression* (presenting one's personal view of the world)

- *a special kind of communication* (conveying information in a special kind of language; symbolizing)

- *nonutilitarian* (made for its own sake, having no function)

- *serious and important concerns* (significance, meaning)

- *make-believe* (fantasy, play, wish-fulfillment, illusion, imagination)

- *heightened existence* (exalted emotion, ecstasy, self-transcendence)

Which of these meanings or connotations are included in our notions of rock art? Philosopher Denis Dutton has offered a "cluster" definition of art considered as a universal cross-cultural category.[1] He lists twelve characteristics, most or all of which he claims will be found in artifacts and performances that are typically called art. Dutton's list includes features of works of art themselves as well as qualities of the experience of art. These are:

- giving direct pleasure

- skill and virtuosity

- style

- novelty and creativity

- a critical language of judgment and appreciation

- representation

- a special focus or bracketing-off from ordinary life

- expressive individuality

- emotional saturation

- intellectual challenge

- art traditions and institutions

- imaginative experience

Dutton's characteristics are the result of serious and careful thought, and are worthy of consideration. However, each can be applied to obvious non-art (which Dutton admits), and scholars of rock art will question the applicability of at least some of these, such as pleasure, novelty, representation, individuality, emotional expression, or intellectual challenge in many or all of the markings that they see or study.

Because of all the baggage this tiny word carries, it is not surprising that most archaeologists who study ancient marks on rocks make a great effort to avoid the term "art" altogether. To them it smacks too much of aestheticism and subjective judgment, connotations that, in their eyes, ultimately render the field of parietal art studies "unscientific." To remedy the stigma, they offer instead substitute terms ranging from simple "pictures" or "images" to such esoteric appellations as "ideomorphs," "graphemes," or "symbolic graphisms." Some scholars point out that the word "art" can be used neutrally (as in "child art" or "chimpanzee art," and by extension, "rock art") rather than evaluatively (as in "X is a work of art"). But even this distinction seems useless: Why not just say "scribbles" or "paintings" or "carvings" or some other descriptive term and avoid the problematic connotations of the word art?

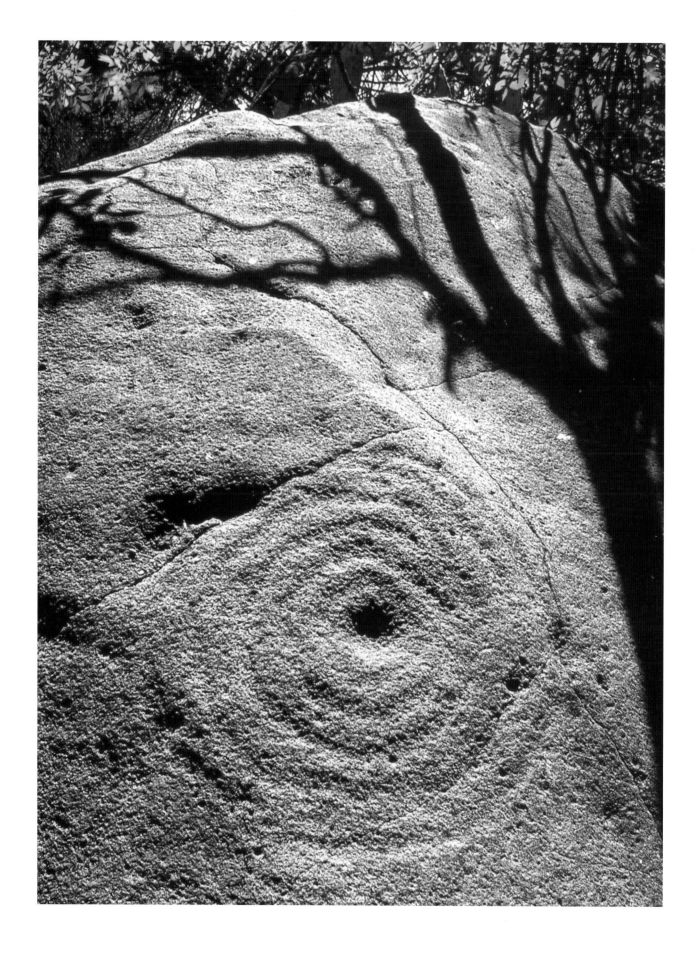

SHIFTING FOCUS FROM NOUN TO VERB

The term "rock art" thus requires a qualification—that "art" be considered as an abbreviation, as it were, of the abstract noun "artification," from the newly coined verb *artify.* This reconceptualization considers rock markings not as things—objects, images, or works that can be called art—but as the outcome of an activity. This completely new way of thinking about art requires what might be called a Copernican shift in one's approach to aesthetic matters. Unlike the modern Western concept of art with its elite idea of *beaux arts* or *fine arts,* artification emphasizes the act of making, not the result—an activity that will be described more precisely in the following discussion.

In this book, the act, not the product, of artifying applies to every instance of what is today called rock art. By conceptualizing art(ifying) as a verb, I think we come closer to most languages in the world, which have verbs for individual activities such as drawing, painting, carving, singing, dancing, and so forth but do not have a noun that refers to these activities as all belonging to a super-category.

Artification refers to *what people do* when they make images, engravings, paintings, and so forth. It is a *behavior* or *process* that allows us to understand rock markings as the result or residue of an activity that—like language and toolmaking—evolved over millennia to help our ancestors adapt to their ways of life as foragers (a term that we use interchangeably with "hunter-gatherers"). Artification is not a method for identifying or interpreting individual marks or styles, which is another, different, matter—one we do not address here.

The concept of artification provides a broader scope and firmer basis for treating the art-like endowments (like dancing, singing, mark-making, etc.) of our species than does the tangled mix of meanings that the concept of art has acquired over the centuries. Questions such as "What is art?" or "Is rock art 'art'?" can be phrased in other ways: "What do people do when they make art?" "Is this an instance of artification?" In using a verb rather than a noun, the emphasis shifts from labeling the artifact to describing the behavior.

It is essential to understand that the word artification is not a synonym for art or art-making. As used here, the concept of artification rests on the capacity of human beings to make ordinary everyday experience (or "ordinary reality") "extra-ordinary" or special. Although artifying is something that all people, even children, do, it has been overlooked (or underappreciated) by scholars who identify distinctive characteristics of our species. As mentioned in the Introduction, neither the word "art" nor the activity of making art is found in Donald Brown's list of human universals. Decoration, dance, music, and poetry are represented there, even though they are, like art, categories of things whose precise nature is not always easy to identify cross-culturally. Like rock markings, they are the *results* of the broader, universal capacity, not shown by any other animal, of artification.

1.2 (*opposite*) Time-worn cup-and-ring motif, Arizona

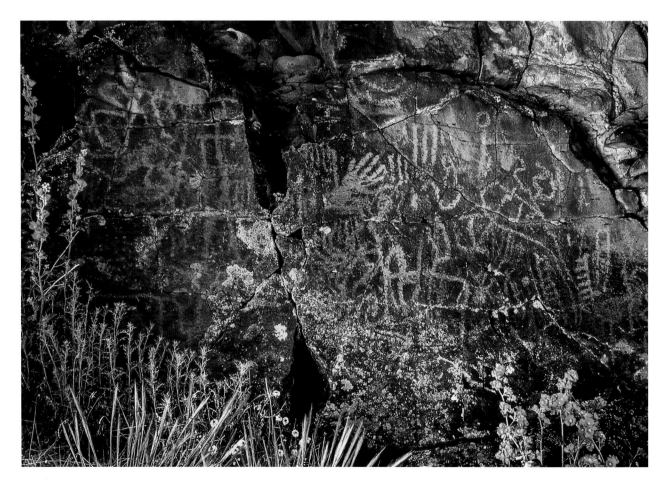

1.3 Complex palimpsest of abstract-geometrics, Nevada

The concept of artification arises from the observation that humans everywhere, unlike other animals as far as we know, differentiate between an order, realm, mood, or state of being that is mundane, ordinary, or "natural," and one that is unusual, extraordinary, even "supernatural." Virtually every ethnographic account of a premodern society anywhere in the world suggests or states outright this distinction. In Native American cultures, for a few examples, anthropologists Dennis and Barbara Tedlock specifically cite Hopi ʻaʼne himu (sic), Sioux *Wakan*, Ojibwa *manitu*, and Iroquois *orende*; they additionally mention "other worlds" of Tewa, Zuni, Wintu, and Papago.[2] Some scholars have argued that in many aboriginal and other small-scale societies, the two realms of ordinary and extraordinary interpenetrate and may have done so in the worldviews of our early ancestors.[3] This argument is well taken. However, even in the technologically simpler groups that ethnographers have described, people employ special practices that access a supernatural realm, indicating that there is a distinction in thought and behavior between quenching one's thirst and imbibing a ritual drink, or between walking around in the forest and dancing in thanks to the forest. In these cases, ordinary behavior is altered, made special, *artified*.

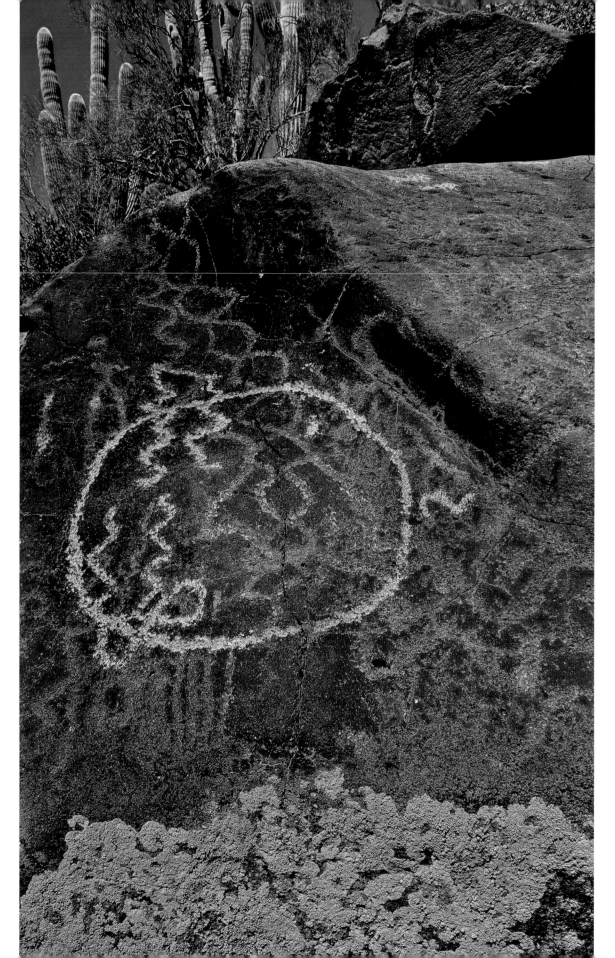

1.4 Ancient abstracts, some "rejuvenated," Arizona

Artification is not the same thing as cultural transformations of nature. Humans, for example, take raw food and transform it for their use by cooking it. Similarly, they take other materials from nature—fiber, stone, wood, bone, clay, animal skin—and make shelters, tools, utensils, weapons, clothing, and the various other things needed for their lives, such as hand axes from flint or microchips from silicon. Herbert Cole, an American historian of African art, has memorably utilized Claude Lévi-Strauss's famous title, *The Raw and the Cooked*, by speaking of the raw, the cooked, *and the gourmet*. Artification can be likened to Cole's addendum. For, in addition to transforming nature by means of culture, humans at some point in their evolution apparently felt that in some circumstances such merely utilitarian transformations were not sufficient. They additionally made their shelters, tools, utensils, weapons, clothing, bodies, surroundings, and other paraphernalia extraordinary or special by shaping and embellishing them beyond their ordinary functional appearance. They "artified" these things, typically when the items or the occasions for their use were considered important.

When did humans begin to artify? Before developing a capacity to make an ordinary thing into something extraordinary, they had to first *recognize* the extraordinary. Of course, all animals know when ordinary reality is no longer ordinary—an unusual sound or smell could signal that a predator is nearby. But beyond reflex alertness to possible dangers, humans at some point began to notice things in their environment that attracted attention for being special in a way that did not call for a reflex response and did not affect immediate survival. About three million years ago, an *Australopithecus* individual perhaps noticed a "face" in the famed Makapansgat pebble.[4] Other unusual stones, such as concretions or shiny minerals, are in this category, and it is known that exotic quartz crystals were transported by hominins as early as 800,000 to 900,000 years ago.[5] Some 250,000 years ago, in what is now England, an archaic human picked up and carried to his or her dwelling site a piece of fossil coral that bore an unusually attractive all-over pattern that today is called "starrystone."[6] Other examples of striking fossils or minerals carried from their original locations have been found in occupation sites from many different times and places.

Cognitive archaeologists and prehistorians put forth different dates for the earliest examples of art, depending on what they consider to be "art": cupules, beads, and pendants made of perforated shells or bone, incised ocher fragments, bones with engraved parallel lines. The Lower Paleolithic site of Bilzingsleben in present-day Thuringia (Germany) is noted for its rich archaeological horizon and engraved nonutilitarian artifacts associated with *Homo erectus* bones from 400,000 to 300,000 years ago.[7] Its famous elephant tibia artifact with deliberately scored parallel lines in groups of seven and fourteen (fig. 1.5)[8] was described by archaeologists Dietrich and Ursula Mania, who note that these markings "provide the first unequivocal evidence that *Homo erectus* produced incipient art—thousands of centuries before the advent of Upper Palaeolithic art."[9] If we are looking for evidence of artification (rather than art), any of the just mentioned artifacts will serve.

Perhaps the earliest trace or suggestion of making ordinary things extraordinary is the occurrence of red ocher in hominin occupation sites in southern Africa. In Wonderwerk Cave in the Northern Cape region (also a *Homo erectus* site), every level of the excavation from nearly a million years ago (ca. 900,000 to 800,000 years ago) has yielded ocher fragments.[10] It is not known whether these particular bits were used to make ordinary bodies or objects extraordinary, but certainly, over succeeding millennia, ocher—sometimes modified by grinding or rubbing or even being shaped into crayons— is a common find in hominin sites. Pieces of stone from 125,000 years ago bear ocher markings in Bambata and Pomongwe Caves in Zimbabwe,[11] and a "paint processing kit," comprised of abalone shells with ocher residues inside, quartzite tools (to hammer and grind ocher into a powder), oil from seal bones (evidence of marrow extraction for binding the materials), bone implements to turn and lift the paint pastes, charcoal, grindstones, and hammerstones, was discovered in 2008 at Blombos Cave in South Africa and dated to 100,000 years ago.[12] Dwellers in these early sites may have decorated their bodies, clothing, and other perishable materials with this pigment, although this use remains only conjectural. If they did do so, they were artifying and thus were "artifiers" rather than "artists" (who are generally thought of as possessing the same associations of high skill, originality, and high status as "artists" do in the common modern concept).

1.5 Fan-shaped and subparallel linear incisings on fossil bone from a *Homo erectus* site near Bilzingsleben, Germany. *After Dietrich Mania and Ursula Mania (1988:fig. 3).*

Although for decades our Neanderthal cousins were said to lack ritual and art, three recent discoveries have challenged this assumption. At Bruniquel in southwest France, the opening to a cave that had been naturally obstructed since the Pleistocene was discovered by a fifteen-year-old boy and first explored in 1990 by archaeologist François Rouzaud.[13] In a large chamber 336 meters from the entrance, he found two annular (ring-like) arrangements composed of broken-off stalagmites. Unfortunately, Rouzaud died prematurely in 1999 and access to the cave was restricted until 2013, when a team led by Jacques Jaubert was able to date the regrown tips of the broken stalagmites as being over 175,000 years old, making these constructions the oldest known well-dated fabrications made by humans, and, what is more, the first known incursion into a deep cave by Neanderthals.[14] Whether or not the two rings of broken stalactites can be called an early example of ritual propensity or art, they are most certainly examples of making a place (in this instance, a remote chamber far inside the entrance to a cave) special— again, of artifiers artifying.

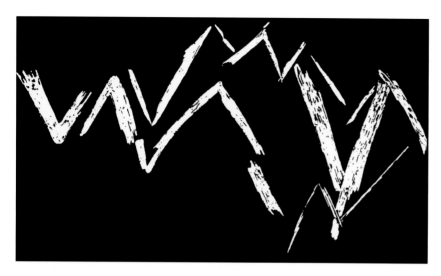

1.6 Zigzag pattern on bone from the Middle Paleolithic site of Bacho Kiro, Bulgaria. *Drawing courtesy of Wikimedia Commons.*

The usefulness of the concept of artification in dealing with early art-like productions is also evident from two paleodesigns attributed to Neanderthal hominins. The first is a zigzag incision on a 47,000-year-old bone fragment recovered from the Mousterian shelter of Bacho Kiro in Bulgaria (fig. 1.6).[15] The second example is an engraved crosshatch motif found on bedrock in Gorham's Cave in Gibraltar (fig. 1.7) under an undisturbed sediment layer with Neanderthal-made stone tools dated to 39,000 years ago and described by some as resembling a hash-tag mark or tic-tac-toe board.

Perhaps the most unexpected early mark of all was found in a cache of fossil freshwater mussel shells that had been collected in the early twentieth century at a *Homo erectus* site called Trinil on the bank of the River Solo in Java, Indonesia, and placed in a museum collection. More than a hundred years later, an archaeologist looked through the collection and photographed some of the shells. To his surprise, there were incised zigzag marks on one of them. They have been dated to 540,000 to 430,000 years ago.

Although some paleoarchaeologists have interpreted abstract patterns of this date and kind as key evidence for human symbolic ability (and hence "cognitive modernity"), zigzags and grids are part of the inherent graphic repertoire found in drawings by small children. There is no need to automatically attribute these or similar deep-time paleomarkings to an intellectual capacity for symbolism or abstraction. These markings are more parsimoniously explainable as natural products of the innate universal human predisposition for artification, without invoking symbolism at all.

Such simple, even crude examples of early paleoart may not interest theorists who are concerned with the exceptionally skilled cave paintings and drawings that were made much later. However, the motivation for what the later "artists" did and its personal significance may not be substantially different from that of earlier artifiers, or indeed from the artifications of ordinary people in all times and places. Even today, when people care about something—say, an important occasion like a marriage proposal or a significant anniversary—they are often moved to make things associated with it special, unusual, even strange or weird, using materials or techniques that are beautiful, costly, excessive, or otherwise extraordinary. That is to say, artifications, unlike examples of "art," may be unskilled, unoriginal, or even pedestrian. Not all love poems or holiday decorations would pass the "art" test, but all are examples of artification. Similarly, many markings on rock surfaces are also undistinguished.

1.7 Simple crosshatched design (*left*) from Neanderthal horizon in Gorham's Cave, Gibraltar. *Photographs courtesy of Stewart Finlayson, Gibraltar Museum.*

WHAT DO ARTIFIERS DO?

The concept of artification—art as a behavior, not a thing—was initially developed for explaining the evolutionary origin of performing arts, specifically singing and other forms of music-making, including dancing.[16] Because these arts take place in time, vanishing after their performance, it is easy to think of them as "behavior" in an ordinary as well as ethological sense. Visual art, in contrast, is static (once it is completed). It is not so obvious that it is the product of behavior, yet it can be considered as the lasting residue of the "performance" of mark-making, which—like singing or dancing—also vanishes when the activity stops.

The extraordinariness of artification is achieved by means of at least five "aesthetic operations" (that will later sometimes be called "proto-aesthetic operations") used by all artifiers (including makers of marks on stone surfaces):

Formalization (a term that includes shaping, composing, organizing, simplifying, forming a pattern or comprehensible whole, rather than leaving the "ordinary" thing—a rock wall, a stone surface—as it is naturally)

Repetition of elements of the marks—lines or motifs—often in a regularized, even rhythmic manner, different from natural marks that may be on the surface

Exaggeration of lines or motifs, whether by enlarging or deepening them

Elaboration (or dynamic variation) of lines or motifs, as with stripes, colors, and other ornamental additions

Manipulation of the perceiver's expectations, as when a mark is made in an unexpected place or strongly contrasts with an adjoining mark[17]

Readers who are familiar with ethological concepts will recognize these operations as characteristics of "ritualized behaviors" as described in writings by ethologists such as Julian Huxley, Irenäus Eibl-Eibesfeldt, Niko Tinbergen, and others.[18] These devices are evident in many animals, even in some birds and reptiles, when ordinary physical characteristics (like feathers, crests, antlers, or tails), sounds, and body movements become extraordinary during courtship and territorial displays.

In ritualized displays by birds, the operations serve to *attract attention* to a (usually male) individual and to *sustain interest* and *create emotion* in a (usually female) observer. I suggest that, in humans, the same operations comprise the behavior of artification, with the same effects. The operations are relevant to the behavior of artification in general and its application to mark-making in particular.

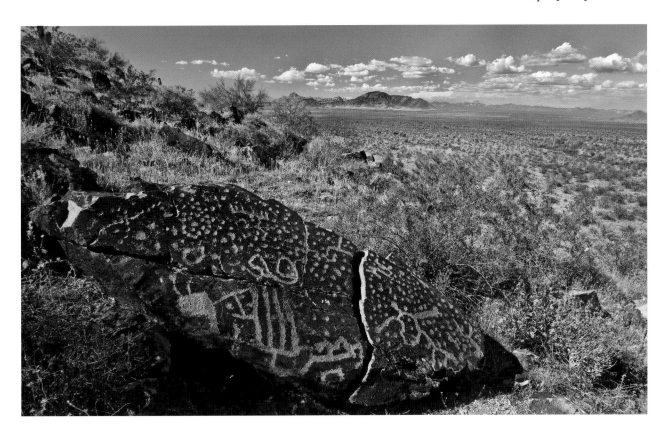

WHY USE A NEW TERM, "ARTIFICATION"?

The concept of artification provides a fresh, new way to approach the subject of early abstract-geometric mark-making. Shifting focus—from consideration of a lasting artistic end product (the mark) to the vanished temporal activity that brought it into being (a behavior of mark-making)—seems especially appropriate to rock art study. To begin with, we don't have to use the concept "rock art," which cannot help but imply the irrelevant connotations of Western views of art. Indeed, some Native Americans consider the term "art" degrading and/or offensive because it so easily projects Euro-American values and belief systems on imagery they hold to be sacred and spiritual in character. In particular, as rock art specialist Polly Schaafsma points out, "They narrowly misconstrue art as a Western concept confined to secular pieces, framed and hung on the walls of galleries and museums, signaling out in particular its commercial properties."[19]

The notion of artification allays this sort of criticism by being more inclusive than the Western concept of art, even when the latter is now often routinely applied to non-Western objects and cultural phenomena. Artification refers to a universal human behavior that is more comprehensive than any particular instance of it, rather as the word "language" refers to the faculty of speech but is unconcerned with particular languages, their peculiar details, or the various purposes to which speaking is put. Similarly, artification can embrace modern Western notions of the arts as being the product of

1.8 Medley of loosely placed dots and erratic geometric marks, Arizona

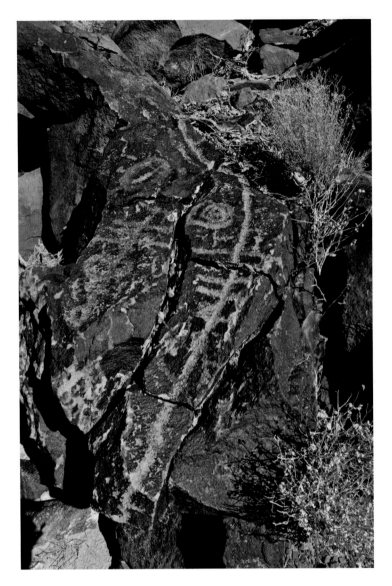

1.9 Mélange of crudely cut petroglyphs on severely fractured block, Nevada

creativity and originality, or as having aesthetic qualities such as beauty, skill, and representational accuracy. *But it need not.* This is not to discount these topics and qualities, but only to say that they are less relevant to early mark-making than to specialist discussions of objects that are typically called "art."

Another advantage of a concept of artification is that looking for the beginning of "art" does not require that one find evidence of symbolizing ability. It similarly has no problem embracing "crudely" or "awkwardly" executed pictographs and petroglyphs composed of the simplest geometric markings (fig. 1.9). Even the smearing of ocher paste onto an implement or body or the hammering of a simple cupule on a plain rock surface may intentionally make that tool or surface different and extraordinary compared to its original, ordinary state—and if so, it is artified. Although such a predisposition may seem rudimentary, I point out that only humans (including preverbal children) do this, they have done it from very early times, and it is the first principle of art-making, even of the most contemporary or sophisticated kind.

It is of course possible to look at examples of non-iconic rock art without caring whether they should be called "art" or "artifications" or, for that matter, anything at all. However, apart from offering a neutral alternative term for describing rock art, we find that the ethological, evolutionary, and cross-cultural framework of the concept offers a fruitful starting point for reassessing some contentious questions of why archaic and other rock markings were made in the first place and what they were for—that is, questions of motivation, function, and meaning. The notion of artification can contribute to long-standing questions in paleoarchaeology about the early human mind in general, and its mark-making proclivity in particular.

The concept of artification differs from other approaches to the arts, including rock art, and is supported by the following axioms:

1. *Humans are animals.* Understanding our present and past requires a grounding in biology. Ethological and evolutionary thinking are essential to understanding human cognition and behavior. Paleoamericans, like their Pleistocene ancestors, would have been motivated to secure the physical and psychological necessities for their lives: nourishment, health, safety and comfort, status, predictability, sexual partners, healthy

offspring, and social relationships that are reliable and reciprocal. Considered in this way, as fundamental hominin needs and goals that arise from basic subcortical emotional systems, it is clear that, even before being able to articulate them in language, the concerns of our ancestors reflected their desire to cope with biological requirements that were uncertain, difficult, and sometimes dangerous to meet.

2. The requirements of several million years of hunter-gatherer life remain active in human psychology. Although early evolutionary psychologists spoke of the "environment of evolutionary adaptedness"—a time in the Pleistocene past when what is called human nature was being embedded in our genes—it is now recognized that foragers of the past, as well as their recent descendants, inhabit a multitude of environments and cannot be forced into one generic category. Nevertheless, even science writer Nicholas Wade, one of the main proponents of hunter-gatherer diversity, finds overlap, if not identity, noting that the "principal lineaments of human nature are the same in societies around the world, suggesting that all are inherited from a single source."[20] In addition, it is not unwarranted to assume that the ways of life and modes of thought of recent forager and small-scale horticultural societies bear greater resemblance to those of prehistoric individuals than our lives do.[21] It is reasonable to extrapolate from what we know of recent traditional societies to our speculations about the past.

If we take into account our affective (emotional) value systems, there are regularities (even "universals") to be found in the psychology and emotional needs of individuals that warrant our speculations about ancestral psychology. Despite differences in stature, body shape, skin color, physiognomy, allergic reactions, and so on, early hunter-gatherers bequeathed to us important traits (a "Pleistocene psychology") that developed and were adaptive over hundreds of thousands of years of forager life.[22]

Regardless of the dates one accepts as relevant for describing the behavior of early *Homo sapiens* and its forebears, it seems that they all relied on local resources for subsistence—plants and animals (including fish), as opposed to tilling the ground. As British evolutionist Robert Foley says, there needs to be a term that refers to this way of life.[23]

Most anthropologists would agree that despite diverse climates and environmental challenges, the general ways of life of foragers share important characteristics. All live in what have been called "societies of intimates"[24] (as contrasted with "societies of strangers," the larger and more complex groupings that began to develop slowly in different parts of the world around 12,000 years ago and depended on agriculture). Their mode of subsistence as foraging nomads requires a restricted territory and a small group size—in some cases, fewer than 15 people and occasionally as many as 50 to even 150. At either end of this population scale and at all stages in between, individuals have face-to-face acquaintance with each other. There is cultural homogeneity and stability, and an egalitarian social structure with consensual leadership and kinship-based social cooperation.[25] In general, technology is not specialized except for tasks that require the physical strength of males, who are also more mobile than females, who bear and tend young.

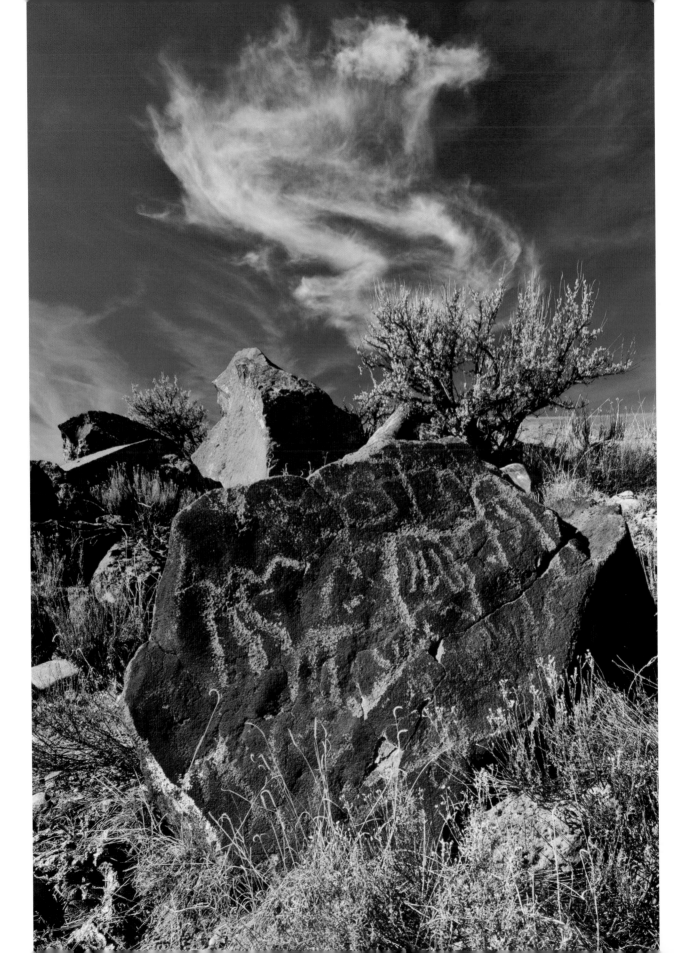

Other evolutionary adaptations of the forager way of life, some shared with other primates, can also be detected in spontaneous behaviors of infants and children:[26] the seeking and establishment of close dyadic (two-way) relationships with adults,[27] observable in infant attachment behavior and even earlier in the mother-infant dialogue.[28] Another evolved psychological predisposition is for group affiliation and in-group favoritism; and fear of and hostility toward strangers (related to in-group belonging). These behaviors, essential for reproductive success and survival in Pleistocene times, are clearly still evident in contemporary humans who live in a complex, pluralistic world.

Mutuality and affiliation are developed and reinforced in play, an evolved behavior, before they are employed in adulthood. Play is one of several features that are not often mentioned in inventories of characteristics that paleoarchaeologists find relevant to a predisposition to make marks. Forager children (and adults) play, and we can easily assume that even the earliest hominins, being primates, also must have played. Playfulness is so obvious as not to require mentioning, although if it is not mentioned, theorists may overlook its implications for adult motivation and behavior.

Similarly, it is obvious that everything needed in forager life is obtained or constructed with one's own body and hands. Although all wild-living animals use their bodies (and their paws, as with raccoons or squirrels), humans are unique among other species and even other primates for their flexible, dexterous hands, left free by bipedalism to develop the precision grip and opposable thumb that make skilled tool making and tool use possible. The untaught and highly pleasurable impulse to use one's hands and explore their many possibilities is unmistakably evident in babies and small children as well as in many contemporary adolescents and adults who feel satisfaction when making or repairing things. Lacking motivation to use one's hands would have been maladaptive to ancestral people.

The hunter-gatherer way of life, then, predisposed people to artify and, what is more, to artify in similar circumstances or for similar reasons. Because sharing and cooperating were necessary, communal relationships were encouraged—coordinated and reinforced through periodic, often frequent, rites or ceremonies. Artifying (as singing, dancing, and elaborating the body and surroundings) is an essential and primary feature of ceremonial ritual. Distinguished archaeologist and prehistorian Jean Clottes, has proposed that the *Homo* species' name, *sapiens* (wise), be replaced with *spiritualis*, because he aptly considers our species' taxonomic name to be "really too optimistic."[29] He suggests that *Homo spiritualis artifex* might be a more appropriate appellation because of the close bond between spirituality and art.[30]

3. All humans alive today and from at least 100,000 years ago are members of the same species, Homo sapiens. If raised from infancy in a specific culture, each of us would have grown up to be participating members, accepting the values and customs of our group. Differences in beliefs and practices of one group can seem vast to people of another, but all arise from the same evolved human nature. Underlying the variety of cultures are diverse but universal commonalities.[31] Just as each language is different

1.10 (*opposite*) Ancient engravings, some refreshed by repecking, New Mexico

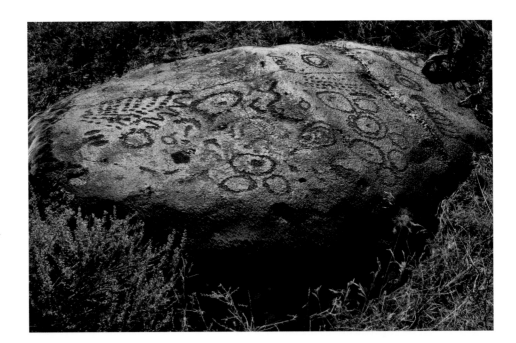

1.11 (*right*) One of the Melon Gravels along the Snake River with an assortment of stand-alone geometric primitives, Idaho

1.12 (*below*) Boulder façade, fully covered with time-worn parallel lines, Idaho

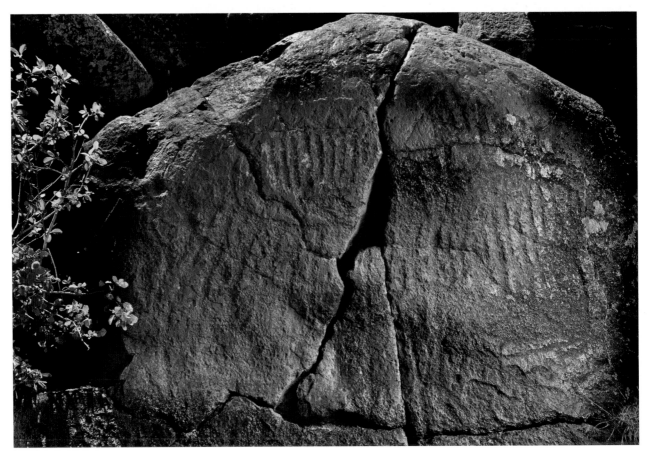

but all humans are predisposed to learn to speak, the arts of a society are different but all humans are predisposed to artify and will do so if the surrounding culture enables it.

4. Artification is an adaptive (evolved) behavior. That is to say, it is a universal behavioral predisposition like other characteristic behaviors such as language, tool-making, attachment in infants, maternal care, adult pair bonding, group living, ritual/religious practices, warfare, ethnocentrism, and many other behaviors that are found in all cultures. Artification includes appreciation (what has been called "aesthetic experience") but is based on active making and participating. Like other evolved behaviors, it arises from brain activity whose biological purpose is to motivate and reward appropriate responses to one's environment—to things that are good (positive) or bad (negative) for our survival and reproduction.

5. All humans are cultural creatures. Being acculturated is biologically predisposed. Adult psychology and experience (of arts or anything) grow from and build upon inborn capacities, motives, and preferences.

6. Preverbal affective and aesthetic mechanisms continue to influence human cognition and language. They are also critical, if neglected, components of scientific studies of the arts, including rock art. Typically, scientific studies of our ancestors are concerned with cognitive capacities of the mind. Yet nonverbal and emotional concomitants of forager life are equally influential and relevant to the motivations for mark-making as those described in axiom 2—the pleasure to be found in play and hand use.

For example, it is clear (but rarely mentioned) that foragers must be alert to their surroundings. Their hunting success and safety depend on observation and interpretation of the world they inhabit—its weather, seasons, terrain, the behavior of the animals they track and kill. As it has been observed that nomadic herders of cattle in East Africa find their animals' coat colors and shapes of horns infinitely fascinating,[32] we can assume that ancestral foragers were similarly preoccupied with the animals they feared or hunted for food.[33] Once language evolved, they perhaps told and listened to stories or recitative-like "animal songs" that could have arisen from vocal impersonations of animals, as one finds today in North American native cultures.[34]

In their precarious, subsistence way of life, ancestral hunter-gatherers had to be mutually interdependent in ways that are not required of members of large settled and anonymous populations who, especially today in the West, extol individuality and personal liberty. As with their observations of other animals, their observations of one another in varied circumstances and the tacit intimate knowledge that comes from shared intense experiences would have drawn upon (and contributed to) nonverbal but intimate interpersonal and social skills.

Although language certainly became important, the work of neuroscientist and psychiatrist Allan Schore has established that the early developing right-brain ("the emotional brain," "the social brain"), and not the later-maturing linguistic left brain, remains dominant in human experience,[35] although in modern highly literate societies we may not be aware of it.

Schore's pioneering work describes the shift in theoretical perspective in psychotherapy from the *behavioral* framework of the 1960s and 1970s to the dominance of the *cognitive* paradigm that arose in the 1970s and 1980s. The latter observed not only maladaptive external behavior but internal cognitive processes such as memory, attention, perception, representational schemas, consciousness, narrative, and language—with the goal of changing the patient's cognitions. Schore's work has been paramount in the most recent emphasis from the mid-1990s to the present on bodily based emotional and psychobiological states: that is, to the shift from cognitive to emotional development.

According to Schore, the most fundamental problems of human existence cannot be understood without addressing this primal realm.[36] Implicit, nonconscious survival functions of the right cerebral hemisphere, and not the language and analytic functions of the left, are dominant in development and in psychotherapy. Among these are the highest and most complex human functions—stress regulation, intersubjectivity and empathy, compassion, humor, morality, creativity, and intuition.[37] Surely one half of human brain function should not be overlooked when we try to understand ourselves or the early human mind.

7. Western preconceptions about the arts are largely irrelevant to rock art studies. This conclusion is an obvious one to reach after reviewing the previous six axioms. Taken together, they suggest that the prevailing and mainstream views of early human minds by modern cognitive and evolutionary scientists are unconsciously influenced by their own academically trained minds, which are characteristic of only a miniscule proportion of the entire population of all humans who have ever existed. A provocative and widely cited paper by three psychologists at the University of British Columbia identifies the preponderance of studies by and about Western, Educated, Industrialized, Rich, and Democratic (WEIRD) people, and concludes that the usual subjects of these studies—university undergraduates—are "among the least representative populations one could find for generalizing about humans, and that there are no obvious *a priori* grounds for claiming that a particular behavioral phenomenon is universal, [if the claim is] based on sampling from a single subpopulation."[38] Certainly, all WEIRD scholars, including the authors of this book, must rigorously review our own assumptions about the universal components of human nature.

For example, the relatively new field of evolutionary aesthetics (sometimes called "Darwinian aesthetics") is suffused with modern Western notions about art. So far their speculations about rock art are few.[39] However, neuroscientific analyses of the visual perception of works of art are typically illustrated by Western masterpieces—"Art" with a capital *A*—static entities perceived by static individuals.[40]

In the case of early mark-making, based on anthropological reports about the context for visual art in many societies, the concept of artification includes the possibility that making marks may well have been part of a larger event, an occasion for (or a way of) accessing a nonordinary realm, consecrating a special place, or accomplishing some desired aim. From what we know of the production of visual artifacts in aboriginal

1.13 (*opposite*) Coherent ensemble of deeply graven designs, Nevada

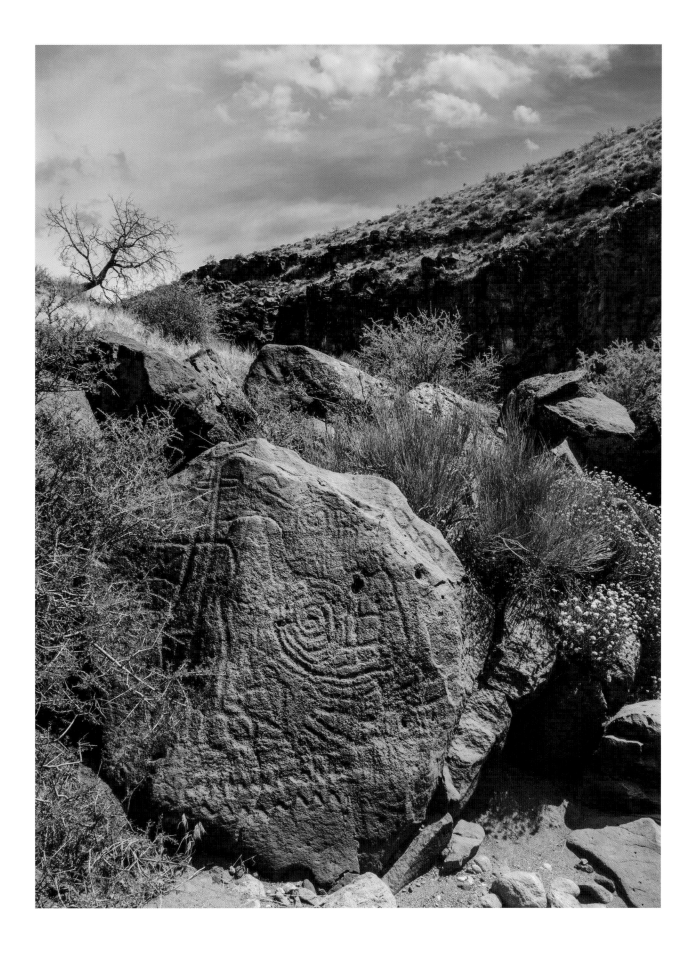

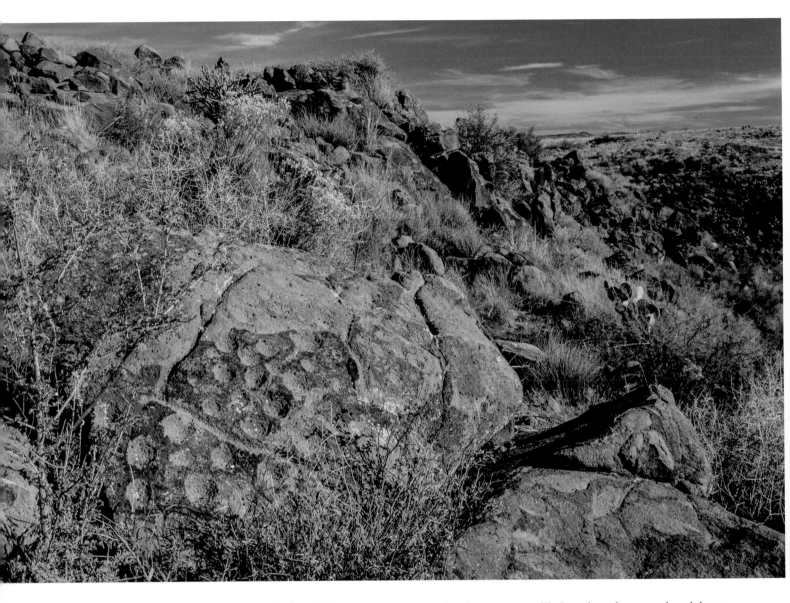

1.14 Cupules on sloping rock surface, Arizona

societies of the recent past, rupestrian images are unlikely to have been made solely or even primarily for private contemplation. On the contrary, they were probably components of a ceremonial occasion that included other artified behaviors—chant, song, dance, performance. For example, recent findings that the most densely painted areas of Upper Paleolithic caves in Western Europe are also those with the best acoustics suggest that painted images may have been accompanied by vocalized or other sound and perhaps dancing.[41] Archaeologist Dale Guthrie contends, however, that many representational images in Ice Age art were indeed made for private pleasure.[42]

Evolutionary aesthetics and neuroaesthetics are both concerned with preferences for visual or other sensory perceptions that signal biological reward. These emphases

are important, but they address only half of the human art impulse: they ignore significant emotional aspects that are the motivation for the activity of artifying in the first place, apart from any perceived biological "meaning." Concentrating on the neural mechanics of visual perception overlooks contexts that may be preverbal, presymbolic, cross-modal, supra-modal, participative, temporally organized, affective, and affiliative. These aspects are central to the concept of artification.

Researchers in both evolutionary aesthetics and neuroaesthetics often assume that art can be characterized by (or even be considered synonymous with) beauty, talent or virtuosity, originality, and creativity. Yet studies of recent and contemporary small-scale societies indicate that tradition is typically valued over novelty and creativity,[43] and power may be a more important attribute than beauty.[44]

By reconceptualizing art as a behavior of making ordinary reality extraordinary, the notion of artification includes types of rock markings that do not fit into the assumptions of "art" held by theorists in neuroaesthetics or evolutionary aesthetics. Some rock markings to be discussed in the following pages—cupules (fig. 1.14), the Gault incised plaquettes, and very early marks discovered elsewhere in the world—may not strike us with their beauty or show evidence of virtuosity, originality, and creativity. They are frequently assumed to be "symbolic," although in many instances this is only conjecture.

Spoken language, religion, art, and symbolic thought set humans apart from other animals. But each of those traits is not an all-or-nothing ability. If the Western concept of art (as depicting real and symbolic referents) is based on the more elementary capacity of artification, then language, religion, and the use of symbols also occur on a spectrum of complexity and sophistication. Apart from other imputed qualities, they have their own intrinsic value as early instances of the universal impulse to artify.

1.15 Archaic painted motifs, affected by the ravages of time, Arizona

———

Before further addressing the implications of the axioms that underlie the concept of artification, we will turn a to more concrete, factual view of terminological, chronological, stylistic, and other related archaeological issues concerning Western Archaic Tradition (WAT) paleoart, manifested as both rock art and portable art.

2

TERMINOLOGY, CHRONOLOGY, AND DATING OF NORTH AMERICAN PALEOMARKS

EKKEHART MALOTKI

THE ABSTRACT-GEOMETRIC DESIGNS reproduced on these pages can be appreciated simply for their visual appeal. If we wish to try to understand more about them, however, it is necessary to become acquainted with current factual information before moving on to more theoretical speculations by us and others. Dating, for example, can be determined for known portable art objects that, unlike rock paintings and engravings, are associated with stratigraphic or archaeological contexts and stylistically have the telltale geometric markings that characterize early paleoart of the American West.

TERMINOLOGICAL CLARIFICATION

Throughout the western United States and northwest Mexico, from Canada to Chihuahua and from Texas to the Pacific Coast, canyon walls, boulder faces, and rock shelters were the matrices for the most ancient artists of the Americas. The motifs with which they and their descendants artified their world were—as with the earliest mark-makers everywhere—almost exclusively abstract-geometric. Whatever has survived of their creative efforts, primarily in the form of petroglyphs and pictographs but also in the form of portable art incised on mammoth ivory, bone, and stone, is designated here as belonging to the Western Archaic Tradition (WAT).

The term Western Archaic *Tradition* is used here in place of Western Archaic *Style* for the reasons originally established by rock art researcher Ken Hedges, namely that the broad tradition's body of designs subsumes a number of stylistic expressions that are distinguished by regional variability within what most would view as a related artistic "family."[1] This observation was also made by archaeologist Angus Quinlan when he

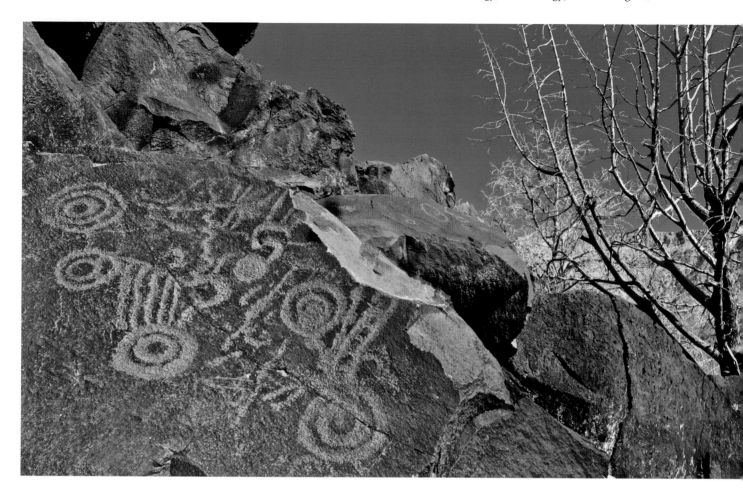

2.1 Typical Western Archaic Tradition petroglyphs, Utah

pointed out that the widespread occurrence of abstract rock art throughout western North America does not rule out the existence of localized expressions marked by certain graphic preferences and/or idiosyncrasies.[2]

The label "Western" in the tradition's name points to the geographical part of North America that offers the heaviest concentration of WAT-style imagery. However, it in no way implies that the tradition is limited only to this portion of the continent. Encountered wherever one finds people on the planet (fig. 2.2), the universality of geometric marks is no doubt related to primitives of perception and motor control in the human brain. The "Western" label is more a function of utility and reference than an indication that the tradition only occurs in one portion of the world.

Nor is the tradition restricted in time as suggested by the word "Archaic." Solveig Turpin, an authority on the rock art of the Lower Pecos area of Texas, for example, holds that the consistent nature of WAT-type imagery appears to be "insured by the Ur-culture of hunting and gathering people."[3] Furthermore, ample pictorial evidence shows that, with a few curious exceptions, the tradition continued to be in vogue over much of the region up to about 700 or 800 CE in areas that developed sedentary agricultural societies,

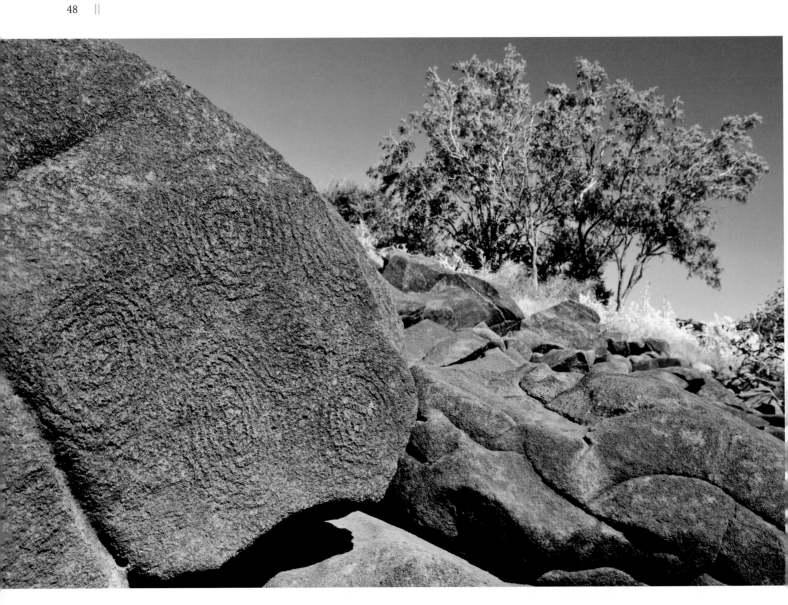

2.2 Aboriginal engravings belonging to Australia's Pleistocene petroglyph tradition, Burrup Peninsula, Western Australia

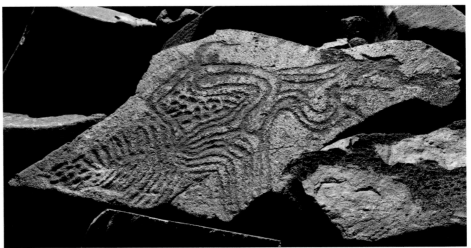

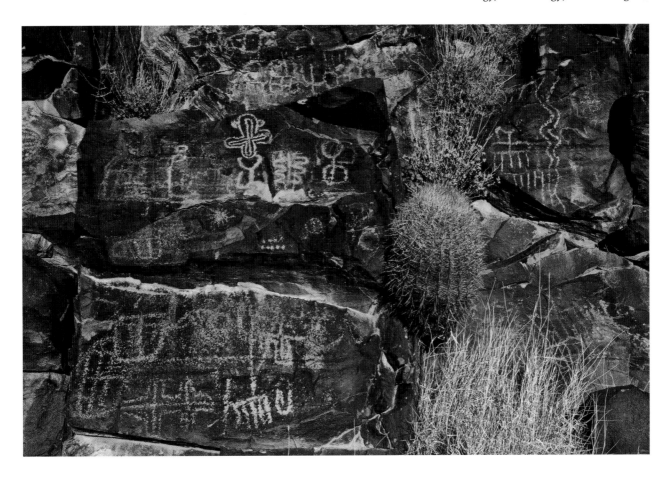

2.3 Haphazard jumble of petroglyphs resulting from several pecking episodes, California

and even to much more recent times in areas where groups maintained a semisedentary or hunter-gatherer lifeway. Thus, in commenting on the various rock art sites along the Gila River west of Phoenix, Arizona, Hedges and Hamann found that all contain noniconic components, "demonstrating a continuum in basic design elements from early times to the late prehistoric."[4] For Turpin, too, the term Archaic implies "non-agricultural people whose organizational level was relatively similar, whether they lived 10,000 or 100 years ago."[5] One can conclude therefore that the geometric motifs characterizing WAT are encountered primarily among people with a particular mode of subsistence. "Archaic" refers to the tradition's earliest occurrence on artified stone and bone at Paleoindian sites produced as early as 14,000 to 13,000 years ago, and its continuance as the primary artistic expression in the American West for thousands of years.[6]

Often displaying unlimited exuberance in compositional configurations without any apparent regard for careful spatial placement of the individual design elements (fig. 2.3), WAT iconography conveys the impression of "a complex but very loosely structured, asymmetrical, and almost unbounded art."[7] Nevertheless, various classifications have been suggested for the myriad geometric motifs that comprise the tradition's endlessly variable graphic repertoire, which remained so thematically

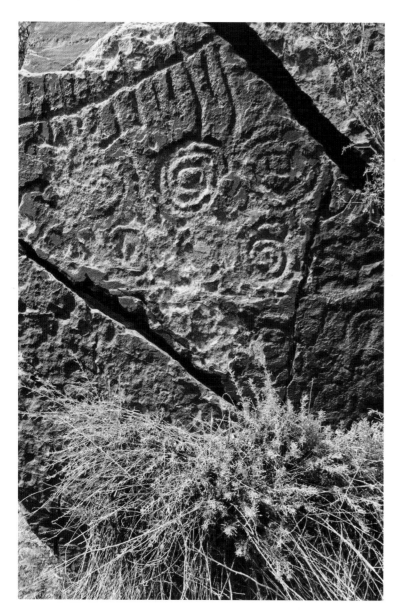

2.4 Heavily revarnished geometrics, indicative of deep antiquity, Utah

consistent through time and across space in the American West and beyond. Turpin, for example, follows the Heizer-Baumhoff model, which divides the abstract-geometric elements into curvilinear and rectilinear substyles.[8] The curvilinear substyle includes circles, concentric circles, chains of circles, sun disks, meanders, stars, and asterisks. Rectilinear abstracts, on the other hand, include various dots, rectangular grids, rakes, and crosshatchings.[9]

Archaeologist Alanah Woody, well aware of the occasional ambiguity of her own classificatory scheme, also differentiates two categories: those whose constituent parts are basically circular and those she considers to be morphologically geometric. Among the circular examples she lists such motifs as cupule, dumbbell, tailed dot, atlatl, and filigree, while in the geometric examples, in addition to straightforward geometric configurations, she includes plants, trees, and grooves.[10] For the Colorado Plateau, rock art specialist Sally Cole offers a tripartite division for the abstract design types: closed elements (circles, dots, concentric circles, spirals, wheels, and gridirons), open elements (lines, rakes, frets, crosshatches, one-pole ladders, and squiggle mazes), and complexes (chains of circles, lines with attached circles, and rows of dots).[11] Other researchers have compiled long catalogs without subcategorizations. Perhaps the most detailed list, with hundreds of individually described elements, is found in anthropologist Karen Nissen's analysis of several sites in the Western Great Basin, which she aptly refers to as a "dictionary" of design elements.[12]

Numerous closely associated terms have been applied to the basic abstract designs that characterize the Western Archaic Tradition. Among the more colorful ones are archetypal symbols, desert abstracts, entoptic forms, geometric primitives, graphic universals, ideograms, ideomorphs, indeterminate marks, nonfigural art, phosphene-like shapes, pre-iconic markings, primal artistic idioms, protomarks, psychograms, symbolic Gestalts, and 2-D abstract patterns. This book refers to this class of designs globally as paleomarks or paleoart, often with additional modifiers—such as abstract-geometric, noniconic, nonfigurative, and nonrepresentational. All of these descriptors refer to the same intrinsic qualities of the marks.

THE PEOPLING OF THE AMERICAS

One of the most hotly debated and enduring issues of New World archaeology concerns the dispersal of *Homo sapiens* into the Western Hemisphere: when the first people arrived, where they came from, how they made their way—on foot or by watercraft, how many waves of migration there were, and how the newcomers adapted to the manifold environments they encountered as they journeyed across the landscapes of the Americas. These issues are essentially unresolved and controversial, with no consensus in sight.

In the early 1930s, following the discovery of several distinctive leaf-shaped projectile points near the town of Clovis, New Mexico, the Paleoamerican makers of these points were believed to be members of the founding population of the Americas. This

2.5 Basalt boulder with abstract squiggles, Arizona

assumption, which became known as the "Clovis-First paradigm," dominated scientific and popular thinking about the earliest inhabitants of the New World until the end of the twentieth century. Advocates of the model essentially postulated that some 13,500 years ago small bands of big-game hunters from northeast Asia, who tracked mammoths, mastodons, and other megamammals, were the initial migrants into an unpeopled continent. They were believed to have entered it by crossing Beringia, a now submerged landmass that, at the end of the Ice Age, when sea levels are estimated to have been some 100 meters lower, served as a "land bridge" between northern Asia and Alaska. In this scenario with its now stereotypical claims, after passing through the Ice-Free Corridor that had been formed in western Canada by the retreat of the Cordilleran and Laurentide ice sheets, the people became "Clovis" as they spread, in the course of just a few hundred years, all the way to Tierra del Fuego in southernmost South America. The time frame generally accepted for the Clovis culture complex is a relatively brief period of about 13,300 to 12,800 calendar years BP.[13]

Now pronounced defunct by the majority of paleoarchaeologists, the model's fallacy first became apparent when the Monte Verde site along the Chilean coast, dated to approximately 14,800 years ago, revealed convincing evidence of much earlier human settlement in the Western Hemisphere.[14] With acceptance of the pivotal Monte Verde dates, claims for several sites of equal or greater antiquity in North America have also become less controversial. Many have yielded stratified deposits with artifacts that provide compelling evidence for the presence of pre-Clovis populations in the New World.[15] Additional sites that have irrefutably undermined the longstanding Clovis-First paradigm include: Meadowcroft Rockshelter in Pennsylvania, with its deep stratigraphy; the Schaefer and Hebior sites in Wisconsin, with their co-occurrence of woolly mammoth bones and stone tools; Cactus Hill in Virginia, with numerous artifacts exceeding the 16,000 year mark; the Manis mastodon site in Washington State, where the tip of a bone spear was found lodged in one of the megabeast's ribs; the Paisley Caves in Oregon, where the currently oldest scientifically dated human remains (in the form of desiccated feces) in the Western Hemisphere were found; the ancient multicomponent Topper site in South Carolina; Page-Ladson, a deep sinkhole site in the bed of the Aucilla River in Florida; and the recently discovered Debra L. Friedkin site in central Texas, which has supplied the final nail for the theory's coffin. Dated to 15,500 years ago by optically stimulated luminescence (OSL), it has yielded, at its lowest tool-laden horizon, a trove of artifacts that reveal occupation more than 2 millennia before the first appearance of Clovis.[16] An even older age was recently reported from the Bluefish Caves site in Yukon, Canada, where bones showing undisputable traces of human butchering activity revealed a radiocarbon age of 24,000 BP.[17]

These new findings have also pretty much upended the long-held assumption that the Clovis technological complex was a foreign import. Its signature projectile point (fig. 2.7), designed to spear big game like mammoths and mastodons and marked by distinctive grooves or "flutes" at the base, did not come from Asia and from all

2.6 (*opposite*) Rayed concentric-circles theme on dolomite marble, California

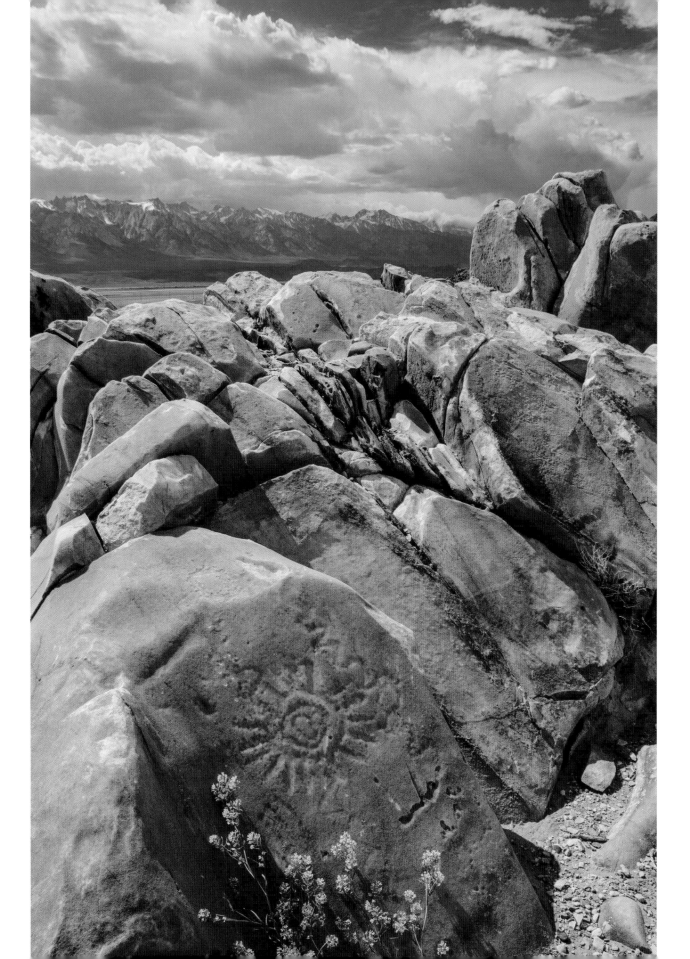

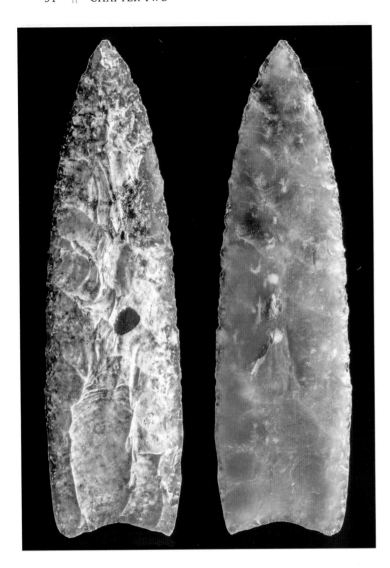

2.7 Spectacular Clovis projectile point, 13.2 cm long, with concave longitudinal "flutes" on both faces, from the Nunn site, Utah. *Photograph courtesy of Peter Bostrom.*

indications was "Made in America." Sometimes referred to as the "first Stone Age weapon of mass destruction," after its invention it must have caught on rapidly across widely scattered preexisting human groups in North America. Because manufacture of this distinctive bifacial artifact seems to have spread virally across the land, it could be considered a "meme," the term coined by evolutionary biologist Richard Dawkins for a cultural phenomenon that is transmitted from one individual to another by nongenetic means, especially by imitation and repeated use. No other scenario seems to account for the fact that despite the brevity of Clovis culture, its highly characteristic bifacial point has been found in all the contiguous United States as well as parts of Mexico and as far south as Costa Rica.[18]

Still, the origin of Clovis remains a topic of energetic debate. Orthodox, mainstream archaeological opinion continues to hold that the culture arose from northeastern Asian immigrants (Siberia). New confirming evidence that Clovis people came from Asia appears to have been recently obtained through the genome analysis of the remains of a human infant at the Anzick site, Montana.[19]

In a radical departure from this position, archaeologists Dennis Stanford and Bruce Bradley strongly contend in their North Atlantic ice-edge corridor hypothesis that North America's first settlers were Stone Age western Europeans, specifically Solutrean sailors who arrived some 18,000 years ago from southern France and the Iberian Peninsula by navigating along North Atlantic sea ice.[20] This diffusionist hypothesis is regarded with a great deal of skepticism.

The complex question of the peopling of the Americas is far from resolved. While a colonization date of around 15,000 years ago is becoming an acceptable "new basal stratum of American prehistory,"[21] a growing body of evidence consisting of archaeological, genetic, linguistic, and environmental findings is emerging in support of the proposition that the first entry occurred much earlier than this. Some researchers, convinced that conventional science has seriously underestimated the presence of humans in the Americas, hold that the earliest colonization happened before the Last Glacial Maximum, the period of Earth's climate history of approximately 26,000 to 20,000–19,000 years ago when ice sheets were at their thickest and sea levels at their lowest.[22] As a result, anthropologist Michael Collins and colleagues now advocate a much longer period of pre-Clovis human presence. Indeed, they regard the Clovis manifestation as

being at "about the midpoint in the prehistory of the hemisphere rather than at or near the beginning."[23]

The extraordinary plethora of over a thousand indigenous languages in precontact North and South America has prompted linguist Johanna Nichols to state that such a diversity of languages appears much too great for colonization models that posit a single group of Clovis people as antecedents for all of the American peoples (Clovis-First of ca. 13,500 BP, at the time of her writing). Suggesting that the sheer number of American linguistic families—roughly one half of the 300 separate stocks attested worldwide— must have resulted from either multiple migrations or in-situ diversification, she envisages a deep-age estimate for the entry and settlement of the Western Hemisphere to be "before the maximal glacial advance" over 20,000 years ago.[24] On the other hand, based on the fact that language stock diversity is lowest in Africa and Eurasia where the time depth is greatest, biobehavioral researcher Daniel Nettle contends that Nichols's assumptions lack empirical validity, and that the great linguistic diversity in the New World can be reconciled with recent Paleoamerican entry.[25]

As a rule, however, 40,000 years is now seen as the "maximum limiting age" for human entry into the New World, and any claims exceeding this threshold "should be viewed with skepticism."[26] Currently, no skeletal remains from the Americas indicate

2.8 Petroglyphs on vertical cliff face overlooking Nevada landscape

2.9 Circle motif filled with an orderly arrangement of wavy lines, New Mexico

the presence of archaic hominins.[27] Therefore, all arriving Paleoamericans are assumed to have been anatomically and cognitively modern *Homo sapiens.* However, a host of other issues, all of them controversial, remain unsettled. Debates are ongoing with regard to such fascinating topics as the actual geographic homeland of the first settlers—Australia/Polynesia, Europe, Southeast Asia, or Northeast Asia; what migration routes they took—a transatlantic one from Solutrean Spain along the North Atlantic ice edge,[28] a Pacific Coast route nicknamed the "Kelp Highway" because of its assumed potential for exploiting aquatic resources along the northern Pacific Rim,[29] or as originally surmised, a course via the Bering Land Bridge and through a deglaciating corridor whose opening has now been pushed back to around 15,000 years ago;[30] how many migratory waves there were, an issue discussed primarily on the basis of genetics[31] and Siberian-American archaeology, but also on linguistic evidence; how many members the original founding bands contained; what their language characteristics were; how the earliest populations evolved; and what the ultimate fate of the Clovis fluted-point-makers was.

But these topics are beyond the scope of our book's subject. What concerns us here is whether there is material evidence that Paleoamericans of the Pleistocene-Holocene transition expressed themselves artistically in the landscape by creating parietal or portable art—corroboration of an innate predisposition to artify.[32] Making such a determination crucially depends on the availability of reliable, scientifically credible dating procedures.

DATING STRATEGIES

The greatest challenge in assessing the most ancient rock imagery anywhere is that of differentiating the old from the new. It is well known that the current state of rock art chronometry is not very encouraging. Indeed, the difficulty of fitting petroglyphs and pictographs into temporal frameworks appears to be the most troubling issue facing rock art research, apart from the extreme challenge of establishing their meaning. Some judge the difficulties in obtaining dates for art on rocks and walls as "tremendous,"[33] while others speak of a "'frontiers' phase of dating methodology" and advise researchers to "exercise considerable caution in the use of existing dates,"[34] or conclude that rock art chronometry is "still in its infancy" and warn against applying any dating results in support of theoretical models.[35] Radiocarbon dating of paintings in the Americas has been described as "less than ideal" and the field as "scientifically immature."[36]

Many of the age determinations cited in the literature have not been independently verified or replicated by any other researcher—a serious scientific issue in light of the fact that dating criteria must be testable and refutable. Checking and cross-checking is vital, not only by sending samples to different laboratories but, where possible, splitting them and submitting the different parts to different laboratories.[37] The obvious lack of age control is no doubt one important reason that many archaeologists have been reluctant to study rock art at all. Despite being intrigued by a painted or engraved work's intrinsic interest, they consider it only marginally or anecdotally valuable in reconstructing and explaining the past.

In addition to the traditional archaeological methods of estimating rock art age—identification and classification of pictorial subject; association with archaeological evidence such as spatial proximity to occupation sites and/or diagnostic artifacts; grooving depth; degree of patination and weathering; superimposition; and the use of style and manufacturing technique—in the past two to three decades a range of new and newly modified dating techniques have come on the scene. Some of these have at first seemed promising but were later exposed as highly tenuous or false. Others still need to stand the test of time—for example, cosmogenic isotope analysis, uranium-thorium dating, or the novel approach of rock surface exposure luminescence dating. Overall, this burgeoning field is tempered somewhat by the use of techniques without serious consideration of their reliability. Because of the highly contentious and controversial nature of rock art chronometry, even results for such sites as Grotte Chauvet-Pont d'Arc in France, arguably the best dated in the world and touted as totally robust and accurate, have been seriously challenged.[38]

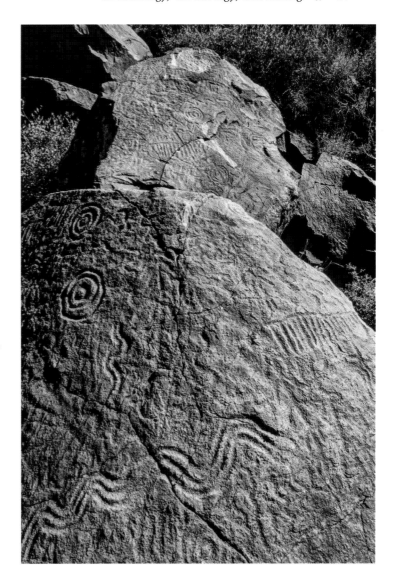

2.10 Curvilinear and rectilinear geometric primitives, Arizona

In the United States, efforts to date rupestrian art directly, in hopes of obtaining scientifically "absolute" ages, initially focused on applying the traditional and field-tested radiocarbon method based on the fact that the naturally occurring radioactive isotope carbon-14, inherent in all organic remains, decays at a fixed rate. This approach was aided by the advent of accelerator mass spectrometry (AMS) technology that permits radiometric dating of extremely small organic samples on the order of 1 milligram with much greater precision than the conventional method. Despite concerns about contamination from the inadvertent incorporation of older or younger carbon into the miniscule sample sizes, the method has yielded relatively acceptable results in the

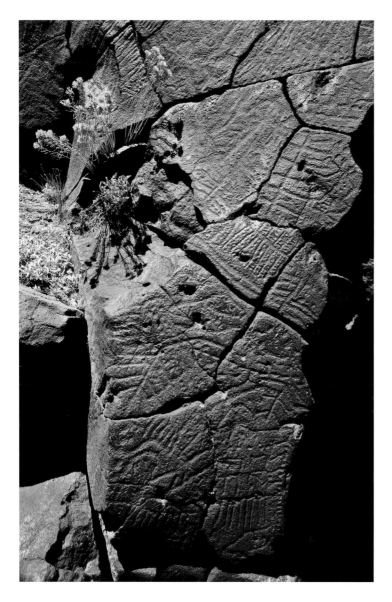

2.11 High degree of varnish blanketing dot-and-line patterns, Oregon

dating of pigmented art. This is the case when a drawing is made with charcoal, or the paint of a pictograph is found to contain organic binders such as animal protein, blood, eggs, plant resin, honey, or even urine.

When applied to petroglyphs, the mass spectrometric method targets suspected organics trapped in the rock varnish that have accumulated since their manufacture. Building up very slowly at a growth rate of only a few microns per one thousand years, varnish formation is not a uniform process (fig. 2.11). It varies drastically depending on orientation, exposure to moisture, climate, proximity to soil and vegetation, and other variables. AMS dating of organics in rock weathering zones and accretionary deposits was eventually recognized as a futile exercise after it was discovered that varnish formation does not occur within a closed system. For this reason it has been unanimously abandoned.

Cation-ratio (CR) dating, relying on the analysis of the chemical composition of a given sample from the overlying rock varnish on petroglyphs, is equally suspect and still deemed experimental by the majority of dating specialists. Since error parameters are quite large, often on the order of several thousand years or more, the technique is generally not accepted as a viable instrument.[39]

A not dissimilar technique for dating petroglyphs is X-ray fluorescence (XRF) analysis. The technique, which uses a hand-held instrument that can be employed directly in the field, is nondestructive, and permits relative dating of rock or desert varnish in dry climate settings. Focused on measuring the level of manganese that has accumulated in the varnish of a petroglyph, the approach is still in its infancy and faces several scientific issues, most critical of which is developing a reliable calibration curve. Since calibration relies on geologically dated rocks, it is likely to have error parameters and concerns similar to those involved in cation-ratio dating.

Among the currently perhaps least controversial new varnish dating strategies that seem to have moved beyond the experimental stage is varnish microlamination (VML). As Tanzhou Liu, chief developer of the technique and owner of a VML dating lab, explains on his website, the novel method, which is independent of cation-ratio and AMS 14C methods, is applicable both in the fields of earth science and archaeology.[40] For the use of VML, it is crucial that rock surfaces exhibit sufficiently solid varnish

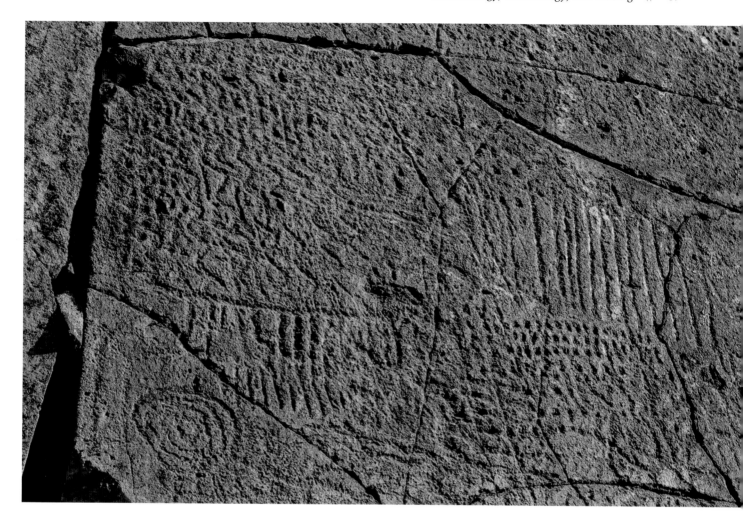

2.12 Cliff face with tightly packed geometric primitives, Arizona

coatings to be capable of nanostratigraphic analysis, whether they are found on desert pavements, lava flows, stone tools, or petroglyphs.

Providing correlative ages, VML rests on the assumption that the individual micro-depositional sequences that make up the rock varnish contain a record of alternating regional wet and dry cycles during the last glacial time. When samples of varnish are sectioned ultrathin and viewed under a microscope, the layers of varnish formation show visible banding that can be examined and compared. Manganese-rich layers, marked by dark bands, indicate that they were laid down during wet periods, while manganese-poor layers, typically of yellow or orange color, formed during drier climes. Correlation of these layers with independently dated phenomena such as lava flows or alluvial fans in the Mojave Desert has established that microstratigraphy is a valid dating tool for surface rock features in the range of 12,000 to 250,000 years ago.

While this range is too coarse for determining the age of Holocene petroglyphs, it appears acceptable for the Mid to Late Pleistocene where the possible age resolution

2.13 Exfoliated polychrome pictograph, Utah

can amount to "a few thousands of years."[41] Overall, the technique's error parameters are quite large, which diminishes its value for rock art researchers. Finally, it has not been used widely enough with soundly calibrated data sets to show its merit in the dating of early rupestrian paleoart, such as that from the Pleistocene-Holocene transition.

WESTERN ARCHAIC TRADITION PORTABLE ART

At present there is still no technique for dating "landscape art" (petroglyphs or pictographs) that meets stringent scientific standards. Fortunately, the situation is less dire regarding the dating of portable paleoart. Portable artifacts made of *organic* material such as bone, ivory, wood, leather, or shell can usually be dated directly by means of radiocarbon analysis. The relative age of *nonorganic* portable art, such as incised stones, or beads and pendants made of stone, can be determined on the basis of stratigraphic position or close association with datable matter. Omitted from the category of portable art as presented here are so-called figure-stones, especially the apparently sculptural stone effigies reminiscent of glacial fauna that allegedly show evidence of human workmanship. Lacking sound archaeological provenience, figure-stones, sometimes called mimetoliths, can most reasonably be attributed to the psychological phenomenon of pareidolia and are best considered as *lusus naturae,* "jokes of nature."

Ornately engraved stones reflect an incising behavior that occurs worldwide and is apparently quite ancient. One of the oldest examples, an incised core with simple repeated stroke marks, was reportedly engraved by archaic hominins at Qafzeh, a Middle Paleolithic rockshelter in Israel dated to ca. 90,000 years ago.[42] Enlène, one of the three Volp Caves in southwestern France, is famous for its abundance of finely incised stone plaquettes. Radiocarbon-dated to the lower end of the Magdalenian period of the Upper Paleolithic (approximately 14,000 to 13,500 years ago), Enlène houses over 1,100 of these plaquettes, most of which feature realistic themes, not only of animals such as bison and horses, but also, uniquely for Upper Paleolithic image-making, of anthropomorphic figures.[43]

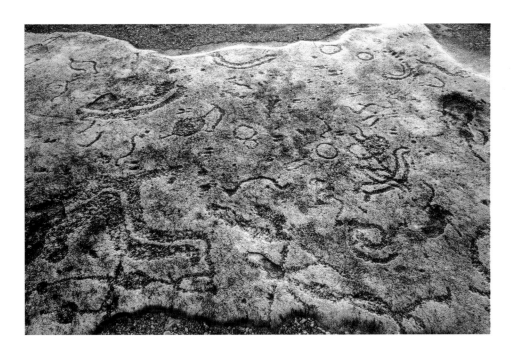

2.14 (*left*) Scattering of enigmatic abstractions on bedrock, Texas

2.15 (*below*) Prominent equidistant cross amid geometric scribbles, Arizona

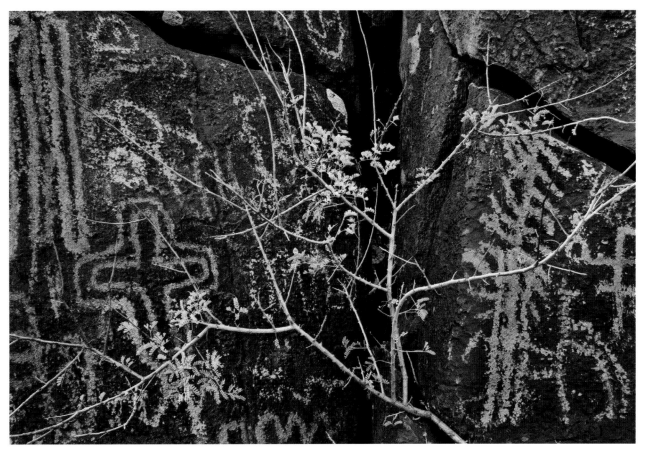

2.16 Finely scored plaquette featuring multiple spirals from the Gault site, Texas. Width, 11 cm. *Photograph courtesy of Clark Wernecke, The Gault School of Archaeological Research.*

In North America, no such naturalistically decorated stones of ascribed Pleistocene antiquity are known. All presently known decorated paleo-objects in the mobiliary art category feature nonfigurative designs. Most famous in this respect are the many decorated chert pieces and limestone plaquettes yielded by the Gault site in central Texas (figs. 2.16 and 2.17),[44] one of the three earliest securely dated sites with engravings in North America.[45] Of the over 100 specimens that have been retrieved to date with "good proveniences ranging from Early Paleoindian (13,600 years ago) to Archaic (9,000 to 1,200 years ago),"[46] eleven, recovered from controlled excavations, can be confidently placed within this Clovis tool tradition of the final Pleistocene.[47] The older ones display primarily perpendicular and parallel line patterns. Most of the others are finely engraved with curvilinear and rectilinear geometric markings, among them spirals, sets of paired lines, zigzags, checkerboard configurations, and herringbone-type crosshatches.

The verdict is still out whether any of the Gault engraved stones might exhibit representational patterns. For example, Dennis Stanford and Bruce Bradley, two Clovis scholars and lithic experts, have recently observed that two of the pebbles may actually be etched with zoomorphic motifs. In their opinion, one "resembles a running fox or a type of canine," while another "seems to represent several fletched spears stuck in an animal."[48]

Clark Wernecke, who as executive director of the Gault School of Archaeological Research is intimately familiar with the incised Gault stones, rejects their figurative interpretation. On the other hand, he is inclined to accept a pebble with diamond-topped lines as possible representational renditions of grass rather than darts. He finds evidence for this reading in the fact that at the time of the site's human occupation the predominant plant would have been "big bluestem grass which has a diamond-shaped seed head in the fall."[49] Big bluestem is a tall grass native to much of the Great Plains and Prairie regions of central North America.

Believed to rank "among the earliest art objects from secure context"[50] and showing a continuity with later art in the Americas in regard to materials, technology, and design, the Gault Clovis-age engraved pebbles may indeed reveal the beginnings of a mobiliary art tradition in North America.[51]

In the American West, stones marked by linear scoring in distinct patterns are found in every state of the Great Basin, most often in open-air locations without a stratified context, but also in rock shelters and caves. For example, the Cedar Valley collection in Utah contains thirty-six stones scribed not only with random geometric graphisms

2.18 Intricately artified stone fragment from the private Cedar Valley Collection, Utah. Length, 8 cm.

2.17 Limestone cobble textured with crosshatch and triangular patterns from the Gault site, Texas. Length, 13.5 cm. *Photograph courtesy of Clark Wernecke, The Gault School of Archaeological Research.*

2.19 Paleoarchaic incised stones from Barton Gulch, Montana. *Drawings courtesy of Leslie Davis.*

but also with complex patterns and compositions (fig. 2.18).[52] Regrettably, because they were collected on the ground surface, they will remain undated like most other such finds from Nevada, California, Oregon, and Idaho.[53] In their designs, however, some of them strongly resemble incised stones retrieved from cultural layers at Hogup Cave, which provide a record of more than 8,000 years in the Great Salt Lake region of Utah.[54] On the other hand, two engraved stone tablets with nonfigurative designs, hailing from Barton Gulch in southwest Montana (fig. 2.19), are securely dated as WAT paleoart. Barton Gulch, according to its lead investigator, shows abundant evidence of a "Paleo-archaic foraging adaptation" around 10,560 years ago.[55] Interestingly, one of the tablets is elaborately incised on both sides with crosshatchings, subparallel lines, and chevrons.

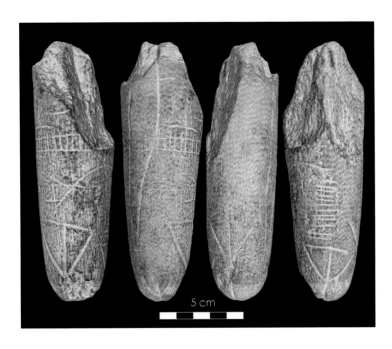

5 cm

2.20 Geometrically engraved limestone (four views), Wyoming. *Photograph courtesy of Todd Surovell.*

Additional pebbles engraved in this abstract-geometric manner have been recovered at several other North American locations, all attributable to Paleoindian antiquity. Specifically associated with Clovis are Wilson-Leonard Rockshelter,[56] Kincaid Shelter,[57] the Levi Rockshelter in Texas,[58] the Clovis type locality Blackwater Draw in eastern New Mexico,[59] Shawnee-Minisink in northeastern Pennsylvania,[60] and the Hardaway site in North Carolina. The latter yielded twenty-one engraved slate fragments and water-worn pebbles at various levels of the excavated area. An additional 259 were found on the surface.[61] Folsom-age[62] campsites with intentionally scored stones are known at the Lindenmeier site in northeastern Colorado[63] and the Agate Basin site in Wyoming.[64] Paleoindian origin is furthermore attributed to a chert flake from the Olive Branch site in southern Illinois deliberately engraved with a reticulate pattern,[65] and to a piece of steatite from the Reagan site in Vermont artified on one side with a deeply grooved X and with a zigzag design on the other.[66]

Many different functions and meanings have been attributed to noniconically artified stones, ranging from their being doodles and graffiti to gaming pieces, trail or boundary markers, fetishes, votive offerings, healing stones, and dozens of other possibilities, all of which are ethnographically unprovable. Probably the most insightful observation, and one that fits the paradigm of artification, is that "the process of manufacture and the patterns employed may have been more important than the decorated object after its initial use."[67]

In addition to the widely occurring artified stones, Clovis-era artwork featuring geometric patterns is also seen on bone and ivory. While the Gault site has now also produced its first incised bone,[68] two Pleistocene examples, one on a bird bone, the other on a proboscidean tusk, originally retrieved in association with early human remains at the Vero Beach site in Florida,[69] are now unfortunately lost.[70] Four specimens of worked bone from the Agate Basin site in Wyoming are of Folsom vintage. Modified with closely spaced lines, three of the calcined fragments may actually stem from one object.[71]

A rather bizarre find that merits mentioning in this context is the "Barnes Tusk" (fig. 2.20). Recovered from a Late Archaic occupation site in the Bighorn Basin of Wyoming, it was initially thought to have been fashioned of mammoth or mastodon ivory, which suggested Early Paleoindian provenience. This age estimate seemed to be confirmed not only by its simple geometric incisions—a series of bisected triangles and a webbing- or ladder-like design—but also the discovery of a Clovis point fragment just a few hundred meters from the site. To explain its retrieval from a Late Holocene location, it was hypothesized that a Late Archaic person had picked it up elsewhere and then carried it to his campsite.[72] Troubled by the artifact's weight—it appeared to be far too dense

to be ivory—archaeologist Todd Surovell, who originally had subscribed to its Pleistocene antiquity, undertook a new chemical analysis. As a result of this analysis it was determined that instead of apatite, the inorganic part of ivory, the artifact consisted mostly of calcite, a mineral component of limestone. Surovell is confident that the material came from the hot springs in Thermopolis, only eight miles from where the artifact was found, and where travertine, a form of limestone, occurs in great abundance.[73] The likelihood that the "Barnes Tusk" represents a genuine piece of Ice Age mobiliary art is therefore not very strong, although it cannot be ruled out. As an artified stone, however, it fits the abstract-geometric profile of WAT graphic expression.

Also attested is a small number of noniconically artified bone and ivory tools whose geometric designs have variously been interpreted as "decorations, ownership marks, or some other kind of symbolic message." Among them are curved ivory points presumably used on thrusting spears, marked with a zigzag pattern and parallel lines, retrieved from Late Pleistocene deposits associated with extinct fauna, including mammoth and mastodon.[74] Of these the Ohmes find from the Aucilla River in Florida, which is usually considered the type specimen, is decorated with a zigzag design on each side that is repeated twenty-eight times. While archaeologists generally refrain from reading specific meanings into such early markings, because "it is possible to overinterpret and assign far deeper meaning than these pieces deserve,"[75] one investigator proposes that it "could possibly represent a lunar cycle."[76] Instead of artification, Stanford and Bradley see functionality and interpret the designs as "intentional roughening to aid in hafting rather than decoration."[77]

The surviving Clovis toolkit also contains several beveled bone rods that appear to have been artified. Two of them, cylindrically shaped and exhibiting simple embellishment in the form of zipper-like incisions down the length of one axis, were discovered in a cache at the East Wenatchee site in central Washington (fig. 2.21).[78] Another such rod, whose beveled face is scored with multiple parallel crisscrossing incisions, is known

2.21 Bi-beveled bone rod (three views) with horizontal zipper-like incisions from the East Wenatchee Clovis site, Washington State. *Photograph courtesy of Peter Bostrom.*

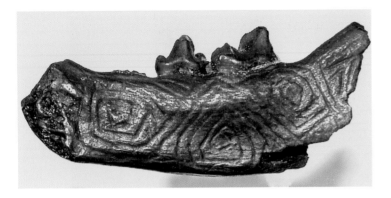

2.22 Bobcat mandible, featuring squarish spirals from Sloth Hole, Florida. Length, 6 cm. *Photograph courtesy of Andrew Hemmings.*

2.23 Peripherally notched bead fragment from the Lindenmeier site, Colorado. *Photograph © Denver Museum of Nature & Science.*

2.24 Artified disk fragment from the Lindenmeier site, Colorado. *Photograph © Denver Museum of Nature & Science.*

from Anzick, a Clovis burial site with a child's remains near the community of Wilsall, Montana.[79]

Finally, a number of other items support the contention that the signature mode of graphic expression during the Pleistocene-Holocene transition in North America was almost exclusively nonrepresentational. Among these are the remains of a 10,000-year-old bison skull with a red zigzag painted on it, found at the Cooper site in western Oklahoma.[80] From Sloth Hole, an underwater site in the middle of the Aucilla River, Florida, believed to have yielded the largest assemblage of Paleoindian bone and ivory tools in North America, comes a bobcat mandible artified with three spiral motifs on each side (fig. 2.22) thought to be of Clovis antiquity[81] and a fragment of a turtle carapace bearing a similar design.[82] Peripherally notched beads and bone disks are reported from the Lindenmeier site in Colorado (figs. 2.23 and 2.24),[83] from Blackwater Draw in New Mexico,[84] and from the Agate Basin site in Wyoming.[85] Considerably younger in age, the Windover site, located in the vicinity of Florida's Cape Canaveral, has produced some finely decorated bone objects that are attributed to the Early Archaic of ca. 8,000 years BP.[86] Finally, a most intriguing if controversial artifact marked with a simple geometric design hails from Petronila Creek in southern Texas. The site, whose exact age has not been conclusively established—dated bone and overlying sediments at its lowest stratum allegedly place it at over 21,000 years ago—contained a number of mammoth molar tools, among them a fragment that may have served as an atlatl hook. Decorated on its flattened side with a pronounced X, it is conceivably the oldest noniconically artified object in the Americas.[87]

Because the number of sites yielding portable cultural objects is extremely low, perhaps such sites are underreported or not recognized. It should be pointed out that objects of this kind may have been made from perishable material that would not survive in early contexts.[88] Still, our sampler of Paleoamerican mobiliary art, while far from exhaustive, demonstrates throughout the continent an overwhelming preference for abstract expression in North America.[89] Again, the question of why this should be so when the New World was settled long after representational artification had developed in Eurasia is a fascinating part of the geometric enigma that remains unresolved. The verdict is still out whether a realistically incised mammoth image discovered on fossil bone at Vero Beach, Florida, is a notable exception. While archaeologist Barbara Purdy and colleagues support its Pleistocene origin,[90] archaeologist Louis Tesar considers it a fake. He believes that he was able to demonstrate that, based on a series of replication experiments, the proboscidean engraving was made on mineralized bone and that the patination coating on the resulting cutmarks was intentionally forged.[91] What may weaken Tesar's conclusion, however, is that he carried out his experiments not on the original bone but on a cast.

3

CUPULES AS AN ARCHETYPAL ARTIFICATION

EKKEHART MALOTKI AND ELLEN DISSANAYAKE

SMALL HUMAN-MADE HEMISPHERICAL hollows or depressions, pounded and/or ground into a rock surface and known as cupules or cup-marks, are probably the most common and pervasive form of surviving paleoart in the world. They have rightly been said to have started "the long and continuous process of socializing the landscape in enduring media."[1] The fact that, planetwide, cupules may indeed be regarded as the oldest surviving paleoart does not rule out that even older forms of mark-making, such as body decoration, existed. Other artified behaviors that vanish as they are performed (song, dance, dramatic performance) do not leave traces for future archaeologists and may be even older than cup-marked petroglyphs.

While they may originally have been inspired by natural hollows, cupules were definitely created by human hands. As a distinct genre in the cultural landscape, these variformly shaped and sized engravings are a significant form of rock marking wherever they occur. In the American West, cupules are taphonomically most closely affiliated with the very early Carved Abstract Style petroglyphs. As such, some rank among the principal rupestrian contenders for possible Pleistocene antiquity. Yet, even though they constitute a sizable part of the Western Archaic Tradition (WAT) motif repertoire, few of the many fans of rock art know about them. Or if they do know, they tend to disregard them. Compared to complex graphemes or images of animals, they might seem simple, even boring.

It is the very unfathomableness of cupules, their enigmatic and mysterious nature, that makes them fascinating and relevant to current concerns in rock art studies. They merit inclusion in any discussion of the evolutionary and cultural origins of mark-making, although as far as we know, no such study has ever taken place. Furthermore, as a vestige of ancient human behavior, cupules add crucial new considerations

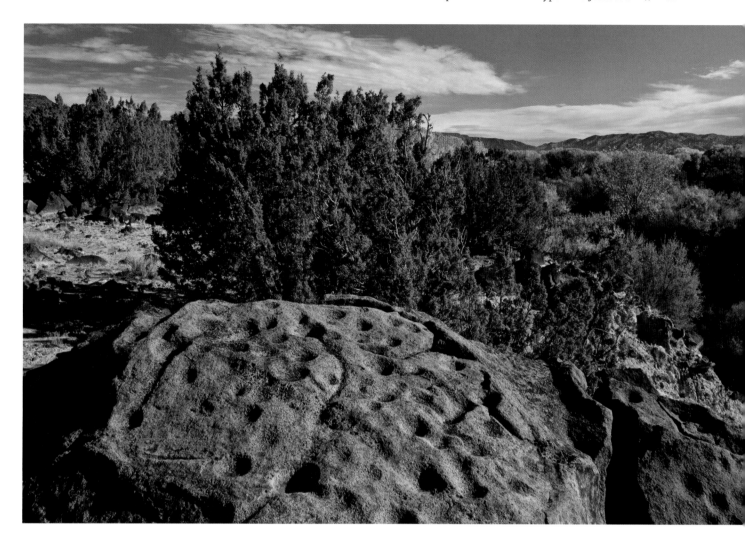

3.1 Deeply pounded cupules, some with interconnecting grooves, betraying deep antiquity, New Mexico

to the current contentious debate about when behavioral and cognitive modernity began, including core assumptions on both sides about the relationship between "art" and "symbol."

Cupules certainly are relevant to the Geometric Enigma. In a word, why would anyone make one cupule, not to mention quantities of them? Although on occasion the bowl-shaped pits are randomly incorporated into the actual configurations of petroglyphs (fig. 3.2) and pictographs, for the most part they appear densely clustered (fig. 3.3) or in the context of deeply cut grooves (fig. 3.4). Sometimes they form the center points of concentric circles (fig. 3.5), and are then referred to as a "cup-and-ring" motif.[2]

Cupules are occasionally found intergrading with utilitarian bedrock milling features such as metates or mortar holes (fig. 3.6). When pock-marking horizontal surfaces, some may have been made for practical purposes such as collecting water (fig. 3.7) or

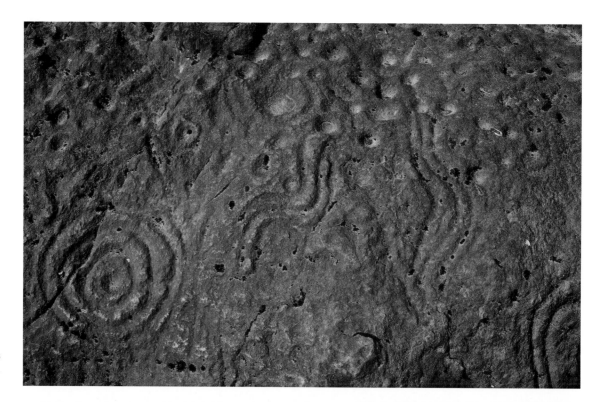

3.2 Random assortment of cupules and curvilinear glyphs, California

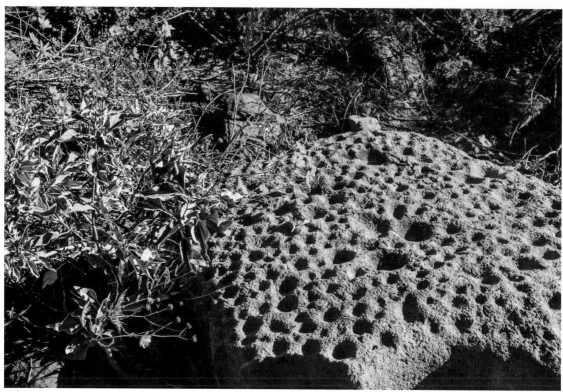

3.3 Boulder top, densely clustered with cup-marks, Arizona

3.4 California boulder showing an interplay of cup-marks and grooves. *Photograph courtesy of Douglas Beauchamp.*

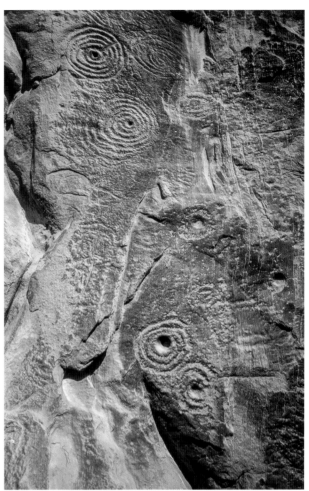

3.5 Concentration of cup-and-ring motifs, some almost completely eroded, Utah

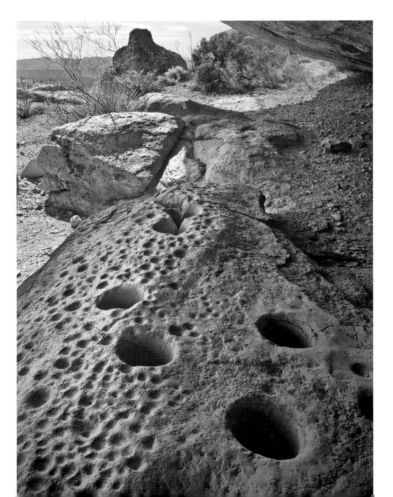

3.6 Mortar holes surrounded by cup-marks, New Mexico

3.7 Water-filled cupules, Utah

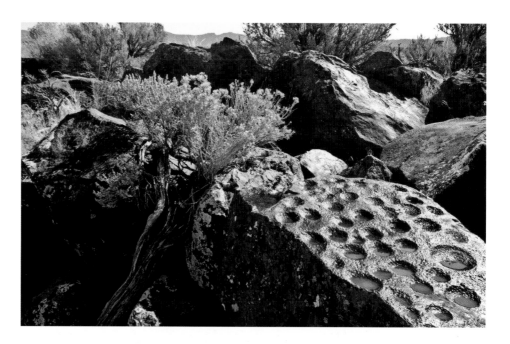

3.8 Cupules skirting a slanting rock outcrop, California

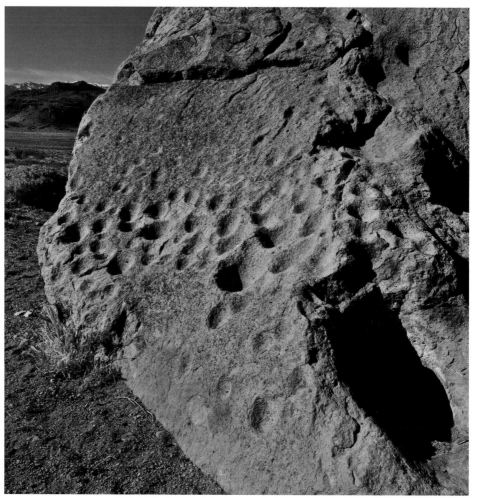

mixing or grinding various animal and/or plant products. However, they also occur on sloping rocks (fig. 3.8) and vertical cliffs, where it is difficult to imagine a utilitarian purpose. Exceptionally, at Boussaingault Cave, located in the Fontainebleau Massif region of France, it is the ceiling that is populated with dozens of cup-marks.[3]

The omnipresence of cupules throughout time and space makes them a unique and archetypal example of artification. Cupule-makers use as their medium the most ordinary and common material, the earth's solid crust. With strong arms, precise grip, inner vision, and determination, they overcome its natural resistance and make it extraordinary. The deep antiquity of cupule-making was first recognized in the 1930s when a massive limestone slab covering a Neanderthal child's grave was unearthed at La Ferrassie, a large cave complex in the vicinity of Les Eyzies, France. The sepulchral capping stone, whose underside is pitted with a patterned arrangement of eighteen cup-marks, most of which are paired,[4] is temporally ascribed to the Middle Paleolithic.[5] The fact that the cupules face the child's skeleton is seen as proof that they were symbolically and ritually associated with the infant burial.[6] Generally estimated to have been created before "more than 50,000 and under 100,000 years ago," these cup-marks are one of the earliest examples of prehistoric artification in Europe. The slab cannot be dated more precisely because the stratum from which it comes exceeds the limits of the radiocarbon method.[7]

The oldest cupules presently known in the world can safely be attributed to the Lower Paleolithic. These are seven small pits on a sandstone slab from Sai Island, Sudan, that have been dated at around 200,000 years old.[8] They rank high on the scale of acceptance because they have been credibly dated with optically stimulated luminescence (OSL). A similar Acheulian age range—"well over 170,000 years old"[9]—has been claimed for numerous cup-marks reported from Auditorium Shelter (Bhimbetka) and Daraki-Chattan Cave (Madhya Pradesh), two sites in central India, but has been refuted by all rock art experts who have since examined the site.[10]

According to paleoarchaeological orthodoxy, humans should not have had the cognitive ability to make "art" before they were able to symbolize. Perhaps cupules are not art. But if not art, what were ancestral humans doing when they made them? One could argue only in a very strained or eccentric sense that cupules embody modern characteristics of art—that is, that they are beautiful or imaginative, give pleasure or intellectual challenge, or that they show signs of expressive individuality, talent, originality, and creativity.[11] This view is also taken by California state archaeologist Breck Parkman as he engages with the "quite nebulous" term "art." In his eyes, if cupules are judged strictly as "marks made for aesthetic and artistic purposes," they do not "qualify as examples of aboriginal art." However, if "all marks on rock" are defined as instances of aboriginal art, cupules can be considered as art.[12] Parkman's definitional dilemma is clearly solved by the broader concept of "artification." Additionally, the time and physical effort required to make a deeply carved cupule call for an evolutionary explanation, since a biological organism does not regularly engage in such costly or labor-intensive behavior without gaining some adaptive advantage.

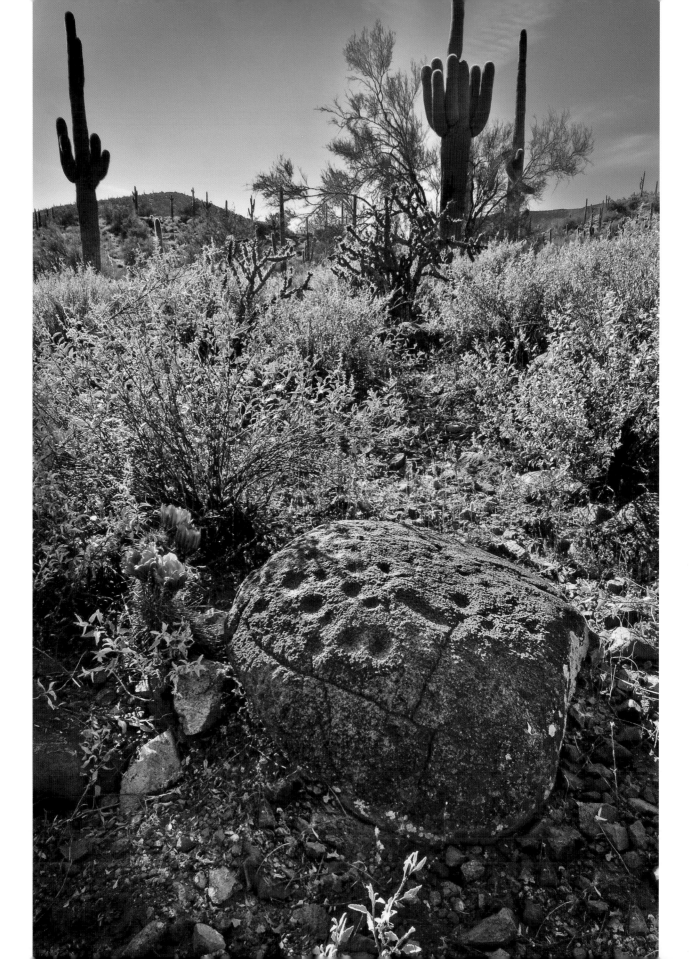

Although people today look at or learn about cupules with twenty-first-century eyes and minds, we would do well to try to understand the makers of such ancient marks as having a way of life and psychology that were adapted to a hunter-gatherer existence. Are they symbolic? Most archaeologists who look for evidence of early symbolic behavior do not include cupules in their arguments pro or con, even though they are certainly intentional human-made marks on rock surfaces, like other marks that have been called symbolic. Robert Bednarik, in his comprehensive article on cupules, does not refer to them as symbolic,[13] although in a later publication he characterizes their long history of manufacture as "patterned symbolic activity unmatched in the history of this planet."[14]

Thinking of cupules as "type specimens" of a *behavior of artification* (not "art") gives them a place in rock art studies and solves the conundrum of how to include them with other kinds of mark-making. The making of cupules need not automatically be interpreted as a by-product of symbolizing ability, and may be the result of other adaptive benefits that do not depend on symbol use. Although cupules may have been symbolic, they still remain as evidence of artification and, importantly, of a motivation to artify.

Additionally, early cupule-making is relevant to the current important controversy in paleoarchaeology about the origin of human symbolic capacity and may give us insights into the minds of the humans who made them.

CUP-MARKS AND THEIR COUSINS IN THE AMERICAN WEST

Cup-shaped marks are distinctive for their ubiquity, incredible longevity, and impressive uniformity. At first blush, the modern notion of a "viral meme" comes to mind as a possible explanation for this observation. However, as rock art scholar Ben Watson has pointed out, it is highly unlikely that this mind-boggling pan-global conformity, not only of cupules but of basic abstract-geometric markings, is a result of "cultural contacts between antipodal regions of the world during the Pleistocene."[15] Rather, the striking similarities are best explained as resulting "from a shared human brain and/ or common human experience." Their artistically, technically, and stylistically elemental appearance has led to the assumption that wherever they occur they automatically indicate deep antiquity. However, this is not always the case: Evidence from oral tradition in North America[16] shows that in some regions of California, they were produced during the Historic period and, in the case of Aboriginal Australia, even into the ethnographic present.[17]

WAT cupules were probably made by direct percussion with a hammerstone or by abrasion, although more qualified microscopic examination may be needed to establish this in individual cases. Most likely both techniques were used in tandem, with pecking coming first and grinding adding the final polishing touches (fig. 3.10).[18] Grinding or even drilling may have been the preferred option on rock surfaces with preexisting natural pits, when simple reaming out of the cavity could achieve the desired cup

3.9 (*opposite*) Cup-marked boulder in the Arizona desert

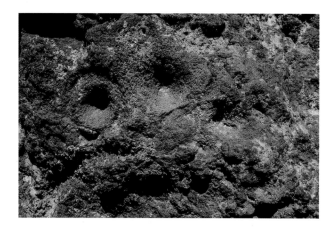

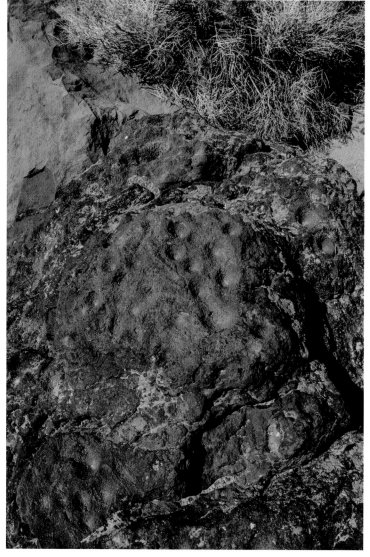

3.10 Cupule boulder (*right*) with closeup detail (*above*) showing evidence of grinding or abrading to finalize symmetrical shape, California

shape (fig. 3.11). Replicative experiments on different types of lithology have shown, in the case of the cupules at Daraki-Chattan in India, that many thousands of blows with a hammerstone were necessary to manufacture even a rather shallow cupule in the hard quartzite matrix.[19] Completion of one of the replicated cupules took more than six hours spread over two days and required the use of ten hammerstones of hard quartzite.[20] The creation of the cupules at Daraki-Chattan demanded physical stamina, skill, planning, and time, and was clearly not the by-product of casual activity. The cupules must have had considerable, even nonutilitarian, importance to their makers. This assumption is further confirmed by the fact that, as in many WAT sites, their placement also includes vertical rock faces, evidence that these cupules could not have served as receptacles.

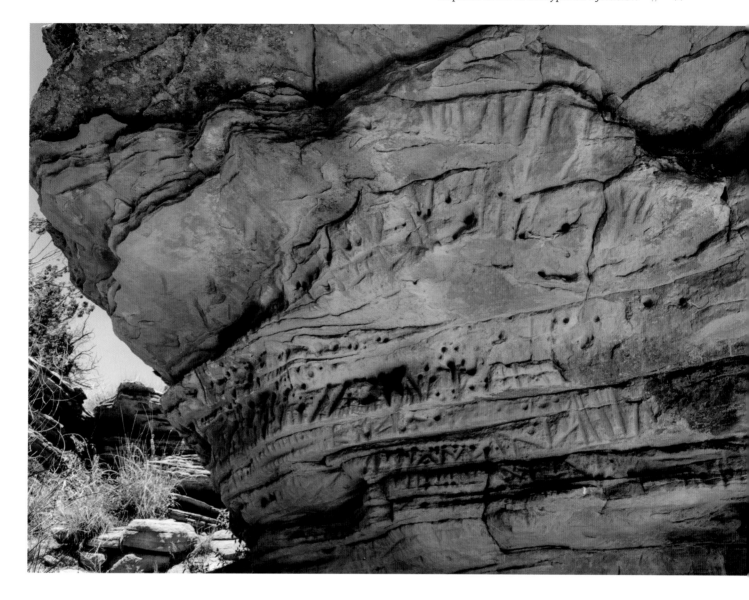

Along with artified stones and other portable art, cupules are generally believed to be among the earliest kinds of rock art (artification) found in the New World. Unlike securely dated portable art, however, no cupule site is specifically known at this time that can unequivocally be attributed to a Clovis horizon of some 13,000 years ago. A possible exception may exist at Nevada's impressive Winnemucca tufa site, whose engravings have been dated to two possible time frames, an early one—14,800 to 13,200 BP—and a more recent one—11,300 to 10,500 years ago.[21] Although cupules are usually found apart from other rupestrian markings, occasionally single cupules do occur, integrated into other, geometrically more sophisticated, designs—for example as center points of concentric circles, radials, or "sunbursts." In some instances, they are connected with deeply pecked lines or accompanied by finely incised "tool grooves."[22] In

3.11 Profusion of drilled (rather than pounded) pits and multiple grooves at an Arizona site

the majority of cases, however, cupules are found in groups, occasionally numbering in the hundreds at single sites. The largest such site currently known to us is a shelter in southwest Arizona whose bedrock floor is crowded with over 700 cupules (fig. 3.12). Occasionally, the pits suggest structured configurations or patterns, but more often their arrangements appear to be random. Because cupule petroglyphs are sometimes jointly found with grooves or other linear incisions, some American archaeologists use the label Pit-and-Groove Style as an umbrella designation for this entire genre of rock surface alteration.[23]

Closely linked with the Pit-and-Groove Style are peculiar petroglyphs typically consisting of a circular or oval groove whose center field appears raised in low relief.[24] Occurring singly or clustered in multiples, the geographic epicenter of this unique rupestrian variant lies in the inland Coast Range of northern California.[25] The hump-like central nuclei that distinguish the markings have given rise to the descriptive label Pecked Curvilinear Nucleated or PCN elements.[26] First identified on Ring Mountain north of San Francisco Bay (fig. 3.13), more than 120 sites are presently known featuring PNC-type petroglyphs in a variety of circular, oval, and vulva-shaped configurations.[27]

Using ethnographic analogy, rock art researcher Donna Gillette, who classifies the PCN phenomenon as a separate tradition, hypothesizes that prehistoric people obtained powder from specific boulder types that "were visually associated with concepts of fertility and that the powders so extracted were then used in further activities and ritual practices concerning issues of fertility."[28] In addition to Ring Mountain, the type-site for the genre, numerous boulders bearing the glyphs with their nucleated centers are located on the rolling hills near Hopland, California.[29] A splendid example with over 100 PCN elements is the Huntley Peak boulder.[30] Heavily revarnished and weathered PCN examples can be seen at densely pitted boulders like Spyrock and Keystone (fig. 3.14) near Ukiah, California. Betraying great antiquity, they clearly fit the profile of the Carved Abstract mode.[31]

Additionally, numerous WAT-type parietal sites contain wall segments or boulders with deeply serrated corners, or "edge grooving" as one article refers to them.[32] Ekkehart labeled this hitherto undescribed rupestrian phenomenon, intermediary between a cupule and a groove, "serriform."[33] Excellent examples of serriforms, all featuring evenly spaced notches, can be viewed at Grimes Point (fig. 3.15) and in Upper Arrow Canyon, Nevada (fig. 3.16); near Long Lake, Oregon; at Chalfant, California; and many other locations throughout the American West.

Corroboration for the hypothesis that Carved Abstract Style petroglyphs were the predominant graphic expression used by the earliest Americans to artify their environment can also be seen in a number of heavily carved monoliths popularly known as "ribstones."[34] Some of the most spectacular examples are found distributed over a relatively confined area straddling parts of the Canadian provinces of Alberta and Saskatchewan, at the Viking site (eastern Alberta) (fig. 3.17) and the Herschel site (southwestern Saskatchewan) (fig. 3.18).[35] The glacially transported erratics are engraved

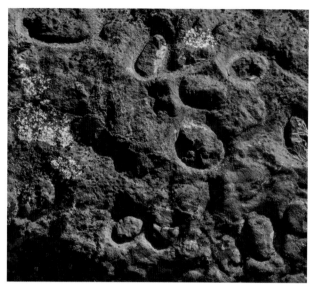

3.13 Typical Pecked Curvilinear Nucleated (PCN)–type petroglyphs at Ring Mountain, California. *Photograph courtesy of Robert Mark.*

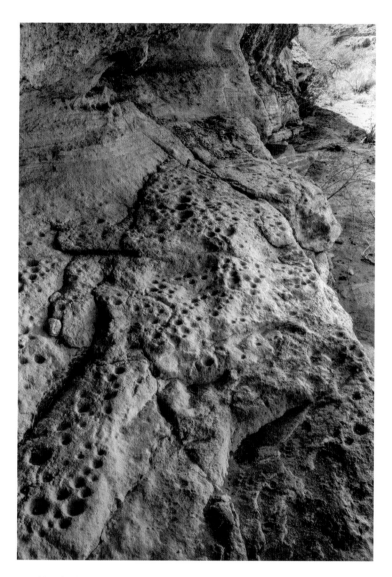

3.12 Hundreds of uniformly shaped cupules of varying sizes on bedrock floor of overhang, Arizona

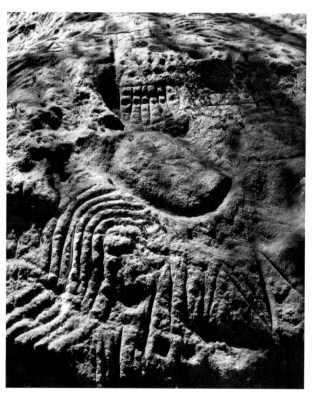

3.14 Closeup of PCN-type petroglyph flanked by simple pits and deeply carved abstracts, California

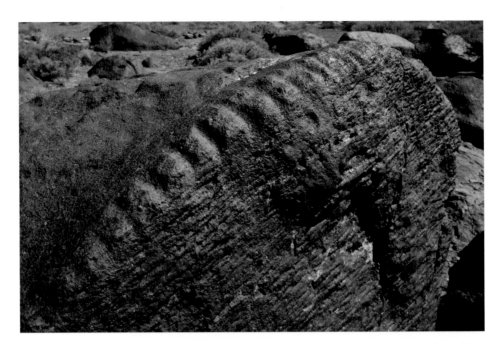

3.15 (*right*) Regularly notched boulder edge, referred to as "serriform," Nevada

3.16 (*below*) Extremely long serriform, Nevada

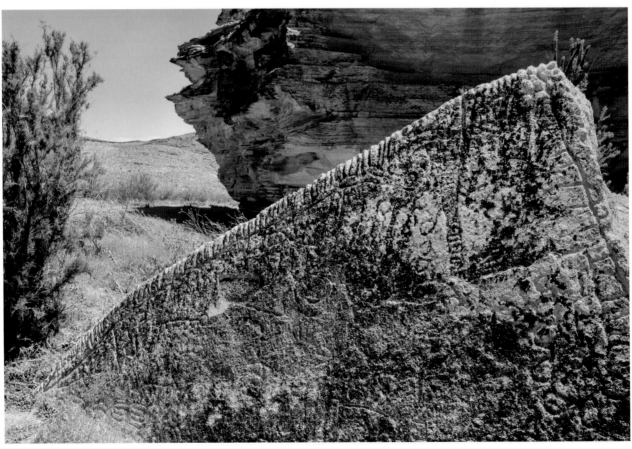

3.17 *"Ribstone" featuring deeply abraded grooves and cupules on a glacial erratic from the Viking site, Canada. Photograph courtesy of Breck Parkman.*

exclusively with the most elemental markings, dots and lines, in the form of cup-marks and grooves. While a unique phenomenon in the eyes of those who have studied them, ribstones are clearly connected with the ubiquitous Pit-and-Groove Style in the American West. Reminiscent of "ribs," the grooves in particular are responsible for the term "ribstone" and the belief held by recent and contemporary Blackfoot people of the Northern Plains that some of the boulders strongly resemble skeletonized bison.[36]

Relevant to Pit-and-Groove alterations of rock surfaces is the so-called Stillwater Faceted Style. Originally observed by Heizer and Baumhoff near the Grimes Point site, Nevada,[37] it is described as consisting of rubbed areas or "facets," either flat or concave, ground into the sides or across the tops of boulders.[38] In the view of archaeologist Karen Nissen, the facets may actually constitute "man's first attempt at modifying rock surfaces which eventually led to the inscribing of true designs."[39] From all indications, however, they are a natural phenomenon formed by abrasion from wave action or pebbles as they rubbed against the boulders. This would have happened at a time when pluvial Lake Lahontan, where the Stillwater site is located, was at a much higher level and covered much of the western Great Basin. As such, these facets are comparable to so-called ventifacts, geomorphic features on rocks that have been abraded, sculpted,

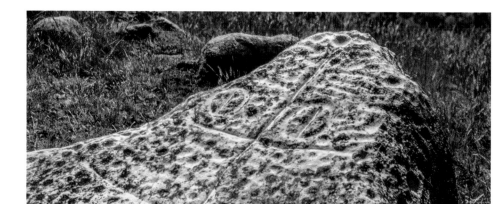

3.18 (*right*) "Ribstone" monolith, totally sculpted with pits and grooves from the Herschel site, Canada. *Photograph courtesy of Breck Parkman.*

3.19 (*below*) Heavily weathered grooves and cupules on basalt, indicating great antiquity, Arizona

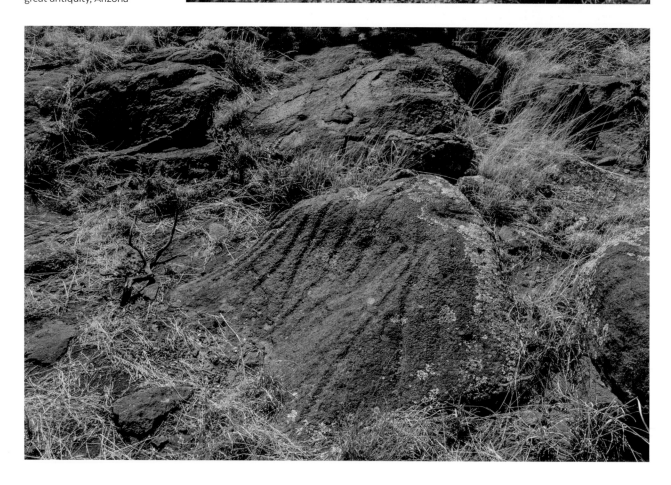

or polished by the action of wind-driven sand.[40] For that matter, it is not always easy to establish whether a single cupule, or even a group of them, is human-made. Similar depressions can occur naturally from erosion, and some shallow mortar holes intended for grinding, crushing, or mixing substances may look like and be mistaken for cupules.

Without the benefit of reliable dating techniques for petroglyphs, not much can be said about the chronological placement of cupules and their kin. Breck Parkman, who is a strong advocate of Pit-and-Groove Style rock art as being the oldest in North America, suggests Paleoamerican origin in the Late Pleistocene, but also does not rule out early Holocene.[41] Alanah Woody, too, believes that cupules appear to be among the oldest surviving forms of parietal art in the desert regions of the American West.[42] The fact that most ribstones are found in a region immediately adjacent to the southern exit of the hypothesized Ice-Free Corridor between the Laurentide and Cordilleran glacial centers might be regarded as an indication that they were created by some of the earliest entrants into North America. However, there currently exists no archaeological evidence for this hypothesis. While the Ice-Free Corridor is generally seen as one along which Beringian-tradition populations expanded south, recent studies apparently have shown that Paleoamerican makers of fluted points may have followed bison dispersing northward into the widening passage.[43]

WHAT ARE CUPULES FOR? A VERITABLE MYTHOLOGY

As one might expect, in light of the paucity of ethnographic accounts on cupules and other Pit-and-Groove art, a veritable mythology of explanatory hypotheses has developed around the phenomenon, most of which are unfalsifiable or, if based on modern ethnographic data, cannot be reliably projected back in time.[44]

The making of some cup-marks can probably be attributed to purely utilitarian purposes, for example serving as territorial markers or employed in the mixing or pounding of various substances such as medicines or pigments.[45] Some could simply be mortar "starts" or the result of pestle manufacturing, especially when found in association with bedrock or boulder milling stations (fig. 3.20).[46] The practical use of natural depressions in stone surfaces certainly could have suggested that human-made circular cup forms might work better. However, cupules on vertical or sloping surfaces are not likely to be utilitarian, and neither are large concentrations of the phenomenon (fig. 3.21).

While the creation of ancient cupules clearly is a form of landscape modification, it is ultimately impossible to say whether this "enculturation" was of a secular or nonsecular nature. For the most part, however, one can assume that cupule sites—like other rock art locations—designated "places of significance." Enhancement of fertility has been cited as a motivation in several widely separated regions.[47] In two instances—in California and in the Northern Territory of Australia—there are firsthand reports from cupule makers about their intentions, and in both accounts it was the resultant finely ground powder that was the reason for making the cupule. Among the Pomo Indians of

3.20 Cupules co-occurring with two bedrock milling slicks, California

3.21 (*opposite*) Boulder outcrop, massively pockmarked with dozens of shallow depressions, Oregon. *Photograph courtesy of Brian Ouimette.*

California, a paste made from the powder was applied to the abdomen of a woman who wished to become pregnant and, in one recorded case, was also inserted into her vagina so that intercourse immediately after this administration "positively assured fertility, because of the magic properties of the rock."[48] In the 1930s, anthropologist C. P. Mountford recorded ethnographic information from a cupule-pounder in the Australian desert, indicating that cup-marks, in some instances, may have been the coincidental outcome of increase ceremonies. He reports the Aboriginal belief that the boulder represents the totemic body of the cockatoo-woman, Tukalili, and that the dust produced from pounding the boulder releases her life essence. As a result, the rising rock dust fertilizes the living female cockatoos, thereby ensuring that they lay more eggs.[49]

Given that cupules and grooves often occur together (fig. 3.22), sexual dimorphism has been suggested as a reason for their existence. From this perspective, concave cupules, seen as inherently receptive and thus female, have been interpreted as symbolic of the vulva and, by extension, of the uterine Earth and procreation (fig. 3.23).[50] Grooves, on the other hand, are said to represent phalli and are regarded as symbols of the male power of creation.[51] In this view, cupule production in itself is thought to be an aid in ensuring conception and/or enhancing female fertility, as in the powder-making practices just described.

Other firsthand accounts have informed researchers that cupules were made for weather control, especially rain-making; or, in particular, that the thunderous sound produced by pounding the "stone drum" of the boulder would attract real thunder by the principle of sympathetic magic.[52]

Some propositions advanced for the presence of cupules are unprovable conjectures of the archaeologist's imagination. For example, an unusual interpretation suggests that the Neolithic and Early Bronze Age cup-and-ring motif (ca. 6,000 to 3,500 BP), found throughout the Atlantic seaboard from Scotland to Portugal, "may have been a symbol for the birth of body and soul, the cup representing the soul and the surrounding ring the body."[53] Or it has been proposed that cupules could have been components of sacrificial altars and served as receptacles for liquid offerings such as sacred water or blood.[54] Their role has also been associated with girls' puberty rites, in which young girls, as

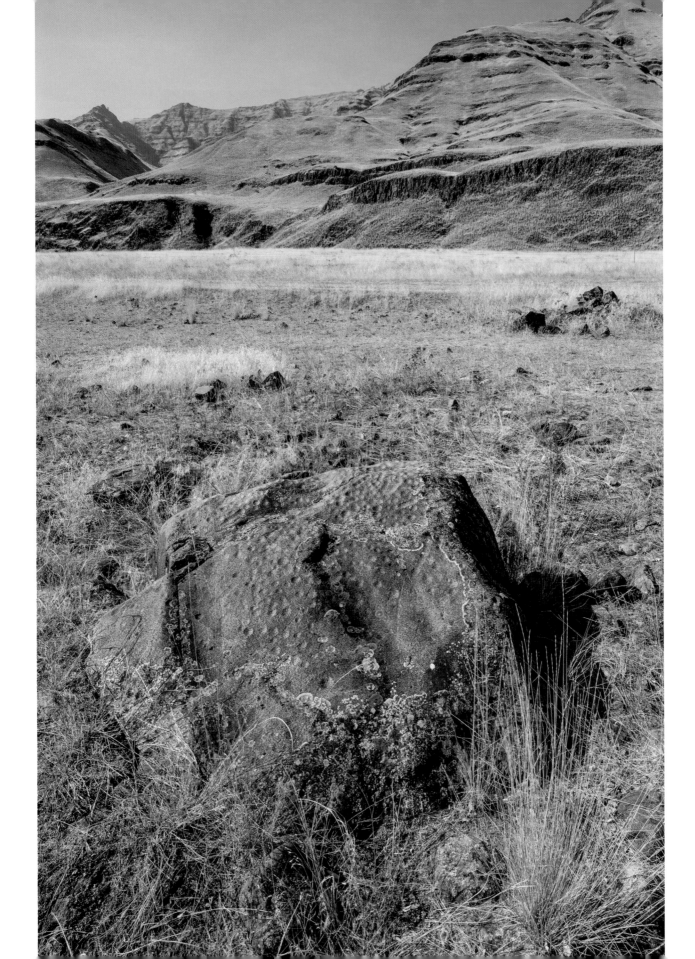

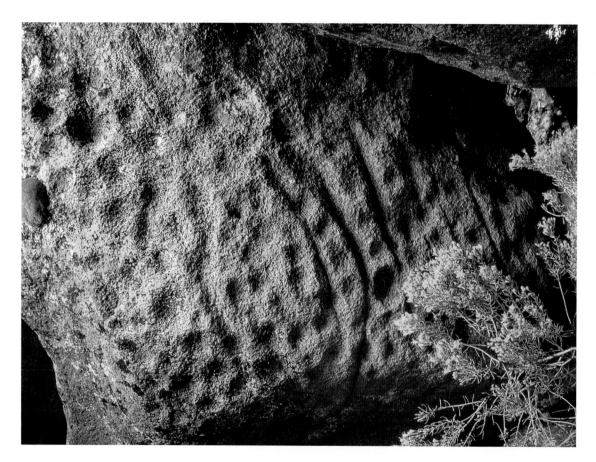

3.22 Heavily eroded cup-marks and grooves on vertical rock surface, Arizona

3.23 Vulviform-like elements embedded in a congeries of cupules, New Mexico

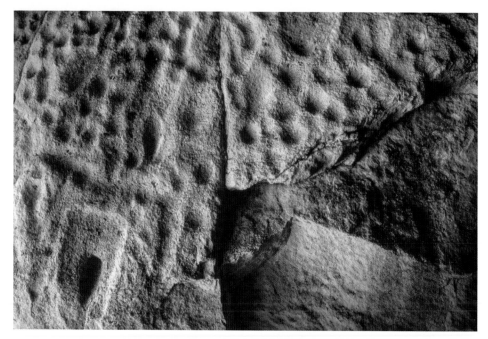

part of their initiation, might have had to demonstrate their readiness to perform hard work.[55] Some researchers with a penchant for archaeoastronomical interpretation claim to see in cupules depictions of star constellations or astral maps. Others propose that cupules were connected with the universal behavior of geophagy—that is, the ingestion of earthy substances, which in this case would have involved the consumption of rock powder resulting from the pounding or grinding process.[56] Australian archaeologist Josephine Flood makes the crucial observation that cupules can be regarded as "a form of gestural rock art, where it was the action involved that was important and the mark left behind was just an incidental by-product."[57]

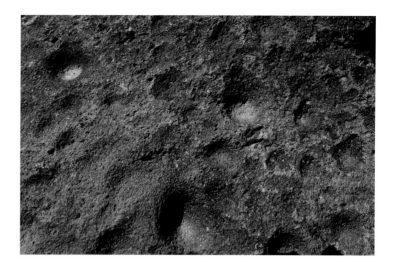

3.24 "Gong rock" or lithophone, featuring cup-like pits resulting from repeatedly striking a rock slab to produce musical notes, Arizona

It has also been proposed that it was the sounds of percussive striking that were part or all of the motivation for cupule making.[58] It is possible that cupules may have been created, at first incidentally, in an effort to exploit the acoustic qualities of so-called ringing rocks, gong rocks, or lithophones, through deliberately and repetitively striking the same rock spot over long periods of time.[59] Although one such boulder at the Hedgpeth Hills site near the Deer Valley Rock Art Center north of Phoenix (fig. 3.24) is resonant (discovered by Ekkehart when he accidentally knocked it with his camera), no mention of lithophonic cupules appears in the detailed report on this extensive site.[60]

Striking a rock deliberately may also have served as a summons[61]—the sound being a signal that people should assemble. Apart from prompting immediate gathering, pounding a cupule could communicate (incidentally or deliberately) that something important is going to happen here (or is happening here)—or record that something important recently happened. That is, a cupule or collection of cupules could be a focus for later ritual participation or merely evidence of participation in the past. Simply striking a rock for its sound may not have required or resulted in a precisely made cupule, but if the cupule was to serve as a permanent record of an event, added to other previous cupules, its careful making may have been considered essential. Indeed, some cupules may have been created in order to make an already important or sacred place even more special (fig. 3.25).

Finally, it has been suggested that the physical activity of rhythmic pounding might have induced altered states of consciousness, leading to a vision sought by the pounder. When performed by a shaman, it is assumed to have brought about the trance state necessary for access to supernatural power.[62] Piercing the rock would have created the necessary portal to the spirit world contained therein and provided a conduit to supernatural power. A fully pitted boulder therefore might indicate that the potency believed to reside in it was repeatedly extracted from it.

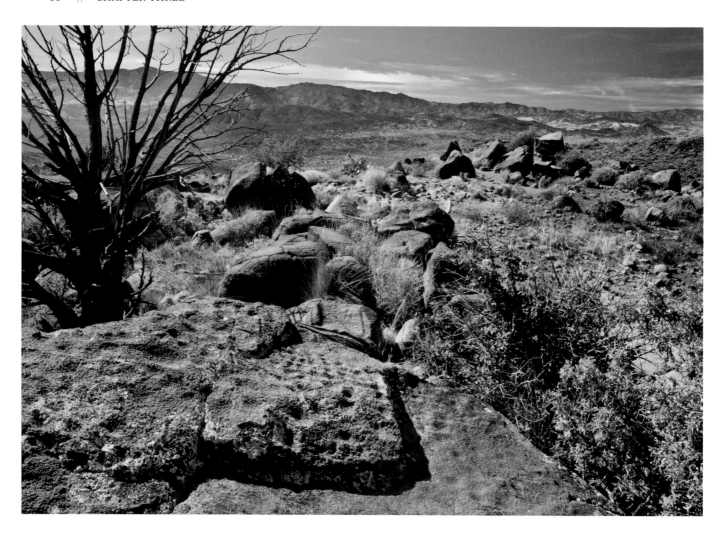

3.25 Pitted boulder top, marking a place in the Arizona landscape as special

Whatever they meant to their makers, cupules indicate the effort that produced them. Once in existence they became a permanent record of their making and were a testament for all time that a person or social group cared enough to make them. And no matter what supernatural success was sought by the cupule-maker, an adaptive explanation will require an "ultimate" reason related to survival and reproductive success in addition to the proximate motivation of the cupule-maker. It should also be appreciated that a ritual explanation that accounts for one set of cupules cannot serve as a blanket account for all. Some of the suggested uses may have been accurate in some instances; none can be said to characterize all.

Archaeologists Jack Steinbring and Anthony Buchner, avoiding the pitfalls of unverifiable speculative scenarios, offer the interesting observation that "simply the mere act of creating [ribstones] [may have been] of primary importance."[63] Their observation recalls the comment by Clark Wernecke and Michael Collins regarding the early engraved portable stones at the Gault site.[64] That is, the process of manufacture and the

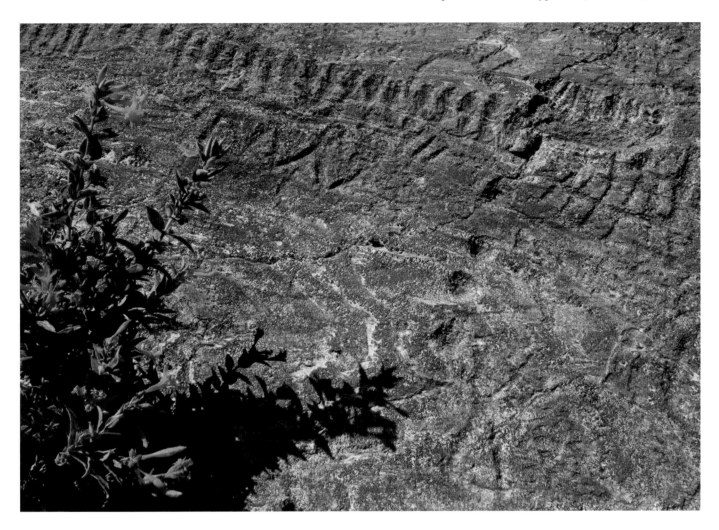

3.26 Cup-marks intersecting a string of vertical bars and other geometrics, California

patterns employed may have been more important than the decorated object after its initial use—an interpretation that is supported by the finding that some of these stones were deliberately broken up after their manufacture. Such suggestions are consistent with the concept of artification, which implies that in the context of at least some paleoart, as in the drawings of modern children and even some adults, the process of making (artifying) is more important than the final product. In this sense, some artifications may be considered as a kind of play, albeit serious play.

With regard to play behavior, we can be certain that hominin juveniles, like the young of all higher mammals, played for the pleasure of it and perhaps also enjoyed seeing their efforts leave traces, as when making handprints or footprints in soft surfaces or scratching marks on them. The persistence and effort required to pound a cupule does not provide much enjoyment, however, so it is difficult to think of children being motivated long enough to make them. Although many adult animals exert considerable persistence in repetitive activity, such as making nests or caching foodstuffs, humans do not seem to

have a genetically driven urge, like these, to grind cup-like forms into recalcitrant stone. Unlike animals' dogged efforts, cupule manufacture in itself cannot be explained as a heritable predisposition that contributed to hominin survival or reproductive success. As a kind of artification, however, cupule making can be considered adaptive.

In recognition of the utter futility of speculating about the possible functions, roles, or meanings of cupules in different cultures and places throughout the world and through time, some scholars, almost by default, have resorted to simply accepting them as the outcome of some unspecified "ritual" behavior[65] or referring to them globally as "symbolic."[66] For example, Parkman, in summing up a whole range of potential functions specifically for ribstones, concludes that they "may represent locations where the natural and the supernatural worlds coalesced and where mortals and immortals communed."[67] Remembering that in some accounts, cupules were reported as being part of magico-religious activities pertaining to subjects important to hunter-gatherers, such as influencing the weather or assuring fertility, increase, and world renewal, this speculation may or may not be true. It seems unlikely that the actual physical effort involved in carving Pit-and-Groove Style petroglyphs such as cupules and ribstones would in itself have been adaptive. It seems more promising to us, as to Parkman, archaeologist Gregory Williams,[68] and others, that they contributed to ritual or religious activities, which we *do* consider adaptive to individuals and groups.[69]

Making cupules was not a mindless pastime. Producing them on hard rock demanded great motivation, commitment, strength, endurance, and patience, as well as skill or accuracy,[70] so clearly they were not the products of cognitively or behaviorally undeveloped individuals. In the majority of cases, no one knows why prehistoric humans made cupules (or rock markings of any kind), but it seems indisputable that there was or is no single motivation for every instance of making any noniconic rock marking—whether cupules or the early engravings and applications of ocher that are often cited as evidence for symbol-making ability 100,000 or 120,000 years ago. Unsettled questions about early human capacities for symbolicity demand a chapter of their own.

ANCESTRAL MINDS AND THE SPECTRUM OF SYMBOL

ELLEN DISSANAYAKE

ANCIENT ROCK MARKINGS fascinate us not only because they are strange and mysterious but because they offer tangible traces of the lives and minds of those who made and lived with them in the distant past. Although on a world scale the petroglyphs and pictographs in the American West are relatively recent, to contemporary Americans they are reminders of the native populations that were here long before us. The enduring images they left behind suggest a life more elemental, more spiritual than ours—especially in comparison to the mundane and often toxic or trashy residue that we are leaving to our descendants. We want to know what the engravings and paintings *meant* to their makers. Some depict life forms such as game animals and humanoid figures, ceremonial scenes, or weather phenomena such as lightning and rain. But how can we interpret the early abstract or geometric marks? What did they signify?

Questions of meaning and interpretation in rock art are often phrased as questions about their *symbolism*. Some figurative images represent animals that were sources of food, or animals as spirits or gods. More abstract designs are undecipherable, but because people spent enormous amounts of time and energy making them, it seems reasonable that they too were symbolically important. We, however, do not attempt to analyze individual marks or sites as to what they "mean" or symbolize.

Of more interest in this chapter are theoretical ideas about interpretation and discussion of an important and contentious ongoing debate in Old World paleoarchaeology, namely the problem of when "anatomically modern" humans became "cognitively and behaviorally 'modern.'" What is at issue in this debate is the attempt to understand the "early human mind"—how it was different from, and similar to, the human mind of today. Participants in the debate agree that the pivotal point of being considered

4.1 Darkly revarnished concentric circles matching the color of the unaltered host rock, Idaho

modern rests on the capacity to invent, use, and make symbols. There is a difference of opinion, however, in what constitutes a symbol and therefore when this important "cognitive/behavioral" capacity developed.

Before discussing this hot, and important, topic, we first briefly summarize what is known today about the origin of our species, *Homo sapiens*, and its achievement of both anatomical and cognitive "modernity."

A BRIEF HISTORY OF *HOMO SAPIENS*

The overall picture of the history of our species changes with each new discovery of yet another hominin fossil in yet another part of the world, and of earlier and earlier signs of material culture. Keeping up with evolutionary archaeology is like trying to keep track of the fast-moving puck in an ice-hockey game. New techniques for dating and sequencing fossil DNA have revolutionized our view of human evolution and its time-

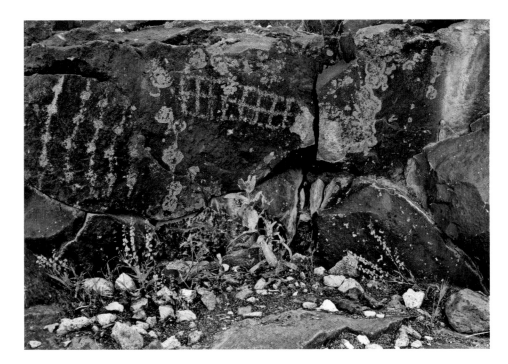

4.2 Knotted strings and chained squares, California

line. The influence of past climates and environments is now also better appreciated. Taken all together, these advances in our knowledge make clear that the single origin ("Garden of Eden," "Noah's Ark") hypothesis and the "multiregional" hypothesis of the 1970s and 1980s are no longer tenable in their earlier forms. It is also now accepted that the movements of our *sapiens* ancestors (and their aunts, uncles, and cousins) around the globe was extremely complicated.

At the time of writing, it appears that the origin of anatomically modern *Homo sapiens* was relatively recent and most likely restricted to East Africa, where along the banks of the Omo River in southwestern Ethiopia, the earliest fossil specimens of our own species, approximately 195,000 years old, were recovered.[1] Some of these modern humans dispersed to southern Africa and to the Middle East around 100,000 years ago, where populations ebbed and flowed, and by about 60,000 years ago some had reached Australia. *Homo sapiens* probably did not enter Europe until around 40,000 years ago, after developing more advanced Later Stone Age tools and complex behaviors starting about 50,000 years ago.[2]

Anatomical modernity refers to the physical characteristics of *Homo sapiens*—all humans who are alive today. Despite minor variations in size and shape, we all have such traits as a large, domed skull that houses a large brain (around 1,300 cc in size), a flat face with slender jaws and small teeth, and a light skeleton—especially compared to the size and shape of these features in earlier species of the genus *Homo*. As just described, anatomical modernity was achieved about 200,000 years ago in Africa. But until recently, the dominant view was that behavioral and cognitive modernity emerged much later—at

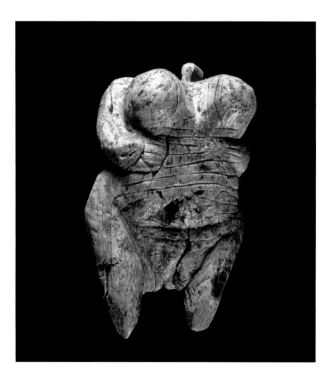

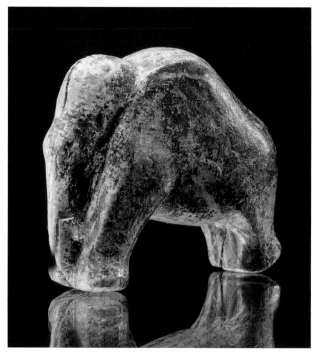

4.3 Two ivory carvings from Germany's Swabian Jura, between 35,000 and 40,000 years old: Venus of Hohle Fels, ca. 6 cm tall (photograph by Hilde Jensen), and Vogelherd mammoth figurine, 3.7 cm long (photograph by Juraj Lipták). *Both images courtesy of Harald Floss, University of Tübingen.*

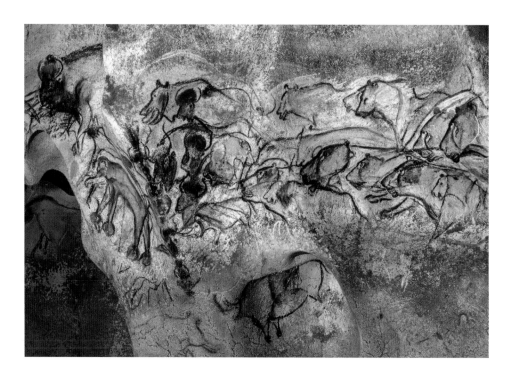

4.4 Panel of the Lions, Chauvet-Pont d'Arc Cave, France. *Photograph courtesy of Jean Clottes.*

about 50,000 to 40,000 years ago—and only in Western Europe, where Ice Age humans created spectacular (and clearly symbolic) artworks such as the ca. 40,000-year-old biomorphic figurines in the Swabian Jura of Germany (fig. 4.3) and the ca. 36,000-year-old paintings and engravings at Chauvet-Pont d'Arc Cave, France (fig. 4.4).[3]

Compared to anatomical modernity, the achievement of *behavioral* and *cognitive* modernity is difficult to assess, since it refers to changes in the human mind that cannot be directly observed or measured but only conjectured from material remains that suggest "modern" behavior. Impressively realistic paintings in deep caves or sculpted female statuettes are no longer required as evidence of modernity by most researchers. A variety of other indicators now suffice—specialized tools, in particular those with sharp blades, burials, long-distance trade, use of pigment or beads presumably for decoration of artifacts and bodies, and so forth.[4]

The earliest inhabitants of the New World have not been part of the discussion of the claims about Ice Age Europeans' possession of cognitive and behavioral modernity. This is true even though the first settlers on the North American continent probably arrived no earlier than the Upper Paleolithic in Europe, when Ice Age *sapiens* living there, especially in France and Spain, were certainly full-fledged makers and users of symbols.[5] Yet the first paleomarks made in the Americas were cupules and abstract designs, in the media of both parietal art and portable art. The overwhelming majority of representational imagery appeared considerably later. One especially puzzling element of the geometric enigma is that the people who found their difficult and precarious way into the Americas were presumably cognitively and behaviorally modern, yet their earliest markings resemble those of Old World inhabitants who lived many thousands of years earlier.

This discrepancy suggests that the body of WAT parietal art brings at least two significant considerations to current thinking about cognitive and behavioral modernity. First, reliance on symbol use as modernity's distinguishing feature may be unnecessary and certainly requires further probing.[6] Second, even though symbolic cognition and behavior indisputably conferred unique benefits on our *sapiens* predecessors, other important mental capacities and concerns were also essential to their ways of life—capacities and concerns that many paleoarchaeologists in their fixation on symbol seem to have ignored, dismissed, or not even recognized. Later in the chapter, we examine these in some detail.

THE GREAT DEBATE: CREATIVE EXPLOSION OR GRADUALISM

In 1982, science writer John Pfeiffer used the term "Creative Explosion" for the title of his best-selling book.[7] Other labels for this phenomenon include the "Human Revolution,"[8] "Big Bang,"[9] and "Great Leap Forward."[10] Until very recently, this has been the mainstream view in cognitive archaeology.[11] It proclaimed that around 60,000 to 40,000 years ago, "something happened" in Western Europe—probably a mutation in

the brain—that created "fully modern humans," *Homo sapiens*, with minds essentially like ours today. They could make and use symbols, as evinced in their invention of language, art, and religion. Although this assumption has been largely modified or replaced, as will be discussed shortly, it still is the *popular* view, as described in a publicity statement for the blockbuster 2013 exhibition at the British Museum called *Ice Age Art: Arrival of the Modern Mind*:

> This unique exhibition will present masterpieces of Ice Age sculpture, ceramics, drawing and personal ornaments from across Europe together for the first time in the UK. These will include the oldest known ceramic figures in the world, as well as the oldest known portrait and figurative pieces, all of which were created over 20,000 years ago. These striking objects will be presented as art rather than archaeological finds and will enable visitors to see the meaning of art made long ago by people with developed brains like our own.
>
> Through archaeological evidence from Southern Africa, we can ascertain that the modern brain emerged just over 100,000 years ago with the appearance of art and complex behavior patterns. This exhibition will demonstrate how the creators of the work on display had brains that had the capacity to express themselves symbolically through art and music.[12]

Note the emphasis on the words "symbol" and "art," which are among the major characteristics that are claimed to indicate modern cognition.[13]

In contrast to the Creative Explosion adherents, those who began to advocate a longer piecemeal or "mosaic" development of modern traits are called "gradualists" or "discontinuists." In the year 2000, an influential paper by American archaeologists Sally McBrearty and Alison Brooks challenged the Creative Explosion position and argued for a different model of the development of human cognitive ability and behavior, stemming from their archaeological work in Africa. As a result, most researchers accept that many of the traits that were supposedly indicative of the Upper Paleolithic Cognitive Revolution appeared earlier in Africa, in separate times and places during the African Middle Stone Age. By coincidence, also in 2000, the discovery of elaborate figurative paintings—human hand stencils and stick-legged animals—on the Indonesian island of Sulawesi was reported. Uranium-thorium dating placed some of the images at a minimum of 39,900 years BP.[14] Consequently, the orthodox belief that *Homo sapiens* in Western Europe was the first "artist" and symbol-maker is no longer tenable.

Although some early geometric marks were known, they had not entered into anyone's idea of "art," much less were they considered evidence of cognitive or behavioral modernity. For example, in 1988, when the parallel and subparallel line engravings on elephant bone at Bilzingsleben were reported and associated with *Homo erectus* (in the age range of 400,000 to 300,000 years ago),[15] they were not considered to be "symbolic"

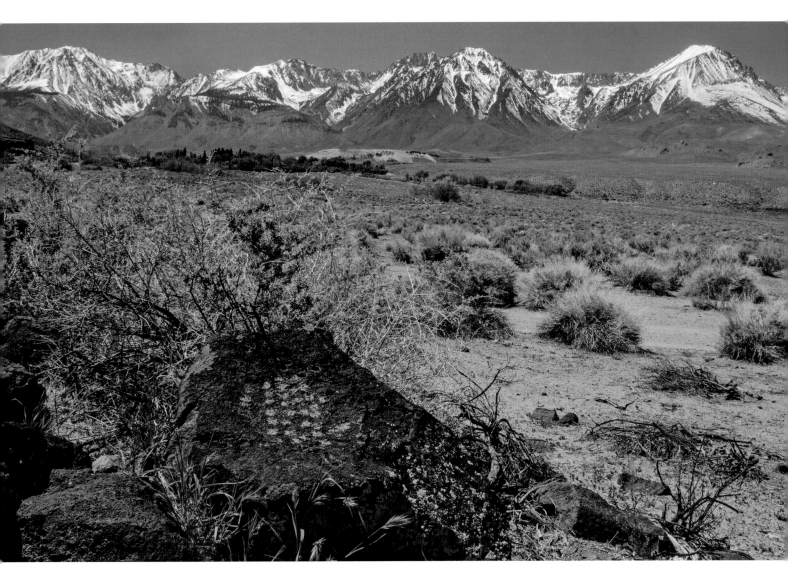

4.5 Boulder accented with patch of simple dots, facing California's majestic Sierra Nevada

or "art,"[16] nor were finds of markings on rocks from early *sapiens* sites, such as ocher coloring on stones in Bambata and Pomongwe Caves in Zimbabwe from 125,000 years ago.[17]

In their groundbreaking paper, McBrearty and Brooks provided many other indicators of cognitively and behaviorally modern abilities in Africa and elsewhere. These include advanced stone technologies (diverse toolkits, more complex tools, use of a wider range of materials to make nets, traps, clothing, and fire); increased geographic range; specialized foraging capacities (use of a wider range of natural resources for food, including colonization across sea barriers in Southeast Asia); complex processing of plants, fruits, and tubers; long-distance trade; burial of the dead; evidence of foresight, planning, and group coordination; and evidence showing distinct local styles of material culture. They and numerous other scholars also described the systematic use of pigments, at sites such

as Kapthurin in Kenya[18] and Twin Rivers in Zambia (270,000 years ago),[19] Sai Island in Sudan 200,000 years ago,[20] Pinnacle Point in South Africa (164,000 years ago),[21] and Bambata and Pomongwe Caves in Zimbabwe (125,000 years ago).[22]

Twentieth-century findings of early geometric marks, further challenged (or confused) the emphasis on Upper Pleistocene pictorial art as the cornerstone of the modern mind. Two instances of geometric incisings by Neanderthals, one from Bulgaria (47,000 years ago; fig. 1.6) and the other at Gorham's Cave in Gibraltar (39,000 years ago; fig. 1.7) were described in chapter 1. And, if we include evidence of a capacity for constructing a geometric form in space, there are the two large ring-like structures made from pieces of broken-off stalagmites deep inside Bruniquel Cave, also made by Neanderthals as early as 175,000 years ago.

Gradually, other authors have proposed additional defining criteria of cultural modernity.[23] But despite general agreement among most paleoarchaeologists today that the "Eurocentric" viewpoint—that Cro-Magnons were the first modern people—has been largely abandoned,[24] and that there was a more gradual development that began around 150,000 years ago in Africa in separate times and places,[25] the question remains: What was it that changed between Middle Stone Age and Ice Age *sapiens*?[26] By 200,000 years ago, human brains had achieved essentially modern volume. If African Middle Stone Age humans had the same "cognitive horsepower" as those of the much later European Ice Age, why did the former take so long to catch up? Some suggest that changes around 50,000 years ago must have been in the organization of the brain (thanks to a mutant gene), not in its sheer size.[27] Still other recent scholars look to the influence on various human populations of changing environmental, cultural, historical, social, and demographic factors.[28]

The predominant response to these questions identifies "symbolically mediated behavior" as the breakthrough capacity or distinctive signature of the modern mind.[29] As British physical anthropologist Chris Stringer puts it, "We do need to find the earliest evidence for symbolic behavior in the archaeological record—a key factor in resolving this debate—and whether it ever extended beyond our species." And he adds: "A critical question [is] how to recognize symbolism."[30]

The examples that archaeologists now take to be the earliest evidence of "symbolicity" (symbolically mediated thought and behavior) are kinds of mark-making: pigment manipulation and use (application on objects and bodies), engraving on stone, and bead manufacture (in the sense that beads are made to be used to decorate or "mark" bodies and clothing).[31] Although the early geometric marks made by Neanderthals, very early *Homo sapiens*, and even *Homo erectus* were (and are) unexpected and confounding, they are often construed to be "art" or "symbolic" (or both), as if it were impossible to be one without being the other.

Although I question the dictum that symbol use was the *sine qua non* of cognitive and behavioral modernity, I appreciate its critical importance in the evolution of *Homo sapiens*. Language, mythologies and their pictorial and poetic representations, and

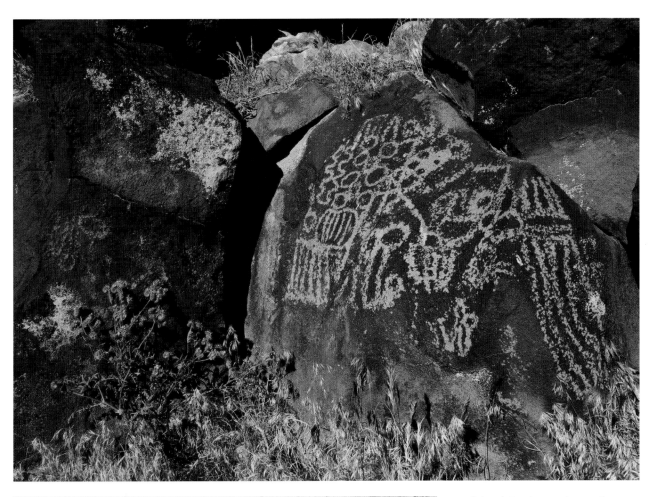

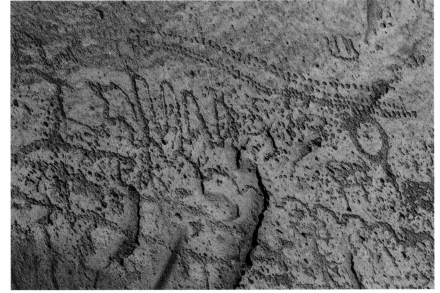

4.6 (*above*) Contiguous cluster of abstract-geometrics, California

4.7 (*left*) Ensemble of dotted lines and indeterminate abstract-geometrics, Utah

other clear evidence of symbolicity are unquestioned hallmarks of our species. Nor do I advocate an extreme view that says that no early mark was symbolic. And in particular, I certainly do not mean to discount or discredit the valuable contributions of the "discontinuist" or "gradualist" archaeologists (those who challenge the Creative Explosion view) whose work on the African continent has revolutionized thinking about human behavioral and cognitive evolution.

Mark-making activities (whether with pigment, engraving tools, or perforated shells), however, can be understood not only as symbol-making but as instances of the broader and chronologically earlier capacity of artification. Indeed, in cognitive archaeology, the label *Homo symbolicus* could be conceptually replaced by *Homo aestheticus*, because modern humans have the capacity to artify, and the ability to make and use marks symbolically is a *subset* of this primary capacity. Although not all ancient marks are symbols, they are all examples of artification, a distinctive cognitive capacity that deserves inclusion in any discussion of the early human mind. Virtually all symbolic marks are instances of artification, but not all artifications are symbolic.[32]

WHAT IS A SYMBOL AND HOW DO WE RECOGNIZE SYMBOLICALLY MEDIATED BEHAVIOR?

In their concern—or obsession—with symbolic behavior as a defining feature of cognitive and behavioral modernity in humans of the past 200,000 years, paleoarchaeologists have focused on manifestations of "art-like" abilities, such as markings on small pieces of stone or ostrich eggshell, the nonutilitarian use of pigment, and the manufacture of beads and pendants, all of which are assumed to be evidence of symbolic thought.

Many scholars who call an early mark "symbolic" tend to employ the term almost by default—as if it referred to something self-evident. As the debate about symbolicity has intensified, others have looked to the academic field of semiotics, which is concerned with symbols as a kind of "sign." Signs, which include words, sounds, images, acts, or objects, have no intrinsic meaning apart from our interpretation of them through other signs.[33] Signs allow us and other animals to understand the world—they are the way that our minds make meaning from its vast complexity. From birth, human brains are prepared to seek out and respond to some signs rather than others—to the sight of human faces and the sounds of human voices, to the taste of milk, to the soothing warmth and touch of loving hands and bodies. And as we grow and develop, we seek out and respond to other signs. What psychologist James Gibson has called "affordances"[34] are signs—things in our environment that contribute to our survival.

From a biobehavioral point of view, everything that we pay attention to can be thought of as a "sign"—a sign of its meaning to our well-being or its opposite, which we then pursue or try to avoid; if a sign has no particular importance, we ignore it. This is the same for other living creatures, for snails and sparrows (who pay attention to different signs) as well as humans. So far, semiotics seems like common sense.

Human minds and brains, however, are unimaginably complex, and so are the signs that we respond to. In addition to simple iconic and indexical learned meanings (e.g., that a drawing of a dog in a children's book resembles or "means" dog; that thunder and lightning indicate or "mean" rain), there are more complicated learned associations with various iconic and indexical signs and *particularly with symbols*, which are connected in our minds by convention[35] rather than by resemblance or causal connection to something in the world. Common examples of symbols are signs with cultural and institutional significance—linguistic, religious, political, or material. Like other signs, they usually have biological significance as they relate to our physical and social environment, including our relationships with other people. Members of a particular cultural group also know the meanings of these symbols: a recent definition of symbolic thinking is "the capacity to attribute specific meaning to conventional signs."[36] Most semioticians would say that other animals, even other higher primates and our earliest hominin relatives, do not make and use symbols.[37]

Paleoarchaeologists Christopher Henshilwood and Francesco d'Errico define a symbolically mediated culture as "one in which individuals understand that artefacts are imbued with meaning and that these meanings are construed and depend on collectively shared beliefs. This criterion is crucial. It explains how human norms and conventions differ from the ritualized behaviours found in nonhuman primates."[38] But focusing on this strict criterion ignores other presymbolic cognitive and emotional sources for mark-making that would also have been essential in early human mentality.

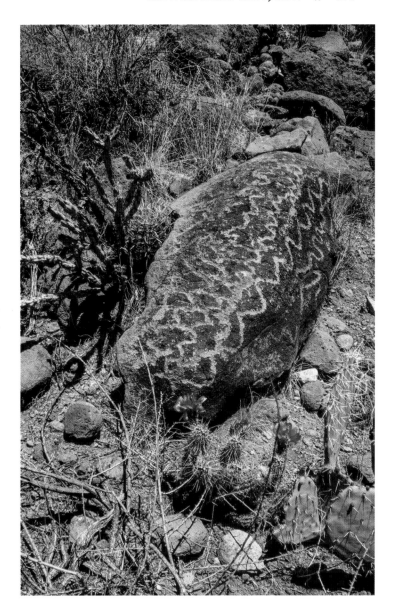

4.8 Set of ancient parallel meanders showing evidence of later repecking, Arizona

THE SEARCH FOR EARLY "SYMBOLIC" BEHAVIOR IN AFRICA: PIGMENT, ENGRAVING, BEADS

Exciting discoveries of apparently nonutilitarian behavior have been reported in South Africa from nearly a million years ago and in East Africa from at least 270,000 years ago. Mineral pigment such as colored ocher (often red) is indicated at every level of Wonderwerk Cave, a *Homo erectus* site in the north Cape region of South Africa, as early

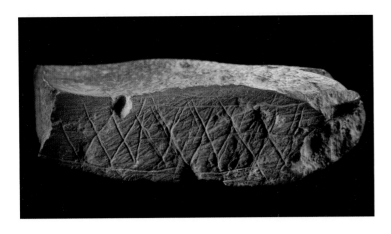

4.9 Artified ocher piece, 77,000 years old, from Blombos Cave, South Africa. Length 7.5 cm. *Photograph © Stephen Alvarez/ photographed at Iziko South African Museum.*

as 800,000 to 900,000 years ago.[39] It will probably never be known what the substance was used for so long ago, but certainly, over succeeding millennia, ocher becomes common in anatomically modern *sapiens* sites of at least 270,000 years ago, such as Kapthurin in Kenya,[40] Twin Rivers in Zambia,[41] and other sites in East and South Africa described previously. At Pinnacle Point in South Africa, an excavation dated to 164,000 years ago yielded over fifty pieces of red ocher, including some that showed traces of grinding and scraping—indicating "all the hallmarks of pigment for body painting and perhaps coloring of other organic surfaces."[42]

A 100,000-year-old assemblage of items found in Blombos Cave, South Africa, can justifiably be called a "paint processing kit"—including quartzite tools (to hammer and grind powder from blocks of ocher), abalone shells with ocher residues still visible inside, pieces of charcoal, and seal bones from which oil may have been extracted and mixed with the powder as a binder—provides evidence of the use of ocherous coloring materials to mark objects and probably bodies.[43]

Other evidence of behavior thought to have been symbolically mediated includes engravings on thirteen small pieces of ocher that were also found at Blombos at levels between 100,000 and 75,000 years old. They are incised with lines—vertical, horizontal, and diagonal, many of them parallel or crossed and others coming together in dendritic or fan shapes.[44]

The most unusual artifact from Blombos is the famed "zigzag" ocher piece (labeled M1-6, dated 77,000 years ago) with a complex pattern composed of a series of superimposed oblique lines that resemble Xs, framed with three vertical bands—one on each of the outside edges and one in the approximate midpoint of the row of Xs (fig. 4.9).[45] Two simpler inscribed zigzag markings were mentioned in chapter 1, the first by a Neanderthal—the 47,000-year-old bone fragment from Bacho Kiro (fig. 1.6), which has received drastically different readings. Paleolithic scholar and archaeologist Alexander Marshack regarded the zigzag form as symbolically related to water.[46] Interdisciplinary researcher John Feliks, on the other hand, after reversing the horizontal alignment of the jagged marking, considers it a literal portrayal of "a person hiking across the Balkan Mountains 47,000 years ago," and goes on to characterize it as "one of the most important examples of Neanderthal mental ability known."[47]

The second zigzag marking—that of a *Homo erectus* at Trinil, Java—was made by hominins who were not even anatomically modern, much less cognitively modern. Dated to between 540,000 and 430,000 years ago, it is four to five times earlier than the earliest markings at Blombos made by *Homo sapiens*.[48] When asked by a science publication to comment, archaeologist Curtis Marean said that the Trinil find could arguably be considered evidence for "symbolic activity," and neuroscientist David Edel-

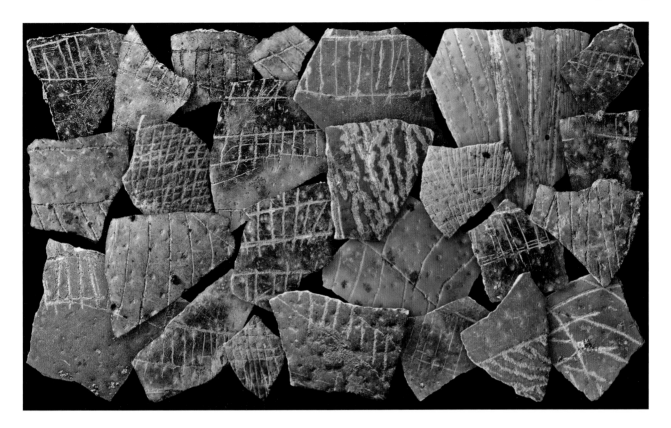

man claimed that it could indicate that *Homo erectus* was equipped with "a mind capable of a uniquely abstract form of conscious 'wandering.'"[49]

Although the most recent abstract marks or designs at Blombos can be dated from about 75,000 years ago, there is a 15,000-year hiatus before other known geometric marks appear in South Africa. These are dots and grids incised on broken pieces of ostrich eggshell (fig. 4.10) found in Diepkloof Rock Shelter, Western Cape, and dated to about 60,000 years ago.[50] (When intact, the empty eggshell was probably used as a storage vessel). Although more sites with zigzag engravings may be found, at present it is difficult to maintain that there was a continuous South African tradition of abstract or even symbolic marks.

The earliest known beads consist of deliberately perforated marine or snail shells, variously found in the Middle East (Skhul at Mount Carmel, Israel, 135,000 to 100,000 years ago),[51] North Africa (100,000 years ago),[52] and South Africa (Blombos Cave, 75,000 years ago). There is standardization, since all the shells found at a particular site are from the same species, although different species were used at different sites. Some beads show signs of wear (from having rubbed against a cord) and some bear traces of red ocher. Personal ornamentation findings drop off after 70,000 years ago, although of course perishable organic materials may well have been used both before and after that date. From about 40,000 years ago, beads again appear at African, Eurasian, and

4.10 Incised ostrich eggshell fragments, 60,000 years old, from Diepkloof Rock Shelter, South Africa. *Photograph courtesy of Pierre-Jean Texier.*

4.11 Mursi decorated woman with child from Ethiopia's Omo Valley region. *Photograph courtesy of Wikimedia Commons.*

Australian sites.[53] Subsequently, beads or pendants made of perforated teeth, bones, stones, ivory, and amber are found, in addition to various kinds of shell. Most archaeologists accept personal ornaments as unqualified evidence of symbolic material culture.[54]

When pigment or beads are found in an archaeological site, they are presumed to indicate the decoration of bodies or possessions, which is often interpreted as displaying the status and identity of individuals or groups. As Australian philosopher Kim Sterelny describes, shells can be standardized and compositionally organized; their pattern and placement can itself be a signal. Various arrangements can encode precise information about rank, role, age, status, gender, even individual identity.[55] Abstract marks also could have been insignia that communicated status or band membership. Certainly in traditional societies that have been observed by ethnographers, self- and object-decoration with pigment, abstract patterns (whether painted, engraved, or tattooed), and material from the natural world such as marine and snail shells, as well as more perishable objects—feathers, flowers and leaves, seeds, fibers, peeled bark—are common. People today communicate their status and group membership by hairstyles, clothing, and possessions. Typically these are viewed as "symbolic."

However, adornment (enhancement) may also be understood more parsimoniously as artification—making the ordinary human body extraordinary because it is important to the individual and society. It need not be automatically considered as symbolic. Using pigment on objects and bodies, as well as making engravings on ocher, could also well have been motivated by practical nonsymbolic concerns that had to do with ensuring the achievement of a desired goal.

RETHINKING THE CRITERIA FOR SYMBOLICITY IN EARLY MARK-MAKING

Henshilwood and d'Errico list sixteen indicators that support their a priori assumption of early appearing engravings as being symbolic.[56] For simplicity's sake in addressing engraved marks on stone surfaces and the other two types of early mark-making (pigment manufacture and bead production used for marking—ornamenting—the body), three of these criteria of symbol use are particularly relevant: that the activity or result

(a) shows intentionality or deliberateness, (b) has geometric regularity, and (c) has no obvious functionality. Although the word "art" is not used by most gradualists, they do consider that "nonutilitarian use" of mineral pigment is an important indicator of modern cognition. Nonfunctionality, of course, is also frequently considered to be one of the characteristics that makes something "art."

Intentionality

The surface of the well-known ocher block (Blombos M1–6) on which a zigzag design was engraved 77,000 years ago appears to have been intentionally and specially prepared—flattened and made smooth—before marks were made on it. Some of the lines that make up the pattern have more than one stroke, as if improving or emphasizing them. The geometric design of diagonal lines, Xs, or zigzags implies a preexisting mental pattern and is evidence of neuro-motor control, also suggesting intentional behavior. Additionally, the piece does not appear to have an obvious utilitarian function.

A careful and persuasive reassessment of this famous artifact by scholar of rock art semiotics Matteo Scardovelli, who obtained permission to handle and examine it, found that the characteristics used to attribute symbolicity could have a much simpler explanation.[57] Although he emphasizes that the artifact may possibly be symbolic, he concludes that it is not undeniably so. His full paper should be consulted; here, I merely condense the evidence.

To begin, the engraver did use a prepared and polished surface on which to scratch lines. However, the flat, rectangular surface that looks as though it was specifically prepared for being engraved could just as well have been previously used for another purpose—to scrape something, for example, so that it could be more easily held and flattened (abraded) by being rubbed on another surface. Many other stones found at the same site had also been scraped and smoothed for posited utilitarian reasons, but were not engraved. In other words, it is not conclusive that Blombos M1–6 was prepared specifically for the purpose of being engraved.

Examining the sequence of strokes revealed that the zigzag pattern emerged during the act of incising. That is, it was not produced one consecutive X or diagonal at a time but rather in a haphazard fashion. In fact, the earliest markings on the stone were insecure and imprecise, supporting the conclusion that there was no preexisting mental pattern.

Geometric Regularity

In his study of the Blombos artifact M1–6, Scardovelli also found that the zigzag pattern could be characterized as "more or less regular" rather than resolutely geometric. Like the straight, parallel, perpendicular, crosshatched, and fan-shaped lines that were engraved on other small stones at Blombos (or the dots and grids on ostrich egg shell fragments from Diepkloof, as mentioned previously), such motifs can all be found in

4.12 Elemental curvilinear and rectilinear scribbles by boy aged two years three months

the early mark-making of young children (fig. 4.12), who are not making symbols.[58] Even chimpanzees who are given drawing materials often make a series of straight lines downward in a fan shape or they cross an existing line or lines with another line or lines—an activity that seems to be satisfying to their eyes and hand.[59]

Scardovelli suggests that the "zigzag" may have been made by juveniles, in a sort of play, perhaps while investigating the inside color of the stone. This idea is not as far-fetched as it might seem, as mark-making may indeed have originated, at least in part, in play (which includes curiosity and exploration), where it provided motoric and cognitive practice and pleasure. Interestingly, prehistorian Jean Clottes also is "far from sure" that the Blombos piece "is an incontrovertible instance of symbolic behavior . . . it could also have been a kind of doodling."[60]

Several points about play behavior—a complex subject, observable in many animals—are relevant here.[61] First, it is universal and of vital importance in humans. Even without instruction or encouragement from adults, children everywhere play. In any open space, park, or schoolyard in the world, their play looks and sounds recognizably the same. It is essential to child development. "Play is the child's work" has been noted by numerous psychologists who attribute the statement to Jean Piaget and Maria Montessori, among others.

Evolutionary psychologists and anthropologists emphasize the gradual extension of the period of childhood in the genus *Homo*, compared to the life history of primates or earlier hominins, and how this additional time provides a longer opportunity for play to contribute to learning and acculturation.[62] Our early human ancestors surely played in childhood and beyond, although, with regard to rock art, to my knowledge, only Sterelny uses the words "play" and "explore" in discussing young *habilines* who, he says, would have had opportunities to explore the physical properties of stone and experiment with its angle and power of imprint.[63]

Apart from Sterelny and Scardovelli, the importance of this common everyday behavior does not seem to have been given its due by most paleoarchaeologists who write about early human mentality and behavior. Notable exceptions are Dale Guthrie and Robert Bednarik, both of whom are convinced that "children" (primarily adolescents) were involved in the production of the Paleolithic art corpus.[64] Cognitive archaeologist Merlin Donald mentions play with vocalizations and discusses games, saying that children can distinguish play behavior (mimesis) from "the real thing."[65] Stringer refers to the evolution of childhood and juvenile phases of development where play is vital.[66] Presenting evidence for his theory that human narrative emerged from playfulness,

evolutionary literary scholar Brian Boyd looks both to forms of play in intelligent animals—dolphins and chimpanzees—and to recent neurobiological research.[67]

It is understandable that play is a neglected topic in paleoarchaeology. As ethologist of play Gordon Burghardt has found, just to refer to "play" seems to take on some of the frivolity that the word suggests in ordinary parlance, where it is contrasted with work and adult responsibility.[68] It is often assumed to be not only a nonserious, nonadult kind of pastime, but also a nonserious and childish subject for study.[69]

Yet the seriousness and necessity of play are evident in child development studies, with implications for prehistoric children and adults as well. A study of hand-use in preverbal children has revealed a normal developmental sequence that begins with picking up and placing, then moves on to banging, pairing, matching, sorting, building with bricks, sequencing, and drawing (which in the context of this book can be called mark-making).[70] When practiced by toddlers with toys, these activities are often called play, which doesn't take into account the fact that they are at the same time essential hands-on activities that give children of every culture a foundation for future learning, understanding, and communication. As early motor activities, they display continuity, effort, pleasure, and endless repetition. Is it irrelevant to point out, with regard to sophisticated cupule-pounding and mark-making, that banging (or hammering) precedes the fine motor control of scribbling or drawing, and that continuous, effortful, repetitious activities are highly motivated sources of pleasure? It is not difficult to imagine our early ancestors, young and old, fooling around and finding pleasure in the movements of making marks, as well as seriously doing so for a cultural or personal purpose.

With regard to motoric repetition, studies from various fields make clear its deep roots in our species. Only humans, among higher animals, exhibit "pulse-born behavioral synchrony,"[71] sometimes called entrainment.[72] Contributors to the book *Communicative Musicality* describe some of the effects of "pulse" in the coordination of human communication—pulse being "the regular succession of discrete behavioral events through time, vocal or gestural."[73] Studies of entrainment and pulse support a theory that repetition of sound and action in mark-making on stone—sequential rhythmic blows of hammering with a hammerstone or incising with a mallet and chisel—exercise inherent, unconscious, but essential biological mechanisms that evolved in part to allow us to coordinate with other humans. Such repetitions are observable from earliest infancy (and even prenatally), and at any age provide expressive and emotionally satisfying brain activity that more "cognitive" interpretations of the activities of early humans may easily overlook.

Studies of children's drawing on paper also show sequential development: the first scribbles from the age of two evolve naturally and inevitably into meanders and spirals, and eventually into increasingly refined geometric shapes and variations and combinations of those shapes—circles, concentric circles, concentric arcs, circles with radials, and quadrisected circles.[74] Dots, too, are made both outside and inside other configurations. Children find motor, cognitive, and emotional satisfaction in drawing before

they have symbolic intent. In their early drawing, they do not intend to represent and symbolize. Even their eventual drawings of people or houses are based on conventions that they learn and traits that they know about; they rarely if ever copy directly from something they see or remember. Although early humans should not be compared to children, the sequence of learning to make marks, arising from neurobiological constraints, would follow the same course at whatever age or cognitive/behavioral stage the behavior begins.

Art teacher Rebecca Burrill finds that movement is primary in mark-making.[75] Early scribbling is exploratory and pleasure-based, first in sensorimotor feeling in which the dynamics (intensity of movement) and shape of the activity directly expresses internal states. Then, between ages three and five, children start to make centered and balanced designs from their store of self-taught geometric forms, which gradually, between four and a half to seven years, overlap with Gestalt imaging processes, becoming more reflective and integrative, intuitive, analogical, and metaphorical. This trajectory emerges naturally, without being taught. Although Burrill is describing mark-making with crayon or marker, not engraving on stone, it seems likely that the latter medium would begin similarly—first drawing in sand or earth with one's finger or a stick and then on soft stone with a sharp implement, and eventually scratching or incising a design on a harder surface before making deeper permanent marks. The motoric and movement aspects of mark-making should not be disregarded.

Philosopher of art Thierry Lenain,[76] in his comprehensive and fascinating study of painting by captive monkeys and apes, describes spots or dots made by hitting the painting instrument against the page, as the animals enjoy repeatedly banging objects against hard, smooth surfaces. Lenain suggests that this action allows the apes to verify the object's weight and solidity, which is useful in the wild, for instance, when cracking nuts.[77] Then there are clusters of lines obtained by sweeping the painting implement over the page, to and fro, producing elementary rhythmic, sometimes parallel, lines.

Lenain introduces the notion of "disruption," where any mark made on a blank sheet becomes an element that can (and usually does) elicit further marks. Among the commonest and most important of the successive marks are strokes or groups of strokes that cross a preexisting line.[78] His study, with its many examples and illustrations, repays close reading for showing the similarities of ape art to children's drawing and, by extension, to mark-making in early humans (which his book does not address). He emphasizes that ape art is a kind of play and exploration, as zoologist and ethologist Desmond Morris also described it.[79] Lenain also points out that apes do not seem to use drawing as a means of communication: "the act of marking is the important thing."[80] The same is seemingly also the case for young children and perhaps even our earliest mark-making ancestors. Children, like chimpanzees, do not return to look at or admire their completed work. Making marks on stone that last for millennia is obviously different from making marks on paper with a crayon or paintbrush, so the interest of our ancestors in the finished product may well have been more enduring.

Absence of Functionality

Using the absence of functionality as a criterion for calling an object "symbolic" (or, for that matter, "art") may arise unconsciously, we think, from a modern Western idea that was common more than a century ago—that of Art for Art's Sake. In this view, what made an object "art" was not its usefulness (as a container, for example) or the message it conveyed (religious, patriotic, sentimental) but an indescribable "aesthetic" experience or value based on nonutilitarian qualities.

Gradualist paleoarchaeologists do not seem to regard nonfunctionality in its old-fashioned nineteenth-century "art for art's sake" sense, but nevertheless their use of this criterion can be confused, even contradictory. They maintain that the engraved ochers (like painted bodies or objects and perforated shell beads) are "symbolic." And, as symbols, they are said to provide information to others, such as group or personal identity, or an individual's status. These are functions. Indeed, the arts (and symbols) in traditional societies always have "functions": masks are carved or shields painted to assure their efficacy, to make them "work" for a particular purpose—such as driving away a demon or enemy. To be symbolic is in itself to have a function, though nonsymbolic objects and actions can be functional as well. In other words, while some functional objects and actions are nonsymbolic, *all* symbolic objects and actions have a function—that of conveying a signal or message.

WHAT CUPULES CONTRIBUTE TO THE CULTURAL MODERNITY DEBATE: ARE THEY SYMBOLIC?

It is interesting to realize that cupules—along with pigment manufacture and use, geometric engravings, and bead-making and use—also meet the gradualists' criteria of symbolicity. They are made intentionally, their cup-shaped form is "geometrically regular," and they lack obvious functionality. However, they are rarely mentioned in the context of the cognitive modernity debate,[81] even though—like engraved lines on ocher—they were carefully made by hand with tools on rock surfaces by modern humans and even by earlier species.

Cupule-making indicates the capacity to intentionally make a rock wall or boulder different from its natural state—that is, a capacity to artify. Inasmuch as the earliest cupules date from 200,000 years ago at Sai Island in Sudan (fig. 4.13),[82] and some were made at La Ferrassie by anatomically nonmodern Neanderthals,[83] artification of rock surfaces seems to have been under way in some places well before their makers were "modern," either anatomically or behaviorally. They were made before people in South Africa began to make engraved

4.13 Rock slab from Sai Island, Sudan, featuring several small cupules, reliably dated to ca. 200,000 years BP. *Drawing courtesy of Philip Van Peer.*

marks on small pieces of ocher. As a vestige of ancient human behavior, cupules add crucial new considerations to the debate about the criteria for defining cognitive and behavioral modernity, especially to core assumptions in both camps about the relationship between art and symbol.

Are Cupules Symbolic?

Cupules were manufactured early and continuously in the American West. Known or speculative reasons or motivations for making cupules include their use as receptacles for medicinal or sacrificial substances, to produce rock powder to enhance fertility or for ingesting, making percussive sounds to attract thunder and rain, summoning people to an important event, inducing a trance experience, or demonstrating strength and persistence.

It is important to note that none of these suggested "functions" of cupules is symbolic. Almost without exception, the cupule is made to produce a "product" or effect, from the powder that ensues to the sound that the hammering produces. The cupule itself is incidental to the hoped-for or actual result (fertility, demonstrating one's ability to work hard, entering a trance state, calling people together). The effect is their "function," rather as wetting the ground is the effect of rain. The effector—the cupule-pounding or the rain—is not a symbol.

The cupule itself is there not because someone wanted to make a mark that is symbolic of something. Rather, this hemispheric depression is what is left after the effort that produced it (along with any accompanying wish) and the desired effect have been accomplished. Those who regard it in the future may or may not know what particular effect was sought. My point is that it need never have been "symbolic"—but, rather, inadvertently or deliberately *indexical*—indicating even to us many thousands of years later that something happened here, someone cared about cupule-pounding, even though leaving a mark may not have been the sole or even primary intention of the hammerer.

Such a mental operation—caring enough to pound a cupule—is not symbolic but, rather, *analogical*. That is, evidence of great effort shows, by analogy, that something was of importance to the person who took the time and trouble to make the effort. The resulting cupule thus inadvertently remains as a visual marker or sign of a presumed important cultural occasion or site.

What Symbol Fixation Leaves Out

Although representations of animals are surely symbolic, and some abstract glyphs, like some geometric designs, may well be symbolic, many cupules and other noniconic marks need not have been made with symbolic intent, despite the now almost axiomatic assumptions that the origin of mark-making (or of any other ancestral behavior that appears to "lack obvious function") necessarily required the intention or even the ability to symbolize, or that any mark found on rock was "symbolically mediated." In

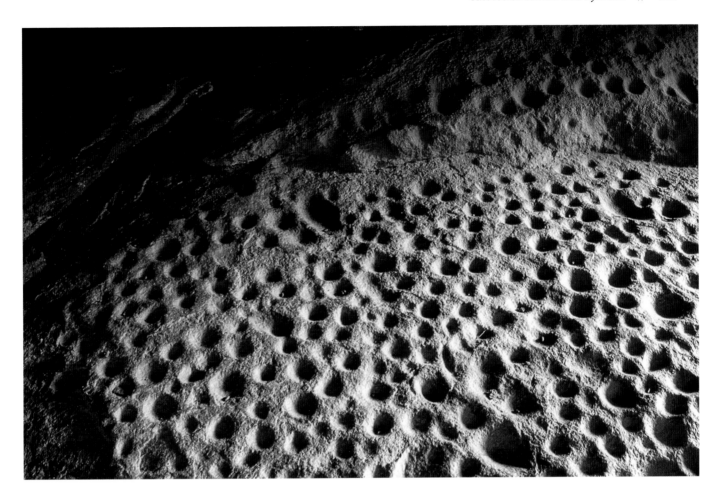

4.14 Massive spread of cupules on gently sloping bedrock inside small alcove, Arizona

fact, arguments attributing symbolic value are no more convincing than those questioning it.

There are at least three noteworthy problems with the assumption that cognitive and behavioral modernity rests upon the ability to make and use symbols:

1. Imprecise or casual use of the term "symbol";
2. Conceptualizing the early human mind as primarily linguistic and cognitive rather than nonverbal and affective;
3. Overlooking *proto*symbolic (or even *non*symbolic) behaviors that were arguably of vital importance to the lives of early humans.

Imprecise or Casual Use of the Term "Symbol"

Too often the term "symbol" is naively, loosely, and idiosyncratically used—reminiscent of the term "art," which many archaeologists have abandoned for the same reason. The word is frequently not defined and, as used, could be conceptualized more accurately

with another semiotic term or category such as sign, signal, icon, index, or related mental activity such as analogy or association.

Henshilwood and d'Errico define symbol as "a sign that has no natural connection or resemblance to its referent,"[84] a definition that shows their familiarity with concepts used by semioticians such as Charles S. Peirce.[85] In this sense, a word (the name for something) is a symbol: the spoken sound or written equivalent of the word or concept "cat" (or *chat* or *Katze*) has no natural connection or resemblance to an actual cat, whether in England, France, or Germany. As with this example, typically a symbol is considered to be a linguistically based sign that others agree on.[86] For Terrence Deacon, author of a seminal study on the development of symbolism in the human animal, the transition from icon to symbol in the evolution of language is a *cognitive* revolution, because a symbol's meaning cannot be learned by an associationist mechanism.[87]

No one knows whether the purported "symbolic" meanings of 100,000-year-old incised marks in South Africa were linguistically based. It is possible that people named rows of incised lines or grids with words that referred to shared meanings such as "adult male," "initiate," or "Mary's container." However, it is possible that such words were not needed, and everyone understood those meanings from associating the marks (or beads) with those categories, rather as children learn by observation that wrinkled skin is a characteristic of old people or that Uncle John has a distinctive laugh. In that case, the paint on someone's face or beads around their neck would not be symbolic but rather an indication by association. Even animals understand associated or indexical meaning: to a cat, its owner's opening a certain cupboard means food, and to a dog the jangling of a leash means that going outdoors is imminent.

For Peirce, signs initiate and mediate all human feeling, thought, and action—they comprise a broad category. Briefly, a sign is anything perceived by an observer that stands for or calls to mind something else and by doing so creates an effect in the observer. This seems sufficient to characterize cupules and other rock art markings, but it also characterizes many other things in the world. Although this chapter is not the place for a short course in Peircean semiotics, it should be said that Peirce identifies three aspects: the sign (or "sign vehicle"), the object (the idea indicated by the sign), and the affect or meaning of the sign-object relation in the person. Furthermore, he distinguishes between three basic ways that people make the connection between a sign and what it stands for (its object); he calls these "icon," "index," and "symbol."

The results of ancestral use of ocherous paints, the incising of geometric and other nonrepresentational marks on rock surfaces (including the hammering of cupules), and the manufacture and wearing of beads can be considered as signs (icons or indexes) without automatically assuming that they imply complex cognitive capacities such as symbol creation and use.[88] Their lack of obvious practical utility, their costliness in terms of energy expended, and their strikingness (difference from the ordinary; unexpectedness) communicates that they are *special*,[89] whether they do or do not have identifiable symbolic referents. They attract attention, making the person, object, or place more

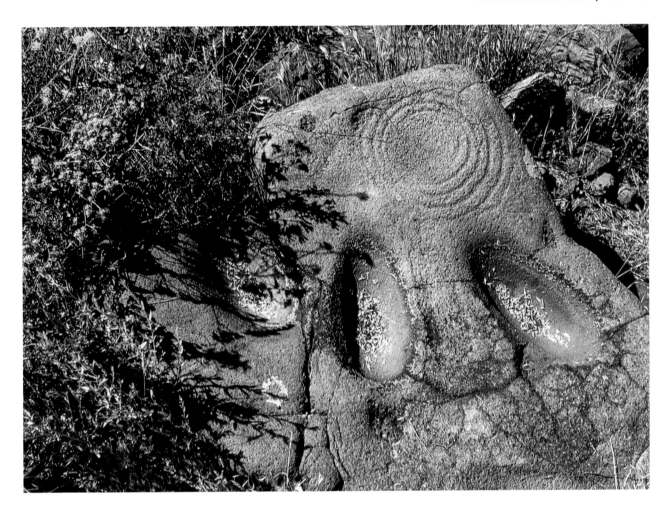

noticeable or noteworthy. Body decorations can make a person startling or threatening and are most plausibly seen as expensive (costly) signs of status, skill, or success.[90]

"Costly signals," however, can signal more than alarm, threat, or individual fitness. As evolutionary psychologists Lawrence and Michelle Sugiyama have nicely phrased it, costly signals may operate "on several frequencies, capable of sending a variety of messages," not only those that attract mates, demand or advertise status, or demonstrate unfakeable commitment—the usual meanings that are assigned by evolutionary psychologists to costly behaviors.[91] Rather, by their extravagance and apparent nonutility, they can be correlative to or "indexical" of the importance the signal holds for the signaler and those who perceive it.[92]

Thus, before verbalizable (or even "conscious") interpretations of body decoration (paint or beads) or marked objects occur, they can communicate that makers or wearers have invested time, skill, and energy to make something special as an indication of *importance*: they obviously are indicators of matters that an individual (or group) cares about. In ritualized behaviors, animals naturally pay attention and are attracted

4.15 Set of concentric circles artifying a milling station with three boat-shaped grinding troughs, Arizona

to unexpected and unusual features in the appearance of their fellows, and we suggest that early humans would have responded to body ornamentation in a similar way, even before imputing cultural meaning.

Archaeologist Paul Pettitt retains the idea of symbol, but suggests that there are different *levels* of symbolic meaning of pigments and shell beads as personal decoration and simple display—from enhancement of a signal ("you will be impressed at red as a sign of my strength"); to showing status or group identity ("it is my right to wear these"); to conveying some environmentally related information ("this is worn at a specific time of year").[93] Stringer agrees that it is certainly possible that some of the earliest uses of red ocher in African sites were not symbolic. That is, it was used for practical reasons such as preserving organic materials or protecting human skin (from sun or insect bites), or its use reflected a low level of symbolic intent (like Pettitt's examples of personal decoration and simple display).[94]

These are not levels of *symbolic* intent, but rather examples of iconic or indexical communication. And there is more to say positively about the enhancements of mark-making than assigning them to "levels" of symbolic communication.

THE EARLY HUMAN MIND AS LINGUISTIC AND COGNITIVE RATHER THAN NONVERBAL AND AFFECTIVE

If we consider arts that are nonlinguistic or generally nonrepresentational, such as instrumental music, drumming, dance, and mime, we find that they do not as easily or automatically lend themselves to "symbolic" interpretation as do painted and incised geometric marks or perforated beads.[95] These "arts of time" are ephemeral: they do not leave permanent traces, although they may well have originated along with or even earlier than the making of visual marks. Even if they sometimes imitate an animal sound or movement (and thus might be called "symbolic"), this is not always or even frequently the case.[96]

Gradualists do not include the arts of time in their arguments about the achievement of cognitive and behavioral modernity. I think, however, that insofar as temporal arts are intentional artifications of sounds and body movements—are generally regularized or patterned, and "nonfunctional"—they are as relevant to ideas about behavioral and cultural modernity as are ocher, engravings on shell or stone, and beads.

In his influential hypothetical reconstruction of the evolutionary development of the human mind, cognitive anthropologist Merlin Donald includes some of these arts of time. He considers mimetic representation to be at the very center of the arts, mentioning pantomime, ritual dance, visual tableaux (drama without words), and more recent early Chinese and Indian dance or Greek and Roman mime.[97] Yet he claims that even in modern culture (and by implication ancestral culture), mimesis may function *apart from its symbolic and semiotic devices*. For example, mime can convey a social role, communicate emotions, and transmit rudimentary skill more efficiently than words.[98]

4.16 (*opposite*) Deeply carved nonrepresentational markings, thought to have been ritually colored red by recent Native Americans, California

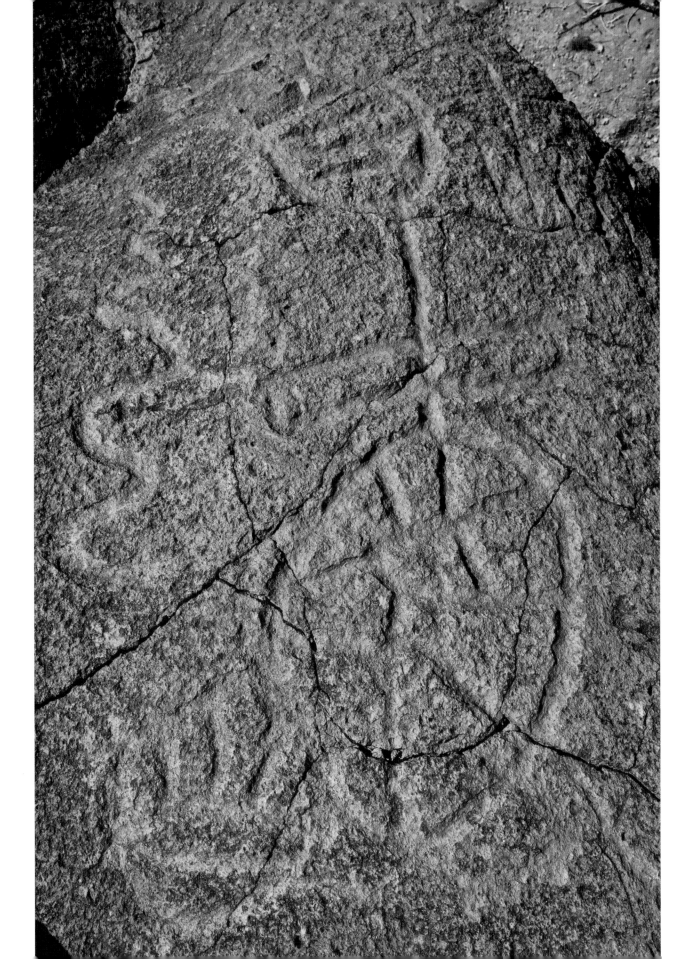

Donald additionally lists other examples of typical human culture that function without much or any involvement of symbolic language: trades and crafts, games, athletics, a significant percentage of art forms, various aspects of theater (again including pantomime), and most social ritual.[99] He describes results of nineteenth-century studies of illiterate deaf-mutes that found that these nonlinguistic persons could operate machines and invent solutions to practical problems, recognize functions of objects, show emotional responses, have social relationships, and be fully able to cooperate and recognize the intentions of others.[100] Donald quotes psychologist Rudolf Arnheim, who argued that language is largely irrelevant to the visual arts.[101] Moreover, Arnheim considered visual thinking to be largely independent of language, as are musical improvisations, athletic activities, and ancient human crafts like pottery and weaving.

Donald's retracing of the origins of the "modern" mind and its preliterate antecedents may or may not be correct in all details, but his book remains an important and provocative achievement and his thought well ahead of his time. One important contribution is to emphasize that our Pleistocene ancestors were nonliterate, as of course were the premodern peoples whose ways of life form the body of ethnographic information that makes up our knowledge of preindustrial societies.[102]

As this book was being written, an article appeared that advised scholars of rock art to take into account the fact that early mark-makers were nonliterate and therefore necessarily had minds different from ours today.[103] Two decades earlier, I devoted the final chapter of my book *Homo Aestheticus* to the effects of what I called hyper-literacy (and the "anomaly" of literacy), stating that modern thought "is *scriptocentric* in the same way that the pre-Copernican world was geocentric."[104] The fact that some rock art experts are at last recognizing the implications of this difference is welcome, but it suggests that even in the twenty-first century many still do not appreciate the effects of reading and writing (or not reading and writing) on the mind. It is too easy, in thinking about "behaviorally and cognitively modern" humans, to assume that, apart from living outdoors, they were just like us.[105]

In addition to lacking literacy, early pounders of cupules, engravers on stone, fashioners of beads and pendants, and daubers of pigment were born into very different social worlds from ours. Unless one has lived in a small-scale, non-Western cultural group for some time, it is not only difficult, but perhaps even impossible to adequately appreciate how different would be the thought and behavior of people whose environments and ways of life are so unlike ours. Our own societies are technologically and institutionally complex, competitive, and individualistic. Researchers who study and make hypotheses about ancestral minds and behavior of oracy-based peoples are products of decades of practice in reading, writing, rational analysis and argument, and systematic organization of their thoughts. Both Ekkehart and I include ourselves in this group, and feel fortunate that events in our lives have allowed each of us to experience traditional cultures in a sustained way so that we can even conceive of the differences.

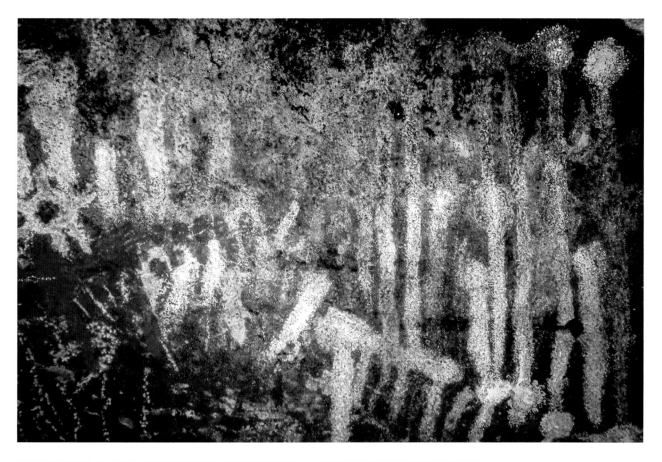

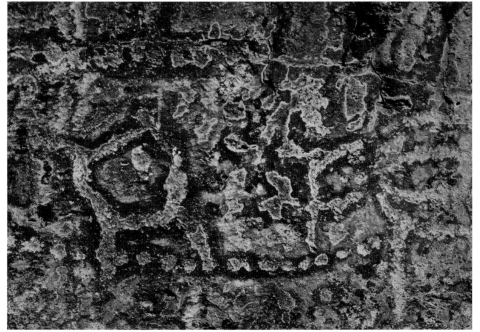

4.17 (*above*) Pigmented panel, featuring multiple superimposed dots and lines, Nevada

4.18 (*left*) Basic glyphs, rendered prominent by overlying mineral accretions, Colorado

In bringing up cultural differences, we also do not mean to say that traditional people act only from emotion or that modern people are always cool and rational or motivated by reasoned argument. Nor do we say that nonliterate societies of the recent or ancient past were "all the same." A number of scholars point out that it is a mistake to treat all hunter-gatherers as belonging in one monolithic category, as some theorists have done.[106] On the contrary, they occupied diverse habitats and had diverse ways of life, which resulted in different customs and even physiologies. We do not dispute this, but we also find that in important respects, hunter-gatherer societies are more like each other than they are like modern societies.

The emotional detachment and "disembedded thinking" that modern schooling tries to instill and that scientific description requires were never part of the innate cognitive abilities of archaic or even contemporary humans. On the contrary, even in modern societies they are laboriously, and often only partially, acquired. In addition, our twenty-first-century minds are crammed with ideas, images, and information overload. Symbols pervade our world, from advertising logos to printed matter. Although such minds seem normal and natural to us, they characterize a miniscule proportion of humans both past and present.

Our Paleolithic predecessors, like pre-modern people of the recent past, lived in societies that in comparison with ours were not only technologically and institutionally simpler, but more cooperative and conformist. People were more embedded in their immediate experience, aware of their surroundings, and connected to their fellows and environments in ways that we probably cannot easily appreciate, especially once we enter school and learn to read and write. Many children struggle to acquire the skills of reading and writing because "our brains aren't naturally wired" for these activities: "infants aren't born with the neural pathways needed for" them.[107] Hunter-gatherer lives simply do not require reading and writing; had they been dependent on literacy, their ways of life would have been quite different.

It is also useful for members of highly literate societies to understand that speech, one of humankind's most remarkable endowments, has prosodic (or expressive) as well as symbolic, syntactical, and semantic components. When we talk, we do not merely exchange information or ideas—what linguists call "propositions" (or "complex propositions").[108] As neuroscientist Jaak Panksepp says, "The brain mechanisms for language were designed for social interactions, not for the conduct of science."[109] After living for years with nonliterate Trobriand Islanders a century ago, British anthropologist Bronislaw Malinowski suggested that language serves not to imitate thought but to move another to act.[110]

These expressive or persuasive aspects of language can be forgotten when we read and write sentences alone in a study, although talking with another person can remind us of "nonverbal" communication, where facial expressions and body movements augment (or confound) the spoken verbal message.

There are techniques that help one to imagine what nonliterate experience is like. We can try to remember our own thoughts and preoccupations and understandings of the

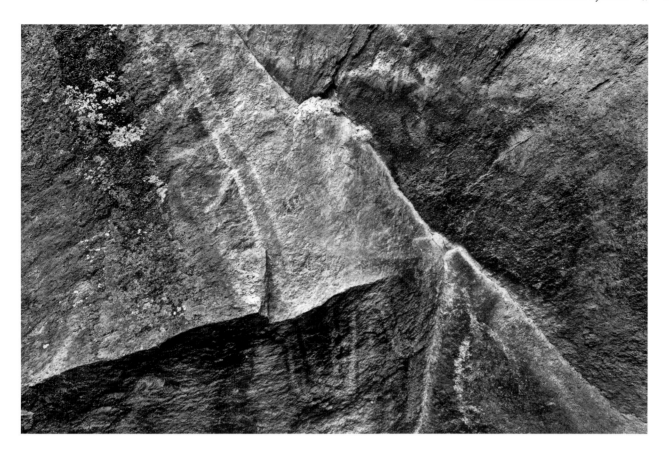

world before going to school and learning to read. Or we can simply observe preschool children. Thought is often "magical," embedded in sensory experience of the here and now; one is easily fearful or wary, can feel helpless, and rarely if ever is (or wants to be) alone. Also we can try to imagine always living outdoors, with all cultural artifacts (such as dwellings, tools, clothing, ornaments) made by hand from natural materials. Like other animals, one would probably feel a part of—at home in—that environment in a way that most of us in today's complex societies would find hard to imagine. Subsistence foragers would also be ever aware of the resources (the affordances) provided by their surroundings. Their inner life would be "in the present" more than in the past and future—the "mental home" for many modern people. They would use their wits to cope with that environment, and not rely on printed instruction manuals. Their knowledge was lore, passed to the next generation, who watched, imitated, and listened to dramatic stories and engaged in multimedia ritual practices. Their arts were immediate and participatory.

Anthropologist C. R. Hallpike has conducted a provocative, if to some controversial, study that examined the thought processes of members of small-scale societies, using the categories utilized by the Swiss psychologist Jean Piaget in his influential studies of children's cognitive development from infancy to adolescence. Hallpike demonstrates that with regard to the development of cognitive processes involved in classification,

4.19 Nonfigurative paint marks, lichen, and mineral precipitates resulting in an abstract tableau, California

number, measurement, conservation, space, time, causality, and symbolization, premodern people do not require what Piaget called "concrete operations" and that for most purposes of their lives, "preoperatory" thought is sufficient.[111] Preoperatory thought is not "rational," according to modern scientific criteria of rationality. Such terse statements of course may raise hackles influenced by political correctness, especially in those who have not read Hallpike's book thoroughly. He emphasizes that his characterization does not mean that preliterate thinking is conceptually simple, inherently mistaken, or incapable of profundity. Saying that such thought is "prelogical" does not imply that it cannot be true, practical, creative, aesthetic, and wise, or that its users are childlike or inferior forms of humanity.

Rationality and scientific thought are indeed narrow aspects of mental functioning, and humans possess an entire cerebral hemisphere that is not rational or scientific. Because preliterate people are not preoccupied with the analytic and sequential tasks that consume the time of us digitalized humans, they pay attention to their right hemispheres more than we academics do (although of course every human uses both hemispheres).[112] Ancestral human minds evolved with myriad adaptive abilities that use the kinds of thought that served them well in a forager way of life rather than scientific rationality or skill in reading and writing. Psychologist Howard Gardner's theory of "multiple intelligences" holds that individuals possess varying degrees of eight broad cognitive capacities: linguistic, logical-mathematical, spatial, bodily kinesthetic, mechanical, interpersonal, intrapersonal, and naturalist. Although all humans have all these capacities, each individual has a unique mixture, a mosaic that is composed of different proportions of each.

An adequate description of the components of these capacities and their interrelationship requires more space than is desirable or possible here.[113] However, it suffices to say that the intelligences described by Gardner have definable neural substrates and would have emerged as adaptive during human evolution. It is not difficult to appreciate that they would all contribute to hunter-gatherer lives or to realize that modern schooling tends to emphasize and reward the first two (verbal skill as reading and writing—not oratory, and mathematical or logical analysis) and generally to disregard the others. All of them, according to Gardner, can be used in making and experiencing art. All require "thinking" (cognition), although in most of the intelligences, formal operational thought or propositional language would not be required.

The questions scholars ask of archaic humans and the interpretations that are made of the traces they left on stone are probably strongly affected by assumptions that have been made possible by literacy (not just language).[114] The degree to which thought depends on language ("Do people think in words?") has been a longstanding subject of discussion in linguistics, psychology, and philosophy, with an increasing agreement that thought does not require words.[115]

Yet the habit dies hard: It has been suggested, for example, that reorganization of the early human brain during the Middle and Later Stone Ages in Africa could have resulted

4.20 (*opposite*) Lichen-covered curvilinear motifs, New Mexico

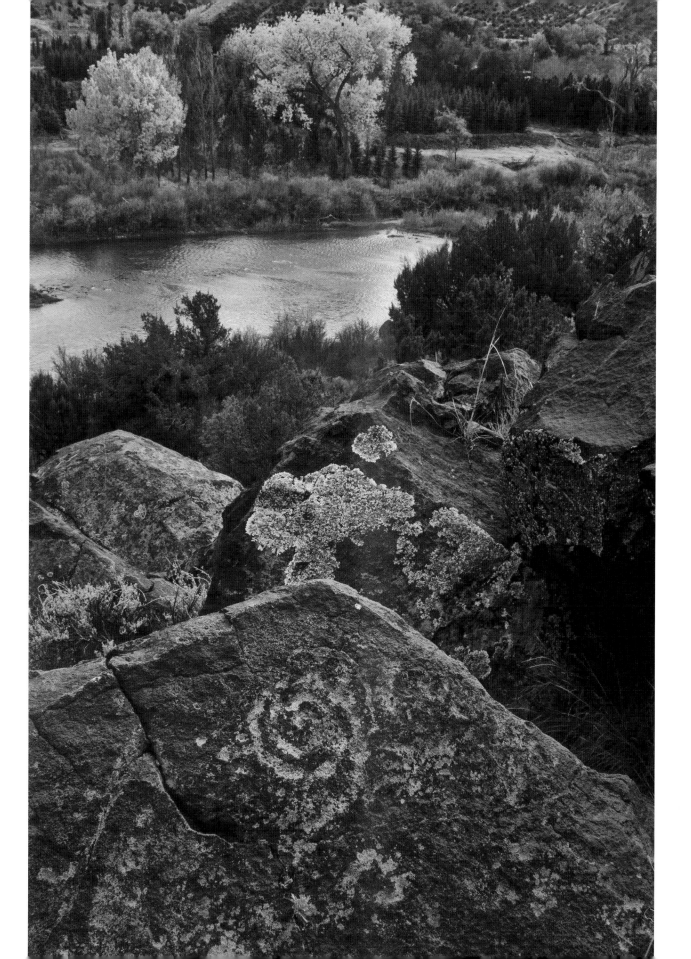

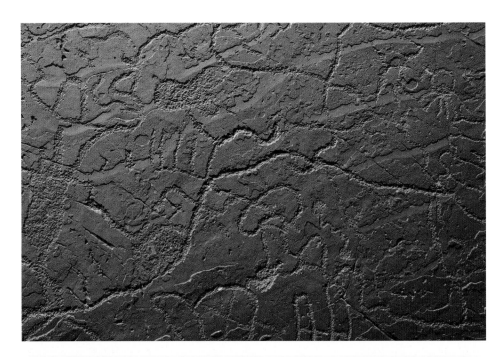

4.21 (*right*) Assemblage of pecked outline and solid infill elements, Nevada

4.22 (*below*) Geometric complex, partially obscured by lichen, Nevada. *Photograph courtesy of Alva Matheson.*

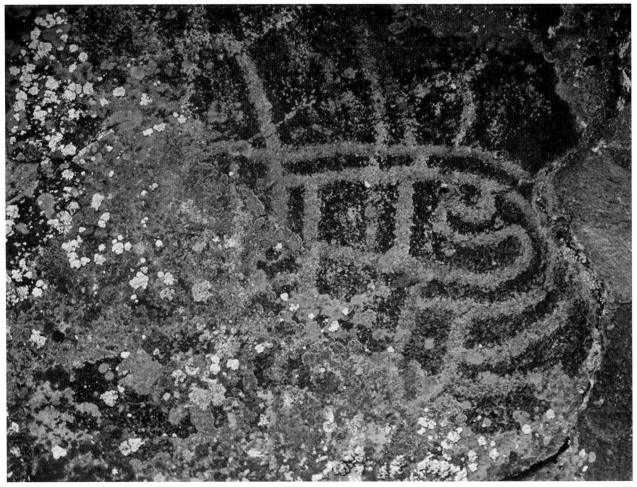

in new networks or links among frontal, temporal, and parietal lobes, hence allowing for "inner speech."[116] That may well be so. Yet what archaeologist ponders the possibility that our ancestors thought in *pictures*, which may be the way that prelinguistic humans thought and preverbal babies think and all of us think some of the time?[117] The articulate spokesperson for autism, Temple Grandin, tells us that she thinks in pictures, and when she learned that others thought with words, she could not imagine what that would be like.[118] She suggests that it is likely that animals think in pictures and use memories of smell, light, and sound patterns much more than people do today. Perhaps in all of us, thought and memory are more pictorial than verbal. Again, try an experiment of thinking, say, of a beloved person far away or of remembering an incident from the past. Do words come to mind first? If we are tracking an animal or preparing a meal, do we think in words or do we use some kind of nonverbal spatial and pictorial mentation?

Even if we decide to call cupules and early engraved or painted marks "symbolic," we should not forget Donald's observation that the value of a symbol depends on the kind of mind that puts it to use. That is, "episodic" or "mimetic" minds (Donald's terms) create episodic or mimetic models of the world, so that attributing our signs or symbols to people with these minds will not change the way they think. Similarly, our modern literate or "theoretical" (in Donald's terminology) minds create and rely on other symbolic models of the world because our thought processes are different.[119] In later work he characterizes "theoretical culture" as "symbol-based, logical, bureaucratic, and heavily dependent on external memory devices, such as writing, codices, mathematical notations, scientific instruments, books, records, and computers."[120]

In sum, as our modern minds try to reconstruct the mental world (or "thought processes") of our ancestors, we need to be aware that their lives were far less mediated by symbols (and by the kinds of symbols), than are our lives. At the very least, we suggest that rock art study would be better off positing something like a *spectrum* of symbol, rather as prehistoric art scholar James Harrod has done with his "taxonomy" of symbolic behavior.[121] At one end there is little or no *symbolic* intention (although a kind of intention can be attributed by someone who sees or hears a cupule being made or who sees it after the fact), and at the other end, one finds obvious symbolic intent whose meaning may be clear or unknowable.

OVERLOOKING PROTOSYMBOLIC (OR NONSYMBOLIC) BEHAVIORS VITAL TO HUMAN EVOLUTION

Emphasis on nonliterate and nonrational modes of thought in the previous section, and on the role of play in mark-making in the section before that, may seem to some readers condescending or demeaning, depicting Pleistocene adults as child-like (or ape-like). The roots of artification can be traced to our prehuman, even preprimate, past and specifically to basic emotions (called *affects*) that prompt all mammals to seek

survival and reproductive success. Like archaeologists, we are looking for the origins of human behavior in earlier hominins, but like psychologists, we gain insights from infants and animals.[122] Continuity with other life forms can be seen instead as part of the mystery and miracle of existence.

It is important to remember that ancestral humans lived as wild animals, concerned with survival in ways that few people today can imagine. In the Pleistocene past, humans desired and sought the same primal requirements that face any wild, group-living animal: sustenance (food, water, shelter, warmth), social acceptance and participation, sex and mutuality, care of offspring, safety, and competence (knowing what to do to survive—to achieve one's goals and satisfy one's needs). Similarly, we evolved to fear and flee from pain and the threat of destruction (sources of anxiety, alarm, and foreboding), social loss (sources of loneliness, grief, separation distress, sorrow, and panic), and body surface irritation, restraint, and frustration (leading to indignation, hate, anger, and rage).[123]

Jaak Panksepp and a few other neuroscientists say that emotions evolved to direct animals (including humans) to promising solutions to survival problems such as: How do I obtain goods? How do I keep goods? How do I remain intact? How do I make sure I have social contacts and supports?[124] Missing from these welcome psychological as well as evolutionary accounts of human emotions, unfortunately, is any mention of the effects of what I call the "aesthetic operations" of artifications in allaying anxiety and contributing to group bonding.

Early manifestations of aesthetic cognition and behavior were further used and developed by ancestral humans in what became ceremonial practices performed to obtain good outcomes necessary for life. Myriad ethnographic studies of premodern societies confirm that the arts are regularly found in ritual practices. In fact, they are indispensable.[125] If beliefs and dogma are stated only as rational propositions, without artification, people will be less able to remember, accept, or guide their lives by them. Instead, attention-grabbing visual, aural, and movement artifications were found by early humans to be essential in creating and sustaining their emotional investment, as individuals and as a group, in obtaining the life needs they had evolved to care about.

Art-filled ceremonies also address and satisfy strong psychoneural emotional needs that humans evolved to have: for mutuality (close relationship with an other or others),[126] belonging to a group,[127] a sense of meaning in life, a sense of competence in being able to address the material and nonmaterial problems of life, and artification—that is, the propensity for physically and behaviorally demonstrating, often with others, that one cares about survival-related outcomes, as in traditional rites and ceremonies.[128] In modern secular societies, these needs are often left unsatisfied in at least some respects, compared to traditional societies, and attempts to satisfy them may take aberrant forms. This cultural "mismatch" is another reason that people today may misinterpret the psychology and behavior of early modern humans.

HOW ARTIFICATION PRECEDES AND EMBRACES SYMBOLISM

It is a mistake to frame the question of why it took so long for anatomically modern humans of the African Middle Stone Age to "catch up" with their European Ice Age descendants in terms of the "cognitive horsepower" that they presumably shared. Instead of using symbolization as the *sine qua non* for cognitive and behavioral modernity, artification is a more appropriate standard. Or, better said, although anatomically modern and even earlier groups may or may not have been making and using symbols, they were unequivocally making and using artifications—a universal behavior that is not present in other animals and has been adaptive in ancestral and later hunter-gatherer populations. Although it is sometimes difficult to recognize symbolically mediated behavior, it is not difficult to recognize artification. And artifying something that one cares about is a unique human activity in its own right, concomitant with the psychobiology of hunter-gatherer societies.

4.23 Incised Clovis-age pebble from the Blackwater Draw site, New Mexico. *Photograph courtesy of George Crawford.*

To put it yet another way, whether early mark-making demonstrates the capacity for symbol use in early humans, it does reliably show the capacity for artification. Cupule-pounding, engraving of lines on small stones (fig. 4.23), the perforation of shells so they can be strung and worn as beads, painted or engraved marks on bodies or shells—all these make rock surfaces, stones, marine or snail shells, and bodies "special," different from their ordinary appearance. They employ some or all of what were identified in chapter 1 as "aesthetic operations"—simplification (formalization), repetition, exaggeration, elaboration, and manipulation of expectation.

These features are means to making ordinary objects and behaviors extraordinary, and by doing so, they attract attention to, sustain interest in, and create and shape emotion with regard to these objects and behaviors. They first appear in mothers' behavior with their infants, then in children as they play—in both instances spontaneously (that is, without being taught). The predisposition to artify was later co-opted for use in ritual and even practical contexts, where aesthetic behavior and features in themselves produce an emotional effect on participants or observers, as Malinowski described for the Trobriand Islanders when he said, "In gardening, fishing, building of houses and industrial achievements, there is a tendency to display the products, to arrange them and even adorn certain classes of them, so as to produce a big, aesthetic effect,"[129] and as various speculations about the functions of cupules suggest.

This view does not contradict the established anthropological view that rituals and the artifications employed in them are symbolic. However, the symbolic content of artifications may not be the most important thing about them. Regarding the subject

4.24 Spectacular example of an artified harvest celebration from Chimbu Province, Papua New Guinea. *Photograph courtesy of Maureen MacKenzie.*

matter or messages of the activity, whether presented directly or symbolically, I want to emphasize that it is artification that makes the content compelling. A simple example provides clarification. The Gogime people of Chimbu Province in Papua New Guinea participate in a celebratory ritual at the time *kairuku* nuts are harvested (fig. 4.24). Adult men adorn themselves with headdresses fashioned of bird of paradise plumes, headbands of red parrot feathers and cuscus fur, bone ear ornaments, shell necklaces, and aprons made of striped woven plant fibers. The men assemble in a group, drumming and singing. If they were to remove the headdresses, headbands, aprons, and adornments, if they were not to carry and play drums or sing and move in unison, there would be no ritual: there would be just a bunch of guys standing around, perhaps exchanging banal comments such as "We're lucky that there were lots of nuts this year," or "The spirits were good to us."

In east-central Arizona, the Hopi kachina dance provides a dramatic example of the power of multiple artifications in ritual, here foremost a "prayer for rain." The fundamental need for life-sustaining moisture, which could be expressed by simply saying "We really need rain" or "If only it would rain!" is instead couched in a public multimedia ceremony whose visual, vocal, verbal, gestural, and performative aspects involve

virtually all the arts—ritualized dance choreography involving rhythmic swaying, shuffling and stomping; complex, specially composed song-poems, often accompanied by drumming and rattles; elaborate costuming and masking; body decoration; and oratory by dance leaders. While the proximate reason for the dance is rain, fertility, and subsistence, the ultimate effect is social cohesion, group harmony, and survival as a culture.

The power of the kairuku or kachina rituals arises not only from their message or subject matter—the expression of thanks and relief in having a source of food for the coming season, in the first example, and the expression of communal yearning for life-giving rain, in the second. It is the specialness of the artifications of body, movement, voice, and message that accomplishes the rituals and creates emotional effects of relief and solidarity.

The late Australian anthropologist Alfred Gell was ahead of his time in recognizing that most art theory, including anthropology of art, was top-heavy with Western assumptions about aesthetic appreciation of objects. He instead looked at aboriginal arts as devices for affecting individuals. He described the arts of Australia and Melanesia as being a "technology of enchantment," in which objects or performances were intended by their makers and users to tantalize, frustrate, or entrance viewers by means of complex patterns, repetitive dots, and other psycho-perceptual techniques, thereby gaining power over them.[130]

Although most of the anthropological literature on the idea of art as technology comes from Oceania, the idea applies to the artifications of the various inhabitants of the New World and of our early ancestors in Africa and Eurasia as well.

Consider the Trobriand *masawa* (ceremonial canoe used for trading journeys to distant neighboring islands). A canoe is a tree trunk that humans have extracted from nature and turned into a cultural product—a vessel that is seaworthy and will hold the required number of men. But that is not enough. Because the journey is culturally important and physically dangerous, they must ensure, by artifying it, that the vessel will perform as desired.

A canoe's prow board is a hydrodynamic necessity, but the Trobriand artifiers go further and make it special, carving it into complex symbolic shapes that are painted with bold contrasting colors, both for spiritual protection during long sea voyages and also to work a kind of psychological warfare on viewers when the competitive exchanges begin. It is hoped that the trading partners will be dazzled, beguiled, captivated, and confused, and therefore susceptible to surrendering their *kula* (shell exchange) valuables.[131]

Similarly, shields of the Asmat in Papua New Guinea bear symbolic apotropaic (evil-deflecting) patterns that entrance and ward off dangerous spirits; they are also important in the psychological warfare of headhunting.[132] Both "decorative" and "representational" art can enchant in this way. Asmat shields and Trobriand canoe prows use stylized motifs of birds (e.g., ospreys), insects (e.g., praying mantises), and mammals (e.g., bats) that have traits of strength, power, and agility—motifs that not only symbolize these qualities but are further enhanced by their perceptual/emotional strikingness.

4.25 So-called "crocodile" scarification used by some Papua New Guinea tribes as part of the coming-of-age ritual for their young men. *Photograph courtesy of Wikimedia Commons.*

With the Yolngu and other peoples of northwestern Arnhem Land (Australia), ancestral power is indicated by the brilliance of painting and repainting and the shimmer and dazzle of crosshatched designs.[133] The concept of symbolic mediation does not satisfactorily cover these sorts of effects. At many rock art sites one can experience similar effects that appeal to the senses and emotions, even when the symbolic content, if any, is unknown.

Body enhancement (fig. 4.25) may, but need not be, symbolic, as Paul Pettitt suggests. Here is a simple question: When a modern woman wears lipstick or a necklace, is she "symbolizing" her beauty, status, or wealth? She may be enhancing or drawing attention to her personal qualities, but is looking better "symbolic"? If people make their ordinary bodies extraordinary, or special with paint, feathers, or leaves, it certainly indicates that they *care* about showing themselves as more attractive than or different from their ordinary bodies. Anthropologist James C. Faris found that the striking and individualized geometric face painting of the Nuba of Sudan was entirely abstract and nonsymbolic.[134] Other instances of nonsymbolic designs are documented for Australian Aborigines[135] and for the Suriname Maroon.[136] In his indispensable book, Franz Boas presented fifty-eight figures that illustrate nonrepresentational and nonsymbolic examples of artistry from people in small-scale societies.[137]

Additionally, the importance of body decoration need not reside wholly in its symbolic meaning but in the further message its extravagance (artification) may convey. Tattooing or cicatrization, for instance, usually indicates the attainment of a life stage such as adulthood. The marks can be said to demonstrate to all that the now-adult person has undergone and borne pain—it is what evolutionary psychologists have called an unfakeable "costly signal." Although such a costly message could be conveyed by random slashes or scars from burning or beating, it is interesting to note that body mutilations are generally artified. For example, Maori facial tattoos with complex designs or decorative scars placed in rows on the bodies of Nuba males attract attention and admiration over and above their status as life history marks. Because these are permanent records of a significant transformation, they are made special to underscore their importance both to the decorated individual and to the society.

Conversely, not all symbols require artification—for instance, a crude map scribbled on a sheet of paper or scrawled in the sand. For reasons of expediency, a cross may be hastily made with two sticks tied together to mark a grave. Because these objects are ephemeral and have no continuing value after they serve their immediate purpose, they are not artified.

Many archaeologists today, like the early proponents of the Creative Explosion hypothesis,[138] postulate openly (or unconsciously assume) that for a work to be called

"art," it must be symbolic. Such a position automatically—and I think erroneously—considers art to be a subset or example of symbolizing ability, as when *New York Times* science writer Nicholas Wade reports that "archaeologists tend to equate full-fledged modern language with art, which only becomes common in the archaeological record some 45,000 years ago," and that "the creation of art implies symbolic thinking in the mind of the artist, and therefore the possession of language to share these abstract ideas."[139] It is limiting to regard art as a sort of late-born stepsister of symbolization. Indeed, it is more reasonable to see artification as the *parent*—that is, to have given rise to mental capacities that led to symbolizing ability.

The readiness to respond to presymbolic affect-laden proto-aesthetic operations, in place at the beginning of life in individual development as in the early evolution of our species, precedes and influences the development of human aesthetic capacities that may but need not always be symbolic. In small-scale societies of the past, symbolic thought and behavior might not have been a priority, but artification was central.

By searching for the earliest evidence of *Homo symbolicus*, scholars have overlooked clues from the archaeological past that indicate that before we were symbol-users or language-users, we were *Homo aestheticus*, a remarkable creature that modern archaeology does not sufficiently recognize and honor.

5

SITES AND STYLES OF THE WESTERN ARCHAIC TRADITION ROCK ART COMPLEX

EKKEHART MALOTKI

WHY DID THE same worldwide developmental progression from simple graphic primitives to complex figurative art also prevail in the New World, although it was colonized long after representational imagery had become the norm in Eurasia? It seems unlikely that the first people entering the New World would have arrived with a blank artistic slate. Unfortunately, not much is known about the Pleistocene paleoart of Asia, presuming that it was the most likely parent tradition for Paleoamerican artification on both rock surfaces and portable objects. Attested only in very limited finds, it is distinguished by an almost complete absence of figurative depiction. Within the corpus of Siberian art, two proboscidean images are currently known, one incised on an ivory plaque from Mal'ta, the other on a mammoth tusk from Berelekh.[1] In addition, two possible woolly mammoth petroglyphs and the engraving of a rhinoceros, believed to be of Paleolithic antiquity, have been reported from the Mongolian Altai region.[2]

Based on universally observable behavior of people moving into unfamiliar territories, one can assume that Paleoamericans, upon entering an uninhabited continent, began enculturating and socializing it in various ways. Environmental enculturation would have included iconographic signposting (artifying) of special landmarks in addition to naming them and eventually endowing them with oral history. The creation of petroglyphs and pictographs would have been part of the process of permanently transforming a natural landscape into a cultural one, that is, turning undefined, open *spaces* into specific, meaningful *places*.[3]

The recent bona fide identification of three realistic images of mammoths in Utah and Florida,[4] animals that are generally believed to have disappeared from the Late Pleistocene landscape by around 13,000 to 12,600 BP, clearly demonstrates that early

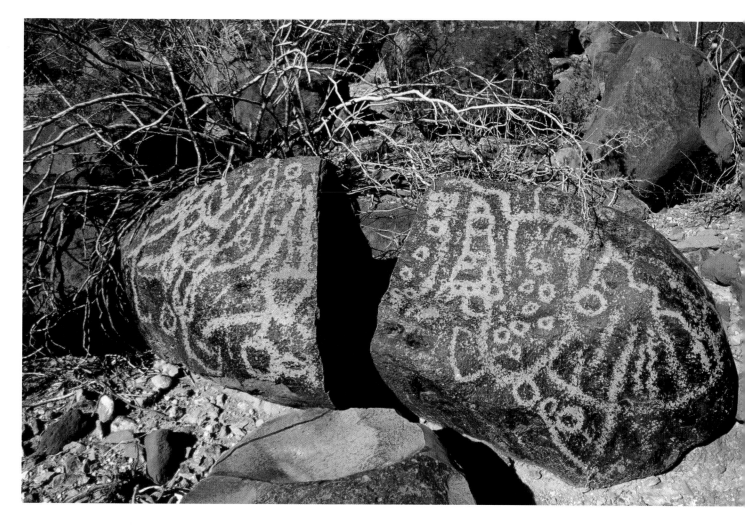

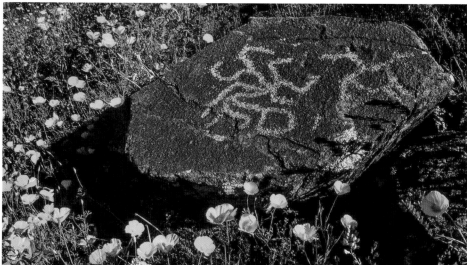

5.1 (*above*) Split basalt boulder, featuring a mix of circular and erratic abstract glyphs, Arizona

5.2 (*left*) Indeterminate archaic glyphs, decorating a volcanic boulder, Arizona

Paleoamericans were capable of iconic representation. Even though it would be a mistake to conclude that these three proboscidean depictions are the only ones that ever existed in North America—similar images may have crumbled over the centuries and others may still await discovery—their existence is highly exceptional, if not anomalous, within the larger picture of earliest North American paleoart. It is safe to assume that the "empty" continent was essentially an *animal landscape*,[5] teeming with life, both apex predators and megaherbivores, similar to Africa's current Serengeti Plain. Mobile forager groups entering this environment, dominated by animals that they depended on for their survival, must have regularly encountered them, including the highly visible and omnipresent keystone species of the mammoth. Yet, with the exception of the three cases just mentioned, animal depictions are absent from the paleoiconography.[6] Hemisphere-wide, abstract-geometric markings were clearly the overriding and preferred motifs of the paleoartists' repertoire. We therefore regard them as the foundational iconography for all of North America. Rupestrian art of the Western Archaic Tradition (WAT), featuring a distinct suite of engravings and paintings, constitutes the major component of this continent-wide graphic tradition.

REPRESENTATIVE SITES AND STYLISTIC OBSERVATIONS

Stylistic analysis and classification of rock art is not a straightforward matter. First, the oldest engravings stylistically attributed to the WAT complex (like the earliest open-air paleoart everywhere) have survived primarily on extremely weathering-resistant rock. An early glyph on a soft surface would have disappeared. Additionally, there exists no dependable and replicable direct dating of WAT rupestrian art, so identification must rely on the traditional techniques: differential repatination, degree of weathering and other alteration by geological processes, superimposition, image content, stratigraphic relationship to datable deposits, apparent association with other datable archaeological remains, and *style*.

To make matters more difficult, the perception of what comprises a given style is highly dependent on intuition and subjectivity. As a concept, style is "notoriously elusive" because "a unitary theory has not been agreed upon,"[7] and hence the assignment of a style to any specific markings suffers from nonfalsifiability. Grouping or classifying paleoart according to style is thus generally regarded as nonscientific, because the process can only reflect the researcher's own system of reality and not that of the original artist. However, since the high expectations that the rock art community once had for a "post-stylistic era"[8] have not materialized, discarding style as a taxonomic device and analytical tool is not an option, especially given the fact that WAT paleoart consists overwhelmingly of nondatable petroglyphs.

The notion of style in rock art will continue to play a major role, and experimental and stylistic dating can fruitfully coexist and complement each other. Stylistic obser-

vations, especially in the realm of manufacturing technique and motif range, must continue to serve as the foremost criteria for a rough temporal framework for WAT-type rock art.[9]

5.3 Boulder face with rayed concentric circles, California

THE MAZAMA SITE: TYPE-SITE OF THE CARVED ABSTRACT STYLE

A truly exceptional rock art site in the Warner Uplands of Oregon's Lake County splendidly corroborates the contention that WAT graphic expression is predominantly "geocentric" (as contrasted to "biocentric"),[10] with emphasis on nonfigurative designs.[11] Situated at the western edge of Long Lake (fig. 5.4), the site lies in the midst of one

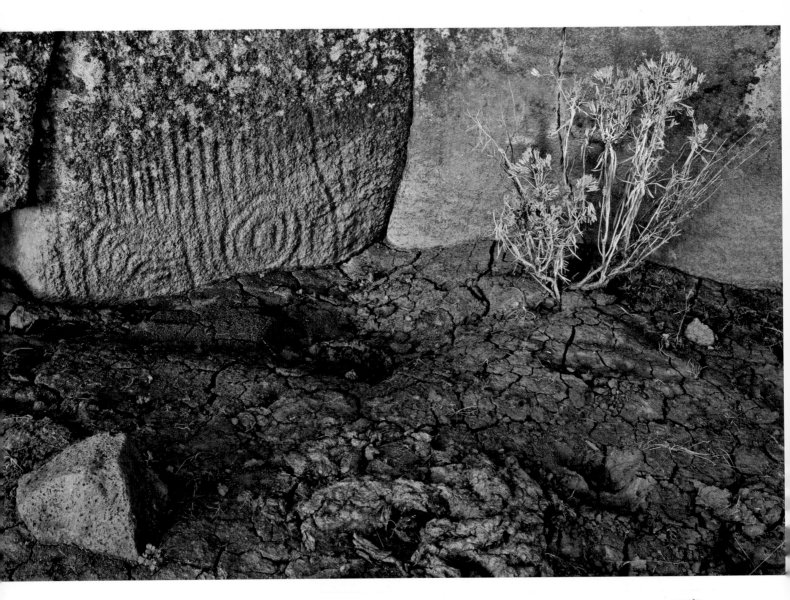

5.4 (*above*) Aboveground portion of the Mazama site at Long Lake, Oregon, type-site for Carved Abstract Style petroglyphs

5.5 (*right*) Tightly interlocking engravings from partially buried Mazama site panels, Oregon. *Drawings courtesy of Mary Ricks.*

of the most petroglyph-rich rock art theaters of the western United States, where rather low-lying basalt escarpments flanking dozens of marsh-wetlands and shallow playa lakes are covered with tens of thousands of the most elemental geometric forms. The site is remarkable in that it contains a valuable time-horizon marker in the form of volcanic ash, which has provided a minimum age for possible Pleistocene-Holocene Transition rupestrian art. "Mazama" seems a good descriptive name for this site, because it was buried by the primary ashfall from the eruption of Mount Mazama, now Crater Lake National Park, some 7,700 years ago.[12] After noting unauthorized digging at the site, which had exposed an exceptionally well-preserved assemblage of buried glyphs, archaeologists William Cannon and Mary Ricks test-excavated the disturbed area.[13] They discovered that a thick layer of volcanic tephra (volcanic ash) had covered part of the petroglyph panel, which extends nearly 1 meter below the present soil mantle (fig. 5.5). The tephra layer had ended approximately 20 centimeters above the lowermost engravings.[14]

The exposed panel consists of the most basic graphic primitives, tightly clustered geometrics, some of which are engraved as deeply as 12 millimeters. Identifiable motifs include straight and sinuous lines, concentric rings, and multiple dot fields, all of which appear to be integrated into a coherent assemblage. Intrigued by the bas-relief, sculpted effect of the deeply hammered marks, the two investigators, who found no "fit" for them in the then-prevailing standardized typology of Great Basin styles proposed by archaeologists Robert Heizer and Martin Baumhoff,[15] labeled these engravings Great Basin Carved Abstract Style.[16]

Worldwide, relatively few instances are known where datable sediments have provided reasonably convincing minimum ages for buried rock art, and the Mazama site is among these few. Considering that it took some 7,700 years for the 70 centimeters of alluvial silts to accumulate above the ash layer, it should be possible for a geomorphologist to calculate the rate of deposition at the site—that is, to estimate how many additional years it might have taken to bury the 20 centimeters of imagery that were sealed off by the volcanic ash.[17] Assuming also that the glyph-maker did not lie on his stomach when pounding out the lowermost designs, they could have been made several thousand years earlier,[18] perhaps about the same time that the Paisley Caves, only about 50 kilometers from the Mazama site, were occupied. Ancient coprolites (fossilized feces) from one of these caves, found to contain human mitochondrial DNA, were dated to be between 14,000 and 14,500 years old,[19] well over a millennium earlier than the long-held Clovis-First threshold. Recovered together with extinct megafaunal fossils, these human feces are presently believed to constitute the oldest directly dated evidence of human remains in the Western Hemisphere.

More recent research at the Paisley Caves has shown that their occupants left narrow-stemmed spear points made by a flaking technique markedly different from that employed by Clovis people. Assigned to a recently named Western Stemmed Tradition, it and Clovis complexes appear to have been contemporaneous but entirely

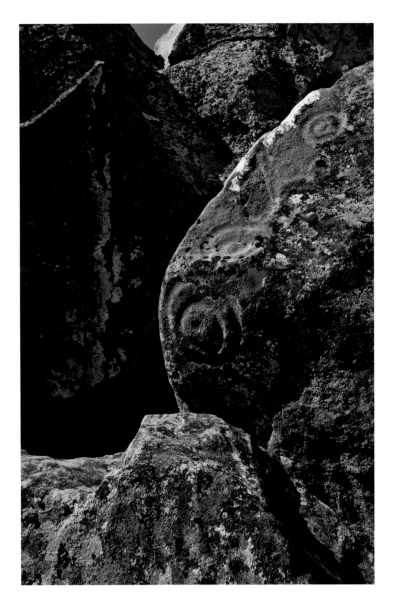

5.6 Deeply sculpted concentric circles and heavily eroded parallel grooves (bottom of image), California

distinct North American technologies. In the eyes of archaeologist Dennis Jenkins and his colleagues, the entire assemblage at the Paisley Caves not only supports the hypothesis that the Western Stemmed Tradition was an indigenous development but is also interpreted as conclusive evidence that the peopling of the Americas involved several technologically divergent and possibly genetically distinct founder populations.[20]

There is growing archaeological evidence that early migrants into the New World may have traveled by boat along the northern Pacific Rim. Archaeologist Jon Erlandson in particular has made a convincing case for coastal migration by suggesting that a "kelp highway," with beds of seaweed stretching along the western coast of the Americas from Alaska to Chile, would have provided food and material resources for maritime people.[21] It is thus conceivable that Paleoamericans, after reaching the Pacific Northwest, would have migrated inland along corridors like the Columbia River and its tributaries to colonize the interior basins of the Intermountain West, including the Warner Uplands region with its hundreds of pluvial lakes, wetlands, and other water sources.[22] The deeply cut glyphs at the Mazama site and others in the vicinity of Long Lake could therefore conceivably be associated with this early Western Stemmed Tradition.

Because illegal digging had occurred at the Mazama site, several rock art researchers felt that the radiometric age obtained by Cannon and Ricks for the volcanic material was "patently unacceptable."[23] According to Cannon, however, this criticism is not warranted.[24] After the disturbed area was squared out, pristine deposits of the ash layer were found to cover the petroglyphs on both sides. It was from these undisturbed deposits that the samples for analysis and dating were obtained. Additionally, it was observed that both the thick ash layer and the rock art panel were found to extend well beyond the illegally excavated area.

It turns out that Great Basin Carved Abstract parietal art—deeply grooved (up to 1 centimeter or more), heavily revarnished (sometimes so completely as to be indistinguishable from the surrounding host rock), and often severely weathered when found in unburied contexts—is not limited to the Great Basin but occurs at numerous other locations throughout the entire American West. For this reason, I employ the simpler and more precise label, Carved Abstract. The Mazama site ideally qualifies as its

type-site, not only because its engravings singularly illustrate the Carved Abstract characteristics but also because of the chronostratigraphic clues that it offers for their potential deep antiquity. The style clearly shows a preference for basic noniconic, purely geometric markings that often fill panels on boulders, cliffs, and pavements with such density that no "white space" is left.[25] The markings include grooves, lines, arcs, hatchmarks and dots; lattices, grids and crosshatchings; untold varieties of circle configurations and spirals, starbursts, and radial figures; zigzags, single and multiple meanders, chain, chevron, and herringbone motifs; ladder- and rake-like motifs, an assortment of maze-like designs, and cupule arrangements. Based on the dating information associated with the sites discussed below, I regard Carved Abstract petroglyphs, because they are taphonomically most resistant to deterioration, to be the oldest surviving layer in the stratigraphy of WAT rupestrian art.

5.7 Large boulder slab with prominent grooves and other geometrics in classic Carved Abstract Style, Nevada

This age assessment is corroborated by archaeologist Emily Middleton and colleagues[26] who, after surveying fifty-five archaeological sites with Carved Abstract rock art in the northern Great Basin, conclude that the style was produced by Paleoamericans sometime during the Terminal Pleistocene/Early Holocene ca. 14,650 to 8,875 years ago. As evidence they cite the fact that the rupestrian sites in question evince a high frequency of associated Paleoindian projectile points—of both the fluted Clovis and Western Stemmed type—that are temporally diagnostic for this early period.

OTHER CARVED ABSTRACT STYLE SITES IN THE AMERICAN WEST

At least three rock art sites associated with dated archaeological remains soundly confirm Paleoindian antiquity for Carved Abstract petroglyphs. All three are located in the Great Basin portion of Nevada. During the Final Pleistocene, the greater part of the northwestern region of this basin was occupied by Lake Lahontan, a gigantic pluvial lake that experienced dramatic fluctuations in water levels caused by a changing climate and its resulting variations in precipitation and evaporation rates. Spectacular tufa formations left behind along its shorelines were another outcome. One such formation, a now partially collapsed dome bordering the western edge of the Winnemucca Dry Lake Basin, exhibits a stunning array of cupules and noniconic designs with a grooving depth that is probably unequaled anywhere else in the American West (fig. 5.8).[27] Rock art investigators Robert and Frances Connick, who referred to the engravings as "monumental style petroglyphs," were the first to describe the site and recognize its possible Paleoindian origin. On the basis of archaeological data and other circumstantial clues available to them at the time, they suggested a maximum age of around 11,000 years

BP and clearly ruled out the Northern Paiutes, current residents on the nearby Pyramid Lake Reservation, as potential rock artists at the monumental site.[28] Paleoamerican presence at various locations throughout the Lahontan Basin is clearly indicated by numerous archaeological finds in the form of human remains and artifacts. For example, bones from the Wizards Beach skeleton near Pyramid Lake, a remnant of ancient Lake Lahontan immediately to the west of Winnemucca Dry Lake, are around 10,600 years old. Fishing cordage made from sagebrush found in the same area is even older, at approximately 10,900 years. Diamond-plaited matting from the archaeological site of Crypt Cave on the opposite side of the Winnemucca Lake Basin is reported to be 10,700 years old.[29] Fishbone Cave, also located on its eastern side, contained datable materials in the 13,000-year-old range.[30]

In 2012, a team of researchers led by geochemist and paleoclimate specialist Larry Benson set out to date the Winnemucca engravings more accurately. In particular, they focused their scientific efforts on the white carbonate encrustations that resulted when the tufa formation was submerged under water. Relying on radiocarbon dates obtained from the encrustations both under- and over-lying the petroglyphs, and on a sediment core revealing the lake level of nearby Pyramid Lake (which at that time formed a single body of water with Winnemucca Lake), Benson and colleagues were able to establish when the base of the artified tufa mound stood above lake level. This finding led to the conclusion that the paleoartists could have been hammering out the glyphs as early as 14,800 to 13,200 years BP or quite a bit later around 11,300 to 10,500 years BP. While artifacts from the Lahontan Basin are clearly more compatible with the latter temporal span, according to the researchers the possibility cannot be discounted that the petroglyphs were created between 14,800 and 13,200 years ago when Pyramid Lake was relatively shallow and Winnemucca Lake had completely dried up.[31] Persuasive evidence for a Paleoamerican occupation of the region during this early phase has recently come to the fore in the form of a cache of chitinous grasshopper exoskeletons. Uncovered at the just-mentioned Crypt Cave, the arthropodal parts are reliably dated to ca. 14,200 calendar years ago.[32] If this time frame is accepted, the likelihood is high that the Nevada engravings at Winnemucca Lake are North America's currently oldest known noniconic rock art.

Some 160 kilometers east of Pyramid Lake lies Spirit Cave, home of Spirit Cave Man. Hair from this famous mummy yielded an age of around 10,600 years BP.[33] This prehistoric abode is part of the extensive Grimes Point archaeological complex east of Fallon, Nevada, with several dry caves and more than 1,000 glyph-bearing basalt boulders.[34] A great many of the engravings, often revarnished to the point of near invisibility, match the Carved Abstract profile.

According to archaeologist Alanah Woody, a prominent third example with multiple panels exhibiting the characteristic Carved Abstract Style can be found at Nevada's impressive Massacre Lake site along the state's extreme western edge. She distinguishes at least four separate generations of petroglyphs at the site, based on both relative

5.8 (*opposite, top*) Tufa mound at Winnemucca Dry Lake, Nevada, offering a stunning assortment of deeply carved geometrics. *Photograph courtesy of François Gohier.*

5.9 (*opposite, bottom*) Complex display of polychrome abstract paintings in black, red, and white, Utah

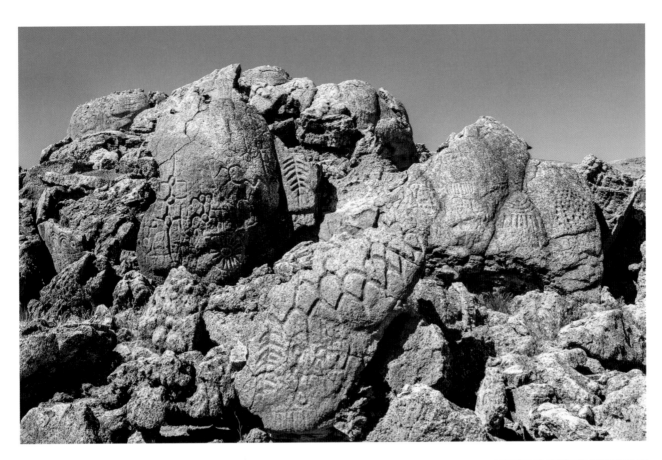

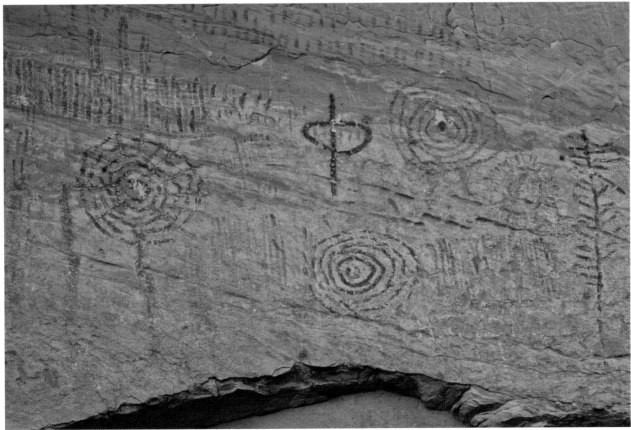

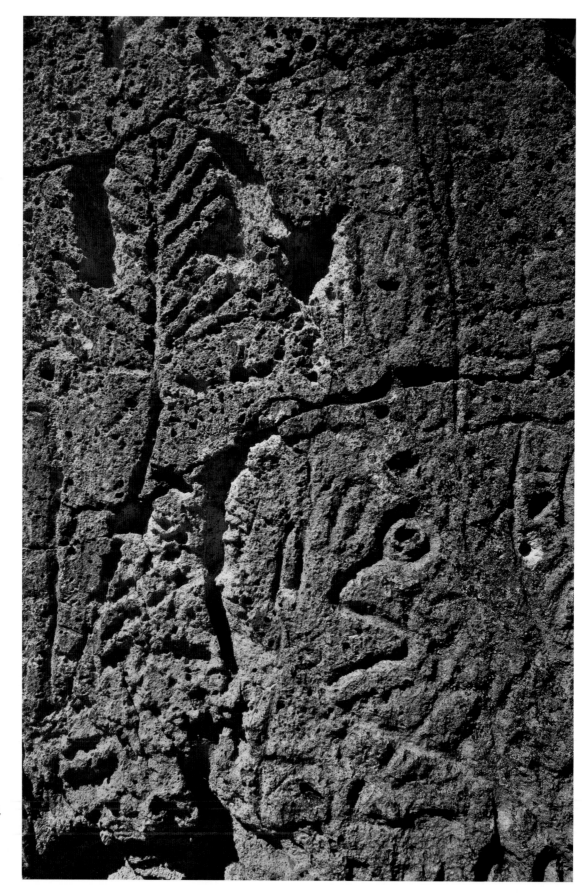

5.10 Miscellaneous abstracts, deeply cut into tufa limestone cliff, California

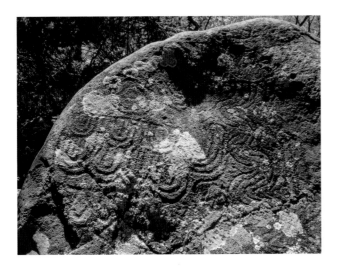

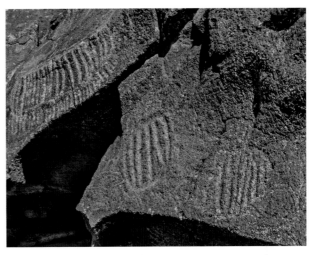

5.11 Meticulously nested U-shapes next to a set of parallel meanders, Arizona

5.12 Bounded oblong and ovoid grid patterns betraying deep-time origin. Little Petroglyph Canyon, California. *Photograph courtesy of Ron Wolf.*

patination and stylistic differences, of which the earliest "may be as old as 11,000 years if temporally diagnostic projectile points at the site are associated with the art."[35]

Numerous other sites throughout the American West exhibit Carved Abstract petroglyphs, often surrounded by or overlain by more recent art. A selection of geographic areas featuring major concentrations of the substyle must suffice to demonstrate their ubiquity throughout our main study area. In Arizona, this rupestrian expression is seen on Perry Mesa (fig. 5.11) and adjacent Black Mesa; north of Kingman; in the vicinity of Hillside; near Ajo; in the larger Phoenix area (with Hedgpeth Hills and Cave Creek to the north, and Saddle Mountain, Eagletail Mountains, and New Water Mountains to the west); and along the entire section of the Gila River from west of Phoenix to the Texas Hill site near Yuma.

In Colorado, imagery of this mode is currently known to me only from the San Luis Valley and a site in Rock Creek, west of Alamosa. California, on the other hand, offers numerous examples—the Palo Verde Mountains region south of Blythe; the Chidago and Riverview sites in the area north of Bishop, and the Swansea Quarry location southeast of the town of Lone Pine; within the Mojave National Preserve; north of Barstow at Black Canyon and Inscription Canyon, and south of Barstow in the Rodman Mountains; at several sites northwest of Needles; in the Hawley Lake area near Blairsden; at Willow Creek near Susanville; the Gottville Boulder along the Klamath River; at Tule Lake in Modoc County; and at the exceptional Petroglyph Point location in Lava Beds National Monument. A deeply incised grid pattern in Little Petroglyph Canyon (fig. 5.12) on the Naval Air Weapons Station near Ridgecrest fully matches the Carved Abstract stylistic profile. For this reason rock art researcher Campbell Grant and colleagues, who recorded the panel, consider it among "the oldest appearing drawings" in the entire Coso Range.[36]

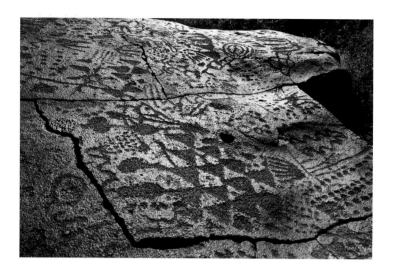

5.13 Superbly crafted boulder top along the Snake River, Idaho, with prominently stacked triangles and a host of other abstracts

Idaho offers spectacular specimens of the style along the Snake River south of Nampa; for example in the area adjacent to the prominent Map Rock site, at Celebration Park, and at the Wees Bar site, which is regarded as the largest petroglyph field in the state. Here many dozens of basalt boulders from the catastrophic Late Pleistocene Bonneville Flood some 14,300 years ago, known today as the Melon Gravels, are covered with deeply cut and heavily varnished engravings. Similar glyphs occur at some of the exposed basalt lava flows in the Bennett Hills north of the community of Bliss, specifically at Tom's Spring and Indian Writing Water Hole.

In New Mexico, petroglyphs attributable to early WAT rock art are especially numerous along the Rio Grande River corridor between Albuquerque and Taos, with impressive examples on Mesa Prieta near Lyden and farther north near Dixon, Pilar, and Arroyo Hondo. In the larger Santa Fe region, these deeply hammered engravings are found at two sites on Glorieta Mesa to the east and near La Bajada and in the Galisteo Basin to the south. Glyphs reminiscent of those on Glorieta Mesa also occur at a site near Roy. In the southern part of the state, the style is mainly represented in the vicinity of Las Cruces.

Besides housing the type locality of the Carved Abstract rupestrian substyle at Long Lake (discussed previously), Oregon contains a host of additional sites featuring the same rupestrian expression. Particularly noteworthy and also located in Lake County are the Paradise Creek and Yocum Valley sites. Indeed, Lake County in the southcentral part of the state can probably be regarded as one of the epicenters of WAT petroglyphs in western North America.[37] Farther to the north can be found the Wallula Monolith (fig. 5.15), one of the most impressive boulders bearing WAT-type glyphs. Named after its original location at the Columbia River's Wallula Gap on the Oregon-Washington border, it is now on public display at the Umatilla Indian Reservation's Veterans Memorial.[38] Seven petroglyph boulders with a distinct WAT-type profile, selected from about thirty along the shoreline beach on the Rogue River near Two Mile Creek, can now be viewed in the museum park of the community of Agness.[39] A spectacular cupule boulder should also be mentioned. Artified with some 400 pits, it flanks the Snake River in eastern Oregon near Dug Bar.[40] Finally, the Yoncalla Boulder in Douglas County is distinguished by having its surface modified with mostly deeply cut and heavily weathered grooves.

In the state of Washington, several sites featuring heavily varnished engravings and cupules line the north shore of the Lower Columbia River. Most remarkable among them are Fisher's Landing, featuring a boulder with a reported 475 pits,[41] and Gentry's Landing.[42] The latter, also known as Ten-Mile Tavern, consists of nearly twenty boulders at the very edge of the river. While predominantly artified with pits, some of them also bear an assortment of heavily eroded geometric designs. A deeply carved boulder from

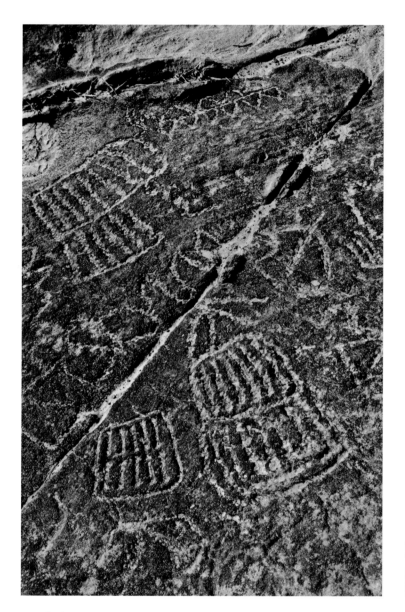

5.14 Gridirons and miscellaneous other geometric elements on bedrock, New Mexico

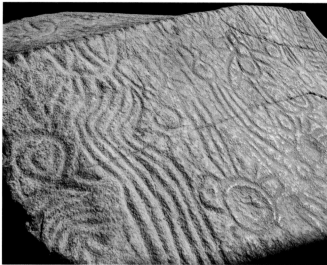

5.15 Inscribed segment of the spectacular Wallula Monolith, Washington State. *Photograph courtesy of Douglas Beauchamp.*

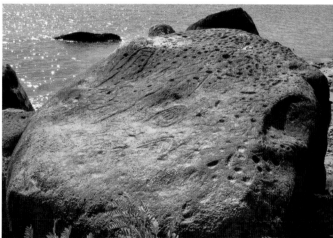

5.16 Pits and abstract elements on a boulder flanking the Columbia River, Washington State. *Photograph courtesy of Eric Iseman.*

Garrison Eddy, originally located along the river, is now on exhibit at the Courthouse Annex in the town of Stevenson.[43]

There are two major Carved Abstract sites in southwestern Texas: the Graef site, located in the vicinity of Balmorhea State Park, and Lewis Canyon, bordering the Devil's River in the Comstock area. In Utah the substyle occurs along the San Juan River near

5.17 Simple boxed-in geometric design of ancient manufacture, Arizona

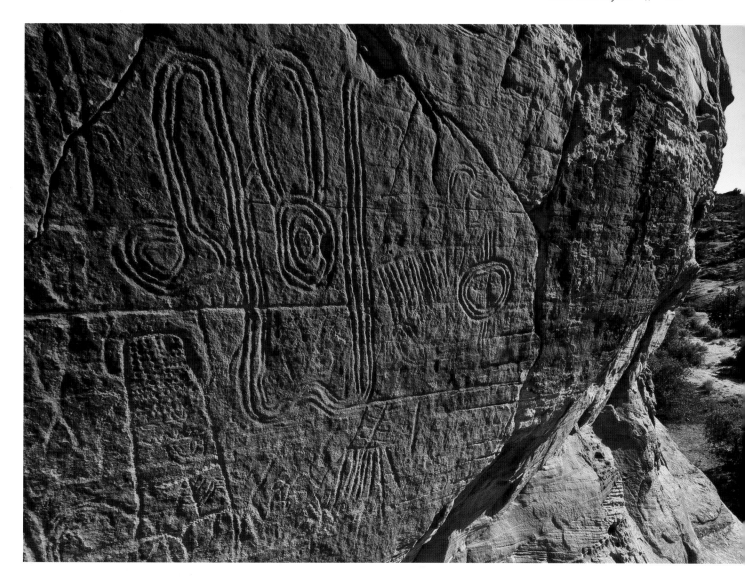

5.18 Sandstone rock wall bearing a medley of carved abstracts, Utah

Bluff; in and around St. George; at the spectacular Parowan Gap; and in the greater Salt Lake City area.

In addition to these sites, all of which are open-air locations, a few caves contain Carved Abstract glyphs. One is at Parowan Gap, Utah. Another, whose walls are completely artified with the style, is situated high above the Aravaipa drainage of Arizona (fig. 5.19). Two others are reported from New Mexico, both of which feature deeply incised bedrock grooves as well as cupules on their bedrock floors: Saddle Mountain Cave south of Luna near the New Mexico border and Map Cave east of Silver City (fig. 5.20).[44] According to Anthony Howell, someone in the 1950s enhanced the glyphs in Map Cave with white paint because the assemblage was thought to provide clues to a treasure left behind by a Spanish conquistador.[45]

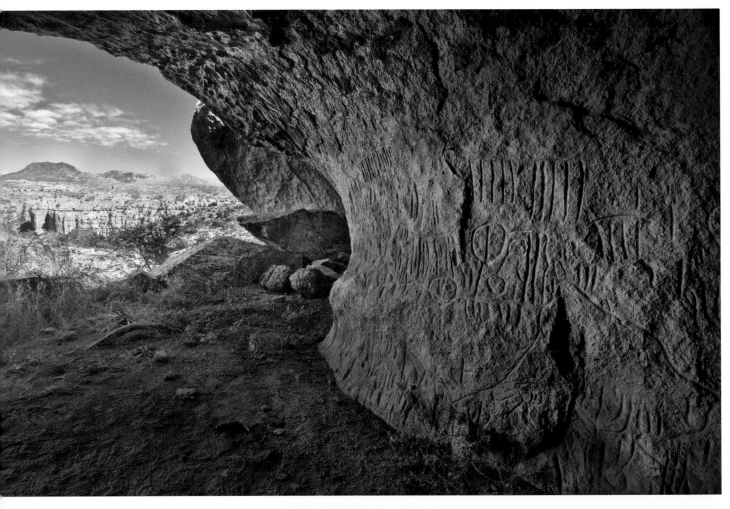

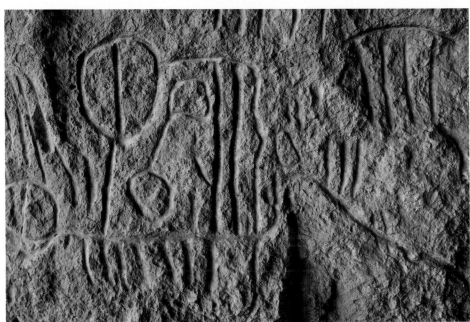

5.19 Well-preserved fine-line abstract-geometrics on inside wall of Aravaipa Cave, Arizona

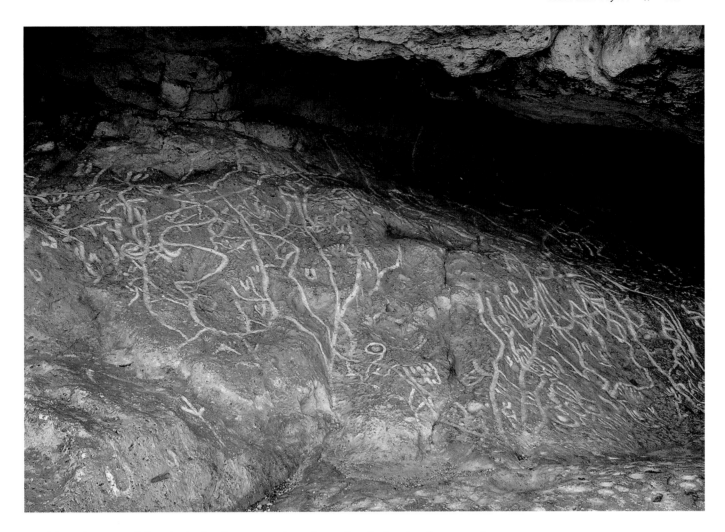

Although none of the glyphs in these caves have been dated, the deeply cut, stylized depiction of a spearthrower, a series of trident-shaped geometrics resembling bird tracks, and a cluster of abraded grooves at O'Haco Rockshelter in the Chevelon drainage south of Winslow, Arizona, may be of Paleoindian vintage. Two charcoal dates obtained from the lowest cultural stratum of the shelter indicate an earliest occupation range of 9,800 to 9,000 years ago.[46] This Early Holocene age seems to be corroborated by a ca. 9,500-year-old sandal recovered at Sandal Shelter, a mere 3 kilometers upstream from the O'Haco site.[47]

5.20 Seemingly unstructured chalked engravings on bedrock floor of Map Cave, New Mexico. *Photograph courtesy of Mark Willis.*

STYLISTIC DEVELOPMENT OF WESTERN ARCHAIC TRADITION ROCK ART

While high mobility among paleoarchaic hunter-gatherers may be responsible for the distribution of WAT-type rock art across vast territories of the American West, it is

harder to find a reason for its relatively uniform and static iconography over thousands of years. It is indeed a paradox that during the long period when populations were quite small and bands foraged in areas that were widely separated from each other, WAT imagery did not experience more dramatic style drift. To be sure, certain regional variations in graphic rendition may be discernible. However, in light of the sparse, fragmentary paleoarchaeological record and based on my own familiarity with early WAT-type sites throughout the American West, I currently see no pictorial evidence for the claim that by Paleoindian times an early development of regional cultural traditions among the first immigrants accounts for *substantial artistic and stylistic variation* in the rock art of the hemisphere.[48] Solveig Turpin, too, concurs when she points out that it is WAT's high degree of abstract geometric consistency that makes it so challenging "to determine the temporal and spatial parameters of defined styles." After all, "the same general iconographic vocabulary and methods of production are found in various combinations across North America, as well as on other continents."[49] Ultimately, a great deal of additional chronometric research will be required to substantiate the claim for a variety of parietal traditions in the paleoarchaic period.

It equally remains to be seen if archaeologist Alice Tratebas's suggestion—that the oldest parietal styles in North America may have had origins in several places in Asia— can be proven.[50] I personally am not aware of an evidentiary trail in the rock art to warrant such a proposed nexus. Given the noniconic homogeneity of Pleistocene-Holocene Transition paleoart in North America, the earliest styles that can possibly be differentiated all appear to have evolved in situ. Tratebas's suggestion would also have to be reconciled with the Beringian Standstill hypothesis, which suggests that the Paleoamerican founding population, upon leaving northeastern Asia during the last Glacial Maximum, lived on Beringia for many millennia before eventually reaching North America some 15,000 years ago.[51]

One distinctive regional expression that can be singled out in addition to the paleoarchaic Carved Abstract mode is the Grapevine Style with its type-site near Laughlin, Nevada.[52] Geographically, its range covers sizeable portions of eastern California's Mojave Desert and west-central Arizona. Oval or oblong frames enclosing internal designs, reminiscent of Egyptian cartouches (fig. 5.21), are emblematic of this nonrepresentational style. Also characteristic are glyphs shaped like the capital letters I, T, and H (fig. 5.22). The fact that human stick figures and masklike elements are part of the motif mix is an indication that the style is a relatively late manifestation within the Western Archaic Tradition, most likely lasting until the time of contact with Euro-Americans.[53]

Overall, however, the design reservoir of WAT rupestrian art is strikingly homogeneous and marked by broad pan-Western if not pan-continental similarities. These similarities clearly point to widespread social interaction among human groups that probably included the sharing of both symbolic systems and ideological beliefs in their struggle for survival.

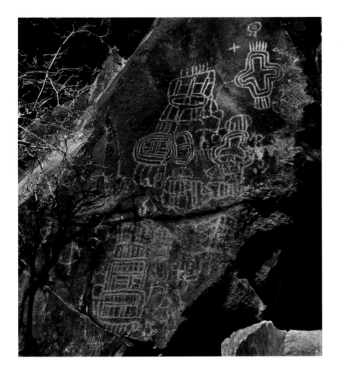

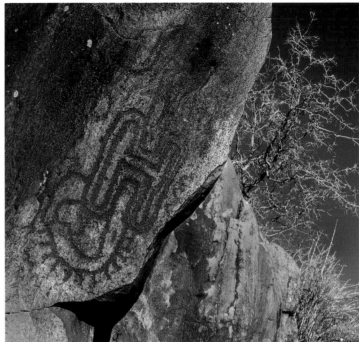

5.21 Typical Grapevine Style motifs, Arizona

5.22 Grapevine panel with "letter-H" element, Arizona

A plausible explanation of why style did not drift is offered by archaeologist Henry Wallace, who suggests that "either the society(s) involved was passively or actively taking strong measures to maintain it, or the style itself confers a strong adaptive advantage."[54] It may be difficult if not impossible to prove whether the production of abstract-geometric markings in particular provided an adaptive advantage to their makers.

No estimates are available for the number of WAT–related sites existing throughout the American West, let alone for the total number of individual glyphs occurring at them. Some fascinating and surprising insights can be derived from a modeling exercise conducted by Wallace for WAT elements in the Picacho Mountains region northeast of Tucson.[55] His goal was to estimate the quantity of imagery in relation to such variables as population size and temporal span. Wallace's data suggested that over the 4,450 year span during which petroglyphs were made, conservatively from 3,000 BCE to 1450 CE, the number of recorded known and unrecorded but assumed-to-exist designs could amount to about 4,650, yielding one design per year total for the entire Picacho Mountain range.[56] When he restricted his sample to WAT petroglyphs over the same period—an estimated 400—he calculated that this "equates to one-tenth of a design element pecked per year, or 10 elements pecked per century." Even doubling or tripling these amazingly low figures to account for environmental loss and degradation, and even taking into consideration that the images were probably made

5.23 Painted remnant featuring concentric circles and a rake-like design, Arizona

over a considerably longer time span than estimated for the statistical exercise, does not appreciably change the results. Ultimately, when applying these remarkably low production rates to archaeological evidence for a much longer human occupation at the Picacho Mountain range (beginning perhaps as early as 9,000 BCE), Wallace arrives at the startling conclusion that "many hundreds of generations of early hunter-gatherers in the area did not hammer out any designs at all, and petroglyph production can hardly be considered a ritual tradition. Most people probably never knew who made the designs or where they came from."[57]

This astonishing finding is obviously of serious consequence for understanding the role of rupestrian paleoart, both in the study area and elsewhere in North America. It implies that in most cases probably only a few individuals in a given prehistoric group were involved in image-making; that they typically did not engage in this activity very often; and that, because of its rare occurrence, its significance must have been high.[58]

GRADUAL CHANGE IN WESTERN ARCHAIC TRADITION ROCK ART

In spite of the long-lasting stylistic stasis of WAT rock art, gradual changes do become apparent over time. This is to be expected, given the extensive geographic distribution of the art and the many generations of image-makers that were involved in its production. Most obvious perhaps is an observable tendency toward shallower engraving, along with increasing motif complexity. Interestingly, Ben Watson reaches a similar conclusion in his comprehensive worldwide study of parietal art motifs from their earliest appearance, finding that although noniconic markings increase in complexity into the Upper Paleolithic, there is a basic range of motifs that persists—remains consistent—throughout time.[59]

In addition, pigment art—which generally survives best when protected in deep caves—begins to appear. Vastly outnumbered by petroglyphs in the American West, one can assume that due to greater vulnerability in open-air shelters and overhangs the majority of pictographic works was lost to natural taphonomic processes. Among the painted sites presently known to me in Arizona that qualify for WAT-style classification are Bender Spring, Balanced Rock, Cochise Stronghold, Fresco Cave, Jumpup Canyon, Lyle's Cave, Lightning Falls, Painted Bluffs, Red Point, Sonoita Creek, Tinajas Altas, and Ventana Cave. Numerous sites featuring multicolored paintings with complex geometric elements that clearly conform stylistically to the WAT profile are also found in New Mexico and Texas. Because of this conformity with WAT, there appears to be no need

to assign them to a separate Chihuahuan Polychrome Abstract Style, as suggested by Polly Schaafsma.[60] Premier examples can be seen at Doolittle Cave, Slaughter Canyon Cave, Painted Grotto (fig. 5.24), Picture Cave, and Hueco Tanks. In Nevada, painted WAT panels occur in Brownstone Basin and at Toquima Cave; in Utah at Black Dragon, the Green Mask site, Motoqua Painted Cave, the Phipps Shelter, and the Sage site.

No credence is given to the claim that the rock art of the Great Basin is manifested in two distinct substyles with a temporal sequence from earlier Abstract Curvilinear to later Abstract Rectilinear.[61] In most identifiable WAT-type rock art, rectilinear and curvilinear geometrics are commingled. As Ken Hedges also points out, the three simplistically defined styles (including representational along with curvilinear abstract and rectilinear abstract images) "lack discrimination" and "are so vague as to have little utility."[62]

There is still no agreement on whether the so-called Scratched Style petroglyphs (fig. 5.25) of the Great Basin are datable to the Pleistocene-Holocene Transition.[63] Representing a distinctive mode of production, scratched art consists mostly of shallow geometric incisings made by a relatively sharp, pointed tool. Archaeologist Eric Ritter, in a detailed study of two scratched rock art complexes in Nevada, believes that "scratched petroglyphs in the Desert West date predominantly within the last 1000 to 1500 years," although in some regions of the Great Basin they "probably range into at least the Middle Archaic."[64] At the majority of sites where I have observed combinations of WAT-type petroglyphs and scratchings, the latter, much less varnished, overlie the former or are associated predominantly with motifs from the Protohistoric and Historic periods. However, in some cases scratch marks constitute the only visible expression. Exhibiting very limited subject matter, they consist primarily of random arrangements of straight lines, grids, simple crosshatchings, rakes, squiggles, and a host of curvilinear elements. The suggestion that scratched rock drawings could have been women's work (implying that gender was a factor in pecked versus scratched mark-making) is a proposition for which no evidence one way or another can be advanced at this time.[65]

Whether Paleoindian origin can be established for some scratched art, as archaeologist Larry Loendorf has posited for finely inscribed designs at the Ancient Hogback site

5.24 Complex abstract-geometric pictographs, splendidly preserved at Painted Grotto, New Mexico

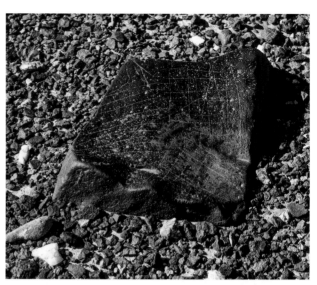

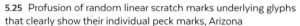

5.25 Profusion of random linear scratch marks underlying glyphs that clearly show their individual peck marks, Arizona

5.26 Scored grid pattern overlying small boulder in California's Yuma Desert. *Photograph courtesy of Richard Colman.*

in Colorado, will depend on the availability of reliable direct dating methods for such glyphs.[66] Considering the current lack of such methods, any age estimate will also have to take into account the fact that finely incised rock art, because it does not penetrate the rock cortex as deeply, tends to revarnish much faster than more coarsely pounded art, thereby providing a falsely old appearance.[67] Nor are the loosely executed scratchings readily identifiable as atlatls, as he claims they are. The typical stylized rendition of the spearthrower consists of a straight line bisecting an oval or circle and projecting beyond, which is not the case at this site. Without the telltale hook for seating the dart, "one cannot tell with certainty if a glyph is depicting a dart with exaggerated fletching or an atlatl with exaggerated finger loops."[68]

Consistent with the worldwide pattern, an overall gradual change from nonrepresentational to full pictorial imagery also holds for large bodies of North American paleoart. In the American West, the older stylistically homogenous graphic tradition, distinguished by near-exclusively nonfigurative markings, gives way in some regions to predominantly representational art vocabularies, whereas in other areas geometric iconography endures. This trend to naturalistic styles, which probably took place over many millennia but becomes clearly apparent around the mid-Holocene, need not be understood in a developmental or replacement sense, which could erroneously suggest that depictive images are somehow the result of more evolved cognitive capabilities.

One can only speculate as to what might have brought about this change toward figurative expression. Certainly, as British anthropologist Robert Layton proposes for both Australian and European rock art traditions, "uniformity of style and content over a wide region suggests that rock art was not utilized as a visual marker of

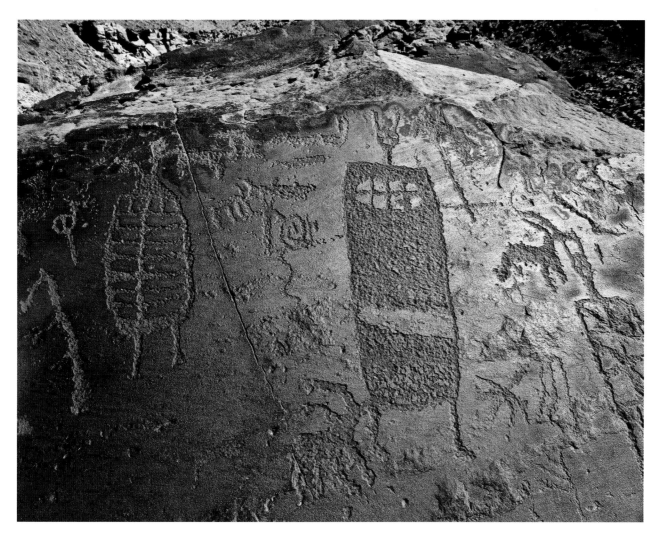

local group differentiation."[69] We can conjecture that in North America the long reign of abstract-geometric rock art would correlate with a relatively small population of hunter-gatherers in separate bands that were not required to compete with each other.

It is probably safe to assume, however, that the drastic break with long established noniconic imagery was the result of equally epochal innovations in the lifeway and worldview of the cultural groups responsible for the shift to representation.[70] Population explosion, less mobility, more permanent settlements, greater territoriality, the gradual adoption of agriculture, new ecological conditions due to climatological changes, environmental stresses, increasing aggression and competition for resources, and higher social complexity within bands are just some of the intertwined factors that may have contributed to the innovation and development of more localized rock art styles. Be that as it may, where before there was homogeneity throughout the American West in the form of a noniconic artistic tradition, we now find heterogeneity in a

5.27 Glen Canyon Linear Style life forms, Arizona

5.28 (*left*) Patterned-body anthropomorph from the Coso Range, California

5.29 (*top*) Barrier Canyon Style mix of life forms and geometrics, Utah

variety of regionally restricted "biocentric" styles sharing an emphasis on life forms, whose leitmotifs are full-bodied human and animal figures. Although detached geometric elements continue to be present at most sites, more often than not they are integrated into the bodies of animals and humans, which has led to the figures being labeled as patterned-body anthropomorphs and zoomorphs. Prominent among the "biocentric" bodies of rock art described in the literature are the Glen Canyon Linear (fig. 5.27),[71] Grand Canyon Polychrome,[72] Palavayu Anthropomorphic,[73] Coso Range (fig. 5.28),[74] Barrier Canyon (fig. 5.29),[75] Pahranagat,[76] Dinwoody,[77] and Pecos River[78] Styles.

PROTOICONIC FORERUNNERS IN THE WESTERN ARCHAIC TRADITION

Various authors have addressed the graphic vocabulary of Western Archaic Tradition paleoart and offered insightful tabulations and classifications of its most typical motif elements.[79] To my knowledge, however, none of them has recognized that early WAT imagery contains a number of simple figurative designs that gradually appear in the mix of abstract-geometrics, and thus may have functioned as "bridging" elements between noniconic and more fully developed iconic or representational art. I regard these elements as protoiconic precursors to full-fledged iconicity.

Among the elements most frequently observed in this role are animal and bird tracks, and human handprints and footprints.[80] Atlatl and vulva depictions could possibly also be regarded as protoiconic. However, because of their essentially stylized conceptualization, they can be considered part of the geometric repertoire. Atlatl portrayals typically feature a circle bisected by a straight line, and female genitalia are usually schematized by oval or (sub)triangular forms, as is also reflected in the term "pubic triangle."

Due to dating uncertainties and the lack of absolute dating methods, this "protoiconic hypothesis" is currently not scientifically testable but may be verified or falsified as rock art researchers pay greater attention to such images. For example, Australian archaeologist Ken Mulvaney is convinced that "a specific petroglyph tradition existed in arid central Australia, from around the late Pleistocene where track and simple geometric elements were produced, often forming an amalgam of images on large rock faces."[81] The hypothesis certainly must not be understood as endorsing a sort of "creative explosion" explanation. After all, the earlier noniconic markings were not *replaced* by iconic ones. What is very obvious, however, is that when looking at the broad spectrum of WAT rock art sites, a pattern with unprecedented or novel traits appears.

As has been described, earliest paleoart seems characteristically devoid of iconic markings over a long period of time. Yet within this framework of fundamentally stylistic continuity, a gradual emergence of protoiconic motifs becomes clearly apparent. This admixture of prefigurative motifs can thus be regarded as an inceptive or transitional step toward fully developed, two-dimensional iconicity that at different times in the American West replaces WAT-style imagery. Typically, subsequent representational art occurs together with abstract-geometric forms. Such a gradual trend from simple geometrics to greater graphic complexity centered on figurative images also seems to be borne out by recent dating results from Paleolithic cave art in Spain. With dates obtained by the uranium-series method, a red disk (40,800 years), a hand stencil (37,300 years), and a claviform-like symbol (35,600 years) "support the notion that the earliest expression of art in Western Europe was less concerned with animal depictions and characterized by red dots, disks, lines, and hand stencils."[82]

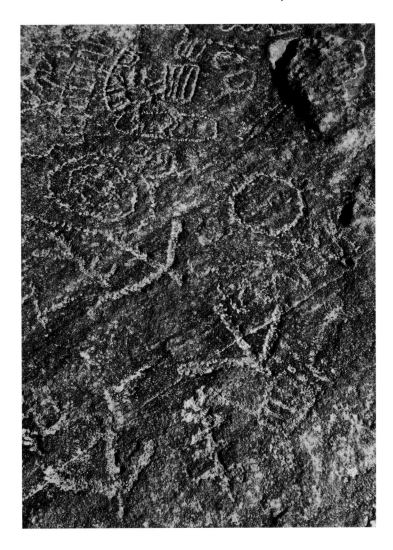

5.30 Trident-shaped bird tracks among abstract-geometrics, New Mexico

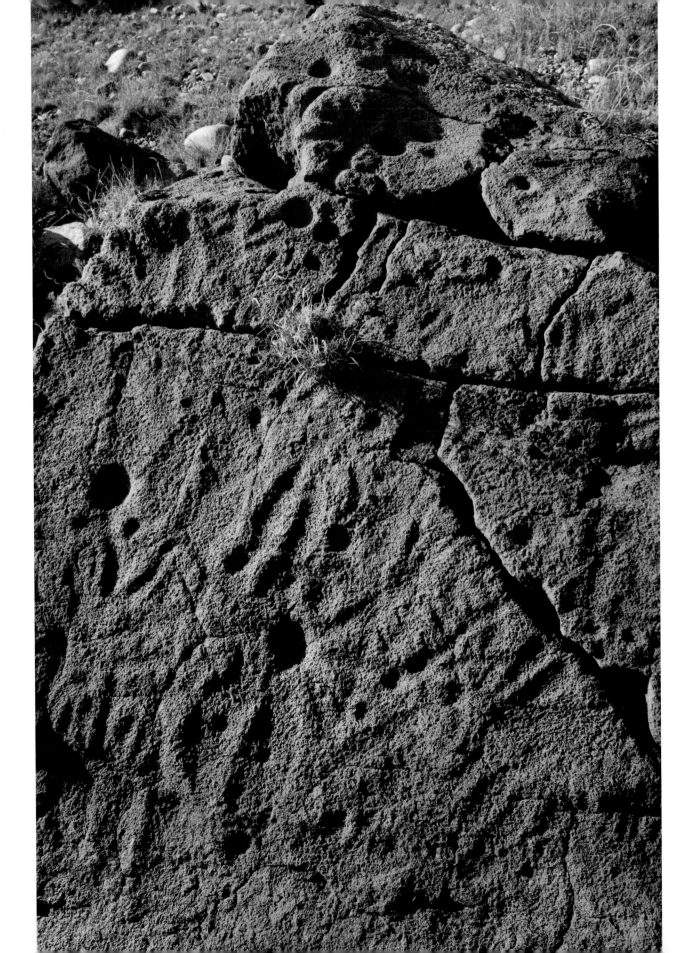

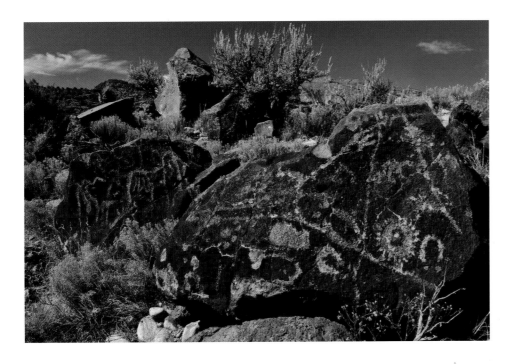

5.32 Admixture of abstracts and animal tracks, New Mexico

Prehistorian Jean Clottes has pointed out that, with the exception of cupules and abstract signs, hands, feet, and animal prints are among the most common depictions.[83] Animal tracks are especially prevalent, which makes sense considering that most parietal art anywhere was produced by hunter-gatherers for whom an ability to read animal tracks or "spoor" was important to survival. Animal tracks are essentially "indexical signs" with explicit visual resemblance.[84] Usually, their referential properties are such that the kind of animal whose track is depicted is easily identifiable.

Other scholars have made suggestions regarding the initial inspiration that motivated pictorial image-making. Derek Hodgson and Patricia Helvenston, in the context of hominin evolution, actually hypothesize that archaic humans, by initially scratching animal tracks in mud and sand and then later fixing them on rock surfaces in the form of paintings and engravings, "were already commandeering 'representation' . . . to gain advantage in the cut and thrust of survival."[85] Interdisciplinary scholar John Feliks has proposed that it was primarily through the examination of fossils that early hominins "came to understand the concept of 'imagery'" before they began to evolve graphic representation.[86] For example, by collecting shells, fossils, and quartz crystals, all featuring basic angles characteristic of the outspread hand, early humans discovered the "fan motif."[87]

One wonders, though, whether such finds could have been made often enough to develop this "abstract concept of convergent lines." It seems as likely, if not more so, that three-toed, trident-shaped bird tracks would have been plausible models for this scenario. Neuropsychologist John Bradshaw also is unconvinced that fossils were the

5.31 (*opposite*) Paired animal tracks, some with dewclaws, interspersed among numerous cupules and a serriform, New Mexico

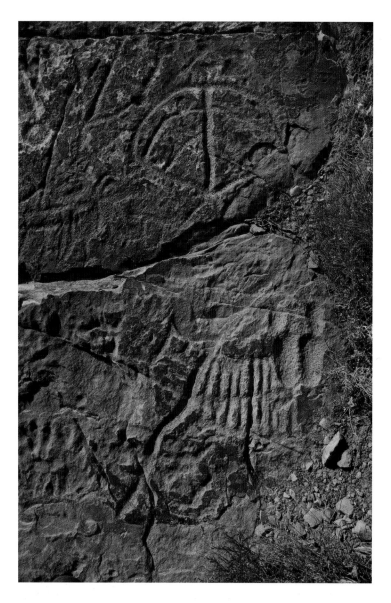

5.33 Animal hooves with dewclaws (extreme right) next to an array of geometric primitives, Utah

prime movers in stimulating the production of representational art.[88] He suggests that other patterns in nature such as tracks in sand would have been more influential. Not only do they occur naturally with much greater frequency than the just mentioned collectibles, but as hunters and trackers, early humans must have been keen observers of their own prints as well as those of animals, both predators and prey.

Tracks, indeed, may have played a significant role in the development of visual representation and cognitive evolution overall. It thus comes as no surprise that they occur integrated into Pleistocene paleoart of the American West. Alice Tratebas, for example, posits a Late Pleistocene age bracket of between 14,000 and 17,000 years for her so-called Hoofprint Tradition—distinguished by hoof prints, abraded grooves, vulvas, and bear paws—conceding nevertheless that "more research is needed to develop a better understanding of the age and longevity of these petroglyphs."[89]

None of the animal tracks so far discovered in WAT rock art appear to be indicative of extinct megafauna. The animals most frequently depicted in the sense of "the part standing for the whole" seem to be cloven-hoofed ungulates such as deer, wapiti (elk), pronghorn, mountain sheep, and bison. Even though tracks of these animals are not always identifiable with an absolute degree of confidence, a particular species can often be discerned from the rather naturalistic portrayal of its hoofprints. For example, deer and wapiti hoofprints display distinctive vestigial toes known as dewclaws, generally represented by two round points behind the twinned spoor. Pronghorn prints, on the other hand, lack dewclaws and overall are more pointed. Bison tracks seem to occur with and without the vestigial toes. They can generally be recognized by their cloven heart shape and they are also much rounder than those of other cloven-hoofed ungulates. Bear paws are easily identifiable due to their claw marks, as are the feline prints of mountain lion or cougar. Characteristically, their depictions feature a hemispherical central heel pad surrounded by four circular hollows indicating toes. Finally, most bird tracks seem to be species-indeterminate, usually consisting of linear trident-shaped designs, sometimes with the addition of a posterior spur.

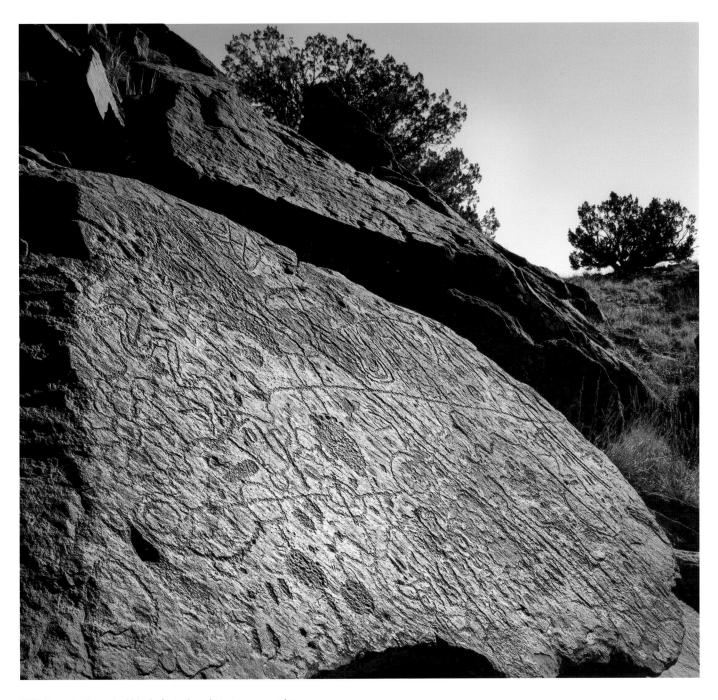

5.34 Densely decorated block, featuring abstract-geometrics
and animal tracks, New Mexico

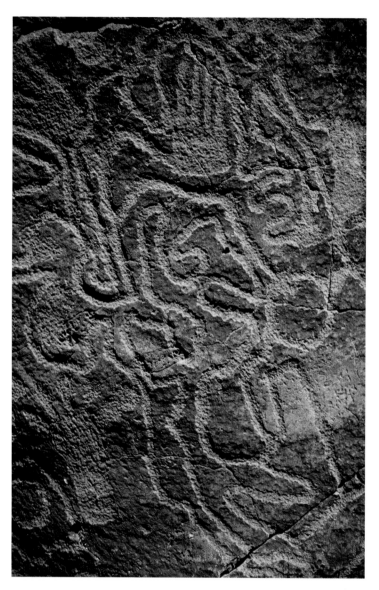

5.35 Handprint and footprint incorporated into a maze of erratic lines, Arizona

Ranking among the most frequently depicted rupestrian motifs on every continent, handprints and footprints are easily recognized and usually stand out quite vividly in assemblages of otherwise abstract-geometric paleoart. Obviously symbolic of humans, isolated examples of hands or feet are found early in WAT art and for this reason are considered here as protoiconic forerunners.

Interestingly, my observations of protoiconic elements at numerous WAT sites also seem to hold true for paleoart in other parts of the world. Thus, as shown elsewhere, a strong case for the early appearance of tracks can be made for Panaramitee and Karake Tradition petroglyphs in Australia as well as for rock art of the Pleistocene-Holocene boundary in South America.[90] For example, the unique engravings of the hooves of *Hippidion*, an extinct Ice Age horse, make the rock shelters of Piedra Museo in Patagonia one of the most significant rock art sites in the New World.[91] It is clear that without the support of reliable and independently verifiable dating, any proposition for elements bridging noniconicity and full iconicity must remain hypothetical. Still, whether or not the sequence for WAT paleoart proposed here will ultimately be proven, it is important to recognize that there is a limited but near-universal repertoire of the same representational motifs occurring in the context of early depictions of abstract designs.

ORIGINS AND FUNCTIONS OF ABSTRACT-GEOMETRIC MARKINGS

EKKEHART MALOTKI AND ELLEN DISSANAYAKE

WHEN PEOPLE SAY that face-to-face encounters with ancient rock art are compelling, even addictive, they are usually referring to representational images. As a number of archaeologists and other rock art scholars have noted, nonfigurative markings have been overlooked by researchers and the public alike—as meaningless scribbles, mere scratches or, at best, regrettably indecipherable and therefore not worth bothering with. Specifically with regard to Western Archaic Tradition (WAT) rock art, Ken Hedges resignedly admits that "so-called abstract art . . . has so far eluded stylistic analysis";[1] Paul Bahn sees its study as "one of the long-neglected challenges to archaeology";[2] Derek Hodgson reminds us that "early mark-making needs to be taken more seriously within a global context as an important index of early human cognitive ability";[3] and Solveig Turpin, noting the globalism of early abstract-geometric designs, intimates that it may be their very simplicity and consistent uniformity that makes them "the most ambiguous and difficult to interpret."[4] Archaeologists James Keyser and Michael Klassen reach a similar conclusion for the virtual nonexistence of published descriptions and analyses of Pecked Abstract Tradition rock art and blame it on "this tradition's formal simplicity and lack of representational motifs [that] make it so difficult to interpret."[5] While they specifically target the Northwestern Plains area, it is nevertheless seen by them as "part of [a] widespread Archaic period petroglyph tradition"—our WAT—"that extends across western North America from northern Mexico to the Great Basin and Great Plains regions of the United States."

It is not surprising that the more recent "realistic" and striking images of animals have received the most scholarly attention and stimulated the public imagination. Humans are born zoophiles. Biological anthropologist Pat Shipman actually suggests

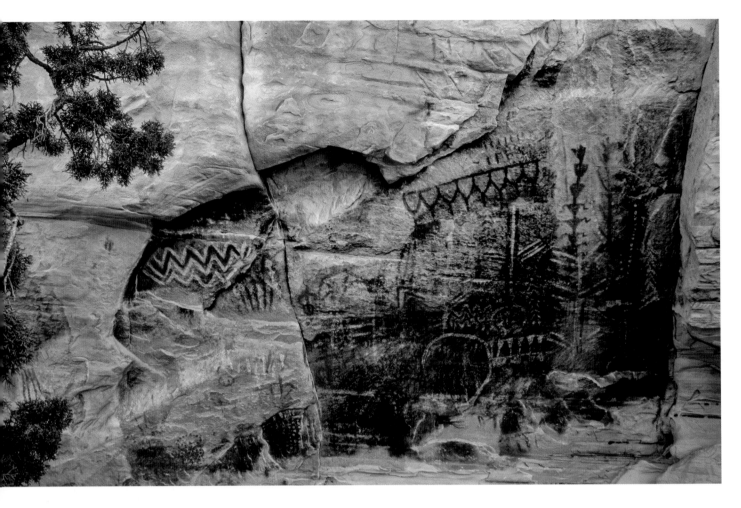

6.1 Sandstone alcove, rendered special with multicolored abstract ornamentation, Nevada

that a defining trait of the human species is our connection to animals, and that it is this connection that makes us truly human.[6] Children everywhere take a rapt and precocious interest in living creatures of any kind, from ants to elephants—even as pictures in books. They learn the words for dog, cat, horse, and other animals earlier (and presumably more easily) than for common but inanimate objects such as a chair or door, or even for noisy and conspicuous mechanical contrivances such as vacuum cleaners or lawn mowers. As adults, we continue to find the animate world fascinating. We keep pets, enjoy looking at them or at wild animals in zoos, and feel a vital connection. When we ourselves lived as wild animals—predators of some and prey of others—intense interest in their appearance and habits was a necessity.

Responses to the skilled naturalistic large animal paintings and engravings from the classic cave art of France and Cantabrian Spain build upon this inborn and essential fascination, especially when we discover that these images were made by people who lived tens of thousands of years ago but obviously must have been a lot like us. The images speak across the millennia, their unexpected beauty and intensity promising a signif-

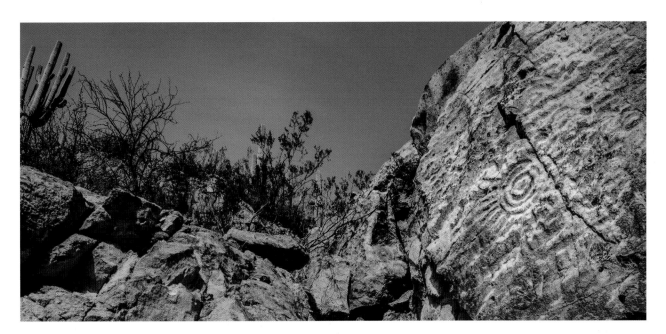

icance that many feel as spiritual—not simply a recording of likeness. In contrast, it is much more difficult to feel emotional connectedness to nonfigurative geometric signs or indeterminate marks[7] that resist interpretive insights—especially when compared to the artistically eloquent images of powerful, captivating animals.

In the late nineteenth and early twentieth century, Franz Boas, along with other German ethnologists,[8] addressed the question of whether the earliest art developed from realism to "conventionalism" (abstraction) or whether geometric designs existed first, with meaning "read into" them, after which was developed a more realistic form.[9] Although he was writing about "primitive ornaments" on artifacts—not rock art—Boas found evidence of both possibilities. He also claimed that pleasure was conveyed by "purely formal elements that were not primarily expressive of emotional states or ideas."[10]

Today we know that the oldest graphic marks on stone, everywhere in the world, are nonrepresentational—that is, roughly or indisputably geometric, "formal,"—"*abstract.*" But the question of why abstract-geometric marks came first remains an enigma, not solved by Boas's dated concepts. "Pleasure" is indicative of a positive "emotional state," and "ideas" can also give pleasure. Boas's thinking, like that of everyone including ourselves, was influenced by his time, when art was widely thought to give "aesthetic experiences" that had less to do with subject matter than with detached appreciation of formal elements.[11] Nevertheless, we find Boas's work to be inspiring for even mentioning the term "emotional states" that, along with "ideas," could motivate the earliest mark-making.

Despite the widely held assumption that the earliest marks conveyed "ideas" that were symbolic and cognitive, abstract-geometrics could just as well be approached as

being expressions of "emotional states"—that is, to have emotional motivation and meaning. The Boasian term is useful here for consideration of the artifications of our early ancestors, like those of all humans, as being motivated by a desire to make ordinary reality extraordinary, thereby showing that the mark (or its intended function) was of emotional (not only cognitive) importance to the maker.

EXPLANATORY THEORIES

Although several of the following theories were first formulated in the context of European Ice Age art, in some cases they can be or have also been applied to abstract-geometric markings that are the hallmark of WAT paleoart. None need be regarded as a mono-causal explanation for all rock art. As a class, noniconic signs have varied functions and a diversity of origins, even as their basic motivation is emotional. There is probably some truth in each of the explanatory models and, when appropriate, we briefly express our agreements and reservations about them. Two of the explanations—the neurovisual resonance hypothesis and the body-marking hypothesis—will be given more extensive treatment in their own subsections.

The Hunting Magic Hypothesis

Among the earliest researchers to comment on abstract markings in the European Ice Age was the French priest and archaeologist Abbé Henri Breuil, who, until his death in 1961, dominated the field of cave art interpretation and advocated what came to be known as the "hunting magic hypothesis."[12] Related to the concept of sympathetic or compulsive magic, Breuil's hypothesis proposes that, within the broadly conceived framework of religious belief, humans strive to attain certain desired results or events by ritually impersonating them, whether by acting them out dramatically, or, in the case of rock art, depicting them graphically. Based on the principle of "like begets like" and the notion that an image can stand as a substitute or proxy for its subject, the most obviously practical objective behind this magico-religious strategy was survival.

Impressed by the high degree of artistic excellence and sophistication evident in many of the depictions of Paleolithic animals, Breuil adopted the view that they were graphic attempts to magically ensure increase, fertility, and successful hunting of the animals under the harsh conditions of the Ice Age. When Breuil copied the animal depictions on site, he frequently filled in their missing parts. Upon encountering lines and other simple markings in the rock art that seemed to have no relevance to the animal outlines, he dismissed them as *traits parasites* ("parasitic strokes")[13] and consequently left them out "as if they had maliciously attached themselves to, or were infesting, otherwise intact and 'healthy' animals."[14] In line with the model of hunting magic, more complex geometric forms, or signs, as they were called, were interpreted literally as whatever hunting paraphernalia they most closely seemed to resemble. For example, so-called "claviforms" were seen as clubs, "tectiforms" as huts or traps, and

6.3 (*opposite*) Geometrically artified rock blocks on steep talus slope, Nevada

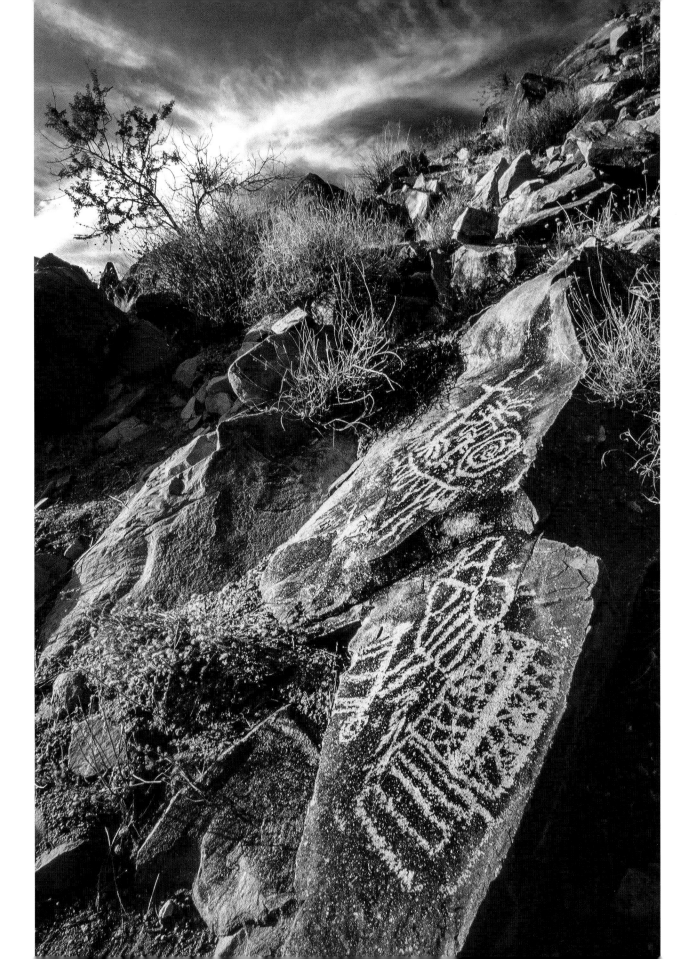

"penniforms" as darts or arrows. Other motifs were thought to be snares, nets, lassos, and so forth.[15]

The hunting magic hypothesis heavily influenced rock art research for the first half of the twentieth century and, although it was a theoretical product of a narrow concentration in the 1960s on primarily depictive European Ice Age art, it also caught on as the leading basis for the interpretation of hunter-gatherer art of the American West. Thus, Robert Heizer and Martin Baumhoff, relying largely on rock art locations in the Great Basin of Nevada and eastern California, claimed that the imagery, even including nonrepresentational geometric motifs, was found mainly along game migration routes, near hunting blinds and ambush spots.[16] Because these images were believed to have been created as a magical aid and sort of good luck charm in ensuring animal fertility and improving hunting success, the making of the imagery was seen as a form of ritual that served the ancient hunters as a fitting way of coping with the harshness of the desert West environment.

This general theory proved highly popular at first, with a number of subsequent archaeological studies seemingly providing support to the idea. Karen Nissen, for example, felt she had found "fairly clear evidence that at least some of the petroglyphs in the Great Basin are connected with hunting magic."[17] Archaeologists Henry Wallace and James Holmlund reported a concentration of noniconic glyphs "on an outcrop adjacent to possible hunting blinds and a natural setting suited to ambushing or trapping game animals in the Picacho Mountains."[18]

More recently, however, the hunting magic hypothesis has been seriously questioned as a satisfactory universal explanation for the origin and function of rock art.[19] Mary Ricks, for example, reports that a survey of some 20,000 engraved and painted elements at 117 rupestrian sites in the Warner Uplands of south-central Oregon showed no correlation between the rock art locations and critical game ranges, which appears to contradict the Heizer and Baumhoff observation that rock art is hunting-related.[20] The frequently made claim that rock art sites tend to be located in association with trails and hunting blinds is simply not borne out archaeologically. Many of the previously known and recently documented WAT sites actually exist in a clearly "domestic context":[21] that is, they are situated near dependable water sources and/or habitation sites, including both villages and temporary campsites. For this reason, Angus Quinlan and Alanah Woody reject hunting magic as a singular raison d'être.[22]

While the apparent validity of the hunting magic hypothesis increases dramatically when applied to figurative rock art showing game animals and actual hunting scenes,[23] the proposition that abstract-geometric markings could have been used to represent game animals or other hunting-related activities and objects—in a coded way that we are merely unable to decipher—can only be speculative. We therefore do not consider sympathetic hunting magic to be an overriding explanatory model for the origin of WAT-style paleoart.

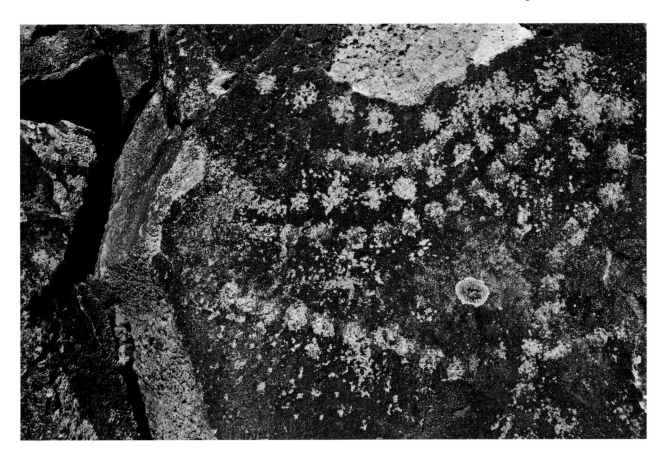

The Sexual Duality Hypothesis

6.4 Configured dots, Oregon

The interpretative stranglehold that the hunting magic hypothesis held over rock art research for nearly half a century was finally broken in the 1960s under the influence of structuralism, a radical new intellectual movement from France. The task of adapting its ideas to archaeology, and in particular to rock art, primarily fell to anthropologist and prehistoric archaeologist André Leroi-Gourhan, who offered an all-encompassing new scheme for the whole of European cave art. Premised on a binary, "structuralist" opposition of the sexes, it could be dubbed the "sexual duality hypothesis." He grouped the geometric signs that are of interest to us here into male (phallic) and female (vulvar) sets, which he later renamed "thin" (*signes minces*) and "full" (*signes pleins*) signs. In accordance with this presumed symbolism of sexual polarity, the category of male signs comprised single dots, rows of dots, short strokes, barbed elements, and hooked or spear-thrower signs. Those categorized as female included triangular, oval, quadrangular, and claviform signs. The same degree of arbitrariness and subjectivity that governed the structuralist approach was also evident in the choice of sexual roles that were assigned to the depicted animals. Thus, to Leroi-Gourhan, the horse represented

the male principle, the bison the female one. His student, Annette Laming-Emperaire,[24] on the other hand, arrived at exactly the opposite conclusion.[25] This dichotomy, then, was also correlated with the layout of the caves, with different signs applied to entrance, central, and end zones.

Not surprisingly, the structuralist perspective with its "Procrustean-bed" approach, which forced everything into a one-size-fits-all schema of gender polarity, did not gain wide acceptance. It certainly never caught on in North America. In the end, Leroi-Gourhan himself dropped his emphasis on sexual symbolism when he finally realized that the explanatory power of his theory was simply too subjective to survive the rigors of scientific debate.

The Notation Hypothesis

One of the most prominent critics of the structuralist approach was independent scholar Alexander Marshack. He found Leroi-Gourhan's comprehensive categorization of geometric signs into a structural duality evoking either maleness or femaleness "highly subjective and comparatively easy," because it required "nothing but the eye and the category."[26] Deploring the fact that, for the most part, nonrepresentational Paleolithic art had been neglected by prehistorians, he focused all his attention on its intellectual content, hoping that he might thereby arrive at an understanding of the evolutionary path of human cognition. As the subtitle of his landmark publication, *The Roots of Civilization: The Cognitive Beginnings of Man's First Art, Symbol and Notation*, indicates, one of his main interests was the cognitive phenomenon of "notation," which he studied primarily in the context of mobiliary art. He also introduced the concept of "time-factoring," which he defined as "processes of cognition and recognition, of planning, research, analysis, comparison and interpretation, [which] are also sequential, interrelated, developmental and cumulative."[27] Concentrating his analytical efforts, often aided by the microscope, on repetitive series of seemingly random and meaningless dots, lines, and notches, as well as configurations consisting of chevrons, spirals, crosshatchings, meanders, and other elemental markings, he found them to reflect complex processes of the human mind in the form of numerical and chronological systems and time-factored notation, such as lunar phases. Similar geometric designs in parietal art were equally interpreted by him to contain temporal significance, as is evident from his comments on a grouping of deeply incised grooves on a limestone block at Abri Pataud, France. The grooves, which he describes as "serpentine," were in his eyes symbols and signs of "time and periodicity."[28]

Marshack's "notation hypothesis," as we call it, has been rightly criticized for overinterpreting many artifacts, and for finding numerical and calendrical patterns where none exist,and his structuralist interpretations have been called "excessively numerological."[29] His search in the art for evidence of calendars, records of elapsed time, periodicities observed in nature, including the months and seasons, and the sequencing of events, can perhaps be attributed to the modern "left-brain" perspective, which is most com-

fortable with analysis of information, enumeration, mathematics, quantification, sequences, literacy, counting and calculating, record keeping, and recording of events.[30] Similar functional overinterpretations influenced by this kind of thinking are evident when researchers believe they recognize protowriting, maps, directional markers, and the recording of astronomical events such as supernovae in much of geometric paleoart.

6.5 Flat limestone outcrop, artified with cupules and geometric primitives, California

The Shamanistic Hypothesis

The 1988 publication in *Current Anthropology* of "The Signs of All Times" by South African scholar David Lewis-Williams and archaeologist Thomas Dowson marked the beginning of a novel provocative exegetic approach to paleoart, which claims biological universality based on neuroscientific studies of the brain. Relying specifically on theories derived from both shamanism and neuropsychology, the approach has become known as the shamanistic hypothesis or neuropsychological model. With regard to its neuropsychological component, the model is based on the premise that the *sapiens* nervous system is a biopsychological universal. Altered states of consciousness (ASCs) produced by it must therefore be universal and cross-culturally experienced because all *Homo sapiens* brains are essentially alike. Shamanism, in turn, regarded by scholars of religion as "the most ancient of humankind's religious, medical, and psychological disciplines,"[31] was widely seen to be most closely linked with hunter-gatherer

societies, including Paleoamerican bands who were thought to have brought with them to the New World this "*ur*-religion of all mankind."[32] In recognition that most studies of American rock art had been overly simplistic, some rock art researchers in this country also began to promote the idea that much of the art was "directly related to shamanistic beliefs and practices."[33]

Acting as liaison between this world and the spirit world—that is, as "brokers" and "boundary players"[34] between the realms of the sacred and the profane—shamans were believed to exploit the universally shared biopsychological phenomena of dreams, visions, trances, and hallucinations—all ASCs. Altered states were achieved through a wide variety of techniques, including overexposure to the elements, sensory deprivation, thirsting and fasting, rhythmic and sonic driving such as drumming or dancing, and pain induced by self-mutilation and self-torture such as bloodletting. In addition to these nonchemical methods, shamans were also known to induce powerful hallucinations through the use of psychoactive plants. By harnessing supernatural power from the spirit world in this manner, they would then carry out, on behalf of their groups, such tasks as healing the sick, influencing the weather, controlling game, assuring human, animal, and vegetal fertility, and restoring lost harmony.

Culturally sanctioned means for achieving ASCs, especially in the form of ritualized trance, were believed to be central to hunter-gatherer shamanism[35] and therefore to the entire neuropsychological model. These states are purported to unfold sequentially in three stages, each of which is directly linked to its own type of visionary imagery. As a rule, the initial stage, which is of paramount interest to us here, begins with geometric mental images that have also been called form constants[36] or phosphenes.[37] Lewis-Williams himself prefers to label them "entoptic phenomena," meaning that they were generated within the optic system of the brain. However, since the term "entoptic" (literally "within the eye," as used by neurologists and ophthalmologists) is generally limited in its application to visual phenomena within the eyeball itself and thus excludes the critical role of the visual cortex in the generation of geometric figures,[38] we avoid this nomenclature.

Phosphenic elements are perhaps best understood when characterized as "phantom geometrics seen in the mind's eye."[39] Among those most frequently identified in the initial stage of shamanistic trance are said to be six basic forms: grids, sets of parallel lines, dots and flecks, zigzags, nested catenary curves, and filigrees and meandering lines. These elements, in turn, are believed to be modified and mentally manipulated through several principles of perception into iconic forms as people move into the second and deeper stage of trance and attempt to inject sense into the visions from their storehouse of real-world experience. The visions ultimately take shape, in the third and deepest stage, as actual hallucinatory images, often of a fantastical nature. According to the proponents of the hypothesis, shamanic specialists, after emerging from their trance state, commemorated their visionary experiences by painting or engraving them on stable rock surfaces.

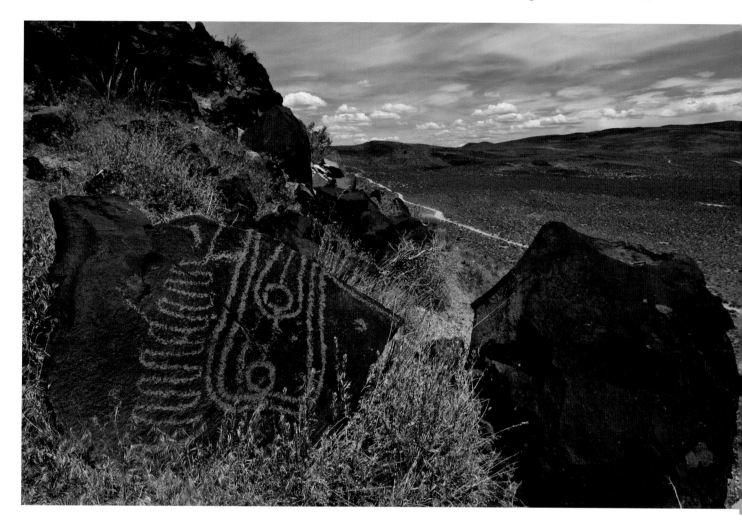

Archaeologist David Whitley, who had worked with Lewis-Williams in South Africa where the neuropsychological paradigm was developed, was among the first to transplant its seminal findings to the United States and has become the "most vociferous proponent of the shamanic interpretation in the United States."[40] Indeed, he "portrays shamanism as the basis for all historic and prehistoric rock art produced in California and the Great Basin."[41] Specifically, claiming ethnographic support for his assertions, he insists that in these parts of the West the "art was made *exclusively by shamans* [italics added]" to illustrate the supernatural events and experiences of their vision quests.[42] In a recent publication in which Whitley discusses the origin of religion and artistic creativity in the Paleolithic caves, he proposes that those responsible for the art were not just ordinary hallucinating shamans but mentally ill shamans who suffered from a particular manic-depressive disorder, bipolar illness, which he refers to as "shamans' disease."[43] Neuropsychologist Patricia Helvenston considers this hypothesis "far-fetched from a scientific viewpoint" and essentially assigns it to the realm of "pseudoscience."[44]

After its introduction into the United States, the idea that most rock art could be attributed to vision quests or quests for power was soon embraced by numerous researchers. Indeed, many saw the model as the "rupestrian Rosetta stone" and the key to "breaking the rock art code." Polly Schaafsma, for instance, found a generalized shamanistic framework "the most useful model" for better understanding the Barrier Canyon and the San Juan Anthropomorphic Styles within the confines of the Colorado Plateau.[45] In similar fashion, Solveig Turpin argued that many of the Pecos River Style pictographs (fig. 6.7) reflected mental imagery resulting from shamanistic trance or ASCs.[46] Specifically, in regard to phosphene-based WAT iconography, she stated that geometric or abstract designs "are produced in the human brain as a result of physiological rather than cultural factors . . . and are thus common to all of humankind across space and through time. Because they are often engendered during trance state [they] form the bridge between rock art and religious belief, elevating the art to the status of ritual communication, even if it can no longer be understood."[47]

Hedges and Hamann are convinced that certain New World aboriginal groups incorporated trance imagery into their design systems, which makes the "visionary image hypothesis . . . a plausible framework for interpretation of the varied non-figurative forms."[48] James Keyser and Michael Klassen also subscribe to this explanatory hypothesis when they suggest that the strange and entirely nonrepresentational forms of Pecked Abstract Tradition rock art (found throughout much of the southwestern United States) "are the vision imagery of ancient shamans."[49] Ekkehart's research in the Palavayu region of east-central Arizona was heavily influenced by the model.[50] Much of its iconography—a plethora of geometric designs, anthropomorphs with patterned or "skeletonized" bodies, depictions of animal spirit helpers and magical flight, an array of power objects, human/animal (therianthropic) figures, and other fantastic motifs—appeared to perfectly match the paradigm of trance signifiers and visionary hallucinations that typically originate from altered states of consciousness.

Understandably, the shamanistic hypothesis, which has been applied all over the world as the most plausible blanket explanation for the universality of much early prehistoric art, has been subject to growing criticism since its inception.[51] Prehistoric specialist Jean-Loïc Le Quellec, for example, makes the point that there is no compelling reason to associate such basic graphic elements as dots, zigzags, grids, and parallel lines with trance. Indeed, in his view, deducing from one of these simplistic drawings "that its author produced it in a state of trance, or in remembrance of that state, is an operation which, in the absence of the artist's testimony, comes close to divination."[52] In particular, Patricia Helvenston and Paul Bahn have severely taken issue with what they call the Three-Stages-of-Trance model.[53] They refute its application to Upper Paleolithic cave art, claiming that the model is compatible only with hallucinations produced by ingesting mescaline, LSD, and psilocybin. According to their findings, none of these psychotropic substances was ever available in the Old World. Therefore, they insist "that the entire rationale for trance-inspired Paleolithic cave art in Europe

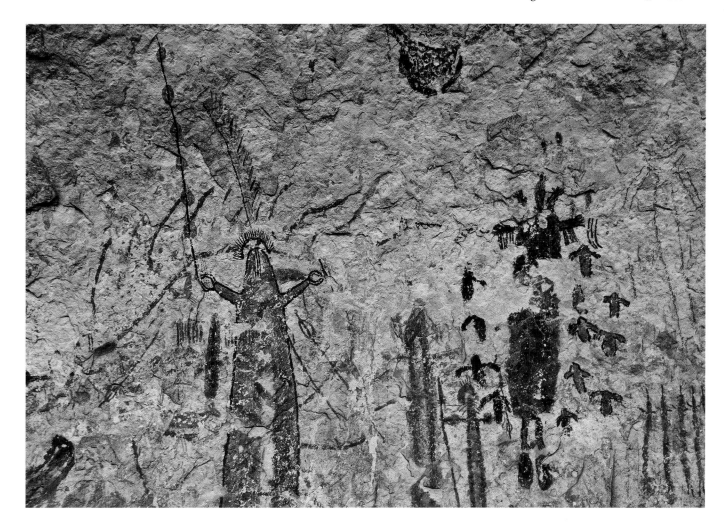

collapses."[54] As a result of this massive criticism, many researchers have begun either to question the validity of the hypothesis as an all-encompassing explanatory key of rupestrian art or to reject it altogether.

More recently, cognitive scientist Tom Froese and colleagues have made renewed efforts to resurrect and uphold the validity of the neuropsychological model.[55] Convinced that shamanic practices played a role in the initial process of developing "abstract imagination,"[56] they argue that ASCs were instrumental in bringing about the origin of abstract art. Derek Hodgson has challenged these arguments.[57] In his view, abnormal states of consciousness "are neither necessary nor essential to understanding the universality of geometric art." He, instead, refers to his own neurovisual resonance hypothesis (described below) which, as a neuromechanical scenario grounded in the neural architecture of the visual cortex, better explains abstract-geometric patterns of early paleoart and, moreover, has the advantage of being rooted in normal rather than abnormal perceptual experience.

6.7 Pecos River Style representational pictographs, Texas

We readily concede that ASCs as emphasized in the shamanistic hypothesis could have played a role in the creation of some prehistoric art, although not in the rigid three-tiered fashion first proposed by Lewis-Williams. We find this hypothesis most useful when it comes to analyzing imagery distinguished by surrealistic and fantastical motifs as they occur in several of the "biocentric" styles in the American West (fig. 6.8).[58] Such imagery could certainly have been inspired by trance, dreams, visions, and hallucinations, although it has been pointed out that simple human imagination "is an entirely sufficient condition of everyday consciousness to evoke the same content of image as hallucination."[59]

However, we no longer accept the reductionist model's theoretical tenets in accounting for the origins and worldwide prevalence of early geometric paleoart. It is simply unthinkable that all the oldest noniconic art, so globally uniform for hundreds of thousands of years, was solely derived from abnormal subjective states such as those experienced by trancing shamans. A crucial weakness of the hypothesis is that it does not explain why indigenous groups that do not practice shamanism or engage in exotic ASCs have the same geometric motifs occurring in their art. Nor is there any way of differentiating elemental noniconic motifs resulting from changed consciousness from those appearing in nonshamanistically oriented cultures.[60]

Another serious flaw in this model is the fact that phosphenic designs appear to be the universal building blocks in the art of young children.[61] Developmental psychologist of art and painter Sylvia Fein has pointed out that children, up to the age of four or so, draw not what they see but what they know, with an "orderly growing complexity,"[62] an observation that should not be surprising if the motifs are "hard-wired" into the brain. Nor is altered consciousness necessary to explain the often-geometric doodling behavior of grown-ups. As a product of mild absent-mindedness, these abstract markings, too, are the product of the visual and motor areas of the brain. Ben Watson, for example, in an analysis of contemporary doodling samples, found that among their recurring elements are elementary geometric forms such as straight parallel lines, circles and concentric circles, arcs, radial figures, and so forth, which he suggests are best explained as having their origin in the human nervous system and the structuring of the visual brain.[63]

Why must there be just one physiological source for the abstract forms that we see in early rupestrian art? Nontrance-related causes such as physical exhaustion, sensory deprivation, sleeplessness, hypnagogia, extreme pain, and certain pathological conditions such as schizophrenia, seizures, or fever deliriums could also have induced phosphenic designs. Neurologist Oliver Sacks, in commenting on hallucinations as an essential part of the human condition, offers experimental data on the occurrence of simple geometric hallucinations during classical migraine attacks.[64] Such elementary geometric forms, he suggests, arise from "the very architecture of the brain's visual systems" and in this way constitute "physiological universals of human experience." Noting the prevalence of migraine-like patterns in the art and architecture of "virtually every culture, going back

6.8 (*opposite*) Palavayu Anthropomorphic Style figurative petroglyphs, Arizona

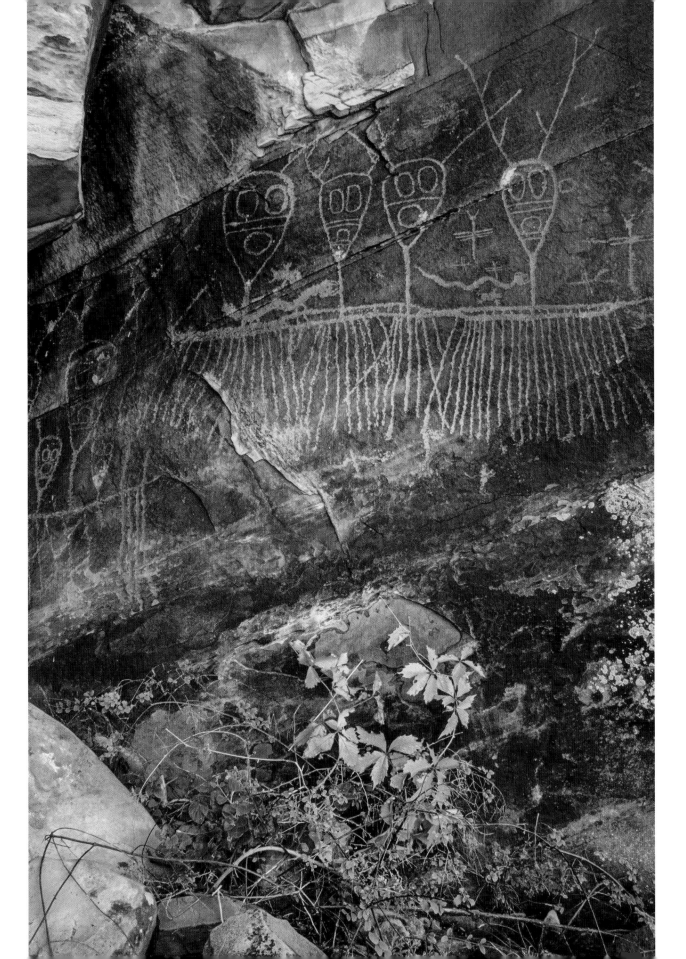

tens of thousands of years," he puts forth the possibility that these universal patterns "provide us with our first intimations of formal beauty."[65] Wallace points out that while many of the designs may actually have originated in shamanic visions, they might have been subsequently replicated by individuals who had nothing to do with shamanism.[66] He further decries the fact that the terms "shaman," "shamanism," and "shamanistic" have been overused and loosely applied in the rock art literature, with little regard for definition. If the terminology is too loosely applied, calling rock art "shamanistic" becomes almost meaningless.[67]

Finally, in light of the fact that almost the entire noniconic design repertoire of WAT paleoart mimics "hard-wired" mental images arising from the universal human nervous system, there is no need to invoke a one-size-fits-all explanatory model grounded in shamanic trance or drug-induced hallucinatory visual experience. Considering the shamanistic model with its postulated three progressive phases (or "stages") of mental imagery as the prime underlying source and mechanism for WAT-type imagery is unwarranted.

The Protowriting Hypothesis

Throughout the rock art literature one frequently encounters the notion that, in one way or another, rupestrian markings were precursors to formal writing systems, what British linguist David Diringer has described as "embryonic writing."[68] James Harrod, for example, in trying to shed light on why hominin artists around the globe used nonfigurative, phosphenic signs, argues that a subset of such signs, at least in Upper Paleolithic Magdalenian times, may have constituted a "protolanguage." In his opinion, "phosphenes were used in art because they were 'good to think.' They could be organized into a conceptual logic and thence into a protolanguage."[69] Reminiscent of (though without reference to) Leroi-Gourhan's basic ideas described earlier, Harrod suggests that geometric marking motifs are iconic rather than noniconic, that they belong to a system of juxtapositions and pairings, and that they have multiple levels of signification. Proposing an innovative hypothesis based on the perceived organization of the signs, he claims not only to have identified a core set of geometric signs that appear to be elements of a "protolanguage," but also to have derived a portion of their possible semantic content.

From a linguistic standpoint, it should be pointed out that employing the term "protolanguage" for such a hypothesized writing system is erroneous, in that "language" is something that is spoken. If anything, the claim should be for "protoscript" or perhaps "prewriting." Paul Bahn, asserting that rock art "was clearly a means of recording and transmitting information," uses the more felicitous term "protowriting," adding, however, that "it was not true writing, which must have a grammar, a word order and a direct relationship to spoken language."[70]

More recently, the supposition that some of the earliest known geometric markings in the world may have functioned as a sort of "rudimentary language system"[71] again

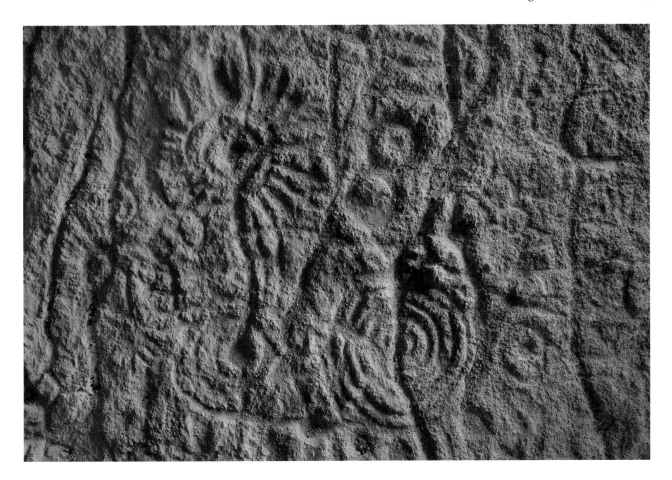

6.9 Evocative dot-centered designs, Nevada

uses the word "language" inappropriately. One should say "writing system," because in the Upper Paleolithic, people were able to speak. In a comprehensive analysis of geometric motifs from 153 cave sites in France, archaeologist April Nowell's student and colleague Genevieve von Petzinger concludes that a specific set of twenty-six such nonfigurative motifs (including circles, squares, dots, lines, and ovals, as well as comb-, fan-, ladder-, cross- and kidney-shaped elements) "demonstrates large-scale networks of symbolic knowledge and diffusion" that remained significant to Late Stone Age hunter-gatherers for the entire duration of the Upper Paleolithic.[72] According to her, repeated use of the same geometric symbols across time and space suggests that they may have had "an underlying meaning that was shared or understood amongst the early modern humans engaging in this behavior."[73] Indeed, since nineteen of the twenty-six signs are already found in the Aurignacian period (35,000 to 28,000 BP), von Petzinger believes that her findings support the argument "that this symboling behavior had a place of origin outside of Europe, and was already a cognitive capacity at the time of the initial out-migrations from Africa."[74]

In extending her research to the entire world, she offers a "Worldwide Geometrics Signs Chart" and suggests the possibility that geometric markings may have consti-

tuted a sort of "written code" that functioned as symbolic communication among early humans.[75]

We, however, consider it inconceivable that the creators of such an allegedly consistent code, 15,000, 10,000, or even 5,000 years apart, could have adhered to it for the entire span of the Upper Paleolithic. As Derek Hodgson has pointed out, symbolic culture always undergoes change, often quite rapidly, even if there is an obvious tradition involved.[76] This is vividly exemplified by the vast differences in writing systems that have come about in the relatively short time since pictographic writing was first invented some 5,000 years or so ago. Thus, the universal occurrence of geometric symbols throughout space and time—as well as their appearance in the earliest drawing attempts of children and the doodling behavior of adults—is not a matter of intentionally mediated linguistic and symbolic behavior but is best explained by the workings of the primary visual cortex as shown by neuroscience and vision research.

Distinguished semiotician Paul Bouissac, long-time critic of rock art scholars who have shown overwhelming preference for realistically rendered animals and humans over geometric designs that are difficult to interpret, feels that "the script-hypothesis," as he refers to the protowriting claim, has been excluded by them a priori.[77] He offers a "semiotic hypothesis" according to which "the earliest humans' elaborate traces are texts in the literal rather than metaphoric sense."[78] Indeed, in discussing the archaeology of writing, he believes the script-hypothesis to be as worthy of attention from a heuristic point of view as any of the other interpretive hypotheses for explaining the existence of geometric marks.[79]

While the idea could certainly be entertained that some geometric items reflect formal arrangements expected of a script, proving it would be another matter. The sheer impossibility of connecting some of the paleomarks to a particular language is vividly illuminated by a modeling exercise offered by evolutionary linguist Mark Pagel on the total number of languages ever spoken. According to this model, assuming that humans began speaking 200,000 years ago, and languages evolved at a rate of one per 500 years, there have probably been at least half a million different tongues. Halving the origin time to 100,000 years and postulating one language per 1,000 years still amounts to about 130,000 different languages ever heard on Earth.[80]

All known human writing systems were invented to mechanically store information that could be retrieved later and used at any time by anyone capable of consulting and decoding it. As such, they are essentially speech surrogates: that is, they are based on the sounds of actual spoken language and differ strategically according to the size of the speech unit captured by the written symbol. In the logographic approach used by the Chinese, ancient Egyptians, and Sumerians, an entire word or other meaningful unit is represented by a grapheme (picture or symbol). The thousands of symbols needed in such a system are drastically reduced when syllables rather than words are chosen, a graphic method found in Japanese and Cherokee, among many other languages. The most economical approach, finally, is the alphabetic one that focuses on

the phonemes or functional sounds of a given language. Since the average language possesses between forty and fifty functional sounds, the number of graphemes becomes quite manageable. Thus, English succeeds in representing all of its forty-odd functional sounds with a mere twenty-six letters, although some of these need to be grouped in digraphs.

Obviously, prehistoric rock engravings or paintings do not meet the criteria for a consistent system of writing sounds. Neither words, nor syllables, nor functional sounds underlie arrays of parietal art symbols in any orderly fashion. Thus, although in popular parlance rock art is occasionally referred to as "rock writing," ancient petroglyphs and pictographs are by their very nature dead-end signs that cannot be decoded. Likening assemblages of phosphenic/geometric markings to a primitive script is unwarranted. They are simply too random and diverse to meet the stringent consistency required of a true writing system, and no one has ever succeeded in transcribing them into a specific language.

6.10 Complicated amalgam of polychrome geometrics, some superimposed, Utah

By the same token, the occasional claim that rock art is intrinsically not so much an artistic expression as it is a form of communication anchored in sign language must be rejected as erroneous. Manual sign languages are as natural as spoken languages, with their own phonological, morphological, and syntactic rules. For example, while speakers of North America, Great Britain, and Australia all share a common oral language, their respective signing systems are mutually unintelligible.[81] It is inconceivable that rock art symbols, many thousands of years old, would have remained stable enough to serve humans of diverse cultural affiliations over many generations as a sort of universal graphic *lingua franca* that should now be amenable to interpretation by the modern investigator.

To conclude our thoughts on the protowriting hypothesis, we should point out that while most serious scholars reject the notion that abstract-geometric paleomarks are a form of writing in the sense of representing actual speech, some nevertheless believe that the millions of rupestrian motifs encountered throughout the world may have functioned as so-called exograms: that is, external symbolic devices capable of storing cultural information.[82] Acting as graphic memory enhancers, they may indeed have held the ideological worldviews, religious beliefs, and everyday hopes, wishes, and concerns of ancestral, preliterate peoples. Unfortunately, due to the abstract nature of most early paleoart, we will never be privy to their specific content.

The Imitation of Accidental Scratch-Making Hypothesis

Adding to the panoply of proposed explanations for the intentional making of noniconic markings, Derek Hodgson has raised the possibility that some of the earliest geometric marks, like simple lines and other graphic primitives, may have been imitative of

random, nonpurposeful scratches or cut-marks resulting from the process of defleshing bones, fashioning tools, or procuring ocher.[83] He bases this reasonable suggestion on the fact that these mundane activities involved repetitive actions that would have "accidentally assumed the configuration of a regular pattern" and therefore could have taken on significance for their makers.[84]

The Inspiration from Fossils and Natural Forms Hypothesis

Rejecting the popular claim that geometric shapes have no readily visible models in the physical world, John Feliks suggests that abstract paleosigns—ranging from simple geometric primitives such as dots, lines, arcs, circles, triangles, and spirals to more complex groupings of such elements—could represent common fossils.[85] Indeed, he finds visual "compatibility" between the geometric imagery of fossils from the natural, physical world and similar phosphenic designs generated by the inner world of the visual brain.[86] In his view, it is more reasonable to consider that inspirations for rock art came from physical images such as fossils than from fleeting neurological phenomena like phosphenes. Derek Hodgson also believes that early hominins would have noticed repetitive or patterned geometric forms occurring in the natural environment, such as ripples in water, rainbows, crystals, honeycombs, and rock strata.[87]

The Auroral Hypothesis

The search for a global inspiration for the production of nonfigurative rock markings has led several physicists to formulate an unusual and rather abstruse proposition. As early as 1976, astrophysicist George Siscoe suggested that moving displays of color spanning the entire sky, familiar to many as Northern Lights (aurora borealis) or Southern Lights (aurora australis), could have given rise to certain "seemingly meaningless doodles" such as the "serpentine meanders or 'macaronis' found on rocks, in habitation sites, and on cave walls from Cro-Magnon times."[88]

While it is easily conceivable that macaroni-shaped finger flutings found in the prehistoric cave art of Europe and Australia may have been the outcome of casual, playful doodling behavior—such as running one's fingertips over soft, pasty, or clayey mondmilch deposits, which leaves instant markings—the same behavior cannot account for carefully graven or painted rock art. Pecking, abrading, or pounding out a petroglyph while a person is absent-mindedly preoccupied is not a feasible manufacturing approach. Engraving even a simple line on hard rock with a hammerstone requires focused attention and controlled hand-eye coordination. Watson's proposition that some paleoart could be the direct result of spontaneous doodling[89] may be acceptable for some scratched designs or paint splatters, but not for deliberate rupestrian engravings.

More recently, American physicist Anthony Peratt of the Los Alamos National Laboratory, New Mexico, has been the prime proponent of the auroral hypothesis. According to him, many of the enigmatic, abstract-geometric shapes in rock art might actually

be "visual representations of intense auroral storms."[90] Laboratory experiments supposedly demonstrate clearly a morphological resemblance between noniconic petroglyphs and the instabilities of high-energy plasma discharges.[91] Millennia in the past, such super solar storms would have produced extremely intense, long-lasting auroras visible for decades, and not just for hours as is usually the case today, thereby likely imprinting themselves on the human mind and facilitating their reproduction on rock surfaces.

6.11 Abstract doodles, all created by the author during conversations on landline telephone

Inspiration for archetypal mark-making can certainly be found in a multitude of sources, in the repetitive ripples of a sand dune or the spiral form of a snail shell, for example. To simply compare marks to the shapes of auroral events or other natural phenomena, without even considering such evidence as neurological constants, strikes us as a futile exercise. One wonders how the just-mentioned authors would explain the fact that children create geometric motifs spontaneously before they draw figuratively, or why noniconics figure so prominently in adult doodling behavior (fig. 6.11). We certainly do not advocate attributing the origin of mark-making to a single narrowly defined paradigm, but are willing to accept multiple working hypotheses. As it stands, however, the auroral hypothesis strikes us as bordering on tabloid archaeology. Equally acceptable, in our opinion, is the Northern Paiute explanation that the millennia-old WAT-type petroglyphs in the Grimes Point area near Fallon, Nevada, were the work of the trickster personage Coyote. Known as *Iza'a tɨ bonnu*, "Coyote's writings," in the Paiute language, they were said to have been created at "The Time When Animals Were People."[92]

In addition to these eight explanations for the origin and function of abstract-geometric rock markings, three others are plausible, although with modifications or additions to the formulations of their authors.

The Phosphene Theory

On the question of art origins, Robert Bednarik has formulated a hypothesis that is grounded in the observation that worldwide, all earliest paleoart is surprisingly uniform in its repertoire of geometric markings, which show striking resemblance to a rather restricted suite of motif types called phosphenes.[93] Sometimes also referred to as "psychograms,"[94] "primitives,"[95] "visual archetypes,"[96] or "entoptic phenomena,"[97] phosphenes, as a biological phenomenon generated in the visual brain, are self-generating light phenomena without the need for an external light source, "ranging from simple elements and points of colored light to complex, constantly changing kaleidoscopic patterns."[98] They can be experienced by all human beings, including the blind, provided

Arcs

Radials

Waves

Lines

Combined figures

Circles

Multiple figures

Odd figures

Quadrangles

Spirals

"Poles"

Lattices

Triangles

Fingers

"Cherries"

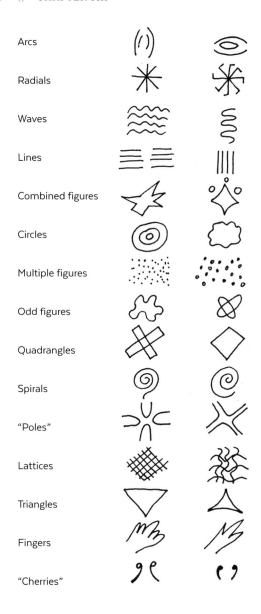

6.12 The fifteen standard phosphene designs, listed in order of frequency. *Redrawn by Julia Andratschke from Kellogg et al. (1965:1129).*

they had prior visual experience.[99] Apart from artificial stimuli (e.g., acoustic, optical, mechanical, electrical, magnetic), they can be induced by a variety of natural means: blows to the head, sensory (visual) deprivation, fatigue or sleep deprivation and fasting, hyperventilation, meditation and intense concentration, migraine headaches, various medical conditions such as eye disease, the ingestion of hallucinatory drugs, and even pressure applied to the closed eye.

The forms taken by these phenomena are restricted to a limited repertoire of shapes—fifteen standard types, by one account[100]—and their occurrence appears to be unaffected by cultural conditioning and individual (ontogenetic) and species (phylogenetic) development.[101] According to esteemed researcher on child development Rhoda Kellogg and colleagues, this set of basic graphic elements (fig. 6.12) also directs the scribblings of children three to four years of age, before they begin to draw figuratively.[102] The phosphene explanation is further corroborated by the doodling behavior of adults who, in their repetitive "subconscious" scribblings, heavily rely on phosphenic shapes. Due to its global ubiquity, the elemental repertoire of the visual arts, consisting of arcs, dots, grids, circles, triangles, sets of parallel lines, radials, spirals, meanders, and squiggles, in an infinite variety of arrangements and constructions, seems to indicate "a kind of universal, innate visual grammar."[103]

Central to Bednarik's theory is his belief that humans can experience phosphenes and, under certain conditions, are disposed to "externalize" or copy them. He admits, however, that the mechanism connecting them with the act of mark-making cannot currently be determined. In comparing the fifteen standard forms proposed by Kellogg and associates with the motif ranges of various bodies of paleoart in the world, he concludes that the more frequently a phosphene type occurs in parietal art, the more archaic it is.[104] Finally, he claims that his phosphene theory is the only one that is falsifiable and therefore the most scientific hypothesis to account for the advent of paleoart, because no evidence disproving the theory has yet been discovered.[105] Bednarik holds that his hypothesis would be significantly weakened only "by the discovery of a major art body of nonphosphenic marks predating the introduction of two-dimensional iconic art.[106]

The Neurovisual Resonance Theory

The neurovisual resonance theory, developed by neuroarchaeologist Derek Hodgson as a critical alternative to David Lewis-Williams's proposition for the shamanic trance

origin of geometric art, is based on the premise of "hard-wired" human neurobiology.[107] While concurring with Bednarik's phosphene theory on the universality of geometric marks and the fact that worldwide they considerably predate representational images, it nevertheless takes issue with Bednarik's proposition that it was conscious awareness and the *experience* of phosphenes that disposed early humans to copy them as "abstract primitives." In Hodgson's view, because phosphenes are insubstantial, fleeting, and experienced in extreme psychological states, it seems unlikely that they provided the original stimulus for any graphic marks. He thus rejects the "externalization" aspect of phosphene theory as proposed by Bednarik and regards phosphenes and altered states of consciousness, both of which are experienced subjectively, as side issues that mainly serve as indicators of how the visual cortex of the brain works in "the process of assembling the visual image itself."[108]

According to Hodgson, after the eye's retina, the first major area involved in processing incoming visual information is the primary visual cortex (V1), an area that experimentally has been shown to be particularly devoted to dealing with the most basic kinds of visual information, such as simple or repeated lines, zigzags, grids, various closed forms that employ angles, and dots.[109] The visual system seeks them out because they are instrumental in recognizing and identifying the existence of solid objects in the world. In the next major area (V2), lines are assembled to make more coherent shapes. Processing beyond this point is given over to more sophisticated and developed aspects of visual perception, such as separating an image from its background, providing color, movement, and so forth.[110] Graphic or form primitives, therefore, have special status for the brain. Indeed, as Hodgson emphasizes, "without them the perception of actual objects would not be possible. Thus, when the brain builds up a 'picture' of the world, it begins by assembling the basic marks in a way similar to that of an artist who builds up form in a painting by starting with more elemental forms."[111]

The thought, then, is that archetypal geometric shapes and patterns are naturally appealing to human beings and can evoke strong visual as well as emotional responses because they were built into the primate brain millions of years ago: that is, they have become an integral feature of the neural structuring shared by all normal humans. The early visual cortex responds or "resonates" when such forms are made or perceived because of its very morphology, which is why the theory is known as "neurovisual resonance." Because they are its building blocks, abstract marks mirror the functioning of the visual cortex.[112] These "default aesthetic biases both stimulate and simulate how the early visual cortex functions."[113] Hence there is no need for an artifier to experience phosphenes. Rather, it is the marks themselves that hyperstimulate the early visual cortex through a sort of feedback mechanism and provide the stimulus for making such marks.

From an evolutionary perspective, therefore, it makes sense that phosphenic marks should appear earlier than representational designs in our graphic repertoire.[114] The innate human tendency toward responding to and creating abstract-geometric forms is

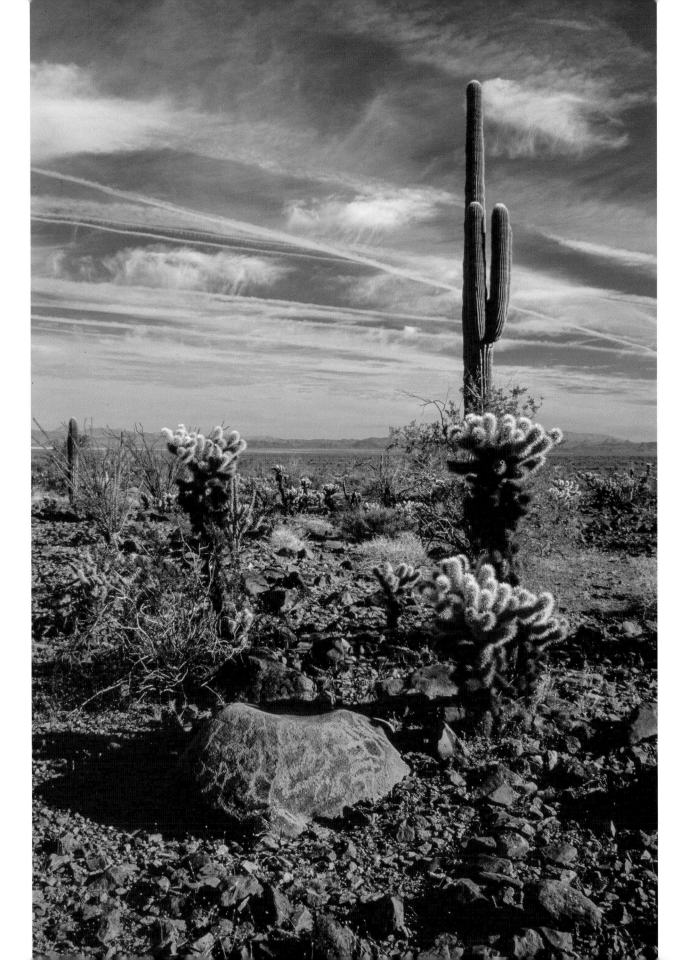

consistent with the fact that children draw simple geometric primitives before making representational drawings. It also accounts for the apparent paradox that, archaeologically, nonrepresentational motifs predate the depiction of natural objects. Logically, one would expect that archaic humans would have tried to depict natural objects because they were readily available in their environment. Geometric shapes, on the other hand, are relatively rare in the natural world and not part of everyday experience. However, because they are an inherent feature of the functional organization of the visual brain, they appeal to humans and so, according to Hodgson, would come to connote what was safe, secure, and understood; provide order in the midst of disorder; and express a sense of pattern and harmony in the midst of the chaos and confusion of nature.[115]

We find Hodgson's theory to be plausible, with a few amendments. By privileging passive visual perception, his hypothesis overlooks the important role of *movement* in mark-making[116] and the motor-neural constraints on *making* marks.[117] Lines, meanders, and circles mimic the types of continuous movements our arms can make, as shown in children's earliest mark-making where the whole arm is involved and the crayon does not leave the drawing surface. Making repeated dots, with the hand knocking the crayon against the surface, is another kind of motor movement that provides practice and the pleasure of having an effect on the world. Although the movement of drawing on paper (or mud, sand, or skin) is obviously different from incising marks into stone, from a purely kinesiological perspective, geometrics are easier to create than figurative art. Cognitively, also, it is more difficult to translate a three-dimensional representational image to a two-dimensional surface. There are not only visual but motor and cognitive reasons for geometrics coming first.

Hodgson's scheme receives support from a contrast between Pleistocene and modern environments. Pleistocene environments were not "carpentered" as are the built environments that in the modern world offer omnipresent horizontals, verticals, diagonals, and other geometrizations. In a Pleistocene environment, human-made marks would be distinctive. However, other primates develop perceptual acuity to deal with their visual and spatial worlds without additional exercise of their sensory apparatus.

Unlike the other described hypotheses, the neurovisual resonance hypothesis offers possible evolutionarily adaptive reasons that making and perceiving geometric marks would be appealing. In the first place, it suggests proximate satisfactions (why people would originally begin to do it), either as a kind of emotionally rewarding cognitive and manual play or as providing a feeling of cognitive order and hence "safety" and "security." Second, it has ultimate adaptive plausibility: reinforcing visual and hence survival-related behavioral responses to biologically significant stimuli. We find Hodgson's well-worked-out hypothesis to be of great interest and value. However, we find that it leans (implicitly) too heavily on cognitive origins and benefits and insufficiently recognizes equally important emotional aspects that motivate mark-making (see chapter 7).[118]

6.13 (*opposite*) Milling slick atop a boulder with archaic markings, Lower Sonoran Desert, Arizona

The Body-Marking Hypothesis

The phosphene and neurovisual resonance hypotheses imply that there must have been graphic precursors to making marks on stone, in the same way that complex singing and dancing must have come from simpler kinds of vocalization and movement.

Recent papers about the Andaman Islanders suggest a new direction for thinking about the origin of mark-making.[119] Their authors describe the Jarawa, one of three remaining small indigenous tribes in the Andaman Islands of the Indian Ocean. All lines of evidence—social, cultural, historical, archaeological, linguistic, phenotypic, and genetic—support the conclusion that the Andaman Islanders as a group were isolated for a substantial period of time and might therefore represent an ancient substratum of humanity in Asia, predating later migrations and agrarian expansion events.[120] Although the majority of Andamanese people and their languages are long dead, their founding populations may have arrived on the islands in the late Pleistocene—that is, 17,000 to 32,000 years ago.[121]

The Jarawa, along with the Onge and Sentinelese, can be differentiated from other Andaman groups first encountered by British colonialists in 1858 by sociocultural, phenotypic, and linguistic delineations and by geographical distribution.[122] Although the Jarawa have been somewhat acquainted with modern technological society since 1999, for the most part they have maintained a traditional hunter-forager-fisher economy, unlike the Onge, who have sustained rapid cultural loss since the 1960s.[123] The "Sentinelese," sole residents of North Sentinel Island, remain isolated and hostile to this day[124] and have not been the subject of ethnographic study.

This history suggests that the cultural practices of the Jarawa may have developed in isolation from the influences of other tribal populations (except for the Onge and Sentinelese with whom they share some cultural features) for as long as 17,000 to 32,000 years, as just described, or even ca. 50,000 to 70,000 years ago.[125] This is not to claim that these ways have not changed since that time but simply to say that the groups have been isolated from other influences for a far longer time than most other contemporary tribal populations that are known to anthropologists and thus may be assumed to provide a close-to-precontact view of one group of hunter-gatherers.[126] In particular, the body decoration of the Jarawa seems worth describing here, insofar as it supports a suggestion that the practice of making geometric designs on the body is ancient.[127] We also hypothesize, more controversially, that body decoration could have been a widespread source for the idea and practice of making marks on other surfaces, whether soft or hard.

It is common knowledge that people who live in small-scale societies in warm climates need few, if any, garments. Yet even when nearly or completely unclothed, they frequently ornament their bodies with selected shells, leaves, flowers,[128] fruits, and animal fur, teeth, or bones; in ceremonial contexts where they sing, dance, and give dramatic performances, they decorate themselves even more elaborately. In many such groups, people may also paint (artify) their bodies and some possessions with what can be called graphic "art" that is exclusively noniconic.

6.14 Modern graffito of a human face in close proximity to prehistoric concentric circles, Utah

The Jarawa are no exception to these practices, wearing ornaments of bone, shell, and woven natural fiber as well as plants, flowers, and—recently—shredded and repurposed red cloth obtained as "gifts" from "contact parties" and, now, tourists.[129] They also smear white clay on their face and body and then scrape a variety of geometrical patterns with their fingernails and fingers. Using a mixture of clay and ocher with pig fat or water and the juice of a creeper, they decorate a few utilitarian artifacts such as chest-guards made of shaped bark, worn by males as protection from the release of a stretched hunting bow.

On faces, bodies, and some artifacts, various noniconic geometric design elements—zigzags, narrowly and widely spaced crosshatches, parallel lines, lozenges, loops, and small circles—occur both as elementary patterns and in combinations as continuous repetitive patterns enclosed between horizontal bands. Although these styles and patterns have names, they are conventional, without additional assigned or "symbolic" meaning.[130] There is no suggestion of an origin in nature for any mark. All members of the Jarawa community recognize the designs. It is interesting that the same design elements are found widely in other parts of the world, from the Blombos ocher piece to rock markings in North America. They are seen also in children's early

6.15 Cavity protecting a set of concentric circles and two antithetical spirals, divided by a vertical dot arrangement, Utah. Diameter of central spiral, 40 cm.

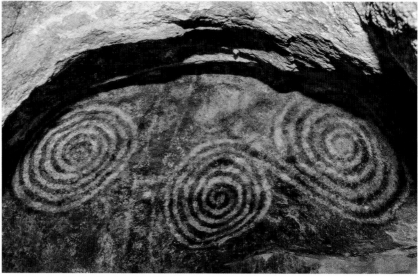

mark-making. Traveling zigzags and traveling loops, used by Jarawa, are common marks made by two- to three-year-old children.[131]

How might the idea of decorating the body have arisen? Like other small-scale societies, the Jarawa treat a variety of ailments, including fever, swellings, or injuries on their bodies, by applying plant parts sometimes mixed with red and white clay. Could graphic body decoration have originated and developed from such a practice? One can imagine our early ancestors applying mud to shield their bodies against the glare of the sun or the bite of the cold, to protect them from insects or other vermin, to treat wounds, and to provide camouflage and/or suppress body odor while hunting. In addition to these purely functional applications, some body embellishment may have been undertaken for ritual or social occasions, even for reasons of aesthetic pleasure and beautification. Bahn, for example, makes the point that, although not directly provable, one can safely assume that people in ancestral societies artified their bodies in various ways—primarily through body pigmentation but also tattooing, scarification, or cicatrization. In addition he opines that body art "was probably one of the first forms of aesthetic expression."[132]

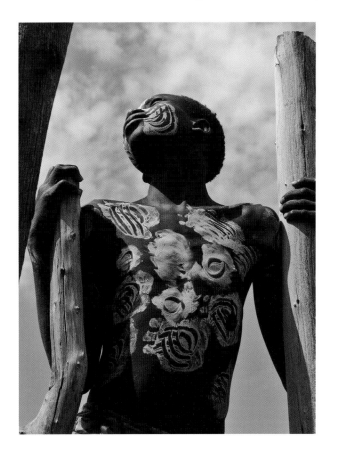

6.16 Pigmented torso of an Omo Valley man, Ethiopia. *Photograph courtesy of Wikimedia Commons.*

Seeing the textures left by finger traces as ridges on the skin could well suggest the deliberate making of such marks with fingers in clay, earth, sand, or (with implements) even on stone.[133] Finger marks naturally create straight parallel lines, both horizontal and vertical, or meanders, as can still be seen in contemporary peoples who paint their bodies with their fingers, such as tribal peoples of the Omo Valley in Ethiopia (fig. 6.16). We suggest that in the remote past, such markings eventually might have been used deliberately in formalized and repeated ways on bodies and possessions, perhaps to distinguish or "brand" people as "human"—just as insects (such as butterflies or beetles), reptiles, fish, and mammals were observed to have their recognizable characteristic designs. Like many tribal peoples, the Jarawa call themselves their word for "human": əng. Although speculative, we find it plausible that the idea could have arisen from displaying this state visually.

The use of white chalk and fingers for body patterning among the Omo Valley tribes may also be ancient, since these people live today in the same region of Ethiopia as the earliest fossil specimens that can be classified as belonging to our species, *Homo sapiens* (195,000 years ago).[134] It is perhaps worth noting that a preoccupation for spectacular geometric face and body painting is found in the Nuba, who live in remote and

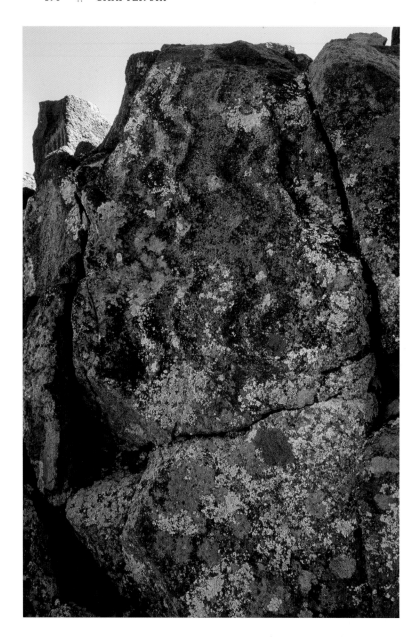

6.17 Broadly cut serpentiforms invaded by multicolored lichen, California

inaccessible regions of central Sudan, suggesting that their traditions, too, may be ancient.[135]

A further speculation is that long before the Ice Age, it was juvenile male humans (inspired by non-iconic body painting designs) who first began to make marks on sandy or clay surfaces, then on stone, in play or to show off for comrades or girls. This is not as unlikely as it might at first appear. By age fourteen or fifteen, at least, Pleistocene males would be essentially as strong as they would ever be but still juvenile in behavior and psychological maturity (or immaturity). Although they would be acquiring male skills all along, they would not be required, at least for a period of time, to take on adult responsibilities. A similar suggestion has been proposed by Dale Guthrie, who makes a plausible case that some makers of images in Ice Age caves were adolescents.[136] Adolescent males would have had the risk-taking propensity, physical agility and strength, motivation, and leisure to explore caves, fool around, talk about animals (the predominant subject matter of the cave images) and female bodies, and draw them. Guthrie himself is a hunter and recalls his own early hunting trips (and conversations) with age-mates. In addition, he made a careful study of almost every handprint in Ice Age caves and compared them with prints of his own students at the University of Alaska, concluding that their makers were young people, both male and female.

Once mark-making became established as a cultural practice, markings could eventually become associated with (a "sign" or even "symbol" of) an idea, appropriated by adult males, and eventually become the focus of ritual observance. Although we may never know, we agree with other proponents of this idea that it is a reasonable hypothesis.

FURTHER THOUGHTS ON ABSTRACT-GEOMETRIC MARKINGS

Colleagues have mentioned to us that abstract-geometric (noniconic) marks may nevertheless be representational, as they "represent" subject matter—events, experiences, ideas, even images—to the people who make or view them. In today's academic

climate, speculating about the minds of other people of our own culture (not to mention a non-Western or prehistoric culture) is to invite skepticism and even hostility. However, the question of whether geometric marks can be "representational" easily slips into the question of whether they are inherently "symbolic."

A related and major topic that we have yet to discuss is whether abstract-geometrics are more or less sophisticated than representational imagery. At least one rock art researcher has asked this question and concluded that figurative imagery is conceptually "primitive," in that it provides an obvious subject. In other words, it takes little brainpower and symbolic ability to "see" what a naturalistic animal represents. It's a simple process, perhaps almost literally "child's play." Abstraction, on the other hand, is considered to be a higher order cognitive skill than representation. The communicative value of an abstract sign is most likely culturally more complex, more sophisticated, and more informative.[137] Its symbolism is "only navigable by possessing the relevant cultural 'software.'"[138] That is to say, perhaps only by being party to the worldview of the maker, or a member of a certain society, or even privy to the thoughts of an individual artist, can one even hope to guess what any noniconic motif means.

An additional, probably related, idea is the possibility that, for the most part, creating a replica of an animal or other image from nature was not considered a meaningful exercise, and this avoidance of iconic images eventually became a cultural preference so that "noniconic art could have been the 'proper' or 'mature' way of artistic expression, whereas iconic production was considered a playful, ludic form, for which there was limited practical use in mature cultural life."[139]

Abstraction is not necessarily always a "higher order process" than representation. The *Concise Oxford English Dictionary* lists one of the meanings of "abstract" as "[being] free from representational qualities." It is in this sense that the earliest rock art markings can be called "abstract" or "abstract-geometric." When invoked by rock art scholars, the cognitive elevation of abstract glyphs over recognizably iconic ones perhaps comes from knowledge of the history of Western painting and sculpture in which "Abstraction" appears in the twentieth century as an artistic process or style in which a known object, such as a guitar or face or body, is viewed in terms of certain features—its individual components or varied angles of vision—and reassembled or reinvented, sometimes with resemblance to its subject but often untraceable to anything recognizable. This activity of "abstracting" is analytic and deliberately reductive. It is self-conscious and depends on an intention of abstraction as taking away or rearranging or expressing the essence of a thing—that is, performing a cognitive operation on it. Abstraction in this sense is different from making marks based on visual primitives or form constants, and from artifying—repeating, exaggerating, and elaborating—them, as children do and early humans did. Thus, the behavioral sequence of mark-making in our species would be abstract-geometrics, then perhaps "bridging" elements, and eventually accompanying representational markings—whether realistic or schematic, depending on the skill or intention of the artifier. Images, such as the so-called Venus

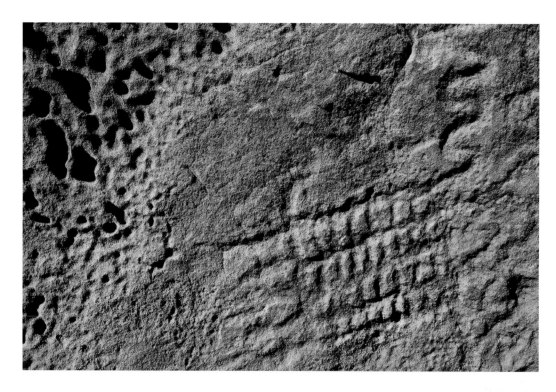

6.18 (*left*) Eroded lattice with attached meander, Utah

6.19 (*below*) Ensemble of curvilinear and rectilinear markings, New Mexico

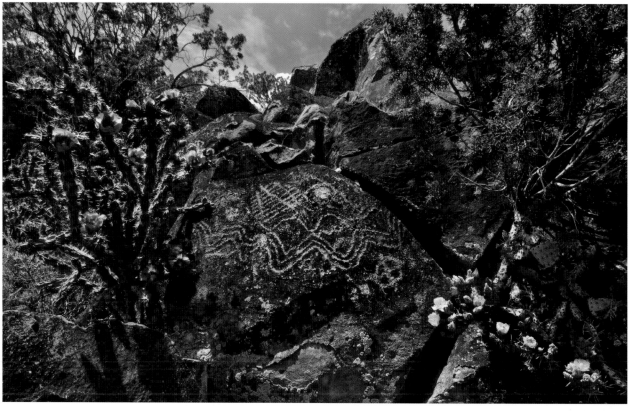

sculptures of the Upper Pleistocene in Europe or the splendid figural masks or carvings of recent and contemporary aboriginal societies, are not so much "abstract" as focused on emotionally important or symbolic aspects that are exaggerated and elaborated.

A provocative study by American artist and critic Suzi Gablik[140] shows that historical change in the ability to represent "reality" in visual art, from Egypt, Greece, and Rome to the twentieth century, reflects characteristics of the stages of cognitive development in children as described by developmental psychologist Jean Piaget[141]—from *preoperational* (as when figures occupy space without relevance to each other, and size is determined not by position in space but by emotional or social importance of the figure) to *operational* (the one-point-of-view or "orthogonal perspective" of Renaissance painting) to *formal-operational* (the distortions of space and subject of twentieth-century modernist artists).

Gablik unfortunately does not include the arts of non-Western or prehistoric societies in her study, but if we accept the work of anthropologist C. R. Hallpike regarding Piagetian-based cognitive development in preliterate societies (see chapter 4), a similar conclusion emerges. The work of these scholars suggests that in ancestral forager and traditional small-scale societies, the way of life did not require concrete or formal operational thought, and thus their art-making could not have been "abstract" in the same sense as the work of artists in modern literate societies. The "abstract" or "geometric" marks made by children as they learn to draw appears to arise from natural motor and visual processes that occur sequentially in development.

Preliterate humans may well have taken these same early "geometric" forms and artified them, using repetition, exaggeration, and elaboration to make them visually arresting, emotionally compelling, and expressive of their strong creative impetus. Because they are not representational of real objects, we may call them "abstract" (an adjective). But the process of arriving at this abstractness is entirely different from the intention to "abstract" (verb) from a realistically portrayed object or form, as occurs in many modern art works.

Both Gablik and Hallpike emphasize that they are not insinuating that early stages of cognitive development are "inferior" to later ones, although their critics hastened to chide them for just that implication. Similarly, by invoking Piaget's general developmental scheme, we do not denigrate the intelligence or wisdom or any other trait of people in premodern societies. Their abstract-geometric marks could not have been made by a child. On the contrary, they display an often breathtaking complexity and impressiveness.

In the child, more and more refinement and combination of "abstract" shapes occurs until mark-making skill bifurcates and, when culturally encouraged, figurative mark-making becomes part of the repertoire. Certainly representational ability itself also becomes more sophisticated, both in individual development and in cultures. In our opinion, once a cultural group produces both abstract-geometric and representational designs, it is a mistake to consider one or the other as more or less sophisticated than the other.

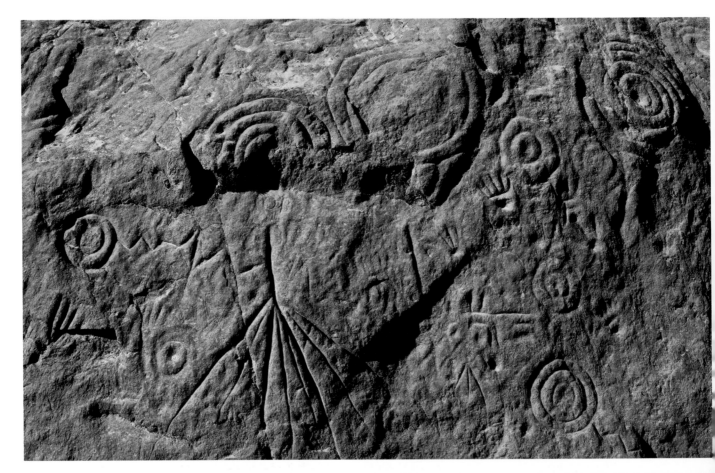

6.20 (*top*) Medley of time-worn cup-and-ring motifs and more recent linear incisions, California

6.21 (*bottom, left*) Concentric circles, betraying the ravages of time, Arizona

6.22 (*bottom, right*) Set of angularized fret designs, Arizona

Human cognitive and behavioral evolution is of high interest to rock art scholars of today, but as their work is usually confined to a particular site, they are not likely to use evolutionary concepts and terminology. All but two of the hypotheses described previously are primarily "cognitive" (verbal, rational), implying that record-keeping, symbolic communication, exercising the visual system, or copying an existing natural or accidental mark were the reasons that people began to artify. Making marks in order to succeed with hunting implies an emotional motivation. Making marks after a trance state in order to illustrate shamanic visions is not in itself emotional but instead informative (a record of what was "seen" in the altered state) or motivated by the wish to preserve traces of a powerful emotional experience. Decorating the body seems most easily explained as resulting from a desire to make the ordinary body extraordinary, which may or may not require a strong emotional motivation.

Mark-making is universal, so we may well ask what about this behavior was (and may still be) adaptive in a Darwinian framework. Of the eleven hypotheses just treated, only one (the neurovisual resonance hypothesis) was conceived or written with a tacit evolutionary (Darwinian) framework in mind. To attempt an evolutionary explanation for a behavior of abstract-geometric mark-making, one needs to propose its evolutionary origin, its intended function (a proximate reason for engaging in it), and an ultimate reason for the behavior. The neurovisual resonance hypothesis would say that mark-making's evolutionary origin lay in the existing structure of the visual brain, the presumed function or proximate motivation was an "innate tendency" to copy or re-create those marks because doing so gave cognitive satisfaction and a sense of safety or order, and its ultimate function was to give practice to the visual system so that one could survive in the real world.

7

WHY DID OUR ANCESTORS ARTIFY?

ELLEN DISSANAYAKE

OUR PRIMARY PURPOSE in this book so far has been to show the amazing variety and unacknowledged allure of abstract-geometric rock art markings made by the early inhabitants of the American West and to describe what is known about them. This chapter has a somewhat different emphasis. Because artification and mark-making have occurred for thousands of years globally, not just in the Americas, there are larger questions to ponder. While we appreciate that some tribal people consider rock markings to be living collections of spiritual meaning—like the California Coso who accept that the spirits of the ancestors reside among the rocks and know what the marks mean and why they were made[1]—our focus in this chapter is on the behavior of mark-making and its worldwide paleoarchaeological and psychobiological origin and significance. For us, rock art markings are physical traces of our own species' earliest surviving art-making and have a special mystique that calls for the examination of deep-rooted answers based in ethology and evolutionary biology.

Any such interpretation can only be speculative[2]—or, stated more positively, hypothetical. There is not enough space here for a fully developed adaptive hypothesis,[3] so I offer a summary of important ideas and cite some studies that support them. All together these provide a new explanation of how and why a behavior of artifying (including mark-making) first originated and has persisted.

THE CONCEPT OF ARTIFICATION: A COMMON DENOMINATOR

The concept of artification is unlike any other theory about art. It is not an alternative idea, but a reconceptualization. As described in chapter 1, it is not concerned with what makes something art but with what artifiers universally *do*. Thinking in this way is something like exchanging a Ptolemaic view of art for a Copernican one.

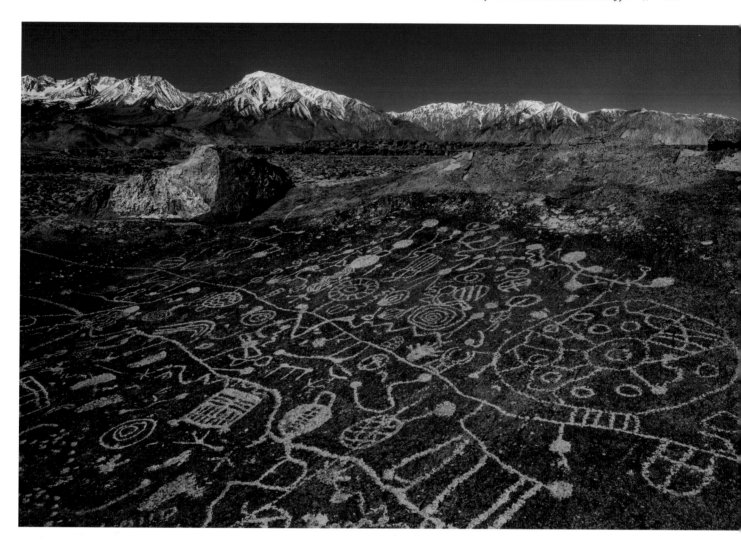

7.1 Panoply of predominantly curvilinear abstracts against the spectacular backdrop of California's Sierra Nevada

Artification (not "art," which has many meanings) is a "behavior" that humans in cultures everywhere have evolved to do—as basic as forming families, establishing territory and social hierarchy, playing, displaying, courting, mating, mourning, and showing aggression and ethnocentrism, among others. Considering the behavior of artification as a common denominator of all the arts, including mark-making, allows us to address in a new way the origins, functions, and meanings of the arts. As a concept, artification moves age-old aesthetic problems one step back, as it were, since it underlies and encompasses the other features that have typically been invoked to characterize art: beauty, imagination, creativity, skill, personal expression, sensory experience, and emotion. These are not synonyms for art, but *ingredients* that artifiers use as they make ordinary things (like rock walls or boulders) *extra*ordinary. Look at anything that is called "art" (including the images in this book) and one will find examples of most or all of five essential characteristics that were briefly introduced in chapter 1 as *aesthetic*

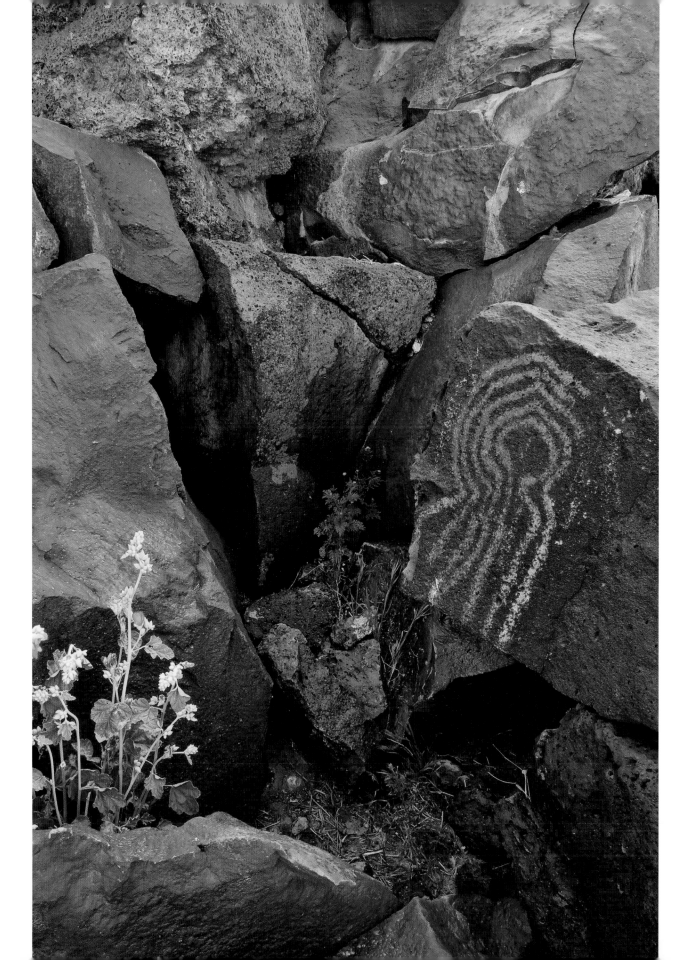

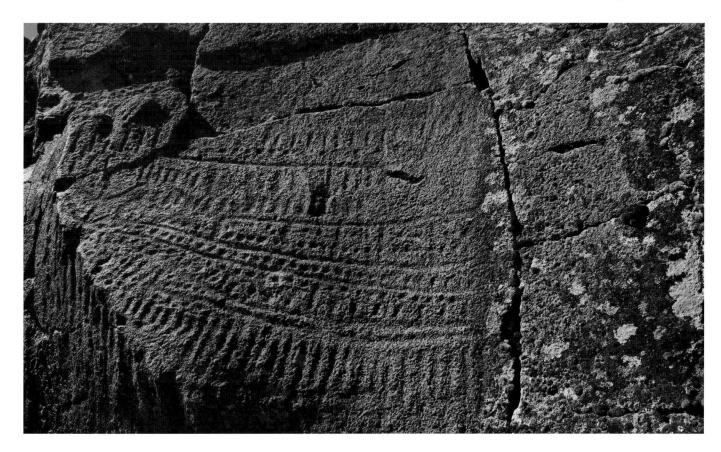

operations—"operations" because they are intentionally "performed on" (or "done to") material, subject matter, movements, sounds, surroundings, and words. Artifiers formalize, repeat, exaggerate, elaborate, and manipulate expectation and thereby make ordinary reality *extra*ordinary (fig. 7.3).

7.3 (*above*) Complex array of repeated dots and lines, in rows, showing definitive patterning, Oregon

7.2 (*opposite*) Petroglyph composed of multiple parallel markings, California

BIOLOGICAL FORERUNNERS OF ARTIFICATION

There are two ethological predecessors of artification in our animal past. The first is the behavior of play, already described in chapter 4. The other is behavior that is "ritualized," occurring most spectacularly in some birds, and, as we shall see, can be presumed to have existed also in the early ancestors of our own genus, *Homo*.

"Ritualized" Behaviors in Other Animals

Art is usually considered to be of a "higher" or more "spiritual" order than everyday life, no doubt because by its nature it looks, sounds, and feels nonordinary. Even so, the operations of artification lie deep in our animal past in a kind of behavioral process first described by ethologists as "ritualization."[4] A ritualized behavior in animals typically occurs in contexts such as courtship or aggression, when it is important to gain the

interest and attention of another, convey an unambiguous message, and affect others' emotions and actions.

In ritualization, components of an ordinary behavior that occurs as part of normal, everyday, instrumental activity—such as nest-building, preening, preparing to fly, or caring for young—are "chosen" or taken out of their everyday context, "ritualized" (altered by means of certain actions or "operations"), and used to signal an entirely different motivation—usually an attitude or intention that will influence (affect or manipulate) the behavior of another animal. For example, when collecting material to build a nest—a common, ordinary activity—herring gulls use their beaks to grab and pull up clumps of grass. If, however, one gull should approach another gull's territory, the latter may use grass-plucking movements in an altered, aggressive way—making them sharper, more repetitive, and more regular. The other gull understands that its neighbor is not simply gathering grass for a nest, and will usually withdraw. In other instances, behaviors derived from feeding young may become ritualized and used for courtship—such as touching bills, offering a token with the bill, and even coughing as if regurgitating—to entice and seduce a mate.

The process of ritualization refers to particular changes or "operations" that make the activity prominent, distinctive, and unambiguous.[5] Unlike the instrumental or "ordinary" precursor behavior (plucking grass), ritualized movements or sounds become "extraordinary" and thus attract attention. They typically become (a) *simplified* (formalized, patterned), and (b) *repeated* rhythmically, often with a "typical" intensity[6]—that is, with a characteristic regularity of pace, as in the herring gull's stereotyped head movements. The signals are frequently (c) *exaggerated* in time and space, and often (d) further emphasized or *elaborated* by the development of special colors or anatomical features. The peacock's courtship display is a well-known example of a ritualized behavior that originated in such simple precursors as pecking the ground for food and lifting, spreading, and fanning the tail feathers for thermoregulation.[7]

Perhaps the most resplendent and virtuoso performers in the animal world are male birds—peacocks, pheasants, birds of paradise, bower birds, lyre birds, cranes—who dance, vocalize, and display their colorfully patterned tails, crests, and other bodily regalia (all having evolved during the process of ritualization) for the approval of females.[8] Darwin devoted many pages to descriptions of these amazing outcomes of evolution and, like many biologists after him, attributed them to what is called sexual selection. Females are seduced by the most impressive performer and persuaded to choose him as a mate. It was not lost on Darwin and later theorists that the lavish products of human artists resemble the displays of birds, even attributing the origin and function of human art-making to sexual selection.[9]

It is easy to see that human ritual ceremony, with its associated and necessary arts, has obvious parallels with the biological display of ritualized signals.[10] But it is important to emphasize that the term "ritualization," despite being obviously related to the words "rites" or "rituals," nevertheless has a precise ethological meaning and should

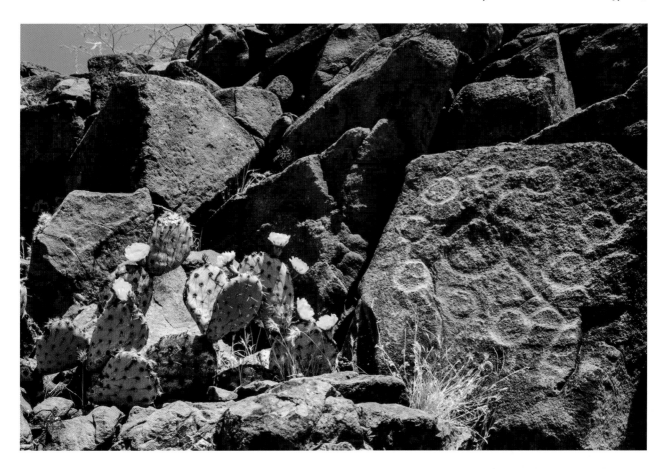

not be confused with anthropological or other uses of "ritualization" applied to human cultural behavior. Before considering human ritual ceremony, it is essential that we examine the second, and perhaps most unexpected, biological source for artification—a ritualized behavior that evolved not in other animals but between early human mothers and infants.

7.4 Boulder inscribed with a constellation of circles, Arizona

Ritualized Behavior in Mother-Infant Bonding

Perhaps the most novel, original, surprising (and engaging) biological contribution to eventual artification comes from ancestral mother-infant interaction. It is as central to the notion of artification as male display is to the idea of sexual selection. Both behaviors (sexual advertisement and maternal nurturance) have to do with reproductive success: males strive for mating opportunity and the transfer of their genes into the next generation; maternal care of infants is necessary to insure that the result of mating—a baby—survives long enough to reproduce in turn. Interestingly, sexual display in human males (which uses the operations of artification to attract the attention of females) arises from the same processes of ritualization that evolved millennia ago between human mothers and infants.

7.5 Deeply scored subparallel lines, Arizona

In hominins and their immediate predecessors, the close bond that can be observed between all primate mothers and their infants became especially intense. Mother-infant interaction in humans can be traced to the clash between two prominent, incompatible, and consequential traits in human evolution. The first is bipedality—walking on two legs.[11] Numerous anatomical adaptations were required to convert a quadrupedal knuckle-walker into an upright bipedal strider. For example, over several million years of evolution, the spine was reshaped and the opening of the spinal cord relocated to the base of the skull, the lower limbs and feet altered, joint surfaces reconfigured, body musculature reshaped, and the rib cage restructured, as were even the tiny bones of the inner ear.

The second significant trait, brain enlargement, began about 2.5 million years ago with the emergence of the genus *Homo*. By the time of *Homo habilis*, between 2 and 1.5 million years ago, the brain had doubled in size from that of earlier four-legged forms. Another spurt of brain growth, again doubling in size, occurred around 500,000 to 200,000 years ago.[12]

What does this paleoanatomical information have to do with mother-infant communication? Everything, once it is pointed out that among the suite of anatomical changes required by bipedality was a reshaped pelvis. It was gradually shortened from top to bottom and broadened from fore to rear in order to center the trunk over the hip joints and thereby reduce fatigue during upright locomotion.[13] This reconfiguration secondarily resulted in a serious obstetric problem[14]—giving birth to babies (whose head size was gradually growing larger) through an increasingly narrowed birth canal.[15]

Over millennia, further anatomical adaptations gradually addressed this particular difficulty. These included a pubic symphysis that separates slightly during childbirth; a neonate skull that is compressible at birth (the fontanelle or "soft spot"); and alterations in the timing of brain growth so that significant expansion occurs outside the womb—at four years of age, the modern infant brain is three times larger than at birth.[16]

Importantly, the period of gestation became reduced,[17] thereby insuring a smaller neonate head. The extent of this reduction can be appreciated once we know that in order to conform to the general primate fetal developmental pattern, a human baby should be born at around eighteen months[18] and weigh twenty-five pounds.[19] After only nine months gestation, a newborn human is quite immature, requiring assiduous care

from adults for much longer than any other primate.[20] Researchers have posited "intense maternal care" or "intensive parenting" as early as 1.8 million years ago,[21] at about the same time that the trend toward difficult births and greater infant immaturity was well under way in *Homo ergaster*[22] and *H. erectus*.[23]

In addition to anatomical adaptations for childbirth, a *behavioral* adaptation that assured diligent maternal care of a helpless infant would have been advantageous. And so arose the affectionate communicative behavior that psychologists call "motherese"[24]—more broadly termed "intersubjectivity" by developmental psychologists[25] and colloquially, by the rest of us, "baby talk." The well-known phenomenon of "motherese" generally refers to altered vocalizations—the peculiar singsong voice in which people (not only mothers) universally speak to infants and babies.[26] It differs from conversation with adults, or even older children, by its higher overall tone, wider tone range, slower tempo, exaggerated vowels, repetitions, and a simplified, specialized vocabulary.[27]

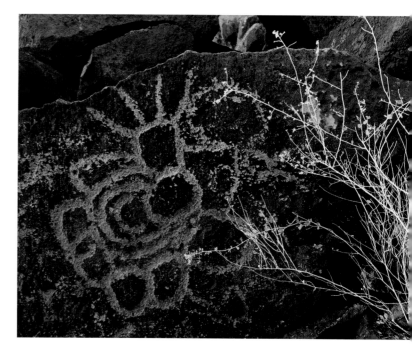

7.6 Multiform conglomerate, Arizona

Maternal *vocalizations* have been widely studied for their contribution to child language-learning. However, frame-by-frame microanalyses of videotaped mother-infant interactions that simultaneously show the faces and upper torsos of both partners reveal that altered *facial expressions* and *head-and-body movements* are as significant in the interaction as vocalizations.[28] The "baby talk" or motherese interaction is really *multimodal*: all three sensory modalities or "languages" of the engagement (that is, gestural, facial, vocal) are processed as a whole in the infant's brain.[29]

It is important to appreciate that babies are not taught to engage with caretakers in this way. If anything, they are the teachers, who by their positive and negative reactions let us know which sounds, movements, and facial expressions they prefer.[30] They are unresponsive to adult-style discourse but reward "extraordinary" signals from face, voice, head, and body with irresistible wriggles, coos, kicks, and smiles.

It is also noteworthy that the alterations of facial expressions, sounds, and movements are derived from common innate signals of friendliness, although caretakers are unaware that their peculiar actions with infants originate phylogenetically from adult signs of actual or potential affiliation and accord.[31] Simply *Looking At* another person is a sign that there is incipient or real social interest; *Mutual Gaze* is exchanged easily only with babies and between lovers. Other visual signals are *Open Eyes* (expressing interest), *Smile* and *Open Mouth* (showing receptivity, pleasure, and liking), *Eyebrow Flash* and *Head Bob Backward* (indicating familiarity and receptivity), *Head Nod* (showing agreeableness), and *Head and Body Lean Forward* (approach). With adult intimates we

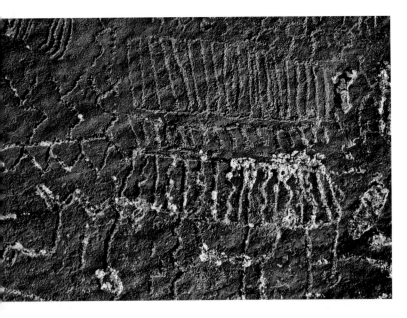

7.7 Utah panel, dominated by fine-line incised grids

speak with a *Soft (nonthreatening) Voice* and use physical gestures of sympathy and devotion, such as *Stroking, Patting, Hugging,* and *Kissing.* Some of these signals can also be seen in affiliative contexts in nonhuman primates, suggesting that it is not unlikely that they were present in early hominins.[32] Tactile communication in bonobos and baboons is often used to signal appeasement, reassurance, and loyalty; embracing is common in monkeys and apes.[33]

Students of mother-infant behavior who are unfamiliar with ethology have not realized that the interaction possesses noteworthy characteristics of a biologically ritualized behavior. The precursor signals that have been made distinctive or special to convey a new message are (like the ritualized grass plucking of herring gulls) the visual, vocal, and gestural expressions drawn from common adult contexts of (in the case of mothers and infants) social receptivity, affinity, and intimacy. These have been simplified or formalized (sustained and stereotyped), repeated, exaggerated (e.g., made larger, held longer), and often given dynamic variation and elaboration (made louder, softer, faster, slower, larger, smaller).[34] Even though "art" or "artification" was not yet in place as mother-infant interaction was evolving, let us think of these ritualized signals as *proto*-aesthetic.

Although mother and baby are simply enjoying each other's company, awash in loving feelings, the mother's intensified signals of friendly interest are, unknown to her, augmenting the release of prosocial hormones that foster maternal behavior in all mammals.[35] Repeatedly making and emphasizing these signals also reinforces her brain's neural circuits for affiliation and devotion (see following discussion), creating tender and loving feelings toward her infant, assuring more attentive care,[36] and making it more likely that she will want to continue caring for a demanding helpless creature for months and years.[37] Compared to other Pleistocene mothers who did not make emphatic affinitive signals that instilled and reinforced such devotion, a baby-talking mother was more likely to have reproductive success. By calling forth such signals from its mother and encouraging her to keep making them, an interactive baby (compared with a less responsive one) inadvertently helped to insure maternal care and therefore its own continuing survival.[38] It seems warranted to consider mother-infant interaction (as described in this section) to be an adaptive behavior in our genus that evolved to address the problem of insuring continued maternal care of highly immature infants.[39]

Apart from the evolutionary importance of mother-infant interaction for sheer survival, developmental psychologists of today describe numerous psychological (emotional and cognitive) benefits of the interaction that are also critical to babies' well-being. Compared to infants who lack reliable maternal input, they learn better

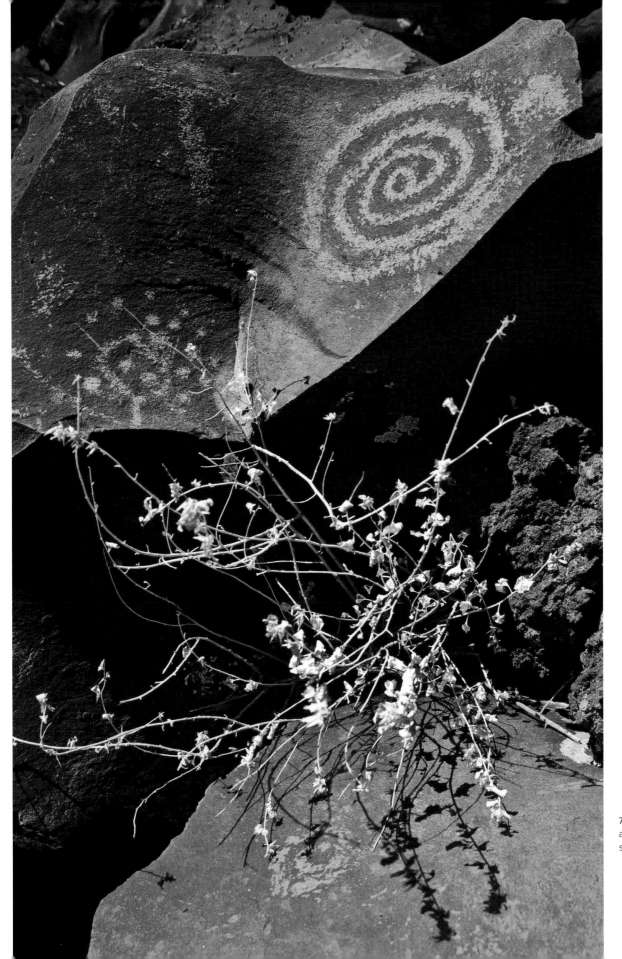

7.8 Dot field and concentric spiral, Arizona

to regulate their emotions, participate in social interactions, become familiar with the sounds of the language they will eventually speak, acquire the culture of their parents, and in other ways develop their minds.[40] The need for intimate interaction from birth is strikingly evident in studies of children who were brought up from birth in Eastern European orphanages, where they received physical care but spent up to twenty hours each day unattended in their cribs. After adoption, they showed mild neurocognitive impairment, impulsivity, and significant attentional and social deficits.[41]

Among the "prosocial" hormones is oxytocin,[42] an ancient hormone (at least 700 million years old, long predating mammals)[43] that became central to mammalian adaptations for caring for others. Although it is present in all vertebrates, the evolution of the mammalian brain adapted oxytocin to new jobs—such as promoting the formation of a pair bond between male and female couples,[44] thereby helping to insure male cooperation in caring for offspring,[45] and eventually for wider forms of sociality, where oxytocin plays an important role in positive social interactions,[46] social empathy,[47] and *ritual behavior*, as we shall see.

THE INVENTION OF RITUAL

Mother-infant interaction, as described in the previous discussion, evolved to insure the continuing care of helpless infants by making use of proto-aesthetic operations that coordinate and unify the two, as in pair-bonding ritualized behaviors of other animals. Ritualization, then, is the pivot between the biologically adaptive bond formation of mothers with infants and the artifications that unite individuals in ceremonial rituals. Although the arts in rituals may differ from one cultural group to another, they are based on the same underlying aesthetic operations, which themselves come from the proto-aesthetic operations of mothers and infants.

Aesthetic Operations, Salience, and the Arts

The ritualized (proto-aesthetic) operations used by mothers with infants, such as those used by peacocks with peahens, serve to make specific signals salient. Prominence or emphasis of any sort is potentially emotional. Normally we spend our lives in a general unremarkable state of ordinary consciousness in which we do not experience emotion so much as what might be called mood fluctuations whose eddies are more or less good (positive), bad (negative), or indifferent. Emotion enters or potentially enters the scene when there is some discordance or change provoking an interest. We appraise a salient or novel cue, anticipating what it means for our vital interests.

As in ritualized behaviors, the process of artification in any medium uses salience to attract attention and manipulate emotional response. We can say that the arts began when our Pleistocene ancestors deliberately began to artify ordinary artifacts and behavior—shaping and enhancing them so that they were then experienced as extraordinary. Drawing upon their innate sensitivity to proto-aesthetic operations in vocal, visual, and

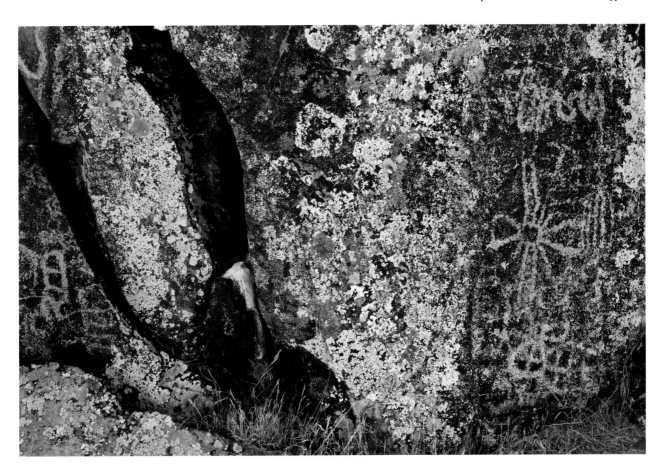

gestural modalities present from infancy, early humans "invented" ritual ceremonies, packages of salient multimodal artifications that we as scholars (unlike they as participants) can classify or separate into various genres: chant, song, literary language, mime, dramatic performance, dance, visual enhancement—that is, the arts.

In the visual arts, for example, ordinary materials and bodies are made special by shaping or patterning: tiny snail shells may be pierced and strung into a necklace or affixed to clothing, where they acquire a new significance as personal décor and are no longer unnoticed detritus. By rounding their shape and combining them with each other, such salient features as shininess and symmetrically rounded contours become exaggerated en masse and thereby even more salient—noticeable in themselves—as does the ordinary human skin or animal hide on which they rest. Ordinary human hair is braided, bound, and adorned with flowers or feathers rather than remaining wild and shaggy like animal fur. Color, such as red ocher, is applied to the shell necklace, human hair, or the human body to make these even more attention-getting and more special.

The same is true for other arts. Whether spoken or written, literary language makes ordinary language special by its form (use of stanzas, rhyme scheme, meter or rhythm) and vividness or color (use of unusual vocabulary and word order, alliteration, assonance,

and other rhetorical or poetic devices). Stories are given shape, emphases, and elaborative details that surpass the bare facts of their plot. In dance, ordinary body movements are shaped, patterned, and made vivid through formalization, repetition, exaggeration, and elaboration. In song, the expressive features of the human voice—melody, rhythm, dynamics—are transformed into conventional intervallic patterns and regulated meter, exaggerated with sustained vowels, and given notable dynamic variation that manipulates expectation.

Although ritual practices occur in every human society, they are not themselves instinctive, like ritualized behaviors, but develop in a specific cultural context and are culturally highly varied and complex. Yet if examined closely, their individual components can be regarded as deliberate applications of the same innate (proto) aesthetic operations that evolved in ancestral mothers so that they (inadvertently) would attract their infant's attention, mold their emotions, and bond with them. In rituals, artifications (using aesthetic operations) do the same.

A society's rituals are its major occasions for making ordinary reality extraordinary. Visually arresting costumes, masks and other body ornamentation, altered and embellished artifacts and surroundings, chanting, dancing, singing, drumming, altered language, and performing—all transform ordinary bodies, objects, environments, movements, and utterances.[48] We can call these extraordinary behaviors "arts," and most rituals, whatever else they may be, can be considered as "collections of arts," for without these transformations it is hard to imagine what a ritual ceremony would consist of.

7.10 Joined circular motifs, lightly patinated, Arizona

EXISTENTIAL ANXIETY

Why did humans invent rituals? I suggest that as our large-brained ancestors were increasingly able to remember the good and bad happenings of the past and wished to affect the good or bad things that might recur in the future, they were emotionally moved to do something to insure a good outcome to their ventures. All societies have rituals,[49] and most of these are intended to affect biologically vital states or circumstances whose attainment is uncertain—assuring or celebrating such goods as food, safety, health, fertility, prosperity, and successful transitions through important life stages—or averting threats to these.

Psychologists confirm that humans are fundamentally motivated to achieve some level of control over events, resources, and relationships that are significant to them

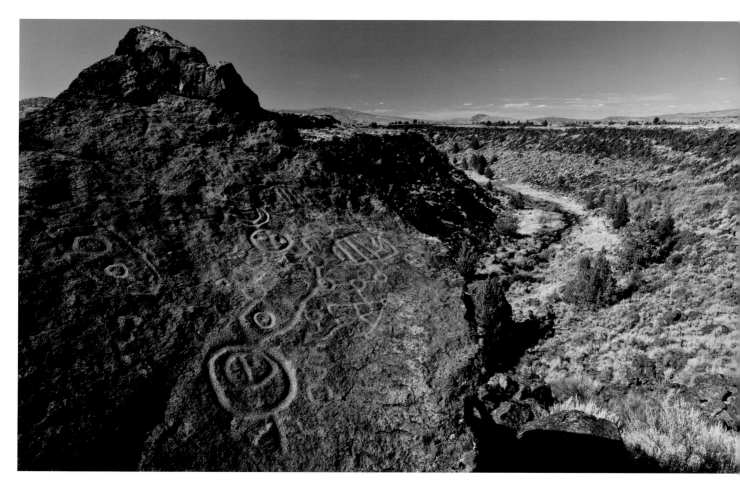

and become distressed when this control is lacking.[50] Individually, humans (like other animals) appraise the circumstances of their lives in terms of elements such as: "Is it pleasant or unpleasant?" "Is it certain or uncertain?" "How much effort is required?" "How much control do I have over it?" "Is it legitimate?" or "Is there an obstacle to overcome to get it (or avoid it)?"[51]

It is reasonable to suggest that existential anxiety—leading to emotional investment or "caring about" vital needs that are in possible or real danger—was the original motivating impetus for the invention of ceremonial ritual. Writing about the Trobriand Islanders in the 1930s, anthropologist Bronislaw Malinowski noted that, "Wherever there is an important human activity, which is at the same time dangerous, subject to chance and not completely mastered by technical means—there is always for the Trobriander a magical system, a body of rites and spells, to compensate for the uncertainty of chance and to forearm against bad luck."[52] It is an anthropological axiom that rituals occur at times of transition and uncertainty,[53] and it is worth mentioning that the instinctive ritualized behaviors in birds, described earlier, also occur when the situation is "ambivalent."[54]

7.11 Carved Abstract Style geometrics on basalt, California

Perceived uncertainty produces fear and anxiety,[55] thereby releasing stress hormones such as cortisol, which over time has numerous deleterious physiological consequences.[56] These pernicious effects are reduced when individuals have a sense of control over uncertain circumstances.[57] Like all primates, humans come together when under threat or other stress.[58] Acting as a group is more reassuring than doing nothing or acting alone.[59]

Therefore it is not at all surprising that humans should behave in ritualized ways when stressed. Even in infancy the proto-aesthetic operations of mother-infant interaction assist biobehavioral self-regulation and homeostasis in infants.[60] Simplified and repeated movements relieve tension in stressed animals.[61] Adult humans show similar behavior, sometimes called "comfort" movements, when they repeatedly tap a foot, wiggle a knee, or wind a strand of hair around a finger.

Examples of "superstition" ("a wrong idea about external reality")[62] are reported even in laboratory pigeons which, when given food at random and thus unpredictable time intervals, begin to perform stereotyped and elaborated movements, as if their behavior might have an effect on the food-releasing mechanism in their cage. Movements include turning around counterclockwise in the cage, thrusting their head into one of the upper corners of the cage, and tossing the head as if placing it beneath an invisible bar and lifting it repeatedly.

Studies by neuroscientists describe neural substrates that may predispose us to engage in ritualized and ritual behaviors. Orbitofrontal cortex (OFC) and other reward centers of the brain, such as periaqueductal gray (PAG), are activated by affinitive behaviors and emotions—like those created and reinforced by the operations of mother-infant interaction (in humans and other mammals) and by participation in temporally coordinated and integrated multimodal (facial, vocal, gestural) behaviors.[63] In both contexts one finds entrainment, joint action, emergent coordination, planned coordination, chorusing, turn-taking, imitation, complementary joint action, motor resonance, action simulation, and mimesis.[64] The involvement of these brain areas in both kinds of behavior strongly suggests that evolution has made use of the temporally coordinated and multimodal operations of mothers' affinitive signals to infants in predisposing adults to using the same operations in their group ceremonies.

Ancestral humans did not need to realize consciously that their coordinated actions of vocalizing and moving together during a fraught event "promoted affiliation and congruence in adult social life."[65] Engaging in highly coordinated action is widespread in pairs and groups of humans and other animals. Even without deliberate orchestration, individuals tend to behaviorally match the actions or postures of others.[66] Communal feeling is literally embodied by the mutual coordination that is enacted.[67]

NEUROCHEMICAL EFFECTS OF RITUAL BEHAVIOR

Just as mothers do not consciously know that their rhythmic sounds and movements are releasing brain chemicals that generate deep feelings of love for their babies, participants in rituals need not know, or have ever known, that their contingent rhythmic

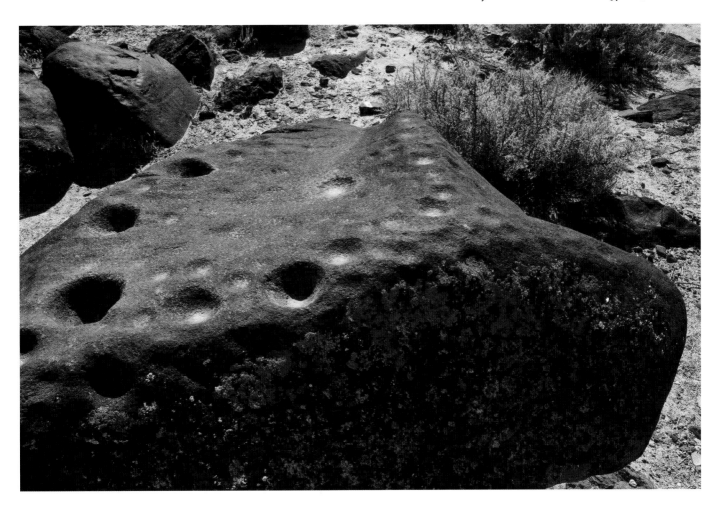

7.12 Basalt boulder bearing heavily weathered incipient and deeply pounded cup-marks, Nevada

actions are releasing the same opioids, which not only make them feel bonded together in confidence and unity but relieved—at least temporarily—of anxiety.

There are few neuroscientific studies of physiological or psychological effects in ritual participants.[68] In 2000, neuroscientist Walter Freeman speculated that dancing and singing could induce altered states of consciousness by means of brain chemicals, like oxytocin, which lead to feelings of trust and receptivity to new knowledge—a conjecture quite similar to the one proposed.[69] Other research supports a claim that engaging in ceremonial rituals has beneficial effects. For example, participants in musical activities, such as singing, dancing, and drumming (which by their nature require coordinating regularized behavior with other individuals), had a higher pain threshold, lower levels of depression, anxiety, and fatigue, and an increase in vigor after the session compared to a control group.[70] It seems more than plausible that these results can be attributed to the release of endorphins or endogenous opioids like oxytocin, referred to above as a "bonding" hormone. Panksepp and Biven describe further positive effects of these neurohormones, such as behavioral indications of individual confidence and social comfort.[71]

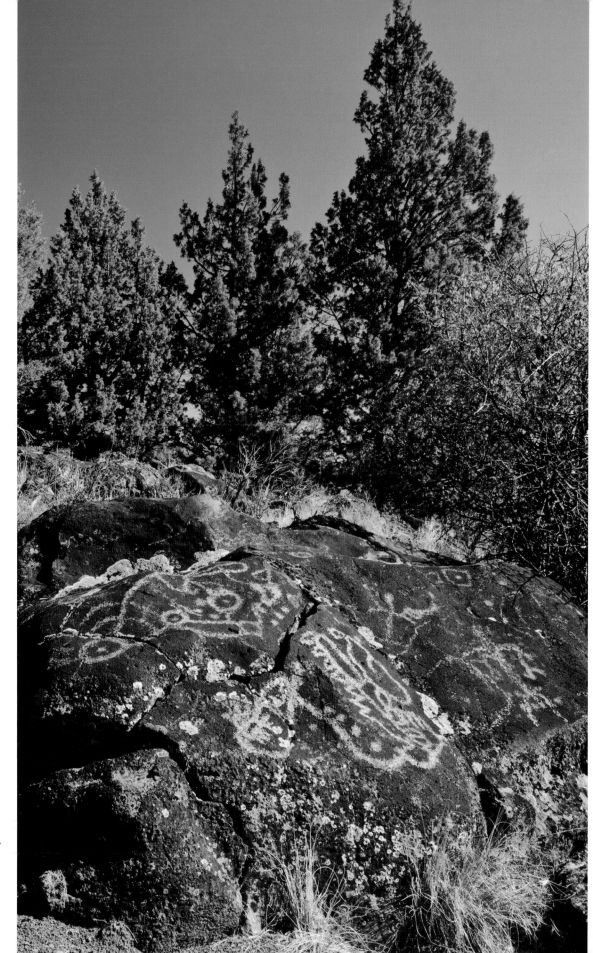

7.13 Scatter of
abstract-geometrics,
Oregon

Even though oxytocin's primary function in all mammals seems to be its role in maternal nurturing, its contribution (along with other endorphins) to the reduction of the stress hormone cortisol[72] supports an argument that participation with others in coordinated music-making, as in the songs and dances of ritual practice, promotes cooperation and relieves individual anxiety and emotional tensions.[73] Further evidence for this claim comes from other recent studies of synchronous behavior.

In three experiments, Stanford psychologists Scott Wiltermuth and Chip Heath found that acting in synchrony with others (as opposed to casual walking or the performance of tasks that required differing degrees of synchrony) led people to cooperate with group members more than did controls. The authors suggest that cultural practices involving synchrony (e.g., music, dance, and marching) may enable groups to mitigate the "free rider problem" and more successfully coordinate in order to take potentially costly social action. (The "free rider problem" refers to the possibility that an individual in a cooperative society might reap its benefits without paying its costs.) Synchronized rituals may therefore have enabled some cultural groups to survive where others failed.[74]

An interdisciplinary study in New Zealand found that synchrony achieved in shared participation in music and dance promoted cooperation more powerfully when it was framed as a collective goal.[75] The researchers concluded that their findings supported conjectures by evolutionary scholars that collective music and dance are biocultural adaptations for cooperation and that "the framing of coordinated behavior with purposes that transcend personal interests produces an even more powerful cooperative response than synchronous interaction in isolation from collective goals." The statement is an excellent description of the common interests of individuals in egalitarian societies like those of our ancestors who shared goals of prosperity, fertility, health, safety, victory, and the other subjects of collective rituals.

Other studies suggest that opioids such as oxytocin are released in the brain during rhythmic, repetitive activity with other persons, instilling feelings of elation, trust, and bondedness, while these same chemicals also reduce the pernicious effects of stress-induced cortisol—all obvious adaptive benefits of the ritualized and ritual behaviors that foster and sustain these outcomes.[76] It is not farfetched to propose that these effects must have evolved in the past, where they would have been adaptive in ancestral hunter-gatherer societies. However, it remains to propose how mark-making fits in, if it does, to the claims of reducing anxiety and fostering sociality that are present in artifications that are communal and take place in time.

THE COEVOLUTION OF ARTIFICATION AND RELIGION

Although today's rituals can be about anything at all (a high school graduation, the launching of a ship), in traditional societies they are most often associated with religion. Moreover, the reason that arts and ritual are "intimately related"[77] is that rituals,

with their artifications, make the subject of the ritual otherworldly, extraordinary, so that people take notice. When anthropologists conceptualize a society's rituals primarily as part of a symbolic cognitive belief system, they overlook the fact that regardless of the doctrine or meanings that are conveyed, rituals are constituted of art-like behaviors and *would not exist without them*.[78]

In any case, an ethological approach requires that one distinguish between religious belief and religious behavior.[79] Such a distinction revives the emphasis on the behavioral and emotional means of instilling and reinforcing a society's beliefs that was described by early twentieth-century anthropologists such as Bronislaw Malinowski and A. R. Radcliffe-Brown, who proposed that religion in small-scale societies was less a matter of beliefs than of rites, indeed that belief was an *effect* of rites.[80]

Contemporary neuroscience reveals that belief, like other higher cognitive functions, rests on emotion.[81] Although literate people can read doctrinal texts and be persuaded rationally to hold certain beliefs, for most of human history belief was instilled nonverbally in individuals as they participated in song, dance, and other vehicles of entrainment by means of the neurohormonal effects of the aesthetic devices (operations) that were used in these activities. Artifications—emotion-rich multimedia clusters of the extraordinary—have been as integral to the evolution of religiosity as their cognitive counterpart, belief in an extra- (super)natural realm.

Although not all artifications are religious, most religious practice is inseparable from art-like behavior. For this reason, it is plausible that the arts arose in human evolution as components of ceremonial behavior rather than as independently evolved activities. There is no specific area in the brain for "art," but there are neural networks for recognizing and being emotionally receptive to the salient proto-aesthetic operations of multimodal packages of vocal, visual, and gestural behaviors that evolved and were evolutionarily adaptive in mother-infant interaction—as they fostered coordination, trust, and regulation of emotional state. When used in other contexts such as religious ritual—to coordinate and unify groups of people, enabling their confidence and trust in each other and temporarily relieving anxiety in an atmosphere of one-heartedness—these now *aesthetic* operations were also adaptive, or, using stricter evolutionary terminology, *exaptive*.[82]

Ritual behavior gave individuals in small bands something to do in vital but uncertain circumstances they cared about. Whether or not a positive outcome for a particular ceremony was achieved (the "proximate" motivation for performing it), at least two physiological and neurological "ultimate" adaptive effects were accomplished. First, simply participating with others in a time-honored practice that is expected to have positive results reduces anxiety (as measured by stress hormones), leading to better physical and psychological health of individual members of the group. Second, ceremonial participation contributes to group unification, assuring at least for a time that individuals will work together in confidence and unity. These two effects of ceremonies are accomplished by means of active participation in the ongoing temporal

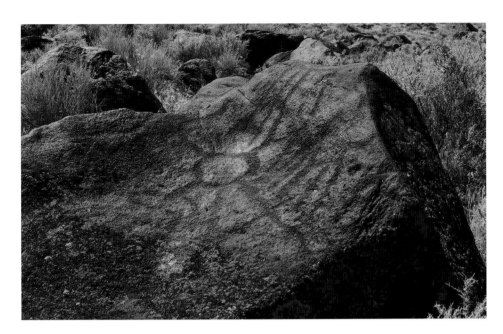

7.14 (*left*) Broadly graven, heavily revarnished, outward-spreading geometric primitives, Nevada. *Photograph courtesy of Carl Bjork.*

7.15 (*below*) Geometric configuration with center dot retaining original patina, California

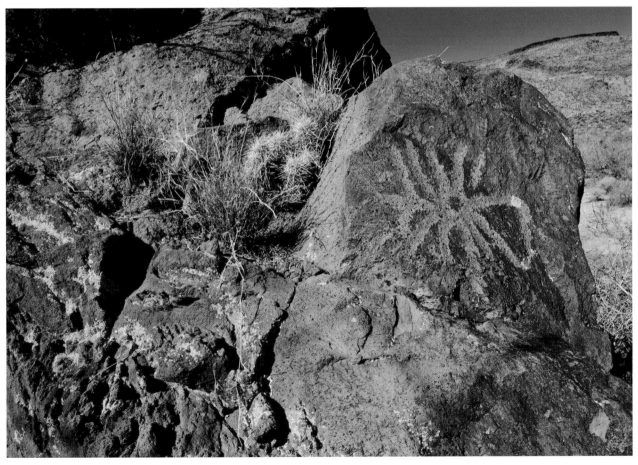

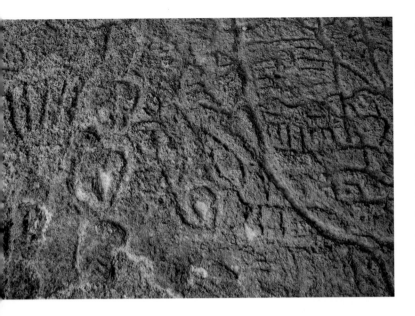

7.16 Geometric markings with embedded vulviform motifs, Nevada

organization and forward movement of the ceremony—through dance and song, which coordinate and unify (entrain) individuals neurologically, physically, emotionally, and psychologically.

What drove the development of ritual behavior (artification)? Evolution is propelled by changes in the environment to which an animal must respond. Cognitive scientists Drew Bailey and David Geary offer strong empirical evidence that it was population density, leading to competition between groups, that drove human cranial capacity (that is, the size of the hominin brain). Neural/behavioral mechanisms to increase cooperation within groups would have been advantageous when competing with outsiders.[83] A number of archaeologists have noted an increase in indications of ritual activity (artification) at times of environmental stress, such as changing climate or competition with invaders over resources.[84]

Evolutionary scholars Derek Hodgson and Jan Verpooten agree with me that "ritual is associated with anxiety" and "ritualized actions" (what I call artifications) "provide short-term reassurance by imposing order in the face of perceived insecurity/danger."[85] However, these scholars do not mention the factors of entrainment and repetition that allow coordination of individuals or the neurohormonal components of "ritualized actions" that both reduce stress and produce feelings of trust and confidence. They also agree that the arts in ritual are not separate domains but intimately related,[86] saying that "there would have been no separation between, on the one hand, the various objects utilized and, on the other hand, the activities invoked in ritual."[87] The term "multimodal" is useful, because it conveys not only that in ritual all the arts tend to occur together (as voice, face, and gesture occur together in mother-infant interaction) but also that all senses are simultaneously stimulated.

However, two other claims that arise from their discussion of ritual and art are questionable: (a) that the arts for both ancient and modern hunter-gatherers were mainly subservient to ritual[88] and (b) that the arts are prone to a range of maladaptive tendencies.[89] Rather than being subservient to ritual, artifications were *essential* to their adaptive effects (fostering prosocial behavior by means of releasing oxytocin). In fact, ritual ceremonies themselves are collections of arts. The maladaptive behavior they cite—ritualized infanticide in pre-Columbian Central and South America—is appalling, to be sure. But the arts-filled ritual that was intended to convey the values to society that the sacrifices were believed to bestow may have relieved the anxieties of other members of the society and unified them in common cause despite the cost to the parents of their murdered infants.

The concept of artification implies that artists of today continue to use aesthetic operations in visual, vocal, and kinesthetic media. If some artifications in complex societies occur outside of ceremonies, or are performed and experienced individually, this is due to massive social and cultural changes. However, the arts of all times and places, even when highly individualistic and transgressive, typically use the five aesthetic operations and are made in response to subjects or for occasions the artifier cares about. I invite skeptical readers to find instances where these criteria do not hold.

THE EVOLUTIONARY PATH TO ARTIFICATION

After assembling evidence from a number of fields, a plausible evolutionary trajectory has unfolded that traces how ancestral mothers' use of ritualized visual-vocal-gestural operations in interactions with their infants could be later coopted (exapted) and become an adaptive behavioral predisposition to artify.

Our Middle Pleistocene ancestors, large-brained hominin foragers, gradually developed—unlike other animals—an awareness of past and future. Rather like eating from the tree of knowledge, they became aware of good and evil—what had happened and could happen that affected their welfare—and felt the need and desire to do something beyond practical preparation to influence the outside forces that affected their lives.

During the long evolutionary process of brain expansion, hominin females were simultaneously adapting to the "obstetric dilemma" of giving birth to large-brained infants through a birth canal that had been reshaped by the requirements of bipedality. Various anatomical changes led to a curtailed gestation period and a highly immature infant. To insure that mothers would willingly care for a helpless baby for the requisite months and years, a behavioral/emotional adaptation developed: an interaction between the pair in which mothers used ritualized variants of the ordinary vocalizations, facial expressions, and head and body movements that they already used with other adults in friendly and intimate social contexts.

These alterations, "operations" of simplification, repetition, exaggeration, elaboration, and manipulation of expectation (the same as the "ritualized behaviors" that ethologists describe in other animals), attracted the baby's attention, sustained its interest, and aroused and shaped its emotions. The interactions became structured on a cocreated temporal pulse and fostered "interpersonal sequential dependency" that further coordinated the pair.[90] Infants also contributed to the interaction, rewarding mothers with appealing sounds, expressions, and movements.[91] Unknown to the mother, the alterations of her affinitive behaviors (and her pleasurable delight at the baby's responses to them) released chemicals in her brain's neural circuits that reinforced pathways for caretaking and emotional attachment.

At the same time, no longer relying primarily on instinct like other animals, our large-brained forager ancestors began to feel existential anxiety and the wish to control

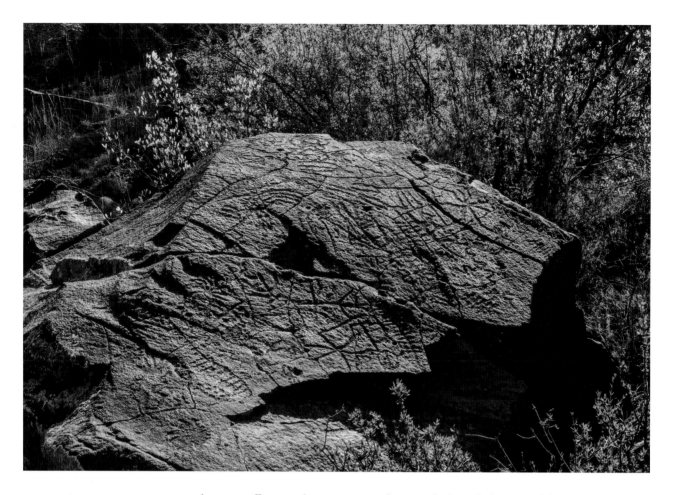

7.17 Basalt boulder, fully decorated with more than one hundred deep-time petroglyphs, including numerous cupules, New Mexico

or have an effect on the outcomes of uncertain but vital parts of their lives. Spontaneously coming together in times of anxiety, they discovered the satisfactions and reassurances of joining with others in multi-modal ritualized behaviors that had been part of their behavioral repertoire from infancy. The behavior of play (which itself simplifies, repeats, exaggerates, elaborates, and manipulates expectation) was in place, contributing to the creation of "as if" or imaginary worlds, different from the everyday.

At first, as these early artifiers gathered together in times of uncertainty or affliction, emotional expressions of anxiety produced coordinated or even entrained movements (say, back and forth swaying) and vocal sounds (weeping, moaning) that in their collective expression were more reassuring than solitary activity or silence, providing something to do to affect the disturbing event. Over time, different cultures embroidered such simplified and repeated behaviors in varied ways, making them more exaggerated and elaborated, even practiced in advance of a dreaded possible event. Visual effects could be added—bodies and surroundings made special, to further indicate "this is not ordinary or everyday." Perhaps cupules were pounded or marks engraved on stone that would express to powerful spirits how sincerely the individ-

ual or group desired or needed their help. The inherent salience of the operations made the messages of the ceremony compelling, as the physical coordination within the constraints of formalized practice helped to shape and control emotions of fear or insecurity about uncertain outcomes. Although particular ritual actions and cultural messages vary from group to group, all are built on the same psychobiological scaffold.

To summarize the argument in evolutionary terms, the predisposition to artify (make ordinary behavior extraordinary or special, in circumstances about which one cares) can be described as an adaptation, as follows. The *adaptive problem* was to foster cooperation and trust in early human groups of foragers, so that they could work together in confidence and unity as a cohesive group to address circumstances that affected their subsistence and survival. The *design features* (or mechanisms) to promote cooperative behavior were already present (as *antecedents*) in the bonding behaviors that had developed between mothers and infants—altering visual, vocal, and gestural behaviors in ways that would attract attention, sustain interest, and evoke and shape emotion, and using the ability to entrain and coordinate body rhythms. The extraordinary nature of artified behaviors attracted the attention of adults (as it did that of infants) and had the proximate reward of providing pleasure to participants (as it did to mother-infant-partners). The brain chemicals that were released in both contexts produced feelings of trust, confidence, and one-heartedness. These positive feelings in adult ritual participants, along with the reassurance of coping, were also part of the proximate *reward*.

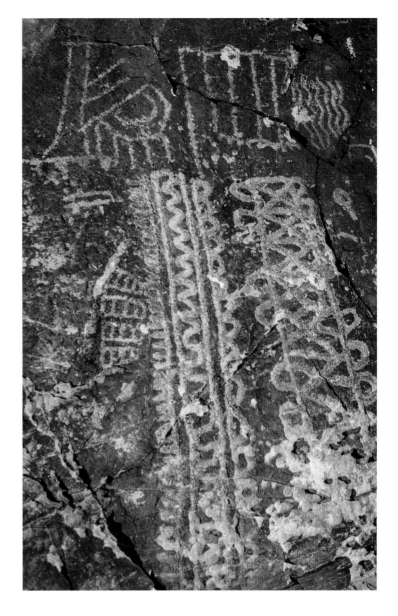

7.18 Western Archaic markings, featuring prominent sets of distinctive "loopline" and meander motifs, Utah

Cognitive archaeologists and evolutionary scholars who study the early human mind typically emphasize the importance of social communication and cooperative behavior evolving in ancestral humans, attributing this to the challenges of living in larger and more complex social groups or responding to environmental change and variability.[92] These factors are surely relevant. However, it is time that theories about the evolution of human cooperation and religion also include the contribution of ceremonial rituals *composed of artifications*. They are fundamental and indispensable mechanisms for conveying communications and instilling cooperation and cohesion in ancestral humans in the face of social and environmental challenges.

220

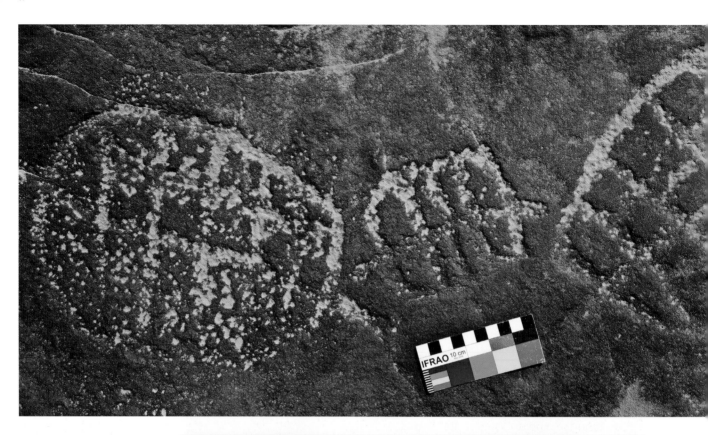

7.19 Completely revarnished glyphs on flat bedrock, "revealed" by blown sand, New Mexico

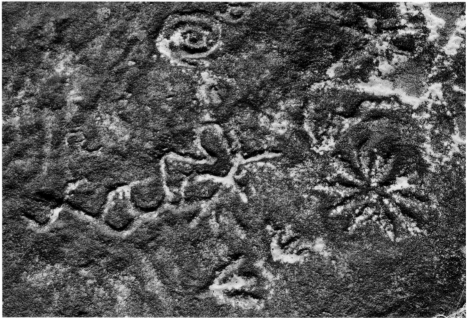

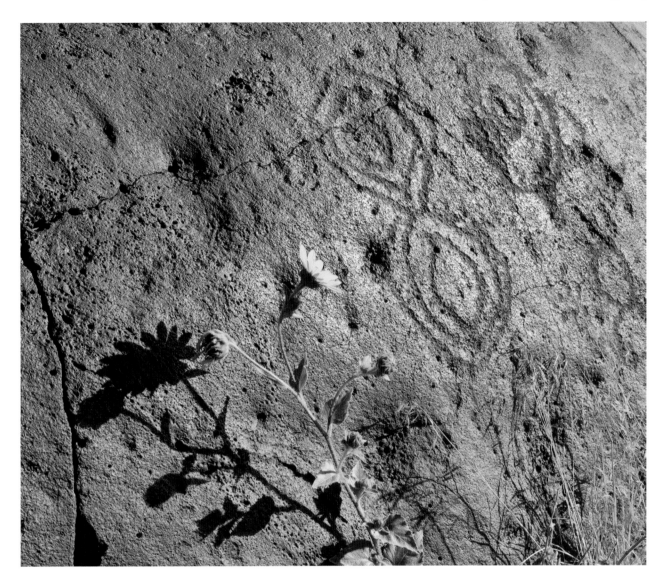

WAS MARK-MAKING ADAPTIVE?

7.20 Concentric diamonds motif on black basalt, Idaho

It is clear that a behavior of making permanent marks on rock by pecking, chiseling, or engraving with a stone tool is different from the arts that take place in time. Although, like song and dance, mark-making requires time and physical effort; the activity is usually solitary; it not only lacks the positive effects of social participation but in the past would have exposed the mark-maker to the potentially harmful curiosity of animal or human predators.

Even though a mark persists after being made or "performed," by the time someone sees it the maker may be long gone—unrecognized for his or her efforts. It is difficult to suggest an adaptive advantage for such apparently pointless and costly behavior, which

depletes energy and time that could be devoted to something more beneficial such as finding or preparing food, courting sexual partners, making tools and weapons, or even just resting.

The costliness of making a mark, however, as with other arts, indicates that it was most likely a consequential, not superficial, activity. The desire to artify generally arises when a person or group keenly cares about something. And so, if an abstract-geometric mark has been made with care, and shows all or most of the five aesthetic operations, it can be assumed to have been important to its maker. It was likely also important to others as a desired component that contributed to the overall effect of a multimodal ritual occasion that unified participants and helped to relieve their anxiety about achieving good outcomes in vital matters.

Once mark-making was in place, it could have been co-opted for use in the emotionally charged and meaning-rich panoply of varied physical activities and sensory impressions comprising a ritual ceremony. It would then have been adaptive as an instance of the broader behavioral predisposition of artification, along with other visual effects—costume and body adornment, masks, altered surroundings, and special objects—that is, as painted or carved marks on stone.

Additionally, if mark-making (in preparation for a ceremony) contributed a regular, repetitive sound or if its purpose and meaning were grasped and responded to by others, it would also lead to group unification and maintaining the social order.

In Aboriginal societies of western Arnhem Land (Australia), stone is in itself related to ideas about power: the material substance of stone can be made into tools that are powerful and its qualities of dazzle or shimmer (as in quartz or quartzite) also exude power. The Ancestral Beings used their power to create the landscape—including large stone arrangements or outcroppings. Not surprisingly, ritual practices that made use of stone were thought to harness or convey this power.[93] Walls and ceilings of escarpments, artified with thousands of hand or hand-and-arm stencils, were felt to tap directly into that power. It could be that people in other parts of the world pounded stone to make cupules and geometric marks for similar reasons.

Cupules in groups (and at least some rock markings?) are likely to be at former sites for ceremonial practices and are today their only vestiges. Such marks may have served as a kind of emotional communication, part of a shared intense experience that imbued the resultant array with power. If they were understood as records of an important event or transfiguring idea, later observers would feel the spot to be special, having meaning for themselves and their fellows. We today respond in this way when viewing the long lists of engraved names at commemorative markers such as the Vietnam Veterans Memorial in Washington, DC, or the National 9/11 Memorial in Lower Manhattan.

Whatever their original purposes, and these surely were manifold, abstract-geometric marks—displayed in these pages in their profuse variety—will remain enigmatic. What we can conclude is that they are evidence of their makers' proclivity for finding meaning and articulating it in tangible, vital form—art for life's sake.

THE GEOMETRIC ENIGMA

EKKEHART MALOTKI AND ELLEN DISSANAYAKE

Watching a coast as it slips by the ship is like thinking about an enigma. There it is before you, smiling, frowning, inviting, grand, mean, insipid or savage, and always mute with an air of whispering, "Come and find out."

—JOSEPH CONRAD, *Heart of Darkness*

AS THE NEARLY 200 noniconic images and many thousands of words of our completed book slip past, what can we say as we revisit the questions that comprise the "geometric enigma" of our title? The marks still seem to whisper. The enigma persists. However, even though abstract geometrics remain inscrutable, some of our key findings deserve to be restated.

Although the earliest Paleoamerican immigrants to the New World were as "cognitively modern" as their *sapiens* cousins elsewhere in the world and were as capable of making representational images, rock art sites across the American West confirm that they chose to create geometrics. It has been estimated that more than 90 percent of all known prehistoric rock art is noniconic (fig. C.2). Although the precise proportion is debatable and, in any case, unknowable, our survey of existing research indicates that geometrics "came first" everywhere, then coexisted with representational marks once they became part of people's graphic repertoire. This panglobal developmental trajectory also prevailed in the New World, even though the North American continent was entered long after representational imagery had developed in Eurasia.[1] For example, in the French and Spanish cave sites of 40,000 to 10,000 years ago, 3,981 animal figures at 154 sites were counted by researchers Georges Sauvet and André Wlodarczyk.[2]

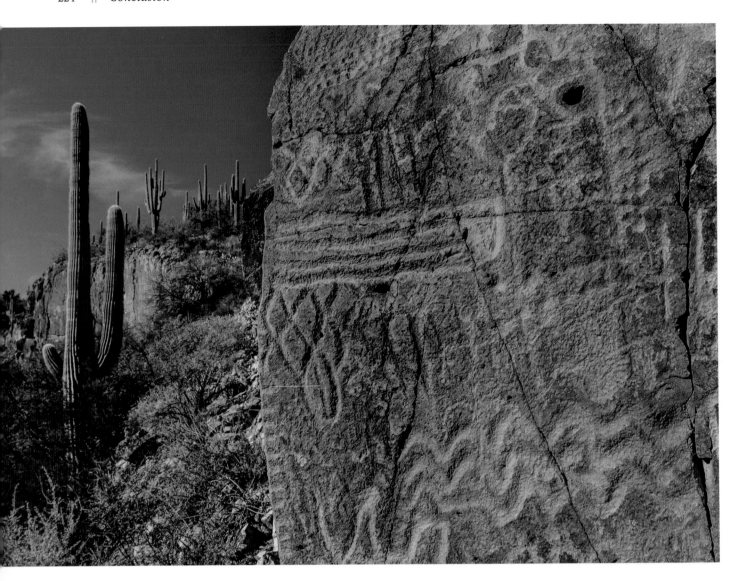

C.1 Deeply gouged, early Western Archaic Tradition petroglyphs, including dot fields, parallel lines and meanders, indeterminate abstracts, and a serrated edge, Arizona

Since it is presently assumed that the earliest entrants to the New World could have arrived before the end of the Last Glacial Maximum at about 20,000 to 19,000 years ago,[3] it seems undeniable that they were physically and mentally no different from their counterparts in the rest of the world. They set foot on a continent teeming with animals and empty of other humans. One would expect these Paleoamericans, whose lifeway was nomadic, based on hunting and foraging, to have left behind, like their Upper Paleolithic counterparts, pictorial representations of large Ice Age herbivores and their predators with whom they shared the Pleistocene landscape. But that is not the case.

One might conclude that the near-total absence of figurative Ice Age art in America is due simply to preservation issues. Unlike Franco-Cantabrian Europe, where most of the visual artworks were preserved in deep limestone caves, rock art in North America exists

predominantly in open-air sites or shallow rock shelters that are vulnerable to the elements and therefore more susceptible to deterioration. Or one could posit some sort of "iconophobia" or taboo prevalent among early migrants. Perhaps they feared that the potency exerted by a naturalistically drawn animal could be harmful and that noniconic designs were less dangerous. But there is no hard evidence to support such a tenuous idea. For whatever reason, not a single depiction of ancient bison, musk ox, horse, camel, tapir, saber-toothed cat, giant short-faced bear, and other now-extinct species has been unequivocally identified.[4] They simply appear to be absent from the Paleoamerican "meme pool."

A lone exception, to date, shows that at least some Paleoamericans could make a pictorial representation—

C.2 Ensemble of Upper Paleolithic linear abstracts from Portugal's Côa Valley Archaeological Park, approximately 12 millennia old

of the Columbian mammoth (*Mammuthus columbi*). There is ample archaeological evidence in the form of kill sites that mammoth and mastodon on occasion were hunted and eaten by the early settlers of North America. Three realistic portrayals of these long extinct beasts are currently known in the Western Hemisphere—two in the form of petroglyphs near the town of Bluff in southeastern Utah (fig. C.4)[5] and one an incised image on a portable piece of fossil bone found at Vero Beach, Florida.[6]

In the absence of reliable dating methods for petroglyphs, the mammoth images can be regarded as their own singular chronological markers. German archaeologist Christian Züchner describes the concept of "self-dating" of a rock art image as "when it shows a certain object, a certain symbol, or an extinct animal species whose age is known."[7] The presumed end-Pleistocene extinction time of mammoths (13,000 to 12,500 years ago) thereby becomes the key parameter in determining the approximate minimum age for their portrayal. Any depiction of a mammoth would have to be at least that old.

The proboscidean images in the New World clearly "speak for themselves." While they demonstrate that some Paleoamerican mark-makers were capable of figuratively representing at least one animal species, both in parietal and mobiliary art, their extremely sparse occurrence equally confirms that their creators were most comfortable artifying their world with abstract-geometric designs.

Our unprecedented approach to mark-making as something that people *do*—an instance of an overarching universal human behavior called "artification" that has evolved over hundreds of thousands of years—encourages new ways of understanding the enigma of abstract-geometric rock art. Every individual manifestation of art in the world, including dance, music, architecture, poetry, and other arts, including each rock painting and engraving, is an instance of artification. The word *art* is unnecessary, even an obstruction to comprehending rock markings.

C.3 Curvilinear abstracts, seemingly emanating from cavity in cliff face, Oregon

This new perspective provides a neutral alternative term for describing parietal art, and its ethological, evolutionary, and cross-cultural framework bestows a new starting point for reassessing some contentious problems: Why were archaic and other rock markings made in the first place? What were they for? These are big questions that concern interpretation, motivation, function, and attribution of cognitive status.

Although most rock art scholars regard even the simplest early human mark as direct evidence for symbolic expression, we find this monolithic emphasis to be unwarranted in light of the earliest instances of cupules and, especially, recently discovered marks made by *Homo neanderthalensis* and even *H. erectus*. With the concept of artification, these astonishing discoveries need not be pressed into the Procrustean bed of symbol, but still hold their deserved respect as early instances of artification.

We regard "abstract," like "noniconic," as a neutral term, used in contrast (or as an antonym) to the term "representational" (even though some abstract marks may "represent" an idea or thing). Without the burden of assuming a describable symbolic meaning—that a given mark stands for a specific referent—one can ask what else the ability to make abstract-geometric marks tells us about the evolution of the early human mind. The universal appearance of geometric marks made by children in their earliest drawings and by adults when doodling suggests that the behavior of play is a serious motivation for the appearance and efflorescence of creating geometric forms. The pleasures of hand use, motor movement, and entraining sound and movement with others can also explain at least some mark-making. The reason for pounding a cupule may be the desire to bring about a particular effect rather than to create a depression in a rock surface. And the very existence of noniconic markings, especially when made with care, indicates long after the fact that for their makers, mark-making itself may have been its own reward. Simply the effort of creating a mark, with or without symbolic intent, expresses and communicates that the mark had individual and perhaps cultural importance. Much of what has been called "symbolic" (which implies a linguistic, intellectual basis) can more reasonably be called analogical or indexical of the individual emotional motivation and consequent physical effort that went into it.

———

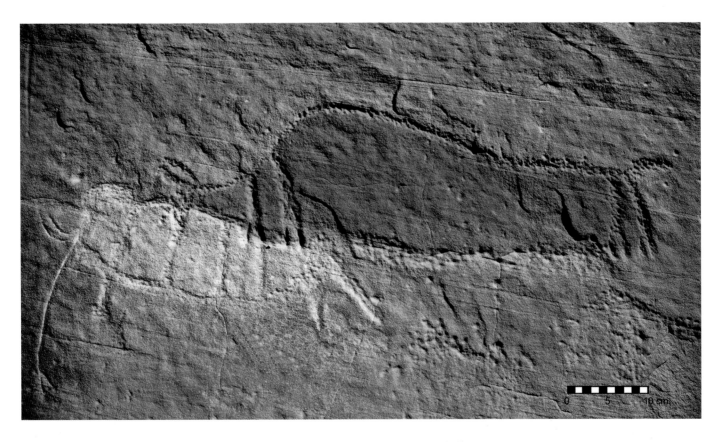

C.4 Mammoth 1 (with overlying bison) and Mammoth 2, the only currently known bona fide figurative Ice Age petroglyphs in the United States, Utah. *Digital enhancements by Julia Andratschke.*

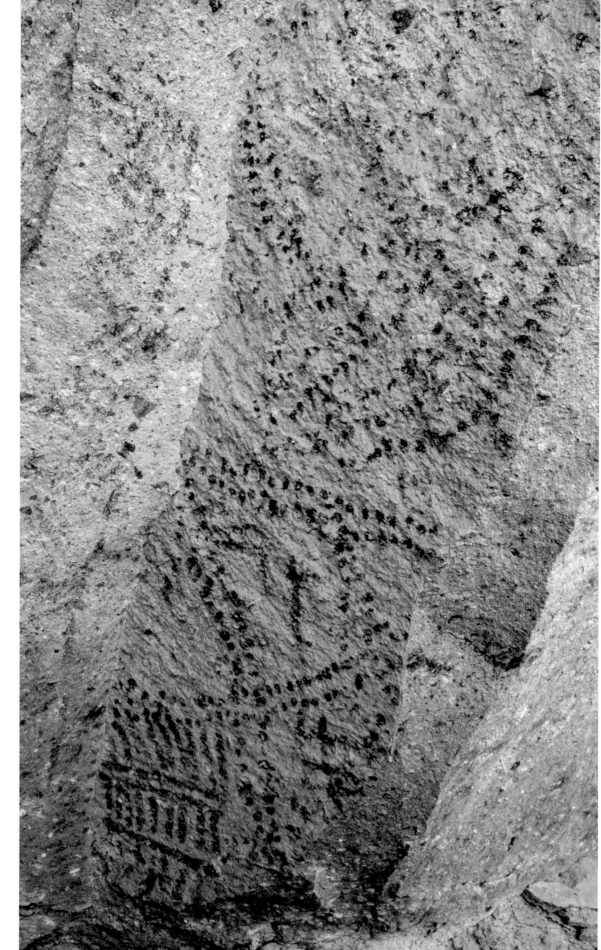

C.5 Painted dot-
and-line patterns,
Arizona

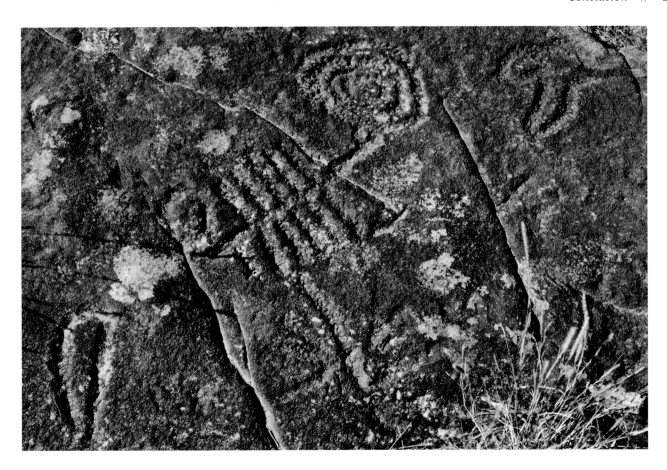

If words and speculations have their shortcomings, no one can deny that the images themselves convey, from mind to mind across the millennia, the aesthetic wonder produced by their makers. The wonder increases when we realize that these New World rock art marks, some of which date from the final stages of the Late Pleistocene, join a body of much older parietal art across the globe that all together provide some of the earliest surviving evidence of human cultural activity wherever it is found. That humans everywhere have been mark-makers is something that is well worth appreciating, even though the images themselves remain mute.

C.6 Elemental geometrics on flat bedrock, New Mexico

Although the images reproduced here were created many hundreds and even thousands of years ago by many different peoples and their original meanings may have been lost over time, their cultural meaning and importance for local native peoples is genuine, deep, and significant. Their heritage is now ours.

The photographs and illustrations are a significant feature of this book, not only to captivate the reader with an assortment of Western Archaic Tradition rock art, but also to instill greater respect for early paleoart with its almost exclusively abstract-geometric markings that have generally been underappreciated by the broader public. There is no question that the American West constitutes one of the premier rupestrian theaters in

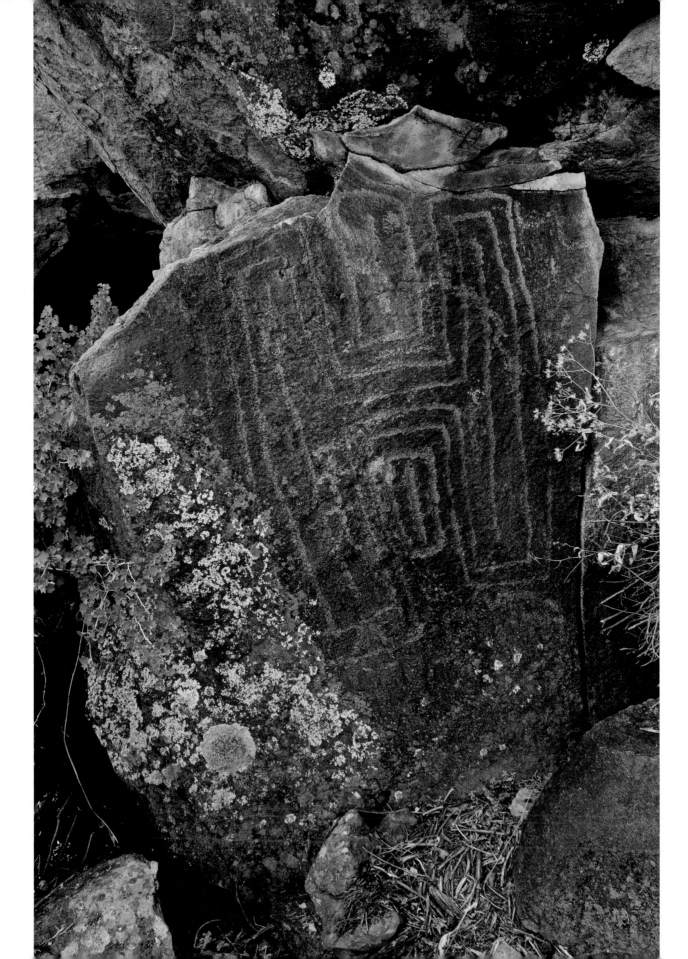

the world, featuring imagery that truly has the power to awe. Its deep-time origin and aesthetic appeal deserve greater acknowledgment as a priceless legacy that Paleo-americans and their descendants have bestowed on us. In addition to presenting this artistic Native American patrimony in the context of the universal behavior of artification, we showcase it through striking images that should help overcome the dominant bias for figurative art and encourage all of us to make every effort to preserve these enigmatic geometrics for future generations to enjoy.

Although this impressive corpus of rock art does not receive the official recognition and protection that it is due, we acknowledge that a number of rock art locales, ranging from entire archaeological districts to small individual panels, can be found on the National Register of Historic Places. Many more are deserving of this status. While the United States can boast a lengthy list of UNESCO World Heritage sites that have been recognized for their primarily natural values, a rock art location of prehistoric cultural singularity still awaits such consideration. We think that there are deserving WAT candidates (such as Wees Bar, Idaho; Winnemucca, Nevada; or Long Lake, Oregon) that would qualify for worldwide recognition and for nomination to UNESCO World Heritage status.

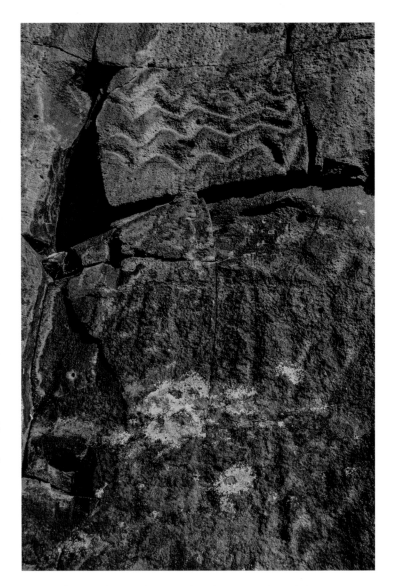

C.8 Deeply gouged serpentine meanders above severely eroded geometrics of indeterminate configuration, Arizona

C.7 (*opposite*) Grapevine Style motif, a late example of the Western Archaic Tradition design corpus, Arizona

NOTES

INTRODUCTION

1 Bilbo et al. 1979:244.

2 The earliest known hand axes are from present-day Ethiopia, dated to approximately 1.7 million years ago (Lepre et al. 2011). Hearths apparently existed from at least 300,000 years ago (Graber 2014), and the oldest known intentional burial occurred ca. 100,000 years ago (Lieberman 1993). *Homo erectus* made geometric markings on bone as early as 400,000 to 300,000 years ago (Mania and Mania 1988) and on shell ca. 500,000 years ago (Joordens et al. 2015). The earliest known cupules are from approximately 200,000 years ago at the Sai Island site in the Nile River of northern Sudan (Van Peer et al. 2003).

3 European researchers of Upper Paleolithic imagery typically employ the designation "sign" for any enigmatic, nonfigurative marking. Since it is not common in the United States, we will not use it here.

4 Feliks 1998; Watson 2009:114–15.

5 For some illustrations, see Brody (1991: figs. 12 and 41–42, and plate 6).

6 For outstanding examples of purely aesthetic geometric configurations, see McCreery and Malotki (1994:figs. 7.1 and 7.4–7.8); Malotki and Weaver (2002:plate 127).

7 Bednarik 2013:68.

8 Clottes, pers. comm., 2014.

9 Bahn 2016:269.

10 We therefore do not share Pat Shipman's conclusion that "the main topic of prehistoric art was undoubtedly medium to large animals" (2010:520).

11 Bahn 1998:xvi.

12 Hodgson 2000:4.

13 Sheridan 2005:423.

14 Kellogg et al. 1965.

15 Representational marks are assumed to have first appeared around 36,000 years ago in southwestern Europe and to have occurred much later on most other continents. However, for a possibly earlier appearance in Southeast Asia, see Aubert et al. (2014) and note 3 in chapter 4. In the category of portable art, the world's oldest known examples of sophisticated figurative sculptures, made from ivory and hailing from the Swabian Jura of southwestern Germany, have been dated to the Aurignacian at 40,000 years BP (Conard 2016:43).

16 As Dale Guthrie (2005) points out repeatedly, contrary to the prevailing literature, much of Paleolithic art was made casually by inexperienced, unskilled artists and therefore is rarely reproduced in art books. We readily admit that our sample of photographs, too, is biased toward the aesthetically most impressive examples of WAT-type paleoart. As it is, millions of abstract-geometrics representing the tradition in the American West are of rather poor quality and are underrepresented in our work.

17 Van Peer et al. 2003. See also Lorblanchet and Bahn (2017:191–92).

18 Ellen Dissanayake has written extensively about other arts and art-making in general (see the bibliography).

19 Boas 1955/1927.

20 Midgley 1978.

21 Scupin 2003:58; Whiting 1986.

22 Brown 1991.

23 Brown 1999:382.

24 Brown 1991:130–41. See also Pinker (2002:435).

25 Pinker 2002:55.

26 Watson 2009:48.

27 Carroll 1956:216.

28 Brown 1991:27.

29 Whorfianism's extreme position that linguistic traits condition and channel people's view of the world is now widely rejected by linguists as a dead proposition. Nevertheless, the idea that language shapes people's thoughts and behavior is very much alive, not only among the lay public but also in the academic world. As McWhorter (2014:xvi) points out, there is a new generation of researchers, known as Neo-Whorfians, who through clever and elegant experiments try to prove a linkage between language and cognition. As a rule, however, their experiments show only that "language's effect on thought is distinctly subtle and, overall, minor."

30 Carroll 1956:57–58.

31 Girdansky 1963:38.

32 Euler and Dobyns 1971:21.

33 Rossi-Landi 1973:18.

34 Malotki 1983:183–86.

35 Malotki 1983:vii.

36 Malotki 1983:239–501.

37 Dissanayake 1992:34.

CHAPTER 1: THE CONCEPT OF ARTIFICATION

1 Dutton 2009.

2 Tedlock and Tedlock 1975: xii–xvi. The correct spelling of the Hopi phrase is *a'ni himu*.

3 For example, Tonkinson 1978:96; Hodgson 2012.

4 Dart 1974; Bednarik 1998.

5 Oakley 1981.

6 Ibid.

7 Steguweit 2003.

8 For photos of the drawn bone fragment in fig. 1.5, see Meller (2005:12–13).

9 Mania and Mania 1988:91. For photos of additional deliberately incised bone finds at the Steinrinne site near Bilzingsleben, see Mania and Mania (n.d.:35). For some reason, the site is not included in von Petzinger's "world's largest database of geometric signs" (2016:264).

10 Beaumont 1990, 1999. McBrearty (2001) reports ocher mining at 285,000 years ago in what is now Kenya.
11 Jones 1940; Cooke 1963; Klein 1978.
12 Henshilwood et al. 2011.
13 Rouzaud et al. 1996.
14 Jaubert et al. 2016.
15 Bahn and Vertut 1997:25.
16 Dissanayake 2000b, 2008.
17 Dissanayake 2009.
18 Huxley 1914; Hinde 1982; Eibl-Eibesfeldt 1989b:439–40; Tinbergen 1952. Also see chapter 7 in this book.
19 Schaafsma 2013:4.
20 Wade 2006:66.
21 Clottes and Lewis-Williams 2007.
22 Dissanayake 2007:784.
23 Foley 1988:213. Foley also reminds us that although very early hominins may not have been hunters in the same ways as later ones, the former were, in any case, not directly ancestral to modern humans.
24 Givón and Young 2002.
25 Ibid.; Boehm 1999.
26 These are described by Bjorklund and Pellegrini (2002:265, based on Harris 1995).
27 Dissanayake 2000a.
28 Dissanayake 1999, 2000a, 2000b.
29 Clottes 2016:29.
30 Ibid.:34.
31 Atran 2001:375.
32 Lienhardt 1961.
33 Guthrie 2005.
34 Keeling 1992.
35 Schore 1994, 2003.
36 Schore 2003.
37 Schore 2012:7. See also McGilchrist (2009).
38 Henrich et al. 2010.
39 However, see Varella et al. (2011); Hodgson (2012).
40 See examples in Zeki (1999) and Solso (1994).
41 Ouzman 1998, 2005; Reznikoff 2008; Clottes and Lewis-Williams 2007.
42 Guthrie 2005.
43 Coe 2003.
44 Anderson and Kreamer 1989; Aiken 1998; Taçon 1991.

CHAPTER 2: TERMINOLOGY, CHRONOLOGY, AND DATING OF NORTH AMERICAN PALEOMARKS

1 Hedges 1982.
2 Quinlan 2012:5.
3 Turpin 2001:405.
4 Hedges and Hamann 1995:89.
5 Turpin 2001:361.

6 Instead of stating radiometric dates with their error parameters marked by ±, we list all dates or ages for the Americas in calibrated calendar years, which reflects more accurately the approximate "actual" time of manufacture. Translation of radiocarbon into calendar years was calculated with the Web-based program CALIB 67.1.1. by Stuiver and Reimer. For simplicity, and because the focus of our work is not dependent on ultraprecise chronological results, only a rounded-off midpoint as the most probable median calendar age is reported.

7 Keyser and Klassen 2001:143–44.

8 Heizer and Baumhoff 1962.

9 Turpin 2001:371.

10 Woody 2000:156.

11 Cole 1990:45.

12 Nissen 1982:391.

13 Adovasio and Pedler 2016:24.

14 Ibid.:27. A pre-Clovis presence of humans in South America has meanwhile also been demonstrated at Huaca Prieta, Peru, with archaeological evidence dated at 15,000 BP (Dillehay et al. 2017). An even earlier age of more than 20,000 years has been postulated for Pedra Furada, Brazil (Boëda et al. 2014).

15 Bradley and Stanford 2004:472. Adovasio and Pedler (2016) offer a synopsis of the most important paleosites in the New World, grouping them into Clovis- and Folsom-age sites, disputed pre-Clovis sites, legitimate pre-Clovis sites, and controversial pre-Clovis sites.

16 Waters et al. 2011.

17 Bourgeon et al. 2017.

18 For a map showing the distribution of approximately 12,000 Clovis points in North America, consult http://pidba.utk.edu. It clearly demonstrates that the southeastern United States produced the overwhelming number of Clovis sites.

19 Rasmussen et al. 2014.

20 Stanford and Bradley 2012.

21 Goebel et al. 2008:1501.

22 Collins et al. 2008:196; Holen 2006:41; Goodyear 2009:8. According to Alison Stenger (2014:5), "We now know that the Americas were occupied 20,000 years before Clovis aged cultures emerged. Well dated sites now extend beyond 31,000 years of age in both North and South America, and multiple sites dating from 30,000–17,000 are not uncommon."

23 Collins et al. 2013:531.

24 Nichols 2002:277.

25 Nettle 1999.

26 Goebel et al. 2008:1500. For a database of human habitation sites in the Americas allegedly surpassing this maximum limiting age with time frames of up to over 200,000 years ago, see Paulette Steeves's website: www.whippdb.com/Western_Hemisphere_Indigeno.php.

27 While it is true that no skeletal remains currently exist that can be attributed to non-*sapiens* humans on New World soil, an explosive new discovery at the Cerutti Mastodon site near San Diego, California, suggests that a mysterious ancient group of people, possibly relatives of Neanderthals, left evidence of butchering or processing a mastodon some 100,000 years earlier than commonly thought. According to archaeologist Stephen R. Holen and colleagues (2017), the site contains spiral-fractured proboscidean femur and molar fragments in direct association with hammerstones and stone anvils which, in the eyes of the investigators, unambiguously indicate human activity. Dated to the early late Pleistocene epoch of 130,000 years BP by Uranium-Thorium radiometric analysis, the Cerutti Mastodon Site would thus

be the oldest reliably documented site in North America and drastically rewrite the arrival time of *Homo* in the Western Hemisphere.

Understandably, this bombshell discovery has set off a firestorm of reactions, ranging from mild skepticism to severe criticism, shock and disbelief, and outright condemnation. In the eyes of many researchers, it is a classic case of an extraordinary claim requiring extraordinary evidence, which they argue the team around Stephen Holen has not provided (Haynes 2017).

28 Stanford and Bradley 2012.

29 Erlandson et al. 2007.

30 Munyikwa et al. 2011.

31 Pringle 2011:38–39.

32 The Pleistocene-Holocene transition is sometimes also referred to as the Paleoarchaic period (Beck and Jones 1997). The beginning of the Holocene tends to be equated with the end of the Younger Dryas cold period at about 11,700 calendar years ago (Grayson 2011:63).

33 Bahn 1998:143.

34 Pettitt and Pike 2007:28.

35 Taçon and Langley 2012:1129.

36 Rowe 2012:573.

37 Bahn 2003:40.

38 Pettitt et al. 2009; Combier and Jouve 2012.

39 For a detailed analysis of the unreliability of cation-ratio dating, see Watchman (2000).

40 Liu, n.d.

41 Liu and Broecker 2008.

42 Hovers et al. 1997.

43 Bégouën and Clottes 1991.

44 Collins 2002:fig. 7.

45 Waters and Stafford 2007.

46 Wernecke and Collins 2012:671.

47 Lemke et al. 2015:114 and table 1.

48 Stanford and Bradley 2012:66.

49 Clark Wernecke, pers. comm., 2012.

50 Lemke et al. 2015:114.

51 Wernecke et al. 2006.

52 Bowen 1986.

53 Klimowicz 1988.

54 Aikens 1970:82–83; Schuster et al. 1986–88:944.

55 Davis et al. 2009.

56 Collins 1998:figs. 7–16e.

57 Online at www.texasbeyondhistory.net/kincaid/stones.html.

58 Greer and Treat 1975:fig. 1.

59 Hester et al. 1972:102, fig. 93g. A second specimen, still unpublished, was brought to my attention by George Crawford, pers. comm. 2013.

60 Gingerich 2009:380.

61 Coe 1964:81–82; Schuster et al. 1986–88:1036–47.

62 Over time the descendants of Clovis became Folsom. Their culture is dated from approximately 12,900 to 12,200 years ago and is thought to have developed on the High Plains as part of a bison-hunting adaptation.

63 Wilmsen and Roberts 1978:fig. 128.

64 Frison and Stanford 1982:fig. 2.109k.

65 Gramly 2002:fig. 49.

66 Robinson IV 2009:fig. 17.

67 Wernecke and Collins 2012:669.

68 Lemke et al. 2015:fig. 7.

69 Sellards 1916:plate 22.

70 Clark Wernecke, pers. comm. 2012.

71 Frison and Stanford 1982:169.

72 Walker et al. 2012.

73 Todd Surovell, pers. comm. 2014.

74 Stanford and Bradley 2012:fig. 2.13; Purdy 2012:fig. 10a.

75 Haynes 2002:156.

76 Hemmings 2004:187.

77 Stanford and Bradley 2012:59–60, fig. 2.13e.

78 Gramly 1993:52.

79 Wilke et al. 1991:fig. 16.

80 Bement 1999:fig. 49.

81 Hemmings 2004:67.

82 Largent 2004:18.

83 Francis 1997; Denver Museum of Nature and Science, http://dmns.lunaimaging.com.

84 Hester et al. 1972:fig. 99b.

85 Walker et al. 2012:701, fig. 5e.

86 Purdy 1991:figs. 81a and c.

87 Lewis 2009:32–33, fig. 15.

88 Gingerich 2009:389.

89 For a compilation of potential Paleoindian art objects in North and Central America, including artifacts of ornamentation, see Lemke et al. (2015:table 2).

90 Purdy et al. 2011; Purdy 2012:215.

91 Tesar 2016.

CHAPTER 3: CUPULES AS AN ARCHETYPAL ARTIFICATION

1 Taçon et al. 1997:961.

2 Cup-and-ring petroglyphs occur throughout the world, but are especially common on the British Isles and other sites along the Atlantic seaboard. In the American West, they are heavily concentrated in the coastal ranges of northern California. For a summary selection of cup-and-ring petroglyphs in California, see Mark and Newman (1995).

3 Duncan Caldwell, pers. comm., 2016. For a photo, see his website: www.duncancaldwell. com/Site/Rock_Art_Photos/Pages/Rock_art_near_Paris,_France.

4 Giedion 1962:137.

5 Peyrony 1934.

6 Michel Lorblanchet, pers. comm., 2014.

7 Jean Clottes, pers. comm., 2013.

8 Van Peer et al. 2003:190.

9 Bednarik 2008b:7.

10 Lorblanchet 1999:200; Lorblanchet 2015:347; Blinkhorn et al. 2012:180. OSL, AMS radio-carbon, and U-Th series dating undertaken by Kumar and Bednarik (2012:202) yielded no satisfactory results other than their conclusion that the petroglyphs must be older than 100,000 years.

11 Parkman 1995a:3–4.

12 Ibid.:3.

13 Bednarik 2008a.

14 Bednarik 2011:125.

15 Watson 2009:50.

16 Nissen and Ritter 1986; Parkman 1995b.

17 Flood 1996:29.

18 Christensen 2005:74.

19 Krishna and Kumar 2012:1239–55.

20 Ibid.:1251.

21 Benson et al. 2013.

22 Christensen 2005:75.

23 Heizer and Baumhoff 1962. With regard to the panglobally observable temporal precedence of noniconic over iconic elements, Steinbring (1995:133) considers pits and grooves as "the theoretical distillate of all forms." Elemental forms, in his eyes, are "the most basic meaningful marks attributable to the human species" that "cannot be further divided in rock-art taxonomies of form."

24 Marymor 2003:2.

25 Gillette 2011:fig. 1.2.

26 Gillette and Hylkema 2010.

27 Donna Gillette, pers. comm., 2012. See also notes 48 and 49 in this chapter

28 Gillette 2011.

29 Photos of PCN-type glyphs from the Hopland area are offered by Beauchamp at rockartoregon.com/pcn-marked-boulders-near-hopland-hrec.

30 See Gillette (2011:fig. 4.2).

31 For a summary listing of PCN locales, see Gillette (2011:44–64).

32 Steinbring and Buchner 1997:76.

33 Malotki 2013:212.

34 Steinbring 2004:141–42.

35 Steinbring and Buchner 1997:80.

36 Parkman 1994:14.

37 Heizer and Baumhoff 1962:20.

38 For two examples of faceted boulders, see Grieder (1982:figs. 13, 14).

39 Nissen 1975; 1982:238–40.

40 Eric Ritter, pers. comm., 2012. For a photo of a "facet," see Nissen (1995:fig. 2). In the same article, Nissen (1995:70) concedes that the curious phenomenon may represent an "ecofact."

41 Parkman 1995b:24.

42 Woody 2000:166.

43 Smith et al. 2013:121.

44 Bednarik 2008a:91–92; Parkman 1995a:8–10, 1995b; Christensen 2005:76–77.

45 A use-wear/residue analysis conducted by Duncan Wright and colleagues at a cupule site in Western Arnhem Land, Australia, determined that some of the cup-shaped petroglyphs contained plant and animal remains, evidence that those pits may have been used for utilitarian tasks such as processing plant materials and animal products. (Wright et al. 2014:97).

46 Henry Wallace, pers. comm., 2009.

47 See note 27.

48 Barrett 1952:387. According to ethnographic sources, among the Pomo such cupule sites facilitating human fecundity and used by couples wishing to have children were known as "baby rocks" (Parkman 1995a:8).

49 For an illustration of the resulting pits, see Mountford (1976:213; plate 206).

50 The obvious juxtaposition of cupules and engraved pubic triangles on an Aurignacian boulder (believed to be some 35,000 years old) at the rock shelter of La Ferrassie, France, is generally seen as one of the earliest known examples for this symbolic connection (Michel Lorblanchet, pers. comm., 2014). For a photo, see Don Hitchcock's extensive website, available at donsmaps.com/ferrassie.html.

51 Grieder 1982:43; Parkman 2007:4.

52 Parkman 1993.

53 Smith and Walker 2011:89.

54 Bednarik 2008d:215.

55 Parkman 1993:101.

56 Callahan 2004.

57 Flood 1997:148.

58 Ouzman 2005. See also other examples in Bednarik (2008a:74–76).

59 Wallace (2008:191) astutely suggests that cupules resulting from chiming points of "bell" or "ringing" rocks should probably not be classified as petroglyphs.

60 Bruder 1983.

61 See examples in Bednarik (2008a:76).

62 Parkman 1993:99.

63 Steinbring and Buchner 1997:77.

64 Wernecke and Collins 2012.

65 Wallace 2008:213.

66 Boas 1955/1927.

67 Parkman 1994:14.

68 Williams 2012.

69 Understandably, establishing ritualistic motivation for a particular cupule panel may be next to impossible. A rare exception appears to be Rhino Cave in Botswana (chronologically placed to the Late Pleistocene period of the Middle Stone Age), where manifold archaeological clues suggest ritualized behavior at the site (Coulson et al. 2011:50).

70 Krishna and Kumar 2012:1252. The authors report that the modern replicators of the Madhya Pradesh cupules suffered fatigue and pain and often had to stop to rest.

CHAPTER 4: ANCESTRAL MINDS AND THE SPECTRUM OF SYMBOL

1 Shea 2008. In 2017, at the Moroccan site of Jebel Irhoud, new discoveries of 300,000-year-old tool assemblages and directly associated human remains with overriding *sapiens* features have challenged the long-held orthodox view that modern humans evolved in East Africa 195,000 years ago (Richter et al. 2017).

2 Stringer 2011:26, 202–3.

3 Conard 2007:2023.

4 For other criteria of cognitive modernity, see following discussion.

5 For more information about the peopling of the Americas, a contentious and unresolved topic in North American paleoarchaeology, see chapter 2 of this book.

6 For example, Nowell 2010:447.

7 Pfeiffer 1982. As late as 2005, archaeologist Nigel Spivey describes the cave paintings of Paleolithic Europe as "the best-preserved and most visible signs of the global creative explosion," a phenomenon that in his eyes "marks the ascendancy of a particular biological species, the 'knowing human' type that has come to dominate the Earth's surface" (Spivey 2005:23–24).

8 Mellars and Stringer 1989.

9 Klein and Edgar 2002.

10 Diamond 1999.

11 Additional well-known proponents and adherents were Mithen (1996) and White (1992).

12 The curator, Jill Cook, also says: "All art is the product of the remarkable structure and organisation of the modern brain. By looking at the oldest European sculptures and drawings we are looking at the deep history of how our brains began to store, transform and communicate ideas as visual images. The exhibition will show that we can recognize and appreciate these images. Even if their messages and intentions are lost to us the skill and artistry will still astonish the viewer."

13 Although Jill Cook mentions archaeological evidence from South Africa that indicates modern cognition from about 100,000 years ago, the exhibition concentrates on Ice Age "art." For most late twentieth-century archaeologists, Aurignacians were the first modern humans.

14 Aubert et al. 2014; Brumm and Aubert 2015.

15 Mania and Mania 1988; Steguweit 2003.

16 Mania and Mania (n.d.), however, speak of a "symbolic-like representation" in regard to the incisions that in their eyes "preconditions . . . the capacity of abstract thinking and consequently also of speech."

17 Jones 1940; Cooke 1963; Klein 1978.

18 Barham 2002:189; McBrearty and Brooks 2000:528.

19 Barham 1998, 2002.

20 See, for example, Van Peer et al. (2003).

21 Marean et al. 2007.

22 Beaumont and Bednarik 2013.

23 For example, Conard (2007). For a longer list, see d'Errico and Stringer (2011:1061). In company with other gradualists, Conard (2010:7622) argues for gradual "polycentric" (rather than "monocentric") origins of cognitive/cultural modernity.

24 Stringer 2011:214.

25 Sterelny 2012:47.

26 As Stringer (2011:214) put it, "something special" happened in the Upper Paleolithic of Europe.

27 Klein, in Stringer 2011:133; Mithen 1996; White 1992.

28 Nowell 2010:438–39.

29 For a representative sample, see Wadley (2001); Henshilwood and Marean (2003); Zilhão et al. (2010); d'Errico and Stringer (2011); Stringer (2011:115); Sterelny (2012:49).

30 Stringer 2011:125.

31 Without using the word symbolicity, Trinkhaus (2013:413) makes the point that "humans are unique in routinely using extrasomatic material to alter one's social persona, and the earliest evidence of this behavior consists of beads of various materials and natural inorganic pigments."

32 One can think of symbolic marks that are not artifications—for example, an information-bearing mark like a directional arrow. See other examples in following text.

33 Semiotics is a complex subject, and my description of it here will be, of necessity, simplified.

34 Gibson 1979.

35 Deacon 1997:70–71.

36 D'Errico and Stringer 2011:1060.

37 A thorough and excellent introduction to the subject of symbolic cognition is Deacon 1997.

38 Henshilwood and d'Errico 2011.

39 Beaumont 1990. Harrod (2014) accepts an even earlier beginning for the emergence of symbolic behavior in the form of paleoart. While in his opinion there already exists archaeological evidence for this onset about 1 million years ago—a timeline not shared by other paleoanthropologists—he suggests that present archaeological findings might actually support pushing this date back to about 2 million years ago as possibly indicated by several Oldowan artifacts attributed to *Homo habilis* (or a sister species) or even an early *H. erectus*.

40 Barham 2002:189; McBrearty and Brooks 2000:528.

41 Barham 1998, 2002. For additional locations with ocher finds dated to the Lower Paleolithic period, see Bahn (2015:327–28).

42 Marean et al. 2007:907.

43 Henshilwood et al. 2011.

44 Henshilwood, d'Errico, and Watts 2009. Readers may remember that similar marks appear on small pieces of stone at the Gault site in Texas that date to the Pleistocene-Holocene transition (see figs. 2.16 and 2.17 in chapter 2).

45 Henshilwood et al. 2009.

46 Marshack 1976:140. For the actual artifact, see Marshack (1976:fig. 6).

47 Feliks 2011. The significance of a second noniconic Neanderthal engraving, the crosshatch motif found on Gibraltar (see fig. 1.7 in this book) has been regarded as definitive proof for the "Neanderthals' capacity for abstract thought and expression" (Rodriguez-Nadal et al. 2014). Grens 2014.

48 Joordens et al. 2015.

49 Grens 2014; Joordens et al. 2015.

50 D'Errico and Stringer 2011.

51 Vanhaeren et al. 2006.

52 Bar-Yosef Mayer et al. (2009) found perforated marine shells with signs of wear from stringing at Qafzeh Cave at 92,000 years; Vanhaeren et al. (2006) at Oued Djebbana at 90,000 years; d'Errico and Hombert (2009) at Ifri n'Ammar at 83,000 years; and Bouzouggar et al. (2007) at Grotte des Pigeons at 82,500 years ago. At Blombos, "perforated marine shell ornaments" are 75,000 years old (Henshilwood et al. 2004). At Denisova Cave in the Altai Mountains of Siberia, carefully perforated, rounded, disc-shaped ostrich eggshell beads, made by a hominin relative of Neanderthals, have been dated to 45,000–50,000 years (Zubchuk 2016).

53 Vanhaeren 2005.

54 White 1992. See also numerous references in Henshilwood et al. (2009:28).

55 Sterelny 2012:53–54.

56 Henshilwood and d'Errico 2011:89.

57 Scardovelli 2013.

58 Kellogg 1969. I emphasize that by referencing children's drawing development here I do not mean to equate the minds or behavior of early human adults with human children of today.

59 Morris 1962; Lenain 1997.

60 Cited in Balter 2002:248.

61 Burghardt 2005.

62 Ellis and Bjorklund 2005; Morley 2017.

63 Sterelny 2012:33.

64 Guthrie 2005. I do not concur, however, with Bednarik's extreme view (2008e:179) that sees only a "possibility that a certain portion of Paleolithic parietal art was created by adults."

65 Donald 1991:187 (vocalizations), 120–21 (games).

66 Stringer 2011:64.

67 Boyd 2009. For example, Boyd notes that play "stimulates the release of the neurotransmitter dopamine . . . which encourages further play" (p. 93). He notes, furthermore, that imitation and imaginative play are natural in children, occurring before language acquisition and the ability to correctly attribute the mental states of others.

68 Burghardt 2005.

69 In my own experience, I have found that similar easy dismissal may occur when the subject of interacting with babies is mentioned, as I do at length in chapter 7.

70 Stroh and Robinson 1993.

71 Merker 2000.

72 Phillips-Silver et al. 2010; Phillips-Silver and Keller 2012.

73 Malloch and Trevarthen 2009:4.

74 Fein 1993.

75 Burrill 2010.

76 Lenain 1997.

77 Lenain 1997:120.

78 Lenain 1997:129.

79 Morris 1962.

80 Lenain 1997:165–66.

81 Bednarik (2011:78) is reluctant to call cupules "art," but he does say that "they are important to the origins of symboling because there can be no question about either their intentionality or their semiotic nature. The manufacture of cupules was highly labor intensive and they have no utilitarian roles whatsoever."

82 Van Peer et al. 2003:190. See also Lorblanchet and Bahn (2017:191–92).

83 Peyrony 1934.

84 Henshilwood and d'Errico 2011:89.

85 Peirce 1998.

86 Ibid.

87 Deacon 1997.

88 See also Sterelny (2012:53).

89 Dissanayake 1988:92-101; Sterelny 2012:51.

90 See "costly signal" in the glossary.

91 Sugiyama and Scalise Sugiyama 2003:182.

92 Tambiah 1979.

93 Pettitt 2011.

94 Stringer 2011:211. Mendoza-Straffon (2014:47) also agrees that "the mere occurrence of ochre or other pigments should not immediately be taken as evidence for either artistic or symbolic behaviour."

95 For semiotics of music, see also Turino 2008. Stringer (2011:116) claims that a series of musical notes can be symbolic, but he seems to refer to a written score (i.e., another person can view and reproduce that series), because in the same passage he also mentions the written word. Elsewhere he says that "in conveying meaning, music [singing and clapping] as a form of communication would have formed an important part of the symbolic revolution" (121–22).

96 Bednarik (2003:127) mentions mime or reenactment, say by a successful hunter.

97 Donald 1991:169.

98 Ibid.:198.

99 Ibid.:167.

100 Ibid.

101 Arnheim 1969.

102 It is interesting that although Bednarik (2011:154–59) is highly critical of Donald's thought on early human mentality, he too, like Donald, prominently emphasizes the effects of literacy on the mind.

103 Helvenston 2013.

104 Dissanayake 1992:203.

105 In H. W. Longfellow's epic poem, *The Song of Hiawatha* (1855), Hiawatha teaches his people the art of painting ("picture-writing") as a means of recording their history. In 1884, George de Forest Brush made a painting called "The Picture Writer's Story" in which a handsome Indian male makes line drawings on an animal hide of hunters with bows riding on horses. Both of these inaccurate depictions come from the fantasies of literate minds trying to present preliterate life.

106 For example, Kelly 1995.

107 See educational psychologist Virginia Berninger, cited in Higgins (2014).

108 Pinker and Jackendoff 2005.

109 Panksepp 1998:302.

110 Malinowski 1925.

111 Hallpike 1979; Piaget 1970. Piaget's scheme is too complex to describe here; interested readers are referred to Hallpike's book or to the original publications of Piaget. It should also be said that Piaget's ideas about successive "stages" of cognitive development are out of favor today, in part because of their reliance on the abilities of Western children. I use his scheme here because it makes clear that Western schooling enables and is meant to achieve disembedded, rational cognition that is not required in nonliterate societies.

112 I do not use this shorthand term for differences in hemispheric function in a naïve way, but with awareness of the broader views of contemporary neuroscientists Allan Schore (1994, 2003) and Iain McGilchrist (2009).

113 Like the influential theories of Piaget (1970), Gardner's, too (1983, 1999), have been challenged and are not accepted in all their details by all psychologists; my use of them is general and serves my purposes here. This is not the place to defend particular aspects of their complexities. Mithen (1996:39–42) also discusses Gardner's 1983 ideas with respect to Pleistocene hominin mentality.

114 Ong (1982) and Goody (1977) are among the early scholars who described differences between oral and literate culture and thought.

115 Langacker 1973:36–37.

116 Stringer 2011:207–8.

117 The phenomenon of cupules made by *Homo erectus* and early modern *Homo* certainly supports the possibility of meaningful *pre*-symbolic marks that were unmediated by language. White (1989) accepts that there was visual thinking in the Ice Age.

118 Grandin 1995.

119 Donald 1991:225.

120 Donald 2006:8.

121 Harrod 2014:139.

122 Schore 1994, 2003; Panksepp 1998; Panksepp and Biven 2012.

123 Panksepp 1998:50.

124 Ibid.: 48–50.

125 While writing this book, it was brought to my attention that a group of people in the Amazon, the Pirahã, have no elaborate arts or ritual practices (Everett 2008:69).

126 Miller and Rodgers 2001.

127 Baumeister and Leary 1995.

128 Dissanayake 2000a.

129 Malinowski 1922:146–47.

130 Gell 1992, 1998. Gell's ideas echo those of Radcliffe-Brown (1948/1922:234) who said that for the Andaman Islanders, "ceremonies are intended to maintain and transmit from one generation to another the emotional dispositions on which a society depends for its existence," and Cole (1969a, b, c), who treated "art as a verb" in his studies of the *mbari* ceremony in the Owerri Igbo of Nigeria.

131 Gell 1992.

132 Thomas 2001:4–5.

133 Morphy 1989; Taçon 1991.

134 Faris 1972.

135 Berndt 1971/1958.

136 Price and Price 1980:108.

137 Boas 1955/1927.

138 For example, Pfeiffer 1982; Klein 1989; Mithen 1996; Wade 2006; Balter 2009.

139 Wade 2006:46.

CHAPTER 5: SITES AND STYLES OF THE WESTERN ARCHAIC TRADITION ROCK ART COMPLEX

1 Bednarik 2013:51.

2 Jacobson-Tepfer 2013:figs. 15, 16, 24.

3 The notion that landscape enculturation transforms *spaces* into *places* has been suggested by Gillespie (2007:172, 183) in his analysis of Clovis artifact caches.

4 Malotki and Wallace 2011; Purdy et al. 2011.

5 Hussain and Floss (2015:46) employ this descriptor when they point to the fact that "in contrast to most westerners today, Pleistocene hunter-gatherer groups were 'animal-landscape dwellers' that lived in mammalian, other-than-human-dominated environments."

6 As discussed in Malotki (2017: 21–24), the probability is high that two zoomorphic petroglyphs at the Track Rocks Site near Barnesville, Ohio, depict extinct mastodons (*Mammut americanum*). The recently discovered pictograph of a glyptodon at the archaeologically important World Heritage Site of Serra da Capivara, a national park in northeast Brazil, also warrants mention here. According to de Souza (2016: 56–63), the large armored mammal that is related to armadillos most likely represents the species *Hoplophorus euphractus*, whose distinctive club-like tail tip is clearly shown in the parietal rendition. As such, it constitutes the first reported bona fide portrayal of extinct Pleistocene megafauna from South America.

7 Quinlan 2012:4.

8 Lorblanchet and Bahn 1993.

9 For a thorough inventory of stylistic WAT elements, see the detailed description of the Atlatl Ridge site in Arizona by Wallace (2008).

10 Malotki 2007:186.

11 A survey of 117 rupestrian art sites in the region conducted by Ricks (1995:102) yielded 1,116 (5.5 percent) Carved Abstract elements, in addition to 121 (0.6 percent) Pit-and-Groove markings, and 3,148 (15.6 percent) Rectilinear Abstract and 13,618 (67.4 percent) Curvilinear Abstract petroglyphs. From a total count of 20,216 rock art elements recorded, including pictographs as well as abraded, scratched, indistinct, and historic elements, fully 18,003 or 89.1 percent were engravings attributable to the WAT category.

12 Bacon 1983.

13 Cannon and Ricks 1986; 2007:figs. 8.1–8.3.

14 For a graph illustrating the stratigraphy of the buried Mazama site, see Cannon and Ricks (1986:fig. 4).

15 Heizer and Baumhoff 1962:200.

16 Ricks 1996:54.

17 Cannon and Ricks 1986:fig. 4.

18 Assuming a relatively constant sediment deposition rate of "~20 cm per 2,170 ± 60 ^{14}C years" at the Mazama location, Middleton (2013:25) also tentatively concludes that the site's glyphs may very well date to the terminal Pleistocene.

19 Jenkins et al. 2012.

20 Ibid.:223.

21 Erlandson et al. 2007.

22 For a map listing the approximately eighty pluvial lakes that dotted the Great Basin (with portions in California, Idaho, Nevada, Oregon, and Utah) during the Late Pleistocene, see Grayson (2011:fig. 5.5).

23 Steinbring et al. 1987:156.

24 Bill Cannon, pers. comm., 2010.

25 Middleton et al. 2014:22.

26 Middleton et al. 2014.

27 For a map showing the location of Lake Winnemucca within the one-time extension of ancient Lake Lahontan, see Benson's *The Tufas of Pyramid Lake, Nevada*, online at http://pubs.usgs.gov/circ/2004/1267.

28 Connick and Connick 1992:94.

29 Kirner et al.1997.

30 Orr 1956, 1974.

31 Benson et al. 2013.

32 Pellegrini et al. 2016.

33 Kirner et al. 1997.

34 Nissen 1982:296.

35 Woody 2000:215.

36 Grant et al. 1968:26–27.

37 For a map showing the high density of Carved Abstract sites in southcentral Oregon's Lake County, see Middleton et al. (2014:fig. 2).

38 Beauchamp 2013.

39 Ibid.: 687.

40 Daniel Leen, pers. comm., 2013.

41 Eric Iseman, pers. comm., 2013.

42 Hill and Hill 1974:248–50.

43 Ibid.:251.

44 A sample of the Saddle Mountain engravings is found in Cosgrove (1947:fig. 52).

45 Anthony Howell, pers. comm., 2014.

46 Briuer 1977: fig. 4.1 and table 4.5.

47 Geib 2000:520.

48 Whitley 2013:1.

49 Turpin 2001:363.

50 Tratebas 2012a:108.

51 Hoffecker et al. 2014.

52 The style owes its eponym to archaeologists Don Christensen and Jerry Dickey (2001).

53 Malotki 2007:46–55.

54 Wallace 2008:221.

55 Wallace 2008.

56 Ibid.:226.

57 Ibid.:227.

58 Ibid.:228.

59 Watson 2009.

60 Schaafsma 1992:43.

61 Heizer and Baumhoff 1962:197–200.

62 Hedges 1982.

63 Heizer and Baumhoff 1962:208.

64 Ritter 1994:61.

65 Ritter 1994.

66 Loendorf 2008:75–79.

67 Woody 2000:162; Watchman cited in Quinlan and Woody 2003:390.

68 Wallace 2008:194.

69 Layton 1991:170.

70 Malotki 2007:56.

71 Ibid.:60–67.

72 Ibid.:68–75. Because the style's sites feature predominantly monochrome elements and occur in a relatively small enclave of the Grand Canyon region, Christensen and Dickey (2004) have renamed this painted expression Esplanade Style.

73 Malotki 2007:76–87.

74 Younkin 1998.

75 Cole 2004.

76 White 2005.

77 Francis and Loendorf 2002.

78 Boyd 2003.

79 Heizer and Baumhoff 1962; Schaafsma 1980; Wallace and Holmlund 1986; Cole 1990; Hedges and Hamann 1993; Woody 2000; Turpin 2001.

80 Contrary to Wallace's contention (2008:198) that handprints and animal tracks have not yet been reported for Arizona's WAT-type rock art, I am aware of numerous sites where they exist. For a nice example along Lyman Lake, see figure 5.35 in this book. Additional examples of these motifs exist at the Ricker site in Arizona's Sierra Ancha Wilderness region; the Punk site north of Ash Fork; the Clamshell site near Fredonia; the Midling site in the Picacho Butte area southeast of Seligman; the Hummingbird Point site along the Gila River; the Double Barrel site east of New River; and the Hardscrabble Wash site north of St. Johns.

81 Mulvaney 2010.

82 Pike et al. 2012.

83 Clottes 2002:92.

84 Hodgson and Helvenston 2007:122.

85 Hodgson and Helvenston 2006:12–13.

86 Feliks 1998:109.

87 Feliks 2006.

88 Bradshaw 1998:126.

89 Tratebas 2012a:108.

90 Malotki 2013.

91 Carden 2009.

CHAPTER 6: ORIGINS AND FUNCTIONS OF ABSTRACT-GEOMETRIC MARKINGS

1 Hedges 2005:100.

2 Bahn 1998:xv.

3 Hodgson 2003:117.

4 Turpin 2001:363.

5 Keyser and Klassen 2001:146.

6 Shipman 2010. According to Shipman (2010:524), the "animal connection," as she calls this human behavior, played such a big role in the evolution of *Homo* that it ultimately led not only to the making of tools but also the development of symbolic behavior, including figurative art and language. If animals were that important to people, one wonders why Paleoamericans for so many thousands of years after their arrival refrained from depicting the plethora of wild megafauna that surrounded them. For humans' aesthetic appreciation of nonhuman animals, see also Stephen Davies (2012:65–85).

7 For Jean Clottes (2008:20), these are "one of the most significant and mysterious characteristics" of European parietal art.

8 See also Gustav Klemm (1989/1851) and Gottfried Semper (2004/1860–63), who speculated that geometric designs preceded figurative imagery. Wilhelm Worringer (1953/1911) proposed that early humans, feeling anxiety and fear in the face of the unpredictability of nature, created as a countermeasure geometrically lawful shapes that they preferred and perpetuated because their order and regularity seemed to control or replace disturbing chaos. None of these important early scholars specifically discussed rupestrian art.

9 Boas 1955/1927:118.

10 Ibid.:13–16.

11 Bell 1914; Fry 1923.

12 Breuil 1952.

13 Bahn and Vertut 1997:51.

14 Eshleman 2008.

15 Bahn and Vertut 1997:172. See also von Petzinger (2016:219–42), who offers additional possible real-world meanings for certain Upper Paleolithic signs.

16 Heizer and Baumhoff 1962.

17 Nissen 1982:200–201.

18 Wallace and Holmlund 1986.

19 Bahn 1998:234–35; Keyser and Whitley 2006:3.

20 Ricks 1995:2, 151.

21 Woody 2000:55.

22 Quinlan and Woody 2003:374–76.

23 Malotki 2007:174–76.

24 Laming-Emperaire 1962.

25 Leroi-Gourhan 1966:513–14.

26 Marshack 1991:398.

27 Ibid.:14.

28 Ibid.:403, 407.

29 Robinson 1992.

30 See also Murray (2013), who believes that many archaic dot and tally configurations may be grounded in numeracy: that is, numerical order relatable to specific cycles such as "lunar synodic months or other celestial periodicities." Unfortunately, his interpretation is epistemologically not testable.

31 Walsh 1990.

32 La Barre 1979:11.

33 Hedges 1976:126.

34 Bean and Vane 1978:127.

35 Lewis-Williams 1996:126.

36 Klüver 1966.

37 Oster 1970.

38 Bahn 2010:70.

39 Derek Hodgson, pers. comm., 2014.

40 Wallace 2008:164.

41 Quinlan 2000:95.

42 Whitley 2000:89.

43 Whitley 2009:220, 243–45.

44 Helvenston 2012.

45 Schaafsma 1994.

46 Turpin 1994.

47 Turpin 2001:363.

48 Hedges and Hamann 1993:64.

49 Keyser and Klassen 2001:139.

50 Malotki 2007.

51 See, for example, Bednarik (1990); Francfort and Hamayon (2001); Hodgson (2006b); Bahn (2010).

52 Le Quellec 2006:168.

53 Helvenston and Bahn 2005:27.

54 Ibid.:48.

55 Froese et al. 2013.

56 Tom Froese, pers. comm., 2014.

57 Hodgson 2014.

58 Malotki 2007:56–87.

59 Bahn 2010:76. Watson (2008b:2), contra Lewis-Williams, believes that there is no need to invoke ASCs to account for the production of rock art. A much more likely source are dreams, considering that they "are experienced universally, and that the nature of their content is ubiquitous (and reflected in the content of paleoart)."

60 This criticism is also expressed by Helvenston (2015:89) when she argues that "there are still no criteria for distinguishing the art created during normal human consciousness from that created during a natural or drug-induced altered state."

61 Kellogg 1969, 1979.

62 Fein 1993.

63 Watson 2008a:41.

64 Sacks 2012.

65 Ibid.:131–32.

66 Wallace 2008:165.

67 Wallace 2008.

68 Diringer 1962.

69 Harrod 2003:116.

70 Bahn 1998:xxii–xxiv.

71 Attributed to April Nowell in Ravilious 2010.

72 Von Petzinger 2009:139.

73 Ibid.:11.

74 Von Petzinger 2009:134.

75 Online at www.bradshawfoundation.com/geometric_signs/sign_types.php. In a more recent publication, von Petzinger claims that, barring a few one-of-a-kind geometrics that do not fit into her classification system, "there were only thirty-two signs in use across the entire 30,000-year time span of the Ice Age and across the whole continent of Europe" (2016:4). If indeed specific meanings were inherent in these geometric markings, we lack the "code-breaker" to render them comprehensible to us.

76 Derek Hodgson, pers. comm., 2012.

77 Bouissac 1994:360–61.

78 Bouissac 1993:203. In 2015, Anati similarly stated that "prehistoric art is 'Writing before Writing.' It was not produced just to embellish the rock surfaces. It contains messages that could be read thousand[s] [of] years ago: the messages are still there; they can be read and decoded today."

79 Bouissac 2008:61.

80 Pagel 2000:395. Ascertaining when speech arose is, of course, highly problematic because, unlike crania, brains do not fossilize to leave an archaeological clue.

81 Johnston and Schembri 2007:31.

82 Donald 1991; Bednarik 2011:157.

83 In addition to these everyday origin contexts for graphic artification, Dissanayake suggests the possibility that in some cases, early hominins became aware of accidentally created simple patterns on their mud-daubed torsos which then provided a "template" for making more coherent designs (see the body-marking hypothesis section in this chapter).

84 Hodgson 2003:117.

85 Feliks 1998:119.

86 Feliks 2003:113.

87 Hodgson 2003:117. See also Watson (2009:114–15).

88 Siscoe 1976:37.

89 Watson 2008a.

90 Van der Sluijs and Peratt 2008:39.

91 Peratt 2003.

92 Fowler 1992:40.

93 Bednarik 1994a.

94 Anati 1981.

95 van Sommers 1984.

96 Bednarik 1994b.

97 Lewis-Williams and Dowson 1988.

98 Watson 2009:51.

99 Bókkon 2008:169.

100 Kellogg et al. 1965:1129.

101 Bednarik 1994b:153.

102 Kellogg et al. 1965.

103 Engel in Fein 1993:back cover.

104 Bednarik 1990:79–80.

105 Bednarik 1994a:176.

106 Bednarik in Hodgson 2000:18.

107 Hodgson 2006b.

108 Derek Hodgson, pers. comm., 2007; 2003:116.

109 Hodgson 2006a.

110 Ibid.:56.

111 Derek Hodgson, pers. comm., 2007.

112 Hodgson 2000.

113 Hodgson 2008:52.

114 Regarding iconic paleoart, Hodgson's neurovisual resonance hypothesis posits that "the higher brain is particularly primed to be sensitive to animal forms." The hypothesis also "predicts that geometrics will tend to predate the representation of animals in 2D by a considerable period, thus reflecting the visual brain's ease of processing and preferences for such forms." Hodgson (2006b:35) feels that the theory's prediction was clearly vindicated by the discovery of the 77,000-year-old geometric Blombos design that predates earliest Upper Paleolithic figurative art by tens of thousands of years (see fig. 4.9).

115 Hodgson 2006a. See also Worringer (1953/1911).

116 Burrill 2010.

117 Steven Brown, pers. comm., 2014. Also see Bradshaw (2000).

118 In a recent article, Hodgson (2013) discusses the emotional brain and the fear response as well as "socio-emotional factors" such as the development of the mirror neuron system and theory of mind as they relate to the development of *representational* markings. We claim that the emotional brain and socio-emotional factors are important in abstract-geometric mark-making as well. See chapter 7. Seghers (2015:20), too, is critical of Hodgson's neuroscientifically inspired explanatory hypothesis when she points to the fact that it is not evolution-based and merely explains "the mechanics, rather than the nature of the behavioral trait of artmaking."

119 Sreenathan et al. 2008; Pandya 2009; Bednarik and Sreenathan 2012.

120 Endicott et al. 2003.

121 Ibid.:182.

122 Endicott et al. 2003.

123 Pandya 2009:157.

124 Ibid.:144.

125 Thangaraj et al. 2003.

126 The first historic European contact with the islands was in 1780; various visitations mainly by the British and Indians took place thereafter. In 1958, a protected forest reserve of 765 square kilometers (a fraction of their former tribal land) was set up for the Jarawa, and until 1999 they were one of the last remaining Andaman Island tribes not to have been assimilated to the neighboring colonial society—especially those Jarawa who lived in the forest interior and the east coast of their territory (Pandya 2009:107, 206, 207). The entire native Andamanese population declined after early contact from approximately 6500 to 485 in the year 2000 (Pandya 2009:74).

127 According to Mendoza Straffon (2014:72), the practice of ornamenting the body "may be considered a veritable universal human behavior, deeply rooted in our species."

128 For new evidence of even earlier humans in Africa, see note 1 in chapter 4. For stunning examples of how some nomadic people from Ethiopia's Omo Valley still combine earth pigments and exotic accoutrements borrowed from nature to decorate their bodies, see Silvester (2009). For Omo and other parts of Africa, see Beckwith and Fisher (2012).

129 Pandya 2009:104, 108, 146.

130 In the Onge, some applications of white clay paint on the body are associated with clan identity and with the individual's season of birth, or to mark recent ritual transitions from states like mourning or illness (Pandya 2009:110). Calling these uses "symbolic" of these states does not seem warranted (see chapter 4 of this book).

131 Matthews 2013:341–42.

132 Bahn 1998:70–81.

133 Sreenathan et al. 2008:381.

134 McDougall et al. 2005.

135 Faris 1972.

136 Guthrie 2005. See also Bednarik (2008e); Bednarik and Sreenathan (2012).

137 Bednarik 2003:101.

138 Bednarik 2008c:7.

139 Bednarik and Sreenathan 2012:211.

140 Gablik 1976.

141 Piaget 1974. See also our discussion of his ideas in chapter 4.

CHAPTER 7: WHY DID OUR ANCESTORS ARTIFY?

1 Said by Harold Williams, the tribal leader of the Coso tribe in California, in the documentary film *Talking Stone: Rock Art of the Cosos*, available at www.talkingstonefilm.com.

2 Wyatt 2010. See also Darwin's comment to A. R. Wallace in a letter, quoted in Burkhardt (1996:183): "I am a firm believer that without speculation there is no good and original observation."

3 The original full treatment of the artification hypothesis became too lengthy for this book. The interested reader can see Dissanayake (2009, 2014), for more complete versions.

4 Huxley 1914. See also Tinbergen (1952, 1959); Huxley (1966); Eibl-Eibesfeldt (1971, 1989b); Lorenz (1982); Hinde (1982).

5 Smith 1977:328; Eibl-Eibesfeldt 1989b:439–40.

6 Morris 1957.

7 Eibl-Eibesfeldt 1971:44–47.

8 A male Japanese puffer fish species of the genus *Torquigener* works twenty-four hours a day for a week to make an astonishing formalized, repetitious, exaggerated, and elaborate circular pattern in the sand with his fins, as a courtship display. See www.wimp.com/pufferfish-courtship-wait-for-it.

9 Darwin 1871; Miller 2000; Dutton 2009; Varella et al. 2011. Unfortunately, it is beyond the scope of this book to discuss in detail the sexual selection hypothesis or recent critiques of it (e.g., Prum 2017).

10 Dissanayake 1979, 1988, 1992; Watanabe and Smuts 1999.

11 Potts 1996.

12 Mithen 1996:11.

13 Klein and Edgar 2002:52–53. As Falk describes the alterations: "The entire pelvis of bipedal hominins became compressed vertically, so it appears short and squat compared to that of a great ape. The flaring blades of the pelvis also curved around the back to the side, creating a bowl-like shape. Meanwhile, the spine changed with upright walking, so the tailbone curves forward near the bottom of the pelvis, adding to the bowl effect. The result of these modifications is a human pelvis that constricts the birth canal in women" (2009:183).

14 Sometimes called the "obstetric dilemma." See Washburn (1960) and Trevathan (1987).

15 *Homo ergaster* had a narrower pelvis than its predecessor, *H. habilis*, in which rapid brain expansion was occurring between 2 to 3 million years ago (Wade 2006:18–22). "Turkana Lad," a specimen of *H. erectus* of 1.6 million years ago, also had a narrow pelvis (Falk 2009:51).

16 Portmann 1941.

17 Selection did not so much "shorten" or "reduce" the period of gestation but prevent it from increasing as much as it otherwise would have been on track to do (Chisholm 2003:148).
18 Tomasello 2003.
19 Portmann 1941; Gould 1977; Leakey 1994:44.
20 Falk 2009.
21 Rosenberg 1992; Leakey 1994; Falk 2004, 2009; Flinn and Ward 2005:31.
22 Falk 2004:499.
23 Flinn and Ward 2005:31.
24 Fernald and Kuhl 1987.
25 Trevarthen 1979.
26 Morley 2013:205.
27 Monnot 1999.
28 Stern 1971; Beebe et al. 1985; Murray and Trevarthen 1985; Beebe and Lachmann 2014.
29 Stern et al. 1985; Beebe and Lachmann 2014.
30 Chisholm 2003; Gergely et al. 2010.
31 Grant 1968, 1972; Eibl-Eibesfeldt 1989b. (Capitalization of the terms in the following text comes from the sources.)
32 Preuschoft and van Hooff 1997; King 2004.
33 Rogers and Kaplan 2000:121–22.
34 They are used only with infants and, in some modern societies, pets (Hirsch-Patek and Treiman 1982).
35 Panksepp 1998; Miller and Rodgers 2001.
36 Carter 1998; Nelson and Panksepp 1998; Carter et al. 1999; Panksepp et al. 1999.
37 See the "social bio-feedback model" of Gergely and Watson (1999) and Scherer and Zentner (2001) for a description of biofeedback.
38 Chisholm 2003.
39 Dissanayake 2000a, 2001; Falk 2009.
40 See list in Dissanayake (2000b:393).
41 See, for example, Chugani et al. (2001) and McLaughlin et al. (2014).
42 Churchland 2011:14, 48–53; Carter et al. 2009.
43 Donaldson and Young 2008.
44 Numan and Young 2016.
45 Miller and Rodgers 2001; Bjorklund and Pellegrini 2002:104; Flinn and Ward 2005:31; Wade 2006:22; Stringer 2011:113.
46 Churchland 2011:50; Panksepp and Biven 2012:296–97.
47 Porges and Carter 2011.
48 Renfrew 2017. Art critic and philosopher of art Arthur Danto titled his influential book about contemporary Western art *The Transfiguration of the Commonplace* (1981).
49 A very few societies have been reported to have no or only perfunctory ritual ceremonies (e.g., Everett 2008). Unfortunately, there is not space here to challenge Everett's claims.
50 Geary 2005; Churchland 2011:37.
51 Ellsworth 1991.
52 Malinowski 1935:vol. 2:217. See also Malinowski (1948: 60); Lopreato (1984); Rappaport (1999).
53 van Gennep 1960/1909; Turner 1969.
54 Hinde 1982:126.
55 Keltner et al.1993.
56 For example, Flinn et al. 1996:127; Lupien et al. 2009.

57 Whybrow 1984; Sapolsky 1992; Huether et al. 1996.

58 Caporael 1997; Taylor 2007; Churchland 2011.

59 Taylor 1992.

60 Gianino and Tronick 1988.

61 Charmove and Anderson 1989.

62 Beck and Forstmeier 2007.

63 Carter et al. 1999; Miller and Rodgers 2001; Bartels and Zeki 2004; Brown and Dissanayake 2009.

64 Phillips-Silver and Keller 2012:3.

65 Morley 2013:211.

66 Bernieri and Rosenthal 1991; Dugatkin 1997; Chartrand and Bargh 1999.

67 Watanabe and Smuts 1999.

68 Studies of possession trance by neurophysiologist Tsutomu Oohashi and colleagues (2002) and fire-walking in the Anastenaria by anthropologist Dimitris Xygalatas (2012) are notable exceptions.

69 Freeman 2000.

70 Koelsch et al. 2010; Dunbar et al. 2012.

71 Panksepp and Biven 2012:310.

72 Uvnäs-Moberg 1999; Heinrichs et al. 2003; Taylor et al. 2008.

73 Koelsch et al. 2010; Dunbar et al. 2012.

74 Wiltermuth and Heath 2009. See also Sober and Wilson (1998); Novak (2006).

75 Reddish et al. 2013.

76 Shaver et al.1988; Freeman 1995; Carter 1998; Nelson and Panksepp 1998; Uvnäs-Moberg 1999; Carter and Altemus 1999; Miller and Rodgers 2001; Heinrichs et al. 2003; Taylor et al. 2008; Zeifman and Hazan 2008; Dunbar et al. 2012.

77 Hodgson and Verpooten 2015:75.

78 For examples of this omission, see Guthrie (1993); Hinde (1999); Pyysiäinen (2001); Boyer (2001); Atran (2002); McCauley and Lawson (2002); Kirkpatrick (2005); and Rossano (2010), among many others. However, see Alcorta and Sosis (2005) who recognize the importance of the arts in ritual ceremonies for instilling cooperation and solidarity.

79 Feierman 2009; Schiefenhövel and Voland 2009.

80 Malinowski 1948; Radcliffe-Brown 1948/1922:155. See also Garfinkel (2017); Renfrew (2017); Watkins (2017).

81 Damasio 1994; Kyriakidis 2017.

82 While an adaptation (such as the ritualized proto-aesthetic operations of mother-infant interaction) emerges through a history of selection to solve an adaptive problem (the survival of highly immature infants), an *exaptation* (predisposition to engage in and respond to aesthetic operations) corresponds to an already present adaptation (the proto-aesthetic operations that foster mother-infant bonding) and gains a new function (reducing anxiety and joining group members in common cause) without subsequent selection (Seghers 2015:338). (Parentheses are my addition to Seghers's explanation). The scope of this book does not allow a full description of the requirements for considering a behavior to be an adaptation, an exaptation, or a by-product. For more discussion, see Gould and Vrba (1982); Jablonka and Lamb (2005); Gangestad (2008).

83 Bailey and Geary 2009.

84 See, for example, Brody (1977); Garfinkel et al. (2003); Mithen (1996); Taçon (1983); Taçon and Brockwell (1995); Taçon et al. (1996).

85 Hodgson and Verpooten 2015:82.

86 Ibid.:75.
87 Ibid.:76.
88 Ibid.:82.
89 Ibid.: 79.
90 Miall and Dissanayake 2003.
91 See Tomasello (1999, 2008); Tomasello et al. (2005).
92 Stringer 2011; Sterelny 2012.
93 Taçon 1991:194.

CONCLUSION: THE GEOMETRIC ENIGMA

1 Bednarik 2013; Bosinski and Fischer 1980; Jacobson-Tepfer 2013; Solodeynikov 2005.
2 Sauvet and Wlodarczyk 2000–2001:217. According to Paul Bahn (pers. comm., 2016), this total is now substantially higher, considering that there are currently over 400 decorated caves known and also numerous open-air sites.
3 Adovasio and Pedler 2016:27–28.
4 Malotki (2018) suggests that the animal overlying Mammoth 1 at the Upper Sand Island site in Utah most likely depicts an ancient bison (*Bison antiquus*) or possibly a musk ox (*Ovibos moschatus*).
5 Malotki and Wallace 2011; Malotki and McIntosh 2015; Clottes 2013:9.
6 Purdy et al. 2011. See also notes 90 and 91 in chapter 2.
7 Züchner 2001.

GLOSSARY

abstract-geometric design: Rock art marking of basic non-representational configuration. Such marks characterize not only the Western Archaic Tradition (WAT) in western North America but also precede figurative paleoart in most other rupestrian corpora of the world.

abstract motif: Nonfigurative or nonrepresentational rock art marking not recognizable as an object of the real world; frequently used synonymously for geometric motif or as a short form for abstract-geometric motif.

adaptation, adaptive: Biological process by which an organism or species is modified over time by natural selection to become adjusted (fitted) to its environment and thus more likely to survive and have reproductive success.

aesthetic operations: Five typical operations that characterize artification in any modality or medium: formalization/simplification, repetition, exaggeration, elaboration, and manipulation of expectation (surprise) intentionally "performed on" (or "done to") material, subject matter, movements, sounds, surroundings, and words.

altered state of consciousness (ASC): Universal human phenomenon that differs from the "normal state" of consciousness along a continuum ranging from daydreaming and sleep to euphoria, deep trance, and near-death experience.

Anthropocene: A recent term proposed for the current geological epoch during which human activities, beginning with the Industrial Revolution, have had rapid and profound effects on the Earth's ecosystems.

anthropogenic: Human-made.

anthropomorph: Object or rock art motif with a human or humanlike shape.

archaeoastronomical: Relating to archaeoastronomy, the discipline concerned with the reconstruction of prehistoric celestial and calendrical phenomena.

Archaic: In a generic sense and written in lower case, typically refers to ancient nonsedentary hunter-gatherer peoples and/or cultures; in regard to rock art, consists primarily of abstract designs, both curvilinear and rectilinear. With the first letter capitalized, and specifically in the archaeologically accepted chronological sequence of pre-Columbian North American cultural stages, designates the time span following the Paleoindian period beginning ca. 8,000 BCE and lasting in the American West in some regions until contact times. In Europe, uncapitalized, refers to hominins thought to have interbred with species of *Homo*, such as Neanderthals, Denisovans, and *sapiens*.

artification, artify: A concept (not a definition of "art") of a fundamental universal behavior evolved in humans, characterized by a predisposition to make ordinary reality *extra*ordinary (different from the everyday), typically in biologically important circumstances about which individuals and groups care.

atlatl: Throwing stick or board designed to add greater propulsion to a dart or spear by extending the thrower's arm.

Aurignacian. Earliest culture phase of the European Upper Paleolithic, lasting from roughly 40,000 to 28,000 years ago.

Australopithecus; Literally denoting "southern ape," an extinct hominin genus that evolved and lived in Africa between ca. 4 and 2 million years ago.

BCE: Abbreviation denoting years before the Common Era, replacing earlier BC, "Before Christ."

biocentric: Characterizing a rock art style emphasizing life forms such as humans and animals. For its opposite, see *geocentric*.

biomorphic: Pertaining to a figure resembling a biological form—human, animal, or plant.

BP: Abbreviation denoting "Before Present," commonly used in archaeological dating. It actually refers to the year 1950, when radiocarbon measurements became prevalent.

Carved Abstract Style: Oldest surviving stylistic expression of the Western Archaic Tradition, consisting exclusively of deeply engraved, heavily revarnished, and frequently severely weathered geometric markings.

CE: Abbreviation denoting "Common Era"; that is, the time after year 1, replacing the traditional AD, "Anno Domini."

Clovis: Paleoindian culture complex (ca. 13,300 to 12,800 BP), widely distributed throughout North America and readily identified by its characteristic fluted projectile points.

cognitive archaeology: Theoretical study of past human thought and mental processes based primarily on the evidence of material remains and the archaeological record.

cortisol: Steroid hormone released in challenging or stressful situations, where it promotes a beneficial rapid "fight or flight" reaction. Chronic stress, however, has numerous deleterious effects on the body and nervous system.

costly: Requiring unusual expense of physical resources or assuming obvious risks. See *costly signal*.

costly signal: In evolutionary biology, a conspicuous or apparently physiologically disadvantageous behavior or anatomical feature that indicates unusual fitness simply because the organism maintains it. Being "hard to fake," it honestly communicates that the individual is truly healthy and strong (has "good genes"). A canonical example of a costly signal is the large, heavy, flamboyant tail of the peacock, which signals sufficient health to sustain and flaunt this "handicap."

Creative Explosion: Term coined in the 1980s by science writer John Pfeiffer to refer to the sudden, abundant appearance of evidence for art and creativity some 40,000 years ago, coinciding with the arrival of *Homo sapiens* in Europe.

cultural relativism: Basic principle in the social sciences claiming that each culture must be analyzed and understood in its own terms and not with regard to characteristics that may appear universally or cross-culturally.

cupule, cup-mark: Small human-made hemispherical depression, hollow, or pit, pecked and/or ground into rock; usually occurring in multiples, on horizontal, slanting, and vertical surfaces.

curvilinear: Consisting of curved lines.

Darwinian aesthetics: See *evolutionary aesthetics*.

engraving: See *petroglyph*.

entrainment: Spatiotemporal coordination between two or more individuals, often in response to a rhythmic signal. Also the mutual sharing of an affective state between individuals.

ethnographic analogy: Comparative technique in which information about a historic period or extant culture is used to gain insights about the archaeological past, based on the assumption that if two cultures are similar in important respects that are known, they are likely to be similar in others.

ethology: Scientific study of the behavior of animals under natural conditions, considering behavior as an evolutionarily adaptive trait. Human ethology investigates behaviors of the human animal.

exaptation/exaptive: In evolution, a term to describe an adaptive trait that has acquired a function other than the one for which it was originally designed by natural selection.

evolutionary aesthetics: Theoretical approach suggesting that basic preferences for particular features of human faces and bodies, or types of landscapes, shelter, weather, and such, contribute to survival and reproductive success.

exogram: External mnemonic record such as a marking on rock as a way of storing memory outside the brain.

figurative: Engravings or paintings that depict animals, humans, or items of material culture that are readily identifiable.

forager: Person whose subsistence consists primarily of searching for food and provisions; sometimes used as synonym for hunter-gatherer.

form constant: See *phosphene*.

genus: A principal taxonomic category that ranks above species and below family, denoted by a capitalized Latin name (e.g., *Homo*).

geocentric. Characterizes a rock art style whose imagery thematically consists primarily of nonfigurative, abstract-geometric configurations. For its opposite, see *biocentric*.

geometric motif: Nonrepresentational rock art motif characterized by simple rectilinear and/or curvilinear elements or shapes. See also *abstract motif*.

geometric primitives: Basic geometric forms or designs such as straight parallel lines, curves, right angles, grids, triangles, circles, meanders, etc., that the primary visual areas of the human brain seek out first to make sense of visual reality.

glyph: Short form for a single petroglyph.

gradualism: The hypothesis that human cognitive modernity with its key characteristics of language, religion, art, and symbolicity did not come about through sudden, abrupt change but was the result of long-time "mosaic" evolution and gradual, often imperceptible changes.

grapheme: Minimal unit in a writing system that represents a phoneme or functional sound. Used by some researchers to refer to rock art figures and motifs.

habiline: A member of the now-extinct human species *Homo habilis,* dating roughly from 2 to 1.6 million years ago.

Historic period: In the American Southwest, generally the time after the Spanish Entrada, ca. 1540 CE.

Holocene: Geologic epoch from the end of the Pleistocene some 11,000 years ago to the present or the beginning of the Anthropocene.

hominin: Comprehensive designation for members of the genus *Homo,* including modern humans as well as all species of extinct ancestral and related forms after the split from the great apes.

Homo: Genus label for all hominins, including modern *sapiens* humans as well as several extinct species such as *Homo neanderthalensis, H. erectus,* and *H. habilis.*

Homo erectus: Translated as "upright man," an extinct fossil species of the human lineage found in Africa and Eurasia dating to between 1.9 million and 250,000 years ago.

Homo ergaster: "Working man," an extinct species of the genus *Homo* generally thought to have preceded African *Homo erectus.*

Homo habilis: "Handy man" or "skillful, able man," an African species considered the first member of the genus *Homo,* dating from ca. 2.4 to 1.6 million years ago.

Homo sapiens: "Wise man," the only surviving species of the genus *Homo,* and the term for all anatomically modern humans who originated in Africa at least 200,000 (and recently proposed, 300,000) years ago.

Homo symbolicus: "Symbolic man"; appellation sometimes used to emphasize that humans are symbol makers and users.

horizon: In archaeology, the stratigraphic layer in which a distinctive set of artifacts occurs.

human universal: Innate, genetically based adaptive propensity shared by all humanity; a trait, behavior, or cultural phenomenon found in all societies.

hunter-gatherer: As opposed to a sedentary farmer, a highly mobile individual whose livelihood is sustained by hunting, foraging for plant foods, and/or fishing. See also *forager.*

Ice Age: Colloquial name for the most recent glacial epoch of the Pleistocene, beginning around 40,000 years ago and lasting to around 11,000 years ago; sometimes used for the entire Pleistocene.

icon: In semiotics, a graphic mode (an image) in which a signifier is perceived as resembling or imitating the signified.

iconic: Relating to the readily identifiable figurative or representational form of an object from the real or imagined world, as opposed to an abstract design.

iconography: Collective corpus of visual representations or images relating to a particular art style or tradition.

iconophobia: Fear of the power attributed to naturalistic images.

kachina: Masked supernatural personage or god prayed to by Puebloan agriculturalists for rain, health, and other life-sustaining blessings.

Last Glacial Maximum (LGM): Last, most recent, and coldest period in the earth's climatological history, roughly dated in the Northern Hemisphere between 26,000 and 20,000 to 19,000 years ago, when continental ice sheets were at their thickest and sea levels at their lowest.

Lower Paleolithic: In the Old World, the oldest subdivision of the Paleolithic period, ranging from ca. 2.7 million to 200,000 years ago.

Magdalenian: Last major cultural phase of the European Upper Paleolithic, dated from 17,000 to 11,000 years ago.

Makapansgat pebble: An approximately 3-million-year-old cobble (rounded stone) found with bones of *Australopithecus africanus* in the South African cave of Makapansgat, some distance from any possible source for the stone. Its shape and natural markings suggest a crude "face," leading to the speculation that it was transported to the cave by its finder, who pareidolically noted its resemblance to a human face.

mark-making: Umbrella term for the universal (evolutionarily evolved and adaptive) human predisposition to make marks on surfaces (stone, skin, sand, wood, and so forth).

meme pool: Sum total of memes—ideas, behaviors, practices, styles, and symbols—shared and transmitted within a human group by nongenetic means, in particular imitation.

Middle Paleolithic: In the Old World, the middle chronological stone tool tradition of the Paleolithic or Old Stone Age, from roughly 200,000 to 40,000 years ago.

Middle Stone Age: Global term used primarily in African archaeology for the intermediate period between Lower/Early and Upper/Late(r) Stone Age.

mobiliary art: Paleoart on stone, bone, wood, shell, ivory, and the like, small enough to be easily transportable; also called "portable" art.

mode/modal: In this book, refers to varieties or kinds of sensory modes—sight, sound, touch, smell, taste, balance—and the felt qualities of these experiences. They are nonverbal and may occur together (multimodal, as when an experience is simultaneously visual, aural, and gestural) or intermingle (cross-modal, as when a sound seems "thin" or a dance movement "heavy"). Supra-modal qualities—such as intensity, contour, duration, or rhythm—can apply to any sense modality. Sensory modalities make up a large component of "aesthetic" experiences and need not depend on symbolic reference.

modernity, modern: In cognitive archaeology, refers to *Homo sapiens'* stage of anatomical and/or cognitive development, implying that cognitively modern individuals possessed language, religion, art, and the ability to symbolize.

motherese: A kind of speech that is simplified and repetitive, with exaggerated vocal contours, used by caretakers to infants. Sometimes called "infant-directed speech (IDS)" or "baby talk."

motif: Recurrent individual image, design, theme, or class of figures with a distinct morphology, usually characteristic of a given style.

Mousterian: Old World cultural division within the Middle Paleolithic tradition, ranging from roughly 100,000 to 40,000 years ago.

Neanderthals: Taxonomically referred to as *Homo neanderthalensis*, archaic humans of western Eurasia dating to roughly 200,000 and 30,000 years ago with whom *Homo sapiens* members sometimes interbred.

neuroaesthetics: Empirical science that studies the neurological and psychological mechanisms or processes that underlie aesthetic behavior.

neuropsychological model. Explanatory model used by advocates of the shamanistic hypothesis for the creation of rock art based on the idea that all humans have the same neural patterns and connections, resulting in the same or similar internally generated imagery in persons who are undergoing or remembering a visionary experience of trance.

neuropsychology: Integrated scientific study of the human nervous system (neurology) and the study of the mind and behavior (psychology).

nonfigurative. See *noniconic.*

noniconic: Rock art element offering no visual information for real-world identification; synonymous with nonfigurative, nonrepresentational, or nonpictorial.

nonpictorial: See *noniconic.*

nonrepresentational: See *noniconic.*

oxytocin: Ancient neuropeptide occurring in the brains of all mammals that promotes such vital activities as maternal behavior, empathy, and social bonding.

Paleoamerican: Representative of the earliest human settlers in North and South America during the final Pleistocene.

paleoart: Used in this book as collective descriptor for WAT-related noniconic paleomarks or paleodesigns.

Paleoindian: Classificatory term for the earliest archaeological and/or cultural stage in the New World, ending ca. 8,000 BCE.

Paleolithic: Customary label in Old World archaeology (Europe, Asia, and Africa, but not used in the Americas) denoting Old Stone Age, ranging from first evidence of tool-using humans some 3.3 million years ago to the final stages of the Ice Age. Traditionally subdivided into Lower, Middle, and Upper Paleolithic.

paleomarks: Generic term for abstract-geometric designs attributable to Western Archaic Tradition parietal art.

panel: Arbitrary assemblage of rock art elements spatially confined to a particular area and set off from neighboring groupings.

pareidolia: The mind's tendency to perceive meaningful patterns in random data or meaningless noise. As a rule, visual pareidolia tends to detect patterns of an animate nature where no representation actually exists. It unfortunately plays a significant role in interpreting rock art.

parietal: Of or relating to a wall, like a cliff, cave, or rock shelter; often used interchangeably with rupestrian.

patina: Thin, dark-colored cortex on rock surfaces caused by chemical alteration of the parent rock itself, specifically oxidation of the iron within it. Often used interchangeably with *varnish.*

petroglyph: Rock art produced by carving, engraving, abrading, drilling, chipping, pecking, or scratching into the darkly varnished surface of the natural rock, thereby effecting a high contrast with the lighter underlying matrix.

phosphene/phosphenic: Abstract design or shape (set of parallel lines, pattern of dots, grid, spiral, zigzag, filigree, etc.) induced in the visual cortex of the human brain without the presence of visual stimuli; also known as form constant.

pictograph: Rock art produced by painting an image on a natural rock surface.

Pit-and-Groove Style: Umbrella label for some of the most elemental parietal forms such as cupules, PCN (pecked curvilinear nucleated) phenomena, grooves, ribstones, and serriforms.

Pleistocene: Geologic epoch beginning about 2.6 million years ago and terminating around 11,700 years ago; sometimes in its entirety referred to as Ice Age.

portable art: See *mobiliary art*.

primitives: Basic elements in a perceptual process, such as (in visual perception) edges, corners, contours, colors, motion. See also *geometric primitives*.

proto-aesthetic operations: The five aesthetic operations when performed by mothers to infants, in behaviors like play, and in animal ritualized behaviors. See also *aesthetic operations*.

proximate: Evolutionary term used to identify psychological and emotional mechanisms that predispose individuals to behave in a certain way that is adaptively beneficial—usually because they feel good or right. For example, consuming tasty food (not grass) and enjoying acceptance (not rejection) by other people are satisfying in themselves, without awareness that they contribute to one's survival and reproductive success, which is the ultimate benefit of these behaviors. See also *ultimate*.

quadruped: Any four-legged image resembling an animal that is not readily identifiable.

rectilinear: Consisting of straight and/or angular lines.

repatination/revarnishing: In regard to petroglyphs, the chemical alteration of the surface of a newly generated engraving by means of weathering and the deposition of iron or manganese oxides. In extremely ancient cases, the repatination or revarnishing of the exposed matrix may eventually equal the coloring of the surrounding host rock.

ritual/ceremony: A social practice (found in diverse forms in all cultures) in which a series of actions is performed in a prescribed and special (not ordinary) way to achieve a (usually important) desired end that ultimately has to do with survival. In this book, it is emphasized that rituals are typically "collections of arts."

ritualization: In ethology (animal behavior) an evolutionary process by which natural selection gradually alters an ordinary instrumental behavior into an effective communicative signal that displays to other animals an entirely different motivation and message (e.g., ordinary preening behavior in males is formalized, repeated, exaggerated, and elaborated to attract a mate).

rock art: Nonutilitarian human-made markings on rock (petroglyphs and pictographs) or on the ground (geoglyphs and rock alignments).

rupestrian: Referring to rock art, as in rupestrian imagery or site; used interchangeably with parietal.

serriform: Edge of a boulder that has been serrated or notched by humans.

Solutrian: Culture phase of the European Upper Paleolithic, spanning the period from 22,000 to 18,000 years ago.

Stone Age: Global term, comprising the entire African archaeological period, beginning about 3.3 million years ago and ending around 12,000 years BP. Featuring tripartite divisions into Lower/Early, Middle, and Upper/Late(r) Stone Age, it broadly corresponds to the chronological system of Lower, Middle, and Upper Paleolithic, the preferred taxonomy for prehistoric Europe and Asia.

style: Standard classification defined by common techniques and attributes, including the range of subjects depicted, the way those subjects are illustrated, and the manner in which the basic elements are combined and organized into compositions. Styles are geographically localized, temporally limited, and generally refer to art of a single cultural entity.

subparallel: Not exactly parallel, but diverging or converging slightly.

superimposition: Placing of paintings or engravings, one on top of another, often of earlier, stylistically quite different images.

symbol: In rock art, abstract or depictional representation used to stand for something else; often multivalent or multireferential. Many prehistorians assume that art began when humans developed the ability to make and use symbols.

symbolicity: Cognitive capacity in humans to make and use symbols.

taphonomy/taphonomic: In rock art research, pertaining to the study of environmental processes (erosion, burial, weathering) that affect the preservation of parietal markings.

tephra: Fragmental material (ash, dust, cinders) produced by a volcanic eruption.

tradition: Classificatory designation indicating long-term continuity in motifs, techniques, expressions, and styles. Traditions have an extended duration and involve large geographic areas.

ultimate: Evolutionary term used for behaviors as they contribute to survival and reproductive success. See also *proximate*.

Upper Paleolithic: In the Old World, the youngest subdivision of the Paleolithic or Old Stone Age from roughly 40,000 to 10,000 years ago.

varnish: Dark discoloration of a rock surface caused by long-term natural chemical alteration, the accretion of tiny wind-borne dust particles, and other weathering phenomena. See also *patina*.

WAT: Western Archaic Tradition.

Western Archaic Tradition rock art: Long-lived and widespread body of archetypal geometric rock markings that originated with hunter-gatherer immigrants in western North America in the final stages of the Pleistocene and, in some areas, remained stylistically more or less unchanged until the Late Prehistoric and Protohistoric (generally the time of first contact between Europeans and Native Americans).

Younger Dryas: Brief geological period, ca. 12,900 to 11,700 years ago, during which Ice Age conditions suddenly reoccurred in the northern hemisphere. Its endpoint is generally regarded as the beginning of the Holocene.

zoomorph: Object or rock art motif resembling an animal.

BIBLIOGRAPHY

Adovasio, James M., and David Pedler. 2016. *Strangers in a New Land: What Archaeology Reveals about the First Americans*. Buffalo, NY: Firefly Books.

Aiken, Nancy E. 1998. "Power through Art." *Research in Biopolitics* 6:215–28.

Aikens, C. Melvin. 1970. *Hogup Cave*. University of Utah Anthropological Papers, no. 93. Salt Lake City: University of Utah Press.

Alcorta, Candace S., and Richard Sosis. 2005. "Ritual, Emotion and Sacred Symbols: The Evolution of Religion as an Adaptive Complex." *Human Nature* 16:323–59.

Anati, Emmanuel. 1981. "The Origins of Art." *Museum* 33:200–210.

———. 2015. "Rock Art: When Why and to Whom." Post to Atelier Etno Google Plus page, February 16.

Anderson, Martha G., and Christine M. Kreamer. 1989. *Wild Spirits, Strong Medicine: African Art and the Wilderness*. Seattle: University of Washington Press.

Arnheim, Rudolf. 1969. *Visual Thinking*. Berkeley: University of California Press.

Atran, Scott. 2001. "The Trouble with Memes: Inference vs. Imitation in Cultural Creation." *Human Nature* 12 (4): 351–81.

———. 2002. *In Gods We Trust: The Evolutionary Landscape of Religion*. New York: Oxford University Press.

Aubert, Maxime, Adam Brumm, Muhammad Ramli, Thomas Sutikna, Emanuel W. Saptomo, et al. 2014. "Pleistocene Cave Art from Sulawesi, Indonesia." *Nature* 514:223–27.

Bacon, Charles R. 1983. "Eruptive History of Mount Mazama and Crater Lake Caldera, Cascade Range, U.S.A." *Journal of Volcanology and Geothermal Research* 18:57–115.

Bahn, Paul G. 1998. *The Cambridge Illustrated History of Prehistoric Art*. Cambridge: Cambridge University Press.

———. 2003 "Chauvet-Nism and Shamania: Two Ailments Afflicting Ice Age Art Studies." *The London Magazine*. Aug./Sept.: 38–47.

———. 2010. *Prehistoric Rock Art: Polemics and Progress*. Cambridge: Cambridge University Press.

———. 2015. "L'art mobilier le plus ancien." In H. de Lumley, ed., *Sur le chemin de l'humanité. Via humanitatis*, 325–43. Paris: Académie Pontificale des Sciences–CNRS Éditions.

———. 2016. *Images of the Ice Age*. Oxford: Oxford University Press.

Bahn, Paul G., and Jean Vertut 1997. *Journey through the Ice Age*. Berkeley: University of California Press.

Bailey, Drew H., and David C. Geary. 2009. "Hominid Brain Evolution: Testing Climatic, Ecological, and Social Competition Models." *Human Nature* 20:67–79.

Balter, Michael. 2002. "From a Modern Human's Brow—Or Doodling?" *Science* 295:247, 249.

———. 2009. "On the Origin of Art and Symbolism." *Science* 323:709–11.

Barham, Lawrence S. 1998. "Possible Early Pigment Use in South Central Africa." *Current Anthropology* 39 (5): 703–10.

———. 2002. "Systematic Pigment Use in the Middle Pleistocene of South-Central Africa." *Current Anthropology* 43 (1): 181–90.

Barrett, Samuel A. 1952. *Material Aspects of Pomo Culture*. Bulletin of the Public Museum of the City of Milwaukee 20 (1).

Bartels, Andreas, and Semir Zeki. 2004. "The Neural Correlates of Maternal and Romantic Love." *NeuroImage* 21 (3): 1155–66

Bar-Yosef Mayer, Daniella E., Bernhard Vandermeersch, and Ofer Bar-Yosef. 2009. "Shells and Ochre in Middle Paleolithic Qafzeh Cave, Israel: Indications for Modern Behavior." *Journal of Human Evolution* 56 (3): 307–14.

Baumeister, Roy F., and Mark R. Leary. 1995. "The Need to Belong: Desire for Interpersonal Attachments as a Fundamental Human Motivation." *Psychological Bulletin* 117 (3): 497–529.

Bean, Lowell J., and Sylvia B. Vane. 1978. "Shamanism: An Introduction." In K. Berrin, ed., *Art of the Huichol Indians*, 118–28. New York: Abrams.

Beauchamp, Douglas. 2013. "Context Interrupted: The Displacement and Re-Situation of Four Unique Petroglyph Boulders in Oregon." *IFRAO 2013 Proceedings, American Indian Rock Art* 40:685–88. DVD.

Beaumont, Peter B. 1990. "Wonderwerk Cave." In P. B. Beaumont and D. Morris, eds., *Guide to Archaeological Sites in the Northern Cape*, 101–34. Kimberly: McGregor Museum.

———. 1999. *Wonderwerk Cave*. INQUA XV International Conference Field Guide: Northern Cape. Cape Town: University of Cape Town.

Beaumont, Peter B., and Robert G. Bednarik. 2013. "Tracing the Emergence of Palaeoart in Sub-Saharan Africa." *Rock Art Research* 30 (1): 33–54.

Beck, Charlotte, and George T. Jones. 1997. "The Terminal Pleistocene/Early Holocene Archaeology of the Great Basin." *Journal of World Prehistory* 11:161–236.

Beck, Jan, and Wolfgang Forstmeier. 2007. "Superstition and Belief as Inevitable By-Products of an Adaptive Learning Strategy." *Human Nature* 18 (1): 35–46.

Beckwith, Carol, and Angela Fisher. 2012. *Painted Bodies: African Body Painting, Tattoos, and Scarification*. New York: Rizzoli.

Bednarik, Robert G. 1990. "On Neuropsychology and Shamanism in Rock Art." *Current Anthropology* 31:77–80.

———. 1994a. "Art Origins." *Anthropos* 89:169–80.

———. 1994b. "On the Scientific Study of Paleoart." *Semiotica* 100 (2/4): 141–68.

———. 1998. "The 'Australopithecine' Cobble from Makapansgat, South Africa." *South African Archaeological Bulletin* 53:4–8.

———. 2003. "The Earliest Evidence of Palaeoart." *Rock Art Research* 20 (2): 89–135.

———. 2008a. "Cupules." *Rock Art Research* 25 (1): 61–100.

———. 2008b. "Mistakes in Pleistocene Archaeology." Epistemology of Pleistocene Archaeology, Lecture 4. www.chass.utoronto.ca/epc/srb/cyber/bednarik4.pdf.

———. 2008c. "Logic in Archaeology." Epistemology of Pleistocene Archaeology, Lecture 6. www.chass.utoronto.ca/epc/srb/cyber/bednarik6.pdf.

———. 2008d. "On Cupule Interpretation." *Rock Art Research* 25 (2): 214–21.

———. 2008e. "Children as Pleistocene Artists." *Rock Art Research* 25 (2): 173–82.

———. 2011. *The Human Condition*. New York: Springer.

———. 2013. "Pleistocene Palaeoart of Asia." *Arts* 2:46–76.

Bednarik, Robert G., and M. Sreenathan. 2012. "Traces of the Ancients: Ethnographic Vestiges of Pleistocene 'Art.'" *Rock Art Research* 29 (2): 191–217.

Beebe, Beatrice, Joseph Jaffe, Stanley Feldstein, Kathleen Mays, and Diane Alson. 1985. "Interpersonal Timing: The Application of an Adult Dialogue Model to Mother-Infant Vocal and Kinesic Interactions." In T. Field and N. Fox, eds., *Social Perception in Infants*, 217–47. Norwood, NJ: Ablex.

Beebe, Beatrice, and Frank Lachmann. 2014. *The Origins of Attachment: Infant Research and Adult Treatment*. New York: Routledge.

Bégouën, Robert, and Jean Clottes. 1991. "Portable and Wall Art in the Volp Caves, Montesquieu-Avantès (Ariège)." *Proceedings of the Prehistoric Society* 57 (1): 65–79.

Bell, Clive. 1914. *Art*. London: Chatto and Windus.

Bement, Leland C. 1999. *Bison Hunting at Cooper Site: Where Lightning Bolts Drew Thundering Herds*. Norman: University of Oklahoma Press.

Benson, Larry V., Eugene M. Hattori, John Southon, and Benjamin Aleck. 2013. "Dating North America's Oldest Petroglyphs, Winnemucca Lake Subbasin, Nevada." *Journal of Archaeological Science* 40:4466–76.

Berndt, Ronald M. 1971/1958. "Some Methodological Considerations in the Study of Australian Aboriginal Art." In C. F. Jopling, ed., *Art and Aesthetics in Primitive Societies*, 99–126. Reprint, New York: Dutton.

Bernieri, Frank J., and Robert Rosenthal. 1991. "Interpersonal Coordination: Behavior Matching and Interactional Synchrony." In R. S. Feldman and B. Rimé, eds., *Fundamentals of Nonverbal Behavior*, 401–32. Studies in Emotion and Social Interaction. Cambridge: Cambridge University Press.

Bilbo, Michael, Jim McCulloch, and Kay Sutherland. 1979. "Indicators of Archaic Rock Art Styles in the Jornada Area." In P. H. Beckett and R. N. Weisman, eds., *Jornada Mogollon Archaeology: Proceedings of the First Jornada Conference*, 227–72. Las Cruces: New Mexico State University.

Bjorklund, David F., and Anthony D. Pellegrini. 2002. *The Origins of Human Nature: Evolutionary Developmental Psychology*. New York: American Psychological Association.

Blinkhorn, James, Nicole Boivin, Paul S. C. Taçon, and Michael D. Petraglia. 2012. "Rock Art Research in India: Historical Approaches and Recent Theoretical Directions." In J. McDonald and P. Veth, eds., *A Companion to Rock Art*, 179–96. Chichester: Wiley-Blackwell.

Boas, Franz. 1955/1927. *Primitive Art*. Reprint, New York: Dover.

Boëda, Eric, Ignacio Clemente-Conte, Michel Fontugue, Christelle Lahaye, Mario Pino, et al. 2014. "A Late New Pleistocene Archaeological Sequence in South America: The Vale da Pedra Furada (Piauí, Brazil)." *Antiquity* 88:927–41.

Boehm, Christopher. 1999. *Hierarchy in the Forest: The Evolution of Egalitarian Behavior*. Cambridge, MA: Harvard University Press.

Bókkon, István. 2008. "Phosphene Phenomenon: A New Concept." *BioSystems* 92:168–74.

Bosinski, G., and G. Fischer. 1980. Mammut- und Pferdedarstellungen von Gönnersdorf. Wiesbaden: Franz Steiner.

Bouissac, Paul. 1993. "Beyond Style: Steps towards a Semiotic Hypothesis." In M. Lorblanchet and P. Bahn, eds., *Rock Art Studies: The Post-Stylistic Era, or Where Do We Go from Here?* 203–6. Oxford: Oxbow Books.

———. 1994. "Art or Script? A Falsifiable Semiotic Hypothesis." *Semiotica* 100:349–67.

———. 2008. "The Archaeology of Graphic Signs: Evolutionary and Systematic Approaches 1." In R. G. Bednarik and D. Hodgson, eds., *Pleistocene Palaeoart of the World*, 57–62. BAR International Series 1804. Oxford: Archaeopress.

Bourgeon, Lauriane, Ariane Burke, and Thomas Higham. 2017. "Earliest Human Presence in North America Dated to the Last Glacial Maximum: New Radiocarbon Dates from Bluefish Caves, Canada." *PLoS ONE* 12 (1): e0169486. doi:10.1371/journal.pone.0169486.

Bouzouggar, Abdeljalil, Nick Barton, Marian Vanhaeren, Francesco d'Errico, Simon Collcutt, et al. 2007. "82,000-Year-Old Shell Beads from North Africa and Implications for the Origins of Modern Human Behavior." *Proceedings of the National Academy of Sciences* 104 (24): 9964–69.

Bowen, Nina. 1986. "Engraved Stones of Cedar Valley, Utah." *Utah Rock Art* 6:57–71.

Boyd, Brian. 2009. *On the Origin of Stories: Evolution, Cognition, and Fiction*. Cambridge, MA: Harvard University Press.

Boyd, Carolyn E. 2003. *Rock Art of the Lower Pecos*. College Station: Texas A&M University Press.

Boyer, Pascal. 2001. *The Naturalness of Religious Ideas: A Cognitive Theory of Religion*. Berkeley: University of California Press.

Bradley, Bruce, and Dennis Stanford. 2004. "The North Atlantic Ice-Edge Corridor: A Possible Palaeolithic Route to the New World." *World Archaeology* 36 (4): 459–78.

Bradshaw, John L. 1998. "Sermons in Stone: Fossils and the Evolution of Representational Art." *Rock Art Research* 15 (2): 125–27.

———. 2000. "Though Art's Hid Causes Are Not Found." *Rock Art Research* 17 (1): 20–21.

Breuil, Henri. 1952. *Four Hundred Centuries of Cave Art*. Montignac, France: Centre d'Études et de Documentation Préhistoriques.

Briuer, Fred. L. 1977. "Plant and Animal Remains from Caves and Rock Shelters of Chevelon Canyon, Arizona: Methods for Isolating Cultural Depositional Processes." PhD diss., University of California Los Angeles.

Brody, J. J. 1977. *Mimbres Painted Pottery*. Albuquerque: University of New Mexico Press.

———. 1991. *Anasazi and Pueblo Painting*. Albuquerque: University of New Mexico Press.

Brown, Donald E. 1991. *Human Universals*. Philadelphia: Temple University Press.

———. 1999. "Human Universals." In R. A. Wilson and F. C. Keil, eds., *The MIT Encyclopedia of the Cognitive Sciences*, 382–84. Cambridge, MA: MIT Press.

Brown, Steven, and Ellen Dissanayake. 2009. "The Arts Are More than Aesthetics: Neuroaesthetics as Narrow Aesthetics." In M. Skov and O. Vartanian, eds., *Neuroaesthetics*, 43–57. Amityville, NY: Baywood.

Bruder, Jimon S. 1983. *Archaeological Investigations at the Hedgpeth Hills Petroglyph Site*. Research Report, no. 28. Flagstaff: Museum of Northern Arizona.

Brumm, Adam, and Maxime Aubert. 2015. "Pigs, Popcorn and the Origins of Prehistoric Art." *Australian Science* 36 (5): 18–22.

Burghardt, Gordon M. 2005. *The Genesis of Animal Play: Testing the Limits*. Cambridge, MA: MIT Press.

Burkhardt, Frederick, ed. 1996. *Charles Darwin's Letters: A Selection 1825–1859*. Cambridge: Cambridge University Press.

Burrill, Rebecca. 2010. "The Primacy of Movement in Art Making." *Teaching Artist Journal* 8 (4): 216–28.

Callahan, Kevin L. 2004. "Pica, Geophagy, and Rock-Art in the Eastern United States." In C. Diaz-Granados and J. R. Duncan, eds., *The Rock-Art of Eastern North America: Capturing Images and Insight*, 65–74. Tuscaloosa: University of Alabama Press.

Cannon, William J., and Mary F. Ricks. 1986. "The Lake County Oregon Rock Art Inventory: Implications for Prehistoric Settlement and Land Use Patterns." In K. M. Ames, ed., *Contributions to the Archaeology of Oregon, 1983–1986*. Association of Oregon Archaeologists Occasional Papers 3:1–23.

———. 2007. "Context in the Analysis of Rock Art: Settlement and Rock Art in the Warner Valley Area, Oregon." In A. R. Quinlan, ed., *Great Basin Rock Art: Archaeological Perspectives*, 107–25. Reno: University of Nevada Press.

Caporael, Linnda R. 1997. "The Evolution of Truly Social Cognition: The Core Configuration Model." *Personality and Social Psychology Review* 1:276–98.

Carden, Natalia. 2009. "Prints on the Rocks: A Study of the Track Representations from Piedra Museo Locality (Southern Patagonia)." *Rock Art Research* 26 (1): 29–42.

Carroll, John B. 1956. *Language, Thought, and Reality: Selected Writings of Benjamin Lee Whorf*. Cambridge, MA: MIT Press.

Carter, C. Sue. 1998. "Neuroendocrine Perspectives on Social Attachment and Love." *Psychoneuroendocrinology* 23:779–818.

Carter, C. Sue, and Margaret Altemus. 1999. "Integrative Functions of Lactational Hormones in Social Behaviour and Stress Management." In C. Carter, I. Lederhendler, and B. Kirkpatrick, eds., *The Integrative Neurobiology of Affiliation*, 361–71. Cambridge, MA: MIT Press.

Carter, C. Sue, James Harris, and Stephen W. Porges. 2009. "Neural and Evolutionary Perspectives on Empathy." In J. Decety and W. Ickes, eds., *The Social Neuroscience of Empathy*, 162–82. Cambridge, MA: MIT Press.

Carter, C. Sue, Izja Lederhendler, and Brian Kirkpatrick, eds. 1999. *The Integrative Neurobiology of Affiliation*. Cambridge, MA: MIT Press.

Charmove, Arnold S., and James R. Anderson. 1989. "Examining Environmental Enrichment." In E. F. Segal, ed., *Housing, Care and Psychological Well Being of Captive and Laboratory Animals*, 183–201. Park Ridge, NJ: Noyes Publications.

Chartrand, Tanya L., and John A. Bargh. 1999. "The Chameleon Effect: The Perception-Behavior Link and Social Interaction." *Journal of Personality and Social Psychology* 76:893–910.

Chisholm, James C. 2003. "Uncertainty, Contingency, and Attachment: A Life History Theory of Theory of Mind." In K. Sterelny and J. Fitness, eds., *From Mating to Mentality: Evaluating Evolutionary Psychology*, 125–53. New York: Psychology Press.

Christensen, Don D. 2005. "Preliminary Report on Cupules in North-Central Arizona." *Rock Art Papers* 17:71–80.

Christensen, Don D., and Jerry Dickey. 2001. "The Grapevine Style of the Eastern Mojave Desert of California and Nevada." *American Indian Rock Art* 27:185–200.

———. 2004. "The Esplanade Style: A Reappraisal of Polychrome Rock Art in the Grand Canyon Region." *American Indian Rock Art* 30:69–85.

Chugani, Harry T., Michael E. Behen, Otto Muzik, Csaba Juhász, Ferenc Nagy, et al. 2001. "Local Brain Functional Activity Following Early Deprivation: A Study of Postinstitutionalized Romanian Orphans." *NeuroImage* 14:1290–1301.

Churchland, Patricia S. 2011. *Braintrust: What Neuroscience Tells Us about Morality*. Princeton, NJ: Princeton University Press.

Clottes, Jean. 2002. *World Rock Art*. Los Angeles: Getty Publications.

———. 2008. *Cave Art*. London: Phaidon Press.

———. 2013. "Two Petroglyphs of Proboscideans at Upper Sand Island, Bluff, Utah (USA)." *International Newsletter on Rock Art* 67:7–10.

———. 2016. *What Is Paleolithic Art? Cave Paintings and the Dawn of Human Creativity*. Trans. O. Y. Martin and R. D. Martin. Chicago: University of Chicago Press.

Clottes, Jean, and David Lewis-Williams. 2007. "Paleolithic Art and Religion." In J. R. Hinnells, ed., *A Handbook of Ancient Religions*, 7–45. Cambridge: Cambridge University Press.

Coe, Joffre L. 1964. *The Formative Cultures of the Carolina Piedmont*. Philadelphia: American Philosophical Society.

Coe, Kathryn. 2003. *The Ancestress Hypothesis: Visual Art as Adaptation*. New Brunswick, NJ: Rutgers University Press.

Cole, Herbert. 1969a. "Mbari Is Life." *African Arts* 2 (3).

———. 1969b. "Mbari Is A Dance." *African Arts* 2 (4).

———. 1969c. "Art as a Verb in Iboland." *African Arts* 3 (1): 34–41.

Cole, Sally J. 1990. *Legacy on Stone: Rock Art of the Colorado Plateau and Four Corners Region*. Boulder: Johnson Books.

———. 2004. "Origins, Continuities, and Meaning of Barrier Canyon Style Rock Art." In R. T. Matheny, ed., *New Dimensions in Rock Art Studies*, 7–78. Salt Lake City: University of Utah Press.

Collins, Michael B., ed. 1998. *An 11,000-Year Archaeological Record of Hunter-Gatherers in Central Texas*. Studies in Archaeology 31; Report 10 (Texas DOT Archeology Studies Program). Austin: Texas Archeological Research Laboratory, University of Texas at Austin, and Texas Department of Transportation, Environmental Affairs Division.

———. 2002. "Peopling of the Americas: The Gault Site, Texas, and Clovis Research." *Athena Review* 3 (2): 31–41, 100–102.

Collins, Michael B., Dennis J. Stanford, Darrin L. Lowery, and Bruce A. Bradley. 2013. "North America before Clovis: Variance in Temporal/Spatial Cultural Patterns, 27,000–13,000 Cal Yr BP." In K. E. Graf, C. V. Ketron, and M. R. Waters, eds., *Paleoamerican Odyssey*, 521–39. College Station: Texas A&M University Press.

Collins, Michael B., Michael R. Waters, Albert C. Goodyear, Dennis J. Stanford, Tom Pertierra, and Ted Goebel. 2008. "2008 Paleoamerican Origins Workshop: A Brief Report." *Current Research in the Pleistocene* 25:195–97.

Combier, Jean, and Guy Jouve. 2012. "Chauvet Cave's Art Is Not Aurignacian: A New Examination of the Archaeological Evidence and Dating Procedures." *Quartär* 59:13–52.

Conard, Nicholas J. 2007. "Cultural Evolution in Africa and Eurasia during the Middle and Late Pleistocene." In W. Henke and I. Tattersall, eds., *Handbook of Paleoanthropology*, 2001–37. Berlin: Springer.

———. 2010. "Cultural Modernity: Consensus or Conundrum?" *Proceedings of the National Academy of Sciences* 107 (17): 7621–22.

———. 2016. *The Vogelherd Horse and the Origins of Art*. Brief Monographs by MUT, vol. 6. Tübingen, Germany: Eberhard Karls Universität.

Connick, Robert E., and Francis Connick. 1992. "The Hitherto Unrecognized Importance of Nevada Site 26Wa3329: A Monumental Site with Southwestern Connections." *Rock Art Papers* 9:73–99.

Cooke, Cranmer K. 1963. "Report on Excavations at Pomongwe and Tshangula Caves, Matopo Hills, Southern Rhodesia." *South African Archaeological Bulletin* 18:73–151.

Cosgrove, Cornelius B. 1947. *Caves of the Upper Gila and Hueco Areas in New Mexico and Texas*. Papers of the Peabody Museum of Archaeology and Ethnology 24 (2). Cambridge, MA: Peabody Museum of Archaeology and Ethnology.

Coulson, Sheila A., Sigrid Staurset, and Nick Walker. 2011. "Ritualized Behavior in the Middle Stone Age: Evidence from Rhino Cave, Tsodilo Hills, Botswana." *Paleoanthropology* 2011:18–61.

Damasio, Antonio R. 1994. *Descartes' Error: Emotion, Reason, and the Human Brain.* New York: Putnam.

Danto, Arthur. 1981. *The Transfiguration of the Commonplace.* Cambridge, MA: Harvard University Press.

Dart, Raymond. 1974. "The Waterworn Australopithecine Pebble of Many Faces from Makapansgat." *South African Journal of Science* 70:16–69.

Darwin, Charles. 1871. *The Descent of Man and Selection in Relation to Sex.* London: Murray.

Davies, Stephen. 2012. *The Artful Species.* Oxford: Oxford University Press.

Davis, Leslie B., Matthew J. Root, Stephen A. Aaberg, and William P. Eckerle. 2009. "Paleoarchaic Incised Stones from Barton Gulch, Southwest Montana." *Current Research in the Pleistocene* 26:42–44.

Deacon, Terrence. 1997. *The Symbolic Species: The Co-evolution of Language and the Human Brain.* London: Allen Lane.

d'Errico, Francesco, and Jean-Marie Hombert. 2009. *Advances in the Emergence of Language, Human Cognition, and Modern Cultures.* Amsterdam: John Benjamins.

d'Errico, Francesco, and Chris B. Stringer. 2011. "Evolution, Revolution or Saltation Scenario for the Emergence of Modern Cultures?" *Philosophical Transactions of the Royal Society, B* 366:1060–69.

de Souza, Iderlan. 2016. "A Paleofauna no Contexto das Pinturas Rupestres da Área Arqueológica Serra da Capivara." Bachelor's thesis, Universidade Federal do Vale do São Francisco (Federal University of São Francisco Valley), São Raimundo Nonato, PI, Brazil.

Diamond, Jared. 1999. *Guns, Germs and Steel: The Fate of Human Societies.* New York: W. W. Norton.

Dillehay, Tom D., Steve Goodbred, Mario Pino, Víctor F. Vásquez Sánchez, Teresa Rosales Tham, et al. 2017. "Simple Technologies and Diverse Food Strategies of the Late Pleistocene and Early Holocene at Huaca Prieta, Coastal Peru." *Science Advances* 3(5). doi:10.1126/sciadv.1602778

Diringer, David. 1962. *Writing.* London: Thames and Hudson.

Dissanayake, Ellen. 1979. "An Ethological View of Ritual and Art in Human Evolutionary History." *Leonardo* 12 (1): 27–31.

———. 1988. *What Is Art For?* Seattle: University of Washington Press.

———. 1992. *Homo Aestheticus: Where Art Comes From and Why.* New York: Free Press.

———. 1999. "Antecedents of Musical Meaning in the Mother-Infant Dyad." In B. Cooke and F. Turner, eds., *Biopoetics: Evolutionary Explorations in the Arts,* 367–97. New York: Paragon House.

———. 2000a. *Art and Intimacy: How the Arts Began.* Seattle: University of Washington Press.

———. 2000b. "Antecedents of the Temporal Arts in Early Mother-Infant Interaction." In N. A. Wallin, B. Merker, and S. Brown, eds., *The Origins of Music,* 389–410. Cambridge, MA: MIT Press.

———. 2001. "Becoming *Homo Aestheticus*: Sources of Aesthetic Imagination in Mother-Infant Interactions." In P. Abbott, ed., "On the Origin of Fictions: Interdisciplinary Perspectives," special issue, *SubStance* 30 (1.2): 85–103.

———. 2007. "In the Beginning: Pleistocene and Infant Aesthetics and 21st-Century Education in the Arts." In L. Bresler, ed., *International Handbook of Research in Arts Education,* vol. 2:783–97. Dordrecht: Springer.

———. 2008. "If Music Is the Food of Love, What About Survival and Reproductive Success?" *Musicae Scientiae* 12 (1 suppl.): 169–95.

————. 2009. "The Artification Hypothesis and Its Relevance to Cognitive Science, Evolution-
ary Aesthetics, and Neuroaesthetics." In special issue on aesthetic cognition, *Cognitive
Semiotics* 5:136–58.

————. 2014. "A Bona Fide Ethological View of Art: The Artification Hypothesis." In C. Sütter-
lin, W. Schiefenhövel, C. Lehmann, J. Forster, and G. Apfelauer, eds., *Art as Behaviour:
An Ethological Approach to Visual and Verbal Art, Music and Architecture*, 43–62. Hanse
Studies 10. Oldenburg, Germany: BIS-Verlag.

Donald, Merlin. 1991. *Origins of the Modern Mind: Three Stages in the Evolution of Culture and
Cognition*. Cambridge, MA: Harvard University Press.

————. 2006. "Art and Cognitive Evolution." In M. Turner, ed., *The Artful Mind: Cognitive Sci-
ence and the Riddle of Human Creativity*, 3–20. New York: Oxford University Press.

Donaldson, Zoe R., and Larry J. Young. 2008. "Oxytocin, Vasopressin, and the Neurogenetics of
Sociality." *Science* 322:900–904.

Dugatkin, Lee A. 1997. *Cooperation among Animals: An Evolutionary Perspective*. Oxford:
Oxford University Press.

Dunbar, Robin I. M., Kostas Kaskatis, Ian MacDonald, and Vinnie Barra. 2012. "Performance
of Music Elevates Pain Threshold and Positive Affect: Implications for the Evolutionary
Function of Music." *Evolutionary Psychology* 10 (4): 688–702.

Dutton, Denis. 2009. *The Art Instinct: Beauty, Pleasure, and Human Evolution*. New York:
Bloomsbury Press.

Eibl-Eibesfeldt, Irenäus. 1971. *Love and Hate: The Natural History of Behavior Patterns*. Trans.
G. Strachan. New York: Holt, Rinehart and Winston.

————. 1989a. "The Biological Foundations of Aesthetics." In I. Rentschler, B. Herzberger, and
D. Epstein, eds., *Beauty and the Brain: Biological Aspects of Aesthetics*, 29–68. Basel:
Birkhauser.

————. 1989b. *Human Ethology*. Trans. P. Wiessner-Larsen and A. Heunemann. Hawthorne, NY:
Aldine de Gruyter.

Ellis, Bruce J., and David F. Bjorklund, eds. 2005. *Origins of the Social Mind: Evolutionary Psy-
chology and Child Development*. New York: Guilford.

Ellsworth, Phoebe. 1991. "Some Implications of Cognitive Appraisal Theories of Emotion." In
K. Strongman, ed., *International Review of Studies of Emotion*, vol. 1, 143–61. New York:
Wiley.

Endicott, Phillip, M. Thomas P. Gilbert, Chris Stringer, Carles Lalueza-Fox, Eske Willerslev, et
al. 2003. "The Genetic Origins of the Andaman Islanders." *American Journal of Human
Genetics* 72:178–84.

Erlandson, Jon M., Michael H. Graham, Bruce J. Bourque, Debra Corbett, James A. Estes, et al.
2007. "The Kelp Highway Hypothesis: Marine Ecology, the Coastal Migration Theory, and
the Peopling of the Americas." *Journal of Island and Coastal Archaeology* 2:16–74.

Eshleman, Clayton. 2008. "Lectures on the Ice-Age Painted Caves of Southwestern France."
Interval(le)s 2.2–3.1. http://labos.ulg.ac.be/cipa/wp-content/uploads/sites/22/2015/07/25_
eshleman.pdf.

Euler, Robert, and Henry F. Dobyns. 1971. *The Hopi People*. Phoenix: Indian Tribal Series.

Everett, Daniel L. 2008. *Don't Sleep, There Are Snakes: Life and Language in the Amazonian
Jungle*. New York: Pantheon.

Falk, Dean. 2004. "Prelinguistic Evolution in Early Hominins: Whence Motherese?" *Behavioral
and Brain Sciences* 27 (4): 491–503.

————. 2009. *Finding Our Tongues: Mothers, Infants and the Origin of Language*. New York:
Basic Books.

Faris, James C. 1972. *Nuba Personal Art*. Toronto, ON: University of Toronto Press.

Feierman, Jay R., ed. 2009. *The Biology of Religious Behavior: The Evolutionary Origins of Faith and Religion*. Santa Barbara, CA: Praeger.

Fein, Sylvia. 1993. *First Drawings: Genesis of Visual Thinking*. Pleasant Hill, CA: Exelrod Press.

Feliks, John. 1998. "The Impact of Fossils on the Development of Visual Representation." *Rock Art Research* 15 (2): 109–34.

———. 2003. "Toward a Comprehensive Paradigm." *Rock Art Research* 20 (2): 111–14.

———. 2006. "Phi in the Acheulian: Lower Palaeolithic Intuition and the Natural Origins of Analogy." In R. G. Bednarik and D. Hodgson, eds., *Pleistocene Palaeoart of the World*, 11–31. *Proceedings of the XV UISPP World Congress*, Lisbon 2006, BAR International Series 1804, Oxford.

———. 2011. "A Prehistory of Hiking—Neanderthal Storytelling." *Pleistocene Coalition News* 3 (2): 1–2.

Fernald, Anne, and Patricia K. Kuhl. 1987. "Acoustic Determinants of Infant Preference for Motherese Speech." *Infant Behavior and Development* 10:279–93.

Flinn, Mark V., Robert G. Quinlan, Seamus A. Decker, Mark T. Turner, and Barry G. England. 1996. "Male-Female Differences in Effects of Parental Absence on Glucocorticoid Stress Response." *Human Nature* 7 (2): 125–62.

Flinn, Mark V., and Carol V. Ward. 2005. "Ontogeny and Evolution of the Social Child." In B. J. Ellis and D. F. Bjorklund, eds., *Origins of the Social Mind: Evolutionary Psychology and Child Development*, 19–44. New York: Guilford.

Flood, Josephine. 1996. "Culture in Early Aboriginal Australia." *Cambridge Archaeological Journal* 6 (1): 3–36.

———. 1997. *Rock Art of the Dreamtime: Images of Ancient Australia*. Sydney: Angus & Robertson.

Foley, Robert. 1988. "Hominids, Humans and Hunter-Gatherers: An Evolutionary Perspective." In T. Ingold, D. Riches, and J. Woodburn, eds., *Hunters and Gatherers I: History, Evolution and Social Change*, 207–21. Oxford: Berg.

Fowler, Catherine S. 1992. *In the Shadow of Fox Peak: An Ethnography of the Cattail-Eater Northern Paiute People of Stillwater Marsh*. Washington, DC: US Government Printing Office.

Francfort, Henri-Paul, and Roberte Hamayon. 2001. *The Concept of Shamanism: Uses and Abuses*. Bibliotheca Shamanistica 10. Budapest: Akadémiai Kiadó.

Francis, Julie E., and Lawrence L. Loendorf. 2002. *Ancient Visions: Petroglyphs and Pictographs from the Wind River and Bighorn Country, Wyoming and Montana*. Salt Lake City: University of Utah Press.

Francis, Peter. 1997. "America's Oldest Beads." *The Margaretologist* 10 (1): 3–11.

Freeman, Walter J. 1995. *Societies of Brains: A Study in the Neurobiology of Love and Hate*. Mahwah, NJ: Erlbaum.

———. 2000. "A Neurobiological Role of Music in Social Bonding." In N. Wallin, B. Merker, and S. Brown, eds., *The Origins of Music*, 411–24. Cambridge, MA: MIT Press.

Frison, George C., and Dennis J. Stanford. 1982. *The Agate Basin Site: A Record of the Paleoindian Occupation of the Northwestern High Plains*. New York: Academic Press.

Froese, Tom, Alexander Woodward, and Takashi Ikegami. 2013. "Turing Instabilities in Biology, Culture, and Consciousness? On the Enactive Origins of Symbolic Material Culture." *Adaptive Behavior* 21 (3): 199–214.

Fry, Roger. 1923. *Vision and Design*. London: Chatto and Windus.

Gablik, Suzi. 1976. *Progress in Art*. New York: Rizzoli.

Gangestad, Steven W. 2008. "Biological Adaptation and Human Behavior." In C. Crawford and D. Krebs, eds., *Foundations of Evolutionary Psychology*, 153–72. New York: Erlbaum.

Gardner, Howard. 1983. *Frames of Mind: The Theory of Multiple Intelligences.* New York: Basic Books.

———. 1999. *Intelligence Reframed: Multiple Intelligences for the 21st Century.* New York: Basic Books.

Garfinkel, Alan P., Geron Marcom, and Robert A. Schiffman. 2003. "Culture Crisis and Rock Art Intensification: Numic Ghost Dance Paintings and Coso Representational Petroglyphs." *American Indian Rock Art* 33:83–103.

Garfinkel, Yosef. 2017. "Dancing with Masks in the Proto-Historic Near East." In C. Renfrew, I. Morley, and M. Boyd, eds., *Ritual, Play and Belief in Evolution and Early Human Societies*, 143–68. Cambridge: Cambridge University Press.

Geary, David C. 2005. "Folklore and Academic Learning." In B. J. Ellis and D. F. Bjorklund, eds., *Origins of the Social Mind: Evolutionary Psychology and Child Development*, 493–519. New York: Guilford.

Geib, Phil R. 2000. "Sandal Types and Archaic Prehistory on the Colorado Plateau." *American Antiquity* 65 (3): 509–24.

Gell, Alfred. 1992. "The Technology of Enchantment and the Enchantment of Technology." In J. Coote and A. Shelton, eds., *Anthropology, Art and Aesthetics*, 40–63. Oxford: Clarendon.

———. 1998. *Art as Agency: An Anthropological Theory.* Oxford: Oxford University Press.

Gergely, György, Orsolya Koós, and John S. Watson. 2010. "Contingent Parental Reactivity in Early Socio-emotional Development." In Thomas Fuchs, Heribert C. Sattel, Peter Henningsen, eds., *The Embodied Self: Dimensions, Coherence and Disorders*, 141–69. Stuttgart: Schattauer.

Gergely, György, and John S. Watson. 1999. "Early Social-Emotional Development: Contingency Perception and the Social Bio-Feedback Model." In P. Rochat, ed., *Early Social Cognition: Understanding Others in the First Months of Life*, 10–36. Hillsdale, NJ: Erlbaum.

Gianino, A., and Edward Z. Tronick. 1988. "The Mutual Regulation Model: The Infant's Self and Interactive Regulation and Coping and Defensive Capacities." In T. Field, P. M. McCabe, and N. Schneiderman, eds., *Stress and Coping*, 47–68. Hillsdale, NJ: Erlbaum.

Gibson, James J. 1979. *The Ecological Approach to Visual Perception.* Boston: Houghton Mifflin.

Giedion, Sigfried. 1962. *The Eternal Present: The Beginnings of Art. A Contribution on Constancy and Change.* New York: Pantheon Books.

Gillespie, Jason D. 2007. "Enculturing an Unknown World: Caches and Clovis Landscape Ideology." *Canadian Journal of Archaeology* 31:171–89.

Gillette, Donna L. 2011. "Cultural Markings on the Landscape: The PCN Pecked Curvilinear Nucleated Tradition in the Northern Coastal Ranges of California." PhD diss., University of California, Berkeley.

Gillette, Donna L., and Linda Hylkema 2010. "Out of Sight, but Not Out of Mind: Revisiting a Significant Rock Art Site in Southern San Benito County, California." *American Indian Rock Art* 36:9–21.

Gingerich, Joseph A. M. 2009. "An Engraved Paleoindian Artifact from Northeast Pennsylvania." *North American Archaeologist* 30 (4): 377–91

Girdansky, Michael. 1963. *The Adventure of Language.* New York: Prentice-Hall.

Givón, Talmy, and Phil Young. 2002. "Cooperation and Interpersonal Manipulation in the Society of Intimates." In M. Chibatani, ed., *The Grammar of Causation and Interpersonal Manipulation*, 23–56. Amsterdam: John Benjamins.

Goebel, Ted, Michael R. Waters, and Dennis H. O'Rourke. 2008. "The Late Pleistocene Dispersal of Modern Humans in the Americas." *Science* 319:1497–502.

Goodyear, Albert C. 2009. "Update on Research at the Topper Site." *Legacy* 13 (1): 8–13.

Goody, Jack. 1977. *The Domestication of the Savage Mind*. Cambridge: Cambridge University Press.

Gould, Stephen J. 1977. *Ontogeny and Phylogeny*. Cambridge, MA: Harvard University Press.

Gould, Stephen J., and Elisabeth S. Vrba. 1982. "Exaptation: A Missing Term in the Science of Form." *Paleobiology* 8:4–15.

Graber, Cynthia. 2014. "Oldest Known Hearth Unearthed in Israel." *Scientific American* podcast, February 7. www.scientificamerican.com/podcast/episode/300kya-hearth.

Gramly, Richard M. 1993. *The Richey Clovis Cache: Earliest Americans along the Columbia River*. New York: Persimmon Press.

———. 2002. *Olive Branch: A Very Early Archaic Site on the Mississippi River*. North Andover, MA: The American Society for Amateur Archaeology.

Grandin, Temple. 1995. *Thinking in Pictures: And Other Reports from My Life with Autism*. New York: Doubleday.

Grant, Campbell, James W. Baird, and J. Keith Pringle. 1968. *Rock Drawings of the Coso Range, Inyo County, California*. China Lake, CA: Maturango Museum Press.

Grant, E. C. 1968. "An Ethological Description of Nonverbal Behavior during Interviews." *British Journal of Medical Psychology* 41:177–83.

———. 1972. "Nonverbal Communication in the Mentally Ill." In R. Hinde, ed., *Non-verbal Communication*, 349–58. Cambridge: Cambridge University Press.

Grayson, Donald K. 2011. *The Great Basin: A Natural Prehistory*. Rev. and expanded ed. Berkeley: University of California Press.

Greer, John W., and Patricia A. Treat. 1975. "Incised and Painted Pebbles from the Levi Site, Travis County, Texas." *Plains Anthropologist* 69 (20): 231–37.

Grens, Kerry. 2014. "Oldest Abstract Etching Yet Found." *Scientist*, December 5. www.the-scientist.com/?articles.view/articleNo/41586.

Grieder, Terrence. 1982. *Origins of Pre-Columbian Art*. Austin: University of Texas Press.

Guthrie, R. Dale. 2005. *The Nature of Paleolithic Art*. Chicago: University of Chicago Press.

Guthrie, Stewart E. 1993. *Faces in the Clouds: A New Theory of Religion*. Oxford: Oxford University Press.

Hallpike, Christopher R. 1979. *The Foundations of Primitive Thought*. Oxford: Clarendon.

Harris, Judith R. 1995. "Where Is the Child's Environment? A Group Socialization Theory of Development." *Psychological Review* 102:458–89.

Harrod, James B. 2003. "Lower Palaeolithic Palaeoart, Religion, and Protolanguage." *Rock Art Research* 20 (2): 115–16.

———. 2014. "Palaeoart at Two Million Years Ago? A Review of the Evidence." *Arts* 3 (1): 135–55.

Haynes, Gary. 2002. *The Early Settlement of North America: The Clovis Era*. Cambridge: Cambridge University Press.

———. 2017. "The Cerutti Mastodon." *PaleoAmerica* 3(3): 196–99. doi: org/10.1080/20555563.2017.1330103.

Hedges, Ken. 1976. "Southern California Rock Art as Shamanic Art." *American Indian Rock Art* 2:126–38.

———. 1982. "Great Basin Rock Art Styles: A Revisionist View." *American Indian Rock Art* 7–8:205–11.

———. 2005. "Rock Art Sites at Palo Verde Point." *Proceedings of the Society for California Archaeology* 18:95–105.

Hedges, Ken, and Diane Hamann. 1993. "The Rock Art of White Tanks, Arizona." *American Indian Rock Art* 21:57–69

———. 1995. "Petroglyphs at Quail Point, Southwestern Arizona." *Rock Art Papers* 12:89–94.

Heinrichs, Markus, Thomas Baumgartner, Clemens Kirschbaum, and Ulrike Ehlert. 2003. "Social Support and Oxytocin Interact to Suppress Cortisol and Subjective Responses to Psychosocial Stress." *Biological Psychiatry* 54:1389–98.

Heizer, Robert F., and Martin A. Baumhoff. 1962. *Prehistoric Rock Art of Nevada and Eastern California*. Berkeley: University of California Press.

Helvenston, Patricia A. 2012. "Pseudoscience in Rock Art Studies." *Rock Art Research* 29 (1): 109–10.

———. 2013. "Differences between Oral and Literate Cultures: What We Can Know about Upper Paleolithic Minds." In R. G. Bednarik, ed., *The Psychology of Human Behavior*, 59–110. New York: Nova Science Publishers.

———. 2015. "Psilocybin-Containing Mushrooms, Upper Palaeolithic Rock Art and the Neuropsychological Model." *Rock Art Research* 32 (1): 84–115.

Helvenston, Patricia A., and Paul G. Bahn. 2005. *Waking the Trance Fixed*. Shelbyville, KY: Wasteland Press.

Hemmings, C. Andrew. 2004. "The Organic Clovis: A Single Continent-Wide Cultural Adaptation." PhD diss., University of Florida.

Henrich, Joseph, Steven J. Heine, and Ara Norenzayan. 2010. "The Weirdest People in the World?" *Behavioral and Brain Sciences* 33 (3): 61–83.

Henshilwood, Christopher S., and Francesco d'Errico. 2011. "Middle Stone Age Engravings and Their Significance to the Debate on the Emergence of Symbolic Material Culture." In C. S. Henshilwood and F. d'Errico, eds., *Homo Symbolicus: The Dawn of Language, Imagination, and Spirituality*, 75–96. Amsterdam: John Benjamins.

Henshilwood, Christopher S., Francesco d'Errico, Marian Vanhaeren, Karen van Niekerk, and Zenobia Jacobs. 2004. "Middle Stone Age Shell Beads from South Africa." *Science* 304:404.

Henshilwood, Christopher S., Francesco d'Errico, Karen L. van Niekerk, Yvan Coquinot, Zenobia Jacobs, et al. 2011. "A 100,000-Year-Old Ochre-Processing Workshop at Blombos Cave, South Africa." *Science* 334 (6053): 219–22.

Henshilwood, Christopher S., Francesco d'Errico, and Ian Watts. 2009. "Engraved Ochres from the Middle Stone Age Levels at Blombos Cave, South Africa." *Journal of Human Evolution* 57:27–47.

Henshilwood, Christopher S., and Curtis W. Marean. 2003. "The Origin of Modern Human Behavior: A Review and Critique of Models and Test Implications." *Current Anthropology* 44 (5): 627–51.

Hester, James J., Ernest L. Lundelius, and Roald Fryxell. 1972. *Blackwater Draw No.1: A Stratified, Early Man Site in Eastern New Mexico*. Taos, NM: Fort Burgwin Research Center, Southern Methodist University.

Higgins, John. 2014. "UW Research on Brain Activity Delivers Lessons on How Kids Learn." *Seatttle Times*, September 21.

Hill, Beth, and Ray Hill. 1974. *Indian Petroglyphs of the Pacific Northwest*. Saanichton, B.C., Canada: Hancock House.

Hinde, Robert A. 1982. *Ethology: Its Nature and Relations with Other Sciences*. Oxford: Oxford University Press.

———. 1999. *Why Gods Persist: A Scientific Approach to Religion*. London: Routledge.

Hirsch-Patek, Kathy, and Rebecca Treiman. 1982. "Doggerel: Motherese in a New Context." *Journal of Child Language* 9 (1): 229–37.

Hodgson, Derek. 2000. "Art, Perception and Information Processing: An Evolutionary Perspective." *Rock Art Research* 17 (1): 3–34.

———. 2003. "Primitives in Palaeoart and the Visual Brain: The Building-Blocks of Representation in Art and Perception." *Rock Art Research* 20 (2): 116–17.

———. 2006a. "Understanding the Origins of Paleoart: The Neurovisual Resonance Theory and Brain Functioning." *PaleoAnthropology* 2006:54–67.

———. 2006b. "Altered States of Consciousness and Paleoart: An Alternative Neurovisual Explanation." *Cambridge Archaeological Journal* 16 (1): 27–37.

———. 2008. "Stopping Doodles from Getting Out of Hand." *Rock Art Research* 25 (1): 51–52.

———. 2012. "The Parasitic Nature of 'Art': Response to Varella et al. and Associated Commentaries." *Rock Art Research* 29 (2): 219–33.

———. 2013. "Ambiguity, Perception, and the First Representation." In K. Sachs-Hombach and J. R. J. Schirra, eds., *Origins of Pictures: Anthropological Discourses in Image Science*, 401–23. Köln: Halem.

———. 2014. "Commentary on Turing Instabilities and Symbolic Material Culture by Froese, Woodward and Ikegami." *Adaptive Behavior* 22 (1): 86–88.

Hodgson, Derek, and Patricia A. Helvenston. 2006. "The Emergence of the Representation of Animals in Palaeoart: Insights from Evolution and Cognitive, Limbic and Visual Systems of the Human Brain." *Rock Art Research* 23 (1): 3–40.

———. 2007. "The Evolution of Animal Representation: Response to Dobrez." *Rock Art Research* 24 (1): 116–24.

Hodgson, Derek, and Jan Verpooten. 2015. "The Evolutionary Significance of the Arts: Exploring the By-Product Hypothesis in the Context of Ritual, Precursors, and Cultural Evolution." *Biological Theory* 10 (1): 73–85.

Hoffecker, John, Scott Elias, and Dennis H. O'Rourke. 2014. "Out of Beringia?" *Science* 343 (6174): 979–80.

Holen, Steven R. 2006. "Taphonomy of Two Last Glacial Maximum Mammoth Sites in the Central Great Plains of North America: A Preliminary Report on La Sena and Lovewell." *Quaternary International* 142–43:30–43.

Holen, Stephen R., Thomas A. Deméré, Daniel C. Fisher, Richard Fullagar, James B. Paces, et al. 2017. "A 130,000-Year-Old Archaeological Site in Southern California, USA." *Nature* 544:479–83. doi:10.1038/nature22065.

Hovers, Erella, Bernard Vandermeersch, and Ofer Bar-Yosef. 1997. "A Middle-Palaeolithic Engraved Artefact from Qafzeh Cave, Israel." *Rock Art Research* 14:79–87.

Huether, Gerald S., Stephan Doering, Ulrich Rueger, and Eckhart Rüther. 1996. "Psychic Stress and Neuronal Plasticity: An Expanded Model of the Stress Reaction Processes as Basis for the Understanding of Adaptive Processes in the Central Nervous System." *Zeitschrift für Psychosomatische Medizin und Psychoanalyse* 42:107–27.

Hussain, Shumon T., and Harald Floss. 2015. "Regional Ontologies in the Early Upper Paleolithic: The Place of the Mammoth and Cave Lion in the 'Belief World' (*Glaubenswelt*) of the Swabian Aurignacian." In P. Bueno-Ramírez and P. G. Bahn, eds., *Prehistoric Art as Prehistoric Culture: Studies in Honor of Professor Rodrigo De Balbin-Behrmann*, 79–91. Oxford: Archaeopress Publishing.

Huxley, Julian. 1914. "The Courtship Habits of the Great Crested Grebe (*Podiceps cristatus*) Together with a Discussion of the Evolution of Courtship in Birds." *Journal of the Linnean Society of London: Zoology* 53:253–92.

Huxley, Julian, ed. 1966. "A Discussion on Ritualisation of Behaviour in Animals and Man." *Philosophical Transactions of the Royal Society, B* 251:247–526.

Jablonka, Eva, and Marion J. Lamb. 2005. *Evolution in Four Dimensions: Genetic, Epigenetic, Behavioral, and Symbolic Variation in the History of Life*. Cambridge, MA: MIT Press.

Jacobson-Tepfer, Esther. 2013. "Late Pleistocene and Early Holocene Rock Art from the Mongolian Altai: The Material and Its Cultural Implications." *Arts* 2:151–81.

Jaubert, Jacques, Sophie Verheyden, Dominique Genty, Michel Soulier, Hai Cheng, et al. 2016. "Early Neanderthal Constructions in Bruniquel Cave." *Nature* 534 (7605): 111–14. doi:10.1038/nature18291.

Jenkins, Dennis L., Loren G. Davis, Thomas W. Stafford, Paula F. Campos, Bryan Hockett, et al. 2012. "Clovis Age Western Stemmed Projectile Points and Human Coprolites at the Paisley Caves." *Science* 337 (6091): 223–28.

Johnston, Trevor, and Adam Schembri. 2007. *Australian Sign Language (Auslan): An Introduction to Sign Language Linguistics.* Cambridge: Cambridge University Press.

Jones, N. 1940. "Bambata Cave: A Reorientation." *Occasional Papers of the National Museum of Southern Rhodesia* 9:11–28.

Joordens, Josephine C. A., Francesco d'Errico, Frank P. Wesselingh, Stephen Munro, John de Vos, et al. 2015. "*Homo Erectus* at Trinil on Java Used Shells for Food Production and Engraving." *Nature* 518:228–31.

Keeling, Richard. 1992. "Music and Culture History among the Yurok and Neighboring Tribes of Northwestern California." *Journal of Anthropological Research* 48 (1): 25–48.

Kellogg, Rhoda. 1969. *Analyzing Children's Art.* Palo Alto, CA: National Press Books.

———. 1979. *Children's Drawings, Children's Minds.* New York: Avon.

Kellogg, Rhoda, Max Knoll, and J. Kugler 1965. "Form-Similarity between Phosphenes of Adults and Pre-school Children's Scribblings." *Nature* 208:1129–30.

Kelly, Robert L. 1995. *The Foraging Spectrum: Diversity in Hunter-Gatherer Lifeways.* Washington, DC: Smithsonian Institution Press.

Keltner, Dacher, Phoebe Ellsworth, and Kari Edwards. 1993. "Beyond Simple Pessimism." *Journal of Personality and Social Psychology* 64:740–52.

Keyser, James D., and Michael A. Klassen. 2001. *Plains Indian Rock Art.* Seattle: University of Washington Press.

Keyser, James D., and David S. Whitley. 2006. "Sympathetic Magic, Hunting Magic, and Rock Art in Far Western North America." *American Antiquity* 71 (1): 3–26.

King, Barbara J. 2004. *The Dynamic Dance: Nonvocal Communication in African Great Apes.* Cambridge, MA: Harvard University Press.

Kirkpatrick, Lee A. 2005. *Attachment, Evolution, and the Psychology of Religion.* New York: Guilford.

Kirner, Donna L., Richard Burky, Karen Selsor, Debra George, R. Erv Taylor, and John R. Southon. 1997. "Dating the Spirit Cave Mummy: The Value of Reexamination." *Nevada Historical Society Quarterly* 40 (1): 54–56.

Klein, Richard G. 1978. "Preliminary Analysis of the Mammalian Fauna from the Redcliff Stone Age Cave Site, Rhodesia." *Occasional Papers of the National Museums and Monuments of Rhodesia, Series A* 4 (2): 74–80.

———. 1989. "Biological and Behavioural Perspectives on Modern Human Origins in Southern Africa." In P. Mellars and C. Stringer, eds., *The Human Revolution,* 530–46. Edinburgh: Edinburgh University Press.

Klein, Richard G., and Blake Edgar. 2002. *The Dawn of Human Culture: A Bold New Theory of What Sparked the "Big Bang" of Human Consciousness.* New York: Wiley and Sons.

Klemm, Gustav. 1989/1851. *The Four Elements of Architecture and Other Writings (Die vier Elemente der Architektur).* Trans. H. Malgrave and W. Herrmann. Reprint, New York: Cambridge University Press.

Klimowicz, Janis. 1988. "Incised Stones from the Great Basin." *Nevada Archaeologist* 6 (2): 28–39.

Klüver, Heinrich. 1966. *Mescal and Mechanisms of Hallucination*. Chicago: University of Chicago Press.

Koelsch, Stefan, Kristin Offermanns, and Peter Franzke. 2010. "Music in the Treatment of Affective Disorders: An Exploratory Investigation of a New Method for Music-Therapeutic Research." *Music Perception* 27 (4): 307–16.

Krishna, Ram, and Giriraj Kumar. 2012. "Understanding the Creation of Small Conical Cupules in Daraki-Chattan, India." In J. Clottes, ed., *L'art Pléistocène dans le monde*, 1239–55. Préhistoire, art et sociétés nos. 65–66. Tarascon-sur-Ariège, France: Société Préhistorique Ariège-Pyrénées. Compact disc.

Kumar, Giriraj, and Robert G. Bednarik. 2012. "The Difficulties of Determining the Approximate Antiquity of Lower Palaeolithic Petroglyphs in India." In J. Clottes, ed., *L'art Pléistocène dans le monde*, 202–3. Préhistoire, art et sociétés nos. 65–66. Tarascon-sur-Ariège, France: Société Préhistorique Ariège-Pyrénées. Compact disc.

Kyriakidis, Evangelos. 2017. "Rituals, Games and Learning." In C. Renfrew, I. Morley, and M. Boyd, eds., *Ritual, Play and Belief in Evolution and Early Human Societies*. Cambridge: Cambridge University Press.

LaBarre, Weston. 1979. "Shamanic Origins of Religion and Medicine." *Journal of Psychedelic Drugs* 11 (1–2): 7–11.

Laming-Emperaire, Annette. 1962. *La Signification de l'Art Rupestre Paléolithique: Methods et Applications*. Paris: Picard.

Langacker, Ronald W. 1973. *Language and Its Structure: Some Fundamental Linguistic Concepts*. 2nd ed. New York: Harcourt Brace Jovanovich.

Largent Jr., Floyd B. 2004. "Diving into Florida Prehistory: The Paleoindian Record at Sloth Hole." *Mammoth Trumpet* 19 (4): 18–20.

Layton, Robert. 1991. "Trends in the Hunter-Gatherer Rock Art of Western Europe and Australia." *Proceedings of the Prehistoric Society* 57 (1): 163–74.

Leakey, Richard. 1994. *The Origin of Humankind*. New York: Basic Books.

Lemke, Ashley K., D. Clark Wernecke, and Michael B. Collins. 2015. "Early Art in North America: Clovis and Later Paleoindian Incised Artifacts from the Gault Site, Texas (41BL323)." *American Antiquity* 80 (1): 113–33.

Lenain, Thierry. 1997. *Monkey Painting*. London: Reaktion Books.

Lepre, Christopher J., Hélène Roche, Dennis V. Kent, Sonia Harmand, Rhonda L. Quinn, et al. 2011. "An Earlier Origin for the Acheulian." *Nature* 477 (7362): 82–85.

Le Quellec, Jean-Loïc. 2006. "The Sense in Question: Some Saharan Examples." *Rock Art Research* 23 (2): 165–70.

Leroi-Gourhan, André. 1966. *Treasures of Prehistoric Art*. Trans. N. Guterman. New York: Harry N. Abrams.

Lewis, C. R. 2009. "An 18,000 Year Old Occupation along Petronila Creek in Texas." *Bulletin of the Texas Archaeological Society* 80:15–50.

Lewis-Williams, J. David. 1996. "Light and Darkness: Earliest Rock Art Evidence for an Archetypal Metaphor." *Bolletino del Centro Camuno di Studi Preistorici* 29:125–32.

Lewis-Williams, J. David, and Thomas A. Dowson. 1988. "The Signs of All Times: Entoptic Phenomena in Upper Palaeolithic Art." *Current Anthropology* 29 (2): 201–45.

Lieberman, Philip. 1993. *Uniquely Human: The Evolution of Speech, Thought, and Selfless Behavior*. Cambridge, MA: Harvard University Press.

Lienhardt, Godfrey. 1961. *Divinity and Experience: The Religion of the Dinka*. Oxford: Clarendon Press.

Liu, Tanzhou. n.d. "Vml Dating: An Introduction." Varnish Microlamination (VML) Dating, www.vmldating.com.

Liu, Tanzhou, and Wallace S. Broecker. 2008. "Rock Varnish Microlamination Dating of Late Quaternary Geomorphic Features in the Drylands of Western USA." *Geomorphology* 93:501–23.

Loendorf, Lawrence L. 2008. *Thunder and Herds: Rock Art of the High Plains*. Walnut Creek, CA: West Coast Press.

Lopreato, Joseph. 1984. *Human Nature and Biocultural Evolution*. Boston: Allen and Unwin.

Lorblanchet, Michel. 1999. *La naissance de l'art: Genèse de l'art préhistorique dans le monde*. Paris: Éditions Errance.

———. 2015. "Les commencements de l'art rupestre dans le monde." In H. de Lumley, ed., *Sur le chemin de l'humanité: Via humanitatis*, 347–89. Paris: Académie Pontificale des Sciences–CNRS Éditions.

Lorblanchet, Michel, and P. G. Bahn, eds. 1993. *Rock Art Studies: The Post-Stylistic Era or Where Do We Go from Here?* Oxbow Monograph 35. Oxford: Oxbow Books.

———. 2017. *The First Artists: In Search of the World's Oldest Art*. London: Thames and Hudson.

Lorenz, Konrad Z. 1982/1978. *The Foundations of Ethology: The Principal Ideas and Discoveries in Animal Behavior*. Trans. K. Z. Lorenz and R. W. Kickert. Reprint, New York: Simon and Schuster.

Lupien, Sonia J., Bruce S. McEwen, Megan R. Gunnar, and Christine Heim. 2009. "Effects of Stress throughout the Lifespan on the Brain, Behaviour and Cognition." *Nature Reviews Neuroscience* 10:434–45.

Malinowski, Bronislaw. 1922. *Argonauts of the Western Pacific*. London: Routledge and Kegan Paul.

———. 1925. "The Problem of Meaning in Primitive Languages." In C. K. Ogden and I. A. Richards, eds., *The Meaning of Meaning: A Study of the Influence of Language upon Thought and of the Science of Symbolism*, 451–10. New York: Harcourt Brace.

———. 1935. *Coral Gardens and Their Magic*. 2 vols. London: Allen and Unwin.

———. 1948. *Magic, Science and Religion and Other Essays*. Glencoe, Illinois: The Free Press.

Malloch, Stephen, and Colwyn Trevarthen, eds. 2009. *Communicative Musicality: Exploring the Basis of Human Companionship*. Oxford: Oxford University Press.

Malotki, Ekkehart. 1983. *Hopi Time: A Linguistic Analysis of the Temporal Concepts in the Hopi Language*. Trends in Linguistics: Studies and Monographs 20. Berlin: Mouton.

———. 2007. *The Rock Art of Arizona: Art for Life's Sake*. Walnut, CA: Kiva Publishing.

———. 2013. "The Road to Iconicity in the Paleoart of the American West." In K. Sachs-Hombach and J. R. J. Schirra, eds., *Origin of Pictures: Anthropological Discourses in Image Science*, 201–29. Köln: Herbert von Halem Verlag.

———. 2017. "The Good, the Bad, and the Ugly: Claims for Proboscidean Depictions in North American Parietal and Mobiliary Art." http://nau.academia.edu/EkkehartMalotki.

———. 2018. "Columbian Mammoth and Ancient Bison: Paleoindian Petroglyphs along the San Juan River near Bluff, Utah, USA." In A. Klostergaard Petersen, I. Gilhus, L. Martin, J. Sinding Jensen, and J. Sørensen, eds., *A New Synthesis: Cognition, Evolution, and the History of Religion, Method and Theory*. Study of Religion Supplement Series. Leiden: Brill.

Malotki, Ekkehart, and Peter D. McIntosh. 2015. "Paleoamericans, Pleistocene Terraces and Petroglyphs: The Case for Ice Age Mammoth Depictions at Upper Sand Island, Utah, USA." http://nau.academia.edu/EkkehartMalotki.

Malotki, Ekkehart, and Henry Wallace. 2011. "Columbian Mammoth Petroglyphs from the San Juan River near Bluff, Utah, United States." *Rock Art Research* 2011:143–52.

Malotki, Ekkehart, and Donald E. Weaver Jr. 2002. *Stone Chisel and Yucca Brush: Colorado Plateau Rock Art.* Walnut, CA: Kiva Publishing.

Mania, Dietrich, and Ursula Mania. 1988. "Deliberate Engravings on Bone Artefacts of *Homo Erectus.*" *Rock Art Research* 5 (2): 91–95.

———. n.d. *Tausand Jahre wie ein Tag (Thousand Years like a Day).* Langenweissbach: Beier & Beran.

Marean, Curtis W., Miryam Bar-Matthews, Jocelyn Bernatchez, Erich Fisher, Paul Goldberg, et al. 2007. "Early Human Use of Marine Resources and Pigment in South Africa during the Middle Pleistocene." *Nature* 449:905–8.

Mark, Robert, and Evelyn Newman. 1995. "Cup-and-Ring Petroglyphs in Northern California and Beyond." In J. Steinbring, ed., *Rock Art Studies in the Americas*, 13–21. Oxbow Monograph 45. Oxford: Oxbow Books.

Marshack, Alexander. 1976. "Implications of the Paleolithic Symbolic Evidence for the Origins of Language." *American Scientist* 64:136–45.

———. 1991. *The Roots of Civilization: The Cognitive Beginnings of Man's First Art, Symbol and Notation.* Mount Kisco, NY: Moyer Bell.

Marymor, Leigh. 2003. "Rock Art Conservation at Canyon Trail Park, El Cerrito, California (San Francisco Bay Area)." *La Pintura* 30 (1): 1–4.

Matthews, John. 2013. "Seven Spots and a Squiggle: The Prehistory of Pictures." In K. Sachs-Hombach and J. R. J. Schirra, eds., *Origins of Pictures*, 311–52. Köln: Halem.

McBrearty, Sally. 2001. "The Middle Pleistocene of East Africa." In L. Barham and K. Robson-Brown, eds., *Human Roots: Africa and Asia in the Middle Pleistocene*, 81–92. Bristol, England: Western Academic and Specialist Press.

McBrearty, Sally, and Alison Brooks. 2000. "The Revolution That Wasn't: A New Interpretation of the Origin of Modern Human Behavior." *Journal of Human Evolution* 39:453–563.

McCauley, Robert N., and E. Thomas Lawson. 2002. *Bringing Ritual to Mind.* New York: Columbia University Press.

McCreery, Patricia, and Ekkehart Malotki. 1994. *Tapamveni: The Rock Art Galleries of Petrified Forest and Beyond.* Petrified Forest, AZ: Petrified Forest Museum Association.

McDougall, Ian, Francis H. Brown, and John G. Fleagle. 2005. "Stratigraphic Placement and Age of Modern Humans from Kibish, Ethiopia." *Nature* 433 (7027): 733–36.

McGilchrist, Iain. 2009. *The Master and His Emissary: The Divided Brain and the Making of the Western World.* New Haven, CT: Yale University Press.

McLaughlin, Katie A., Margaret A. Sheridan, Warren Winter, Nathan A. Fox, Charles H. Zeanah, and Charles A. Nelson. 2014. "Widespread Reductions in Cortical Thickness Following Severe Early-Life Deprivation: A Neurodevelopmental Pathway to Attention-Deficit/Hyperactivity Disorder." *Biological Psychiatry* 76:629–38.

McWhorter, John H. 2014. *The Language Hoax: Why the World Looks the Same in Any Language.* Oxford: Oxford University Press.

Mellars, Paul, and Chris Stringer, eds. 1989. *The Human Revolution: Behavioural and Biological Perspectives on the Origins of Modern Humanity.* Edinburgh: Edinburgh University Press.

Meller, Harald. 2005. *Geisteskraft: Alt- und Mittelpaläolithikum.* Halle (Saale): Landesmuseum für Vorgeschichte.

Mendoza Straffon, Larissa. 2014. "Art in the Making: The Evolutionary Origins of Visual Art as a Communication Signal." PhD diss., University of Leiden, Netherlands.

Merker, Bjorn. 2000. "Synchronous Chorusing and Human Origins." In N. L. Wallin, B. Merker, and S. Brown, eds., *The Origins of Music*, 315–27. Cambridge, MA: MIT Press.

Miall, David S., and Ellen Dissanayake. 2003. "The Poetics of Babytalk." *Human Nature* 14 (4): 337–64.

Middleton, Emily S. 2013. "Paleoindian Rock Art: An Evaluation of the Antiquity of Great Basin Carved Abstract Rock Art in the Northern Great Basin." Master's thesis, University of Nevada, Reno.

Middleton, Emily, Geoffrey M. Smith, William J. Cannon, and Mary F. Ricks. 2014. "Paleoindian Rock Art: Establishing the Antiquity of Great Basin Carved Abstract Petroglyphs in the Northern Great Basin." *Journal of Archaeological Science* 43:21–30.

Midgley, Mary. 1978. *Beast and Man: The Roots of Human Nature*. London: Routledge.

Miller, Geoffrey. 2000. *The Mating Mind: How Sexual Choice Shaped the Evolution of Human Nature*. New York: Doubleday.

Miller, Warren B., and Joseph L. Rodgers. 2001. *The Ontogeny of Human Bonding Systems: Evolutionary Origins, Neural Bases, and Psychological Manifestations*. Boston: Kluwer Academic Publishers.

Mithen, Steven. 1996. *The Prehistory of the Mind: The Cognitive Origins of Art*. London: Thames and Hudson.

Monnot, Marilee. 1999. "Function of Infant-Directed Speech." *Human Nature* 10:415–43.

Morley, Iain. 2013. *The Prehistory of Music: Human Evolution, Archaeology, and the Origins of Musicality*. Oxford: Oxford University Press.

———. 2017. "Pretend Play, Cognition and Life-History." In C. Renfrew, I. Morley, and M. Boyd, eds., *Ritual, Play and Belief, in Evolution and Early Human Societies*, 66–86. Cambridge: Cambridge University Press.

Morphy, Howard. 1989. "From Dull to Brilliant: The Aesthetics of Spiritual Power among the Yolngu." *Man* 24 (1): 21–40.

Morris, Desmond. 1957. "Typical Intensity and Its Relation to the Problem of Ritualization." *Behaviour* 11:1–2.

———. 1962. *The Biology of Art*. New York: Knopf.

Mountford, Charles P. 1976. *Nomads of the Australian Desert*. Adelaide: Rigby.

Mulvaney, Ken. 2010. "Murujuga Marni–Dampier Petroglyphs: Shadows in the Landscape, Echoes across Time." PhD diss., University of New England, Australia.

Munyikwa, Kennedy, James K. Feathers, Tammy M. Rittenour, and Heather K. Shrimpton. 2011. "Constraining the Late Wisconsinan Retreat of the Laurentide Ice Sheet from Western Canada Using Luminescence Ages from Postglacial Aeolian Dunes." *Quaternary Geochronology* 6:407–22.

Murdock, George Peter. 1967 *Ethnographic Atlas: A Summary*. Pittsburgh: University of Pittsburgh Press.

———. 1987. *Atlas of World Cultures*. Pittsburgh: The University of Pittsburgh Press.

Murray, Lynne, and Colwyn Trevarthen. 1985. "Emotional Regulation of Interactions between Two-Month-Olds and Their Mothers." In T. Field and N. Fox, eds., *Social Perception in Infants*, 177–98. Norwood, NJ: Ablex.

Murray, W. Breen. 2013. "North American Rock Art in a World Cultural Context." IFRAO 2013 Proceedings. *American Indian Rock Art* 40:139–46. DVD.

Nelson, Eric E., and Jaak Panksepp. 1998. "Brain Substrates of Infant-Mother Attachment: Contributions of Opioids, Oxytocin, and Norepinephrine." *Neuroscience and Biobehavioural Reviews* 22:437–52.

Nettle, Daniel. 1999. "Linguistic Diversity of the Americas Can Be Reconciled with a Recent Colonization." *Proceedings of the National Academy of Sciences* 96 (6): 3325–29.

Nichols, Johanna. 2002. "The First American Languages." In N. J. Jablonski, ed., *The First Americans: The Pleistocene Colonization of the New World*, 273–94. Memoirs of the California Academy of Sciences 27. Berkeley: University of California Press.

Nissen, Karen M. 1975. "A New Style of Rock Art in the Great Basin: The Stillwater Facetted Style." *Nevada Archaeological Survey Reporter* 8 (2): 10–11.

———. 1982. "Images of the Past: An Analysis of Six Western Great Basin Petroglyph Sites." PhD diss., University of California, Berkeley.

———. 1995. "Pray for Signs? Petroglyph Research in the Western Great Basin, North America." In J. Steinbring, ed., *Rock Art Studies in the Americas*, 67–75. Oxbow Monograph 45. Oxford: Oxbow Books.

Nissen, Karen M., and Eric W. Ritter. 1986. "Cupped Rock Art in North-Central California: Hypotheses Regarding Age and Social/Ecological Context." *American Indian Rock Art* 11:58–75.

Novak, Martin A. 2006. "Five Rules for the Evolution of Cooperation." *Science* 314:1560–63.

Nowell, April. 2010. "Defining Behavioral Modernity in the Context of Neanderthal and Anatomically Modern Human Populations." *Annual Review of Anthropology* 39:437–52.

Numan, Michael, and Larry J. Young. 2016. "Neural Mechanisms of Mother-Infant Bonding and Pair Bonding: Similarities, Differences, and Broader Implications." *Hormones and Behavior* 77:98–112.

Oakley, Kenneth P. 1981. "The Emergence of Higher Thought 3.0-0.2 Ma B.P." *Philosophical Transactions of the Royal Society of London, B* 292:205–11.

Ong, Walter J. 1982. *Orality and Literacy*. New York: Methuen.

Oohashi, Tsutomu, Norie Kawai, Manabu Honda, Satoshi Nakamura, Masako Morimoto, Emi Nishina, and Tadao Maekawa. 2002. "Electroencephalographic Measurement of Possession Trance in the Field." *Clinical Neurophysiology* 113 (3): 435–45.

Orr, Phil C. 1956. *Pleistocene Man in Fishbone Cave, Pershing County, Nevada*. Nevada State Museum Bulletin, no. 2.

———. 1974. "Notes on the Archaeology of the Winnemucca Lake Caves, 1952–1958." *Nevada State Museum Anthropological Papers* 16:47–59.

Oster, Gerald. 1970. "Phosphenes." *Scientific American* 222 (2): 83–87.

Ouzman, Sven. 1998. "Towards a Mindscape of Landscape." In C. Chippindale and P. S. C. Taçon, eds., *The Archaeology of Rock Art*, 30–41. Cambridge: Cambridge University Press.

———. 2005. "Seeing Is Deceiving: Rock Art and the Non-visual." In T. Heyd and J. Clegg, eds., *Aesthetics and Rock Art*, 253–68. London: Ashgate.

Pagel, Mark. 2000. "The History, Rate and Pattern of World Linguistic Evolution." In C. Knight, M. Studdert-Kennedy, and J. Hurford, eds., *The Evolutionary Emergence of Language*, 391–416. Cambridge: Cambridge University Press.

Pandya, Vishvajit. 2009. *In the Forest: Visual and Material Worlds of Andamanese History (1858–2006)*. Lanham, MD: University of America.

Panksepp, Jaak. 1998. *Affective Neuroscience: The Foundation of Animal and Human Emotions*. Oxford: Oxford University Press.

Panksepp, Jaak, and Lucy Biven. 2012. *The Archaeology of Mind: Neuroevolutionary Origins of Human Emotions*. New York: W. W. Norton.

Panksepp, Jaak, Eric E. Nelson, and Marni Bekkedal. 1999. "Brain Systems for the Mediation of Social Separation-Distress and Social-Reward: Evolutionary Antecedents and Neuropeptide Intermediaries." In C. S. Carter, I. Lederhendler, and B. Kirkpatrick, eds., *The Integrative Neurobiology of Affiliation*, 221–43. Cambridge, MA: MIT Press.

Parkman, E. Breck. 1993. "Creating Thunder: The Western Rain-Making Process." *Journal of California and Great Basin Anthropology* 15 (1): 90–110.

———. 1994. "The Canadian Ribstone Petroglyphs." *Pictogram* 7:12–17.

———. 1995a. "California Dreamin': Cupule Petroglyph Occurrences in the American West." In J. Steinbring, ed., *Rock Art Studies in the Americas*, 1–12. Oxbow Monograph 45. Oxford: Oxbow Books.

———. 1995b. "A Theoretical Consideration of the Pitted Boulder." *Papers on Californian Prehistory* 4:1–24.

———. 2007. "If Rocks Could Talk, What We Might Learn by Listening: A Discussion from California's North Coast Ranges." *Science Notes* 84:1–8. Petaluma: California State Parks.

Peirce, Charles S. 1998. *The Essential Peirce: Selected Philosophical Writings*. Bloomington: University of Indiana Press.

Pellegrini, Evan, Eugene M. Hattori, and Larry V. Benson. 2016. "A Paleoindian Grasshopper Cache from Winnemucca Lake, Pershing County, Nevada." Paper presented at the annual meeting of the Great Basin Anthropological Conference, Reno, Nevada.

Peratt, Anthony L. 2003. "Characteristics for the Occurrence of High-Current, Z-Pinch Aurora as Recorded in Antiquity." *IEEE Transactions on Plasma Science* 31 (6): 1192–214.

Pettitt, Paul. 2011. "The Living as Symbols, the Dead as Symbols: Problematising the Scale and Pace of Hominin Symbolic Evolution." In C. S. Henshilwood and F. d'Errico, eds., *Homo Symbolicus: The Dawn of Language, Imagination, and Spirituality*, 141–61. Amsterdam: John Benjamins.

Pettitt, Paul, Paul Bahn, and Christian Züchner. 2009. "The Chauvet Conundrum: Are Claims for the 'Birthplace of Art' Premature?" In P. G. Bahn, ed., *An Enquiring Mind: Studies in Honor of Alexander Marshack*, 239–62. Oxford: Oxbow Books.

Pettitt, Paul, and Alistair Pike. 2007. "Dating European Palaeolithic Cave Art: Progress, Prospects, Problems." *Journal of Archaeological Method and Theory* 14 (1): 27–47.

Peyrony, Denis. 1934. "La Ferrassie. Moustérien, Périgordien, Aurignacien." *Préhistoire* 3:1–92.

Pfeiffer, John E. 1982. *The Creative Explosion: An Inquiry into the Origins of Art and Religion*. New York: Harper and Row.

Phillips-Silver, Jessica, Athena Aktipis, and Gregory A. Bryant. 2010. "The Ecology of Entrainment: Foundations of Coordinated Rhythmic Movement." *Music Perception* 28:3–14.

Phillips-Silver, Jessica, and Peter E. Keller. 2012. "Searching for Roots of Entrainment and Joint Action in Early Musical Interactions." *Frontiers in Human Neuroscience* 6 (26): 1–11.

Piaget, Jean. 1970. *Genetic Epistemology*. New York: Columbia University Press.

———. 1974. *The Construction of Reality in the Child*. New York: Ballantine Books.

Pike, Alistair W. G., Dirk L. Hoffmann, Marcos Garcia-Diez, Paul B. Pettitt, Javier Alcolea, et al. 2012. "U-Series Dating of Paleolithic Art in 11 Caves in Spain." *Science* 336:1409–13.

Pinker, Steven. 2002. *The Blank Slate: The Modern Denial of Human Nature*. New York: Penguin Putnam.

Pinker, Steven, and Ray Jackendoff. 2005. "The Faculty of Language: What's Special about It?" *Cognition* 95 (2): 201–36.

Porges, Stephen W., and C. Sue Carter. 2011. "Neurobiology and Evolution: Mechanisms, Mediators and Adaptive Consequences of Caregiving." In S. L. Brown, R. M. Brown, and L. A. Penner, eds., *Moving Beyond Self-Interest: Perspectives from Evolutionary Biology, Neuroscience, and the Social Sciences*, 53–72. Oxford: Oxford University Press.

Portmann, Adolf. 1941. "Die Tragzeiten der Primaten und die Dauer der Schwangerschaft beim Menschen: Ein Problem der vergleichenden Biologie." *Revue Suisse de Zoologie* 48:511–18.

Potts, Rick. 1996. *Humanity's Descent: The Consequences of Ecological Stability*. New York: William Morrow.

Preuschoft, Signe, and Johan A. R. A. M. van Hooff. 1997. "The Social Function of 'Smile' and 'Laughter': Variations across Primate Species and Societies." In U. Segerstråle and P. Molnár, eds., *Nonverbal Communication: Where Nature Meets Culture*, 171–89. Mahwah, NJ: Erlbaum.

Price, Sally, and Richard Price. 1980. *Afro-American Arts of the Suriname Rain Forest*. Berkeley: University of California Press.

Pringle, Heather. 2011. "The First Americans." *Scientific American* 305 (5): 36–45.

Prum, Richard O. 2017. *The Evolution of Beauty: How Darwin's Forgotten Theory of Mate Choice Shapes the Animal World—and Us*. New York: Doubleday.

Purdy, Barbara A. 1991. *The Art and Archaeology of Florida's Wetlands*. Boca Raton: CRC Press.

———. 2012. "The Mammoth Engraving from Vero Beach, Florida: Ancient or Recent?" *Florida Anthropologist* 65 (4): 205–17.

Purdy, Barbara A., Kevin S. Jones, John J. Mecholsky, Gerald Bourne, Richard C. Hulbert, et al. 2011. "Earliest Art in the Americas: Incised Image of a Proboscidean on a Mineralized Extinct Animal Bone from Vero Beach, Florida." *Journal of Archaeological Science* 38:2908–13.

Pyysiäinen, Ilkka. 2001. *How Religion Works: A New Cognitive Science of Religion*. Leiden, Netherlands: Brill.

Quinlan, Angus R. 2000. "The Ventriloquist's Dummy: A Critical Review of Shamanism and Rock Art in Far Western North America." *Journal of California and Great Basin Anthropology* 22 (1): 92–108.

———. 2012. "The Stylistic Context of Northern Sierra Nevada Rock Art." *Great Basin Glyph Notes* 11 (4): 4–5.

Quinlan, Angus R., and Alanah Woody. 2003. "Marks of Distinction: Rock Art and Ethnic Identification in the Great Basin." *American Antiquity* 68 (2): 372–90.

Radcliffe-Brown, Alfred R. 1948/1922. *The Andaman Islanders*. Reprint, Glencoe, IL: Free Press.

Rappaport, Ray A. 1999. *Ritual and Religion in the Making of Humanity*. Cambridge: Cambridge University Press.

Rasmussen, Morten, Sarah L. Anzick, Michael R. Waters, Pontus Skoglund, Michael DeGeorgio, et al. 2014. "The Genome of a Late Pleistocene Human from a Clovis Burial Site in Western Montana." *Nature* 506:225-29.

Ravilious, Kate. 2010. "The Writing on the Cave Wall." *New Scientist* 205 (2748): 30–34.

Reddish, Paul, Ronald Fischer, and Joseph Bulbulia. 2013. "Let's Dance Together: Synchrony, Shared Intentionality, and Cooperation." *PLoS ONE* 8 (8): e71182.

Renfrew, Colin. 2017. "Introduction: Play as the Precursor of Ritual in Early Human Societies." In C. Renfrew, I. Morley, and M. Boyd, eds., *Ritual, Play and Belief in Evolution and Early Human Societies*, 9–21. Cambridge: Cambridge University Press.

Reznikoff, Iegor. 2008. "Sound Resonance in Prehistoric Times: A Study of Paleolithic Painted Caves and Rocks." *Journal of the Acoustical Society of America* 123 (5): 3608.

Richter, Daniel, Rainer Grün, Renaud Joannes-Boyau, Teresa E. Steele, Fethi Amani, et al. 2017. "The Age of the Hominin Fossils from Jebel Irhoud, Morocco, and the Origin of the Middle Stone Age." *Nature* 546:293–96. doi:10.1038/nature22335.

Ricks, Mary F. 1995. "A Survey and Analysis of Prehistoric Rock Art of the Warner Valley Region, Lake County, Oregon." PhD diss., Portland State University.

———. 1996. *A Survey and Analysis of Prehistoric Rock Art of the Warner Valley Region, Lake County, Oregon*. Technical Report 96-1. Reno: Department of Anthropology, University of Nevada.

Ritter, Eric W. 1994. "Scratched Rock Art Complexes in the Desert West: Symbols for Socio-Religious Communication." In D. S. Whitley and L. L. Loendorf, eds., *New Light on Old Art: Recent Advances in Hunter-Gatherer Rock Art*, 51–66. Monograph 36. Los Angeles: University of California Los Angeles Institute of Archaeology.

Robinson IV, Francis. 2009. "The Reagan Site Revisited: A Contemporary Analysis of a Formative Northeastern Paleoindian Site." *Archaeology of Eastern North America* 37:85–147.

Robinson, Judy. 1992. "Not Counting on Marshack: A Reassessment of the Work of Alexander Marshack on Notation in the Upper Palaeolithic." *Journal of Mediterranean Studies* 2 (1): 1–16.

Rodriguez-Nadal, Joaquín, Francesco d'Errico, Francisco G. Pacheco, Ruth Blasco, Jordi Rosell, et al. 2014. "A Rock Engraving Made by Neanderthals in Gibraltar." *Proceedings of the National Academy of Sciences* 111 (37): 13301–6.

Rogers, Lesley J., and Gisela Kaplan. 2000. *Songs, Roars, and Rituals: Communication in Birds, Mammals, and Other Animals*. Cambridge, MA: Harvard University Press.

Rosenberg, Karen R. 1992. "The Evolution of Modern Human Childbirth." *Yearbook of Physical Anthropology* 35:89–134.

Rossano, Matt. 2010. *Supernatural Selection: How Religion Evolved*. Oxford: Oxford University Press.

Rossi-Landi, Ferruccio. 1973. *Ideologies of Linguistic Relativity*. The Hague: Mouton.

Rouzaud, François, Michel Soulier, and Yves Lignereux. 1996. "La grotte de Bruniquel." *Spelunca* 60: 28–34.

Rowe, Martin W. 2012. "Dating of Rock Art Paintings in the Americas: A Word of Caution." In J. Clottes, ed., *L'art Pléistocène dans le monde*, 573–84. Préhistoire, art et sociétés nos. 65–66. Tarascon-sur-Ariège, France: Société Préhistorique Ariège-Pyrénées. Compact disc.

Sacks, Oliver. 2012. *Hallucinations*. New York: Alfred A. Knopf.

Sapolsky, Robert M. 1992. "Neuroendocrinology of the Stress Response." In J. R. Becker, S. M. Breedlove, and D. Crews, eds., *Behavioral Endocrinology*, 287–324. Cambridge, MA: MIT Press.

Sauvet, Georges, and André Wlodarczyk. 2000–2001. "L'Art Pariétal, Miroir des Sociétés Paléolithiques." *Zephyrus* 53–54:215–38.

Scardovelli, Matteo. 2013. "The Myth of the 'Symbolical' Blombos Cave Piece of Ochre." Paper presented at the IFRAO International Rock Art Congress, Albuquerque, NM.

Schaafsma, Polly. 1980. *Indian Rock Art of the Southwest*. Albuquerque: University of New Mexico Press.

———. 1992. *Rock Art in New Mexico*. Santa Fe: Museum of New Mexico Press.

———. 1994. "Trance and Transformation in the Canyons: Shamanism and Early Rock Art on the Colorado Plateau." In S. A. Turpin, ed., Special Publication, *Shamanism and Rock Art in North America*, 45–72. San Antonio, TX: Rock Art Foundation.

———. 2013. *Images and Power: Rock Art and Ethics*. New York: Springer.

Scherer, Klaus R., and Marcel R. Zentner. 2001. "Emotional Effects of Music: Production Rules." In P. N. Juslin and J. A. Sloboda, eds., *Music and Emotion: Theory and Research*, 361–92. Oxford: Oxford University Press.

Schiefenhövel, Wulf, and Eckart Voland. 2009. "Introduction." In E. Voland and W. Schiefenhövel, eds., *The Biological Evolution of Religious Mind and Behavior*, 1–7. Dordrecht: Springer.

Schore, Allan N. 1994. *Affect Regulation and the Origin of the Self: The Neurobiology of Emotional Development*. Hillsdale, NJ: Erlbaum.

———. 2003. *Affect Dysregulation and Disorders of the Self*. New York: W. W. Norton.

———. 2012. *The Science of the Art of Psychotherapy.* New York: W. W. Norton.

Schuster, Carl, Edmund Carpenter, and Lorraine Spiess. 1986–88. *Materials for the Study of Social Symbolism in Ancient and Tribal Art: A Record of Tradition and Continuity.* Vol. 2, *Book 4: Pebbles.* New York: Rock Foundation.

Scupin, Raymond. 2003. *Cultural Anthropology: A Global Perspective.* 5th ed. Upper Saddle River, NJ: Prentice Hall.

Seghers, Eveline. 2015. "Methodology in the Evolutionary Study of Art: Perspectives in Philosophical Anthropology, Cognitive Archaeology, and Evolutionary Theory." PhD diss., University of Ghent, Belgium.

Sellards, Elias H. 1916. "Human Remains and Associated Fossils from the Pleistocene of Florida." *Florida Geological Survey Eighth Annual Report:* 123–68. Tallahassee, FL.

Semper, Gottfried. 2004/1860–63. *Style in the Technical and Tectonic Arts: Or, Practical Aesthetics (Der Stil in den technischen und tektonischen Künsten).* Trans. H. F. Mallgrave. Reprint, Santa Monica, CA: Getty Publications.

Shaver, Phillip, Cindy Hazan, and Donna Bradshaw. 1988. "Love as Attachment: The Integration of Three Behavioral Systems." In R. J. Sternberg and M. L. Barnes, eds., *The Psychology of Love,* 86–99. New Haven: Yale University Press.

Shea, John J. 2008. "The Middle Stone Age Archaeology of the Lower Omo Valley Kibish Formation: Excavations, Lithic Assemblages, and Inferred Patterns of Early *Homo sapiens* Behavior." *Journal of Human Evolution* 55:448–85.

Sheridan, Susan R. 2005. "A Theory of Marks and Mind: The Effect of Notational Systems on Hominid Brain Evolution and Child Development with an Emphasis on Exchanges between Mothers and Children." *Medical Hypotheses* 64:417–27.

Shipman, Pat. 2010. "The Animal Connection and Human Evolution." *Current Anthropology* 51(4): 519–38. doi:10.1086/653816.

Silvester, Hans. 2009. *Natural Fashion: Tribal Decoration from Africa.* London: Thames and Hudson.

Siscoe, George L. 1976. "Solar-Terrestrial Relations: Stone Age to Space Age." *Technology Review* 78:27–37.

Smith, Brian A., and Alan A. Walker. 2011. *Rock Art and Ritual: Mindscapes of Prehistory.* Stroud, England: Amberley Publishing.

Smith, Heather L., Jeffrey T. Rasic, and Ted Goebel. 2013. "Biface Traditions of Northern Alaska and Their Role in the Peopling of the Americas." In K. E. Graf, C. V. Ketron, and M. R. Waters, eds., *Paleoamerican Odyssey,* 105–23. College Station: Texas A&M University Press.

Smith, W. John. 1977. *The Behaviour of Communicating: An Evolutionary Approach.* Cambridge, MA: Harvard University Press.

Sober, Elliot, and David S. Wilson. 1998. *Unto Others: The Evolution and Psychology of Unselfish Behavior.* Cambridge, MA: Harvard University Press.

Solodeynikov, Alexey. 2005. Research on the Recording of Rock Paintings in the Kapova Cave (Urals). *International Newsletter on Rock Art* 43:10–14.

Solso, Robert L. 1994. *Cognition and the Visual Arts.* Cambridge, MA: MIT Press.

Spivey, Nigel. 2005. *How Art Made the World: A Journey to the Origins of Human Creativity.* New York: Basic Books.

Sreenathan, M., V. Raghavendra, and Robert G. Bednarik. 2008. "Paleolithic Cognitive Inheritance in Aesthetic Behavior of the Jarawas of the Andaman Islands." *Anthropos: International Review of Anthropology and Linguistics* 103 (2): 367–92.

Stanford, Dennis J., and Bruce A. Bradley. 2012. *Across Atlantic Ice: The Origin of America's Clovis Culture.* Berkeley: University of California Press.

Steguweit, Leif. 2003. *Gebrauchsspuren an Artefakten der Hominidenfundstelle Bilzingsleben (Thüringen)*. Tübinger Arbeiten zur Urgeschichte 2. Rahden, Germany: Verlag Marie Leidorf.

Steinbring, Jack. 1995. "The Earliest Rock Art in the Americas: North America." *Rock Art Research* 12 (2): 133–34.

———. 2004. "Elemental Forms of Rock-Art and the Peopling of the Americas." In C. Diaz-Granados and J. R. Duncan, eds., *The Rock-Art of Eastern North America: Capturing Images and Insight*, 126–44. Tuscaloosa: University of Alabama Press.

Steinbring, Jack, and Anthony P. Buchner. 1997. "Cathedrals of Prehistory: Rock Art Sites of the Northern Plains." *American Indian Rock Art* 23:73–84.

Steinbring, Jack, Eve Danzinger, and Richard Callaghan. 1987. "Middle Archaic Petroglyphs in Northern North America." *Rock Art Research* 4 (1): 3–16 and 4 (2): 150–61.

Stenger, Alison T. 2014. "Pre-Clovis in the Americas: Characterizing Early Sites, Material Culture, and Origins." In D. J. Stanford and A. T. Stenger, eds., *Pre-Clovis in the Americas: International Science Conference Proceedings*, 5–15. Washington, DC: Smithsonian Institution.

Sterelny, Kim. 2012. *The Evolved Apprentice: How Evolution Made Humans Unique*. Cambridge, MA: MIT Press.

Stern, Daniel. 1971. "A Microanalysis of Mother-Infant Interaction." *Journal of the American Academy of Child Psychiatry* 10:501–17.

Stern, Daniel, L. Hofer, Wendy Haft, and John Dore. 1985. "Affect Attunement: The Sharing of Feeling States between Mother and Infant by Means of Inter-Modal Fluency." In T. M. Field and N. A. Fox, eds., *Social Perception in Infants*, 249–68. Norwood, NJ: Ablex.

Stringer, Chris. 2011. *The Origins of Our Species*. London: Allen Lane.

Stroh, Katrin, and Thelma Robinson. 1993. *Learning and Communication: Functional Learning Programmes for Young Developmentally Delayed Children* (handbook and video). Suffolk, England: Concord Video and Film Council Ltd.

Sugiyama, Larry S., and Michelle Scalise Sugiyama. 2003. "Social Roles, Prestige, and Health Risk: Social Niche Specialization as a Risk-Buffering Strategy." *Human Nature* 14 (2): 165–90.

Taçon, Paul S. C. 1983. "Dorset Art in Relation to Prehistoric Culture Stress." Études Inuit *(Inuit Studies)* 7:41–65.

———. 1991. "The Power of Stone: Symbolic Aspects of Stone Use and Tool Development in Western Arnhem Land, Australia." *Antiquity* 65:192–207.

Taçon, Paul S. C., and Sally Brockwell. 1995. "Arnhem Land Prehistory in Landscape, Stone, and Paint." *Antiquity* 69:676–95.

Taçon, Paul S. C., Richard Fullagar, Sven Ouzman, and Ken Mulvaney. 1997. "Cupule Engravings from Jinmium-Granilpi (Northern Australia) and Beyond: Exploration of a Widespread and Enigmatic Class of Rock Markings." *Antiquity* 71:942–65.

Taçon, Paul S. C., and Michelle C. Langley. 2012. "Rock Art Dating in Australia and Beyond: What Does It Tell Us?" In J. Clottes, ed., *L'art Pléistocène dans le monde*, 1129–55. Préhistoire, art et sociétés nos. 65–66. Tarascon-sur-Ariège, France: Société Préhistorique Ariège-Pyrénées. Compact disc.

Taçon, Paul S. C., Meredith Wilson, and Christopher Chippindale. 1996. "Birth of the Rainbow Serpent in Arnhem Land Rock Art and Oral History." *Archaeology Oceania* 31:103–24.

Tambiah, Stanley J. 1979. "A Performative Approach to Ritual." *Proceedings of the British Academy* 65:113–69.

Taylor, Shelley E. 1992. *The Tending Instinct: How Nurturing Is Essential to Who We Are and How We Live*. New York: Henry Holt.

———. 2007. "Social Support." In H. S. Friedman and R. C. Silver, eds., *Foundations of Health Psychology*, 145–71. New York: Oxford University Press.

Taylor, Shelley E., Lisa J. Burklund, Naomi I. Eisenberger, Barbara J. Lehman, Clayton J. Hilmert, et al. 2008. "Neural Bases of Moderation of Cortisol Stress Responses by Psychosocial Resources." *Journal of Personality and Social Psychology* 95 (1): 197–211.

Tedlock, Dennis, and Barbara Tedlock. 1975. "Introduction." In D. Tedlock and B. Tedlock, eds., *Teachings from the American Earth: Indian Religion and Philosophy*, xi–xxiv. New York: Liveright.

Tesar, Louis D. 2016. "Vero Beach, Florida, Engraved Depiction of a Mammoth: The Engraving's Antiquity Questioned." *Florida Anthropologist* 69 (4): 174–82.

Thangaraj, Kumarasamy, Lalji Singh, Alla G. Reddy, V. Raghavendra Rao, Subhash C. Sehgal, et al. 2003. "Genetic Affinities of the Andaman Islanders, a Vanishing Human Population." *Current Biology* 13 (2): 86–93.

Thomas, Nicholas. 2001. "Introduction." In C. Pinney and N. Thomas, eds., *Beyond Aesthetics: Art and the Technologies of Enchantment*, 1–12. Oxford: Berg (now Bloomsbury).

Tinbergen, Nikolaas. 1952. "'Derived' Activities: Their Causation, Biological Significance, Origin and Emancipation during Evolution." *Quarterly Review of Biology* 17:1–32.

———. 1959. "Comparative Studies of the Behaviour of Gulls (Laridae): A Progress Report." *Behaviour* 15:1–70.

Tomasello, Michael. 1999. *The Cultural Origins of Human Cognition*. Cambridge, MA: Harvard University Press.

———. 2003. "Recursion as the Key to the Human Mind." In K. Sterelny and J. Fitness, eds., *From Mating to Mentality: Evaluating Evolutionary Psychology*, 155–72. New York: Psychology Press.

———. 2008. *Origins of Human Communication*. Cambridge, MA: MIT Press.

Tomasello, Michael, Malinda Carpenter, Joseph Call, Tanya Behne, and Henrike Moll. 2005. "Understanding and Sharing Intentions: The Origins of Cultural Cognition." *Behavioral and Brain Sciences* 28:675–735.

Tonkinson, Robert. 1978. *The Mardudjara Aborigines: Living the Dream in Australia's Desert*. New York: Holt, Rinehart and Winston.

Tratebas, Alice M. 2012a. "Late Pleistocene Petroglyph Traditions on the North American Plains." In J. Clottes, ed., *L'art Pléistocène dans le monde*, 108-9. Préhistoire, art et sociétés nos. 65–66. Tarascon-sur-Ariège, France: Société Préhistorique Ariège-Pyrénées.

———. 2012b. "North American–Siberian Connections: Regional Rock Art Patterning Using Multivariate Statistics." In J. McDonald and P. Veth, eds., *A Companion to Rock Art*, 143–59. Chichester: Wiley-Blackwell.

Trevarthen, Colwyn. 1979. "Communication and Cooperation in Early Infancy: A Description of Primary Intersubjectivity." In M. Bullowa, ed., *Before Speech: The Beginning of Human Communication*, 321–476. Cambridge: Cambridge University Press.

Trevathan, Wenda. 1987. *Human Birth: An Evolutionary Perspective*. Hawthorn, NY: Aldine.

Trinkhaus, Erik. 2013. "The Paleobiology of Modern Human Experience." In F. H. Smith and J. C. M. Ahern, eds., *The Origins of Modern Humans: Biology Reconsidered*, 393–434. Hoboken, NJ: John Wiley & Sons.

Turino, Tom. 2008. *Music as Social Life: The Politics of Participation*. Chicago: University of Chicago Press.

Turner, Victor W. 1969. *The Ritual Process*. London: Routledge and Kegan Paul.

Turpin, Solveig A. 1994. "On a Wing and a Prayer: Flight Metaphors in Pecos River Art." In S. A. Turpin, ed., *Shamanism and Rock Art in North America*, 73–102. Special Publication 1, Rock Art Foundation, San Antonio, Texas.

———. 2001. "Archaic North America." In D. S. Whitley, ed., *Handbook of Rock Art Research*, 361–413. Walnut Creek, CA: Alta Mira Press.

Uvnäs-Moberg, Kerstin. 1999. "Physiological and Endocrine Effects of Social Contact." In C. Carter, I. Lederhendler, and B. Kirkpatrick, eds., *The Integrative Neurobiology of Affiliation*, 245–61. Cambridge, MA: MIT Press.

van der Sluijs, Marinus A., and Anthony L. Peratt. 2008. "Searching for Rock Art Evidence for an Ancient Super Aurora." *Expedition* 52 (2): 33–42.

van Gennep, Arnold. 1960/1909. *The Rites of Passage*. Reprint, London: Routledge and Kegan Paul.

Vanhaeren, Marian. 2005. "Speaking with Beads: The Evolutionary Significance of Bead Making and Use." In F. d'Errico and L. Backwell, eds., *From Tools to Symbols: From Hominids to Modern Humans*, 525–35. Johannesburg: Wits University Press.

Vanhaeren, Marian, Francesco d'Errico, Chris Stringer, Sarah L. James, Jonathan A. Todd, and Henk K. Mienis. 2006. "Middle Paleolithic Shell Beads in Israel and Algeria." *Science* 312 (5781): 1785–88.

Van Peer, Philip, Richard Fullagar, Stephen Stokes, Jan Moeyersons, Frans Steenhoudt, et al. 2003. "The Early to Middle Stone Age Transition and the Emergence of Modern Behavior at Site 8-B-11, Sai Island, Sudan." *Journal of Human Evolution* 45 (2): 187–93.

van Sommers, Peter. 1984. *Drawings and Cognition*. Cambridge: Cambridge University Press.

Varella, Marco A. C., Altay A. L. de Souza, and José H. B. P. Ferreira. 2011. "Evolutionary Aesthetics and Sexual Selection in the Evolution of Rock Art Aesthetics." *Rock Art Research* 28 (2): 153–86.

von Petzinger, Genevieve. 2009. "Making the Abstract Concrete: The Place of Geometric Signs in French Upper Paleolithic Parietal Art." Master's thesis, University of Victoria, BC, Canada.

———. 2016. *The First Signs: Unlocking the Mysteries of the World's Oldest Symbols*. New York: Atria Books.

Wade, Nicholas. 2006. *Before the Dawn: Recovering the Lost History of Our Ancestors*. New York: Penguin Press.

Wadley, Lyn. 2001. "What Is Cultural Modernity? A General View and a South African Perspective from Rose Cottage Cave." *Cambridge Archaeological Journal* 11:201–21.

Walker, Danny N., Michael T. Bies, Todd Surovell, George F. Frison, and Mark E. Miller. 2012. "Paleoindian Portable Art from Wyoming, USA." In J. Clottes, ed., *L'art Pléistocène dans le monde*, 697–709. Préhistoire, art et sociétés nos. 65–66. Tarascon-sur-Ariège, France: Société Préhistorique Ariège-Pyrénées. Compact disc.

Wallace, Henry D. 2008. "The Petroglyphs of Atlatl Ridge, Tortolita Mountains, Pima County, Arizona." In D. L. Swartz, ed., *Life in the Foothills: Archaeological Investigations in the Tortolita Mountains of Southern Arizona*, 159–231. Anthropological Papers, no. 46. Tucson, AZ: Center for Desert Archaeology.

Wallace, Henry D., and James P. Holmlund. 1986. *Petroglyphs of the Picacho Mountains, South Central Arizona*. Anthropological Papers, no. 6. Tucson, AZ: Institute for American Research.

Walsh, Roger N. 1990. *The Spirit of Shamanism*. Los Angeles: Jeremy P. Tarcher.

Washburn, Sherwood. 1960. "Tools and Human Evolution." *Scientific American* 203:36–43.

Watanabe, John M., and Barbara B. Smuts. 1999. "Explaining Religion without Explaining It Away: Trust, Truth, and the Evolution of Cooperation in Roy A. Rappaport's 'The Obvious Aspects of Ritual.'" *American Anthropologist* 101:98–112.

Watchman, Alan. 2000. "A Review of the History of Dating Rock Varnishes." *Earth-Science Reviews* 49:261–77.

Waters, Michael R., Steven L. Forman, Thomas A. Jennings, Lee C. Nordt, Steven G. Driese, et al. 2011. "The Buttermilk Creek Complex and the Origins of Clovis at the Debra L. Friedkin Site, Texas." *Science* 331:1599–1603.

Waters, Michael R., and Thomas W. Stafford Jr. 2007. "Redefining the Age of Clovis: Implications for the Peopling of the Americas." *Science* 315:1122–26.

Watkins, Trevor. 2017. "Architecture and Imagery in the Early Neolithic of South-West Asia: Framing Rituals, Stabilizing Meanings." In C. Renfrew, I. Morley, and M. Boyd, eds., *Ritual, Play and Belief in Evolution and Early Human Societies*, 192–42. Cambridge: Cambridge University Press.

Watson, Ben. 2008a. "Oodles of Doodles? Doodling Behaviour and Its Implications for Understanding Palaeoarts." *Rock Art Research* 25 (1): 35–60.

———. 2008b. "Reply to J. D. Lewis-Williams." *Before Farming* 2008 (1): 1–2.

———. 2009. "Universal Visions: Neuroscience and Recurrent Characteristics of World Palaeoart." PhD diss., University of Melbourne, Australia.

Wernecke, D. Clark, and Michael B. Collins. 2012. "Patterns and Progress: Some Thoughts on the Incised Stones from the Gault Site, Central Texas, United States." In J. Clottes, ed., *L'art Pléistocène dans le monde*, 669–81. Préhistoire, art et sociétés nos. 65–66. Tarascon-sur-Ariège, France: Société Préhistorique Ariège-Pyrénées. Compact disc.

Wernecke, D. Clark, Michael B. Collins, James M. Adovasio, and Sam Gardner. 2006. "A Tradition Set in Stone: Engraved Stone Objects from the Gault Site, Bell County, TX." Poster presented at the annual meeting of the Society for American Archaeology, San Juan, Puerto Rico.

White, Randall. 1989. "Visual Thinking in the Ice Age." *Scientific American* 260 (7): 92–99.

White, William G. 1992. "Beyond Art: Toward an Understanding of the Origins of Material Representation in Europe." *Annual Review of Anthropology* 21:537–64.

———. 2005. "Anthropomorphic Petroglyphs of the Pahranagat Region." Paper presented at the annual meeting of the Society for American Archaeologists, Salt Lake City, UT.

Whiting, John W. M. (1986). "George Peter Murdock, (1897–1985)." *American Anthropologist* 88 (3): 682–86. doi:10.1525/aa.1986.88.3.02a00120.

Whitley, David S. 2000. *The Art of the Shaman: Rock Art of California*. Salt Lake City: University of Utah Press.

———. 2009. *Cave Paintings and the Human Spirit: The Origin of Creativity and Belief*. Amherst, NY: Prometheus Books.

———. 2013. "Rock Art Dating and the Peopling of the Americas." *Journal of Archaeology* 2013:1–15. doi:10.1155/2013/713159.

Whybrow, Peter. 1984. "Contributions from Neuroendocrinology." In K. Scherer and P. Ekman, eds., *Approaches to Emotion*, 59–72. Hillsdale, NJ: Erlbaum.

Wilke, Philip J., J. Jeffrey Flenniken, and Terry L. Ozbun. 1991. "Clovis Technology at the Anzick Site, Montana." *Journal of California and Great Basin Anthropology* 13 (2): 242–72.

Williams, Gregory E. 2012. "Rock Art and Pre-Historic Ritual Behaviour: A Landscape and Acoustic Approach." *Rock Art Research* 29 (1): 35–36.

Wilmsen, Edwin N., and Frank H. Roberts Jr. 1978. "Lindenmeier 1934–74: Concluding Report on Investigations." *Smithsonian Contributions to Anthropology* 24. Washington, DC: Smithsonian Institution Press.

Wiltermuth, Scott S., and Chip Heath. 2009. "Synchrony and Cooperation." *Psychological Science* 20 (1): 1–5.

Woody, Alanah. 2000. "How to Do Things With Petroglyphs: The Power of Place in Nevada, USA." PhD diss., University of Southhampton, England.

Worringer, Wilhelm. 1953/1911. *Abstraction and Empathy (Abstraktion und Einfühlung)*. Trans. by M. Bullock. Reprint, New York: International Universities Press.

Wright, Duncan, Sally K. May, Paul S. C. Taçon, and Birgitta Stephenson. 2014. "A Scientific Study of a New Cupule Site in Jabiluka, Western Arnhem Land." *Rock Art Research* 31(1): 92–100.

Wyatt, Simon. 2010. "Psychopomp and Circumstance: An Interpretation of the Drums of the Southern Trichterbecher-Culture." In R. Eichmann, E. Hickmann, and L.-C. Koch, eds., *Musical Perceptions—Past and Present: On Ethnographic Analogy in Music Archaeology*. Studien zur Musikarchäologie 7. Orient-Archäologie 25:129–50. Rahden, Germany: Verlag Marie Leidorf.

Xygalatas, Dimitris. 2012. *The Burning Saints: Cognition and Culture in the Fire-Walking Rituals of the Anastenaria*. London: Acumen.

Younkin, Elva, ed. 1998. *Coso Rock Art: A New Perspective*. Maturango Museum Publication no. 12. Ridgecrest, CA: Maturango Press.

Zeifman, Debra, and Cynthia Hazan. 2008. "Pair Bonds as Attachments: Reevaluating the Evidence." In J. Cassidy and P. R. Shaver, eds., *Handbook of Attachment: Theory, Research, and Clinical Applications*, 2nd ed., 436–55. New York: Guilford Press.

Zeki, Semir. 1999. *Inner Vision: An Exploration of Art and the Brain*. Oxford: Oxford University Press.

Zilhão, João, Diego E. Angelucci, Ernestina Badal-García, Francesco d'Errico, Floréal Daniel, et al. 2010. "Symbolic Use of Marine Shells and Mineral Pigments by Iberian Neandertals." *Proceedings of the National Academy of Sciences* 107 (3): 1023–28.

Zubchuk, Tamara. 2016. "Paleolithic Jewelry: Still Eye-Catching After 50,000 Years." *The Siberian Times*, October 31, 2016.

Züchner, Christian. 2001. "Dating Rock Art by Archaeological Reasoning—An Antiquated Method?" www.uf.uni-erlangen.de/publikationen/zuechner/rockart/dating/archdating.html.

INDEX OF PLACES AND SITES

INDEX OF SUBJECTS AND NAMES